Raphael

Roger Jones and Nicholas Penny

Raphael

Yale University Press · New Haven and London · 1983

For Francis and Larissa Haskell

Copyright © 1983 by Yale University

10 9 8 7 6 5

Filmset in Monophoto Bembo and designed by Faith Brabenec Hart

Printed and bound in Slovenia by Gorenjski tisk, Kranj
by arrangement with Korotan, Ljubljana

Library of Congress Cataloging in Publication Data

Jones, Roger, 1947 - 86
 Raphael.

 Includes index.
 1. Raphael, 1483 - 1520. I. Penny, Nicholas,
1949 - II. Title.
N6923.R33J6 1983 759.5 83 - 1390
 ISBN 0-300-03061-4
 0-300-04052-0 (pbk)

(title page) Detail from the *Galatea* (Plate 106).

Preface

In this account of Raphael's achievements and ambitions as a painter, architect, archaeologist and entrepreneur we have tried to emphasise the purposes for which his art was designed. The works now preserved in museums and galleries once served as luxury decorations, diplomatic presents, love tokens and devotional aids, and announced or reinforced dogmatic beliefs, political alliances, social status and dynastic pride. We have also endeavoured to attend as closely as possible to the qualities which Raphael's contemporaries and near contemporaries valued in his art, as well as those that are apparent to us. We hope that it is a full account, but there are a number of paintings and buildings and numerous drawings which we have not discussed.

We know little of Raphael's personality compared with what we know of Leonardo's and Michelangelo's, but it is clear that he was not a rebel, a victim or a failure—which perhaps is one of the reasons for his diminished popularity in modern times. Raphael was also less obviously and less profoundly original as an artist than Leonardo or Michelangelo. Although he was perhaps more influential than either, or than any other European artist, this too has not helped his reputation: a century after his death his works began to be adopted as models for academic instruction and this has determined the rather frigid respect which has often replaced the delight and amazement found in Vasari.

We have depended greatly on the labours of other historians, and must mention in particular Golzio's anthology of documents and early sources, Fischel's magisterial corpus of drawings (now admirably continued by Konrad Oberhuber) and, from among the many monographs, catalogues and articles, the invaluable contributions of Christoph Frommel and, particularly, of John Shearman. To him, and to Howard Burns, we owe an additional and incalculable debt, as we were once their students at the Courtauld Institute.

Most of the text has been read by Francis Haskell and enormously improved by his criticisms. Caroline Elam, Antony Griffiths, David Landau and Michael Hirst have helped us with Raphael's architecture, with the prints and with other queries. John Sparrow translated some Latin. The University of Manchester provided travel grants. We are also grateful to the following: Jonathan Alexander, Sylvie Béguin, Michael Clarke, Sophie Decamps, Monsignor Pietro Garlato, Philip Gaskell, Craig Hartley, John Henderson, Rupert Hodge, Daniela Lamberini, Amanda Lillie, Fabrizio Mancinelli, Bruno Mantura, Jean-Michel Massing, Arnold Nesselrath, Serenita Papaldo, Anne Penny, Paul Quarrie, Martin Royalton-Kisch, Mary Wall.

We would not have completed this book but for the incentives, tolerance, skill and hard labour supplied by John Nicoll and Faith Hart of Yale University Press.

Detail of the '*Fornarina*' (Plate 189)

Contents

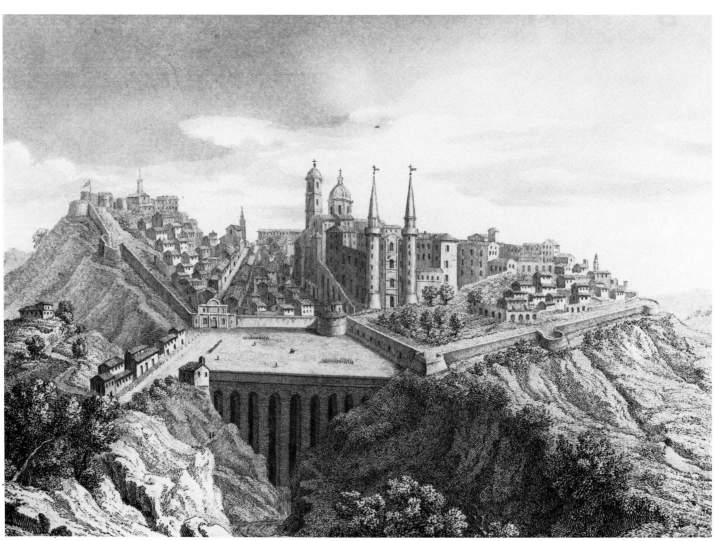

1. A. Marchetti (after Agostino Nini).
View of Urbino and the Ducal Palace from the west. Engraving, *c.* 1850.

I. Raphael Son of Giovanni Santi of Urbino

2. Unknown artist. *Duke Federigo da Montefeltro with his son Guidobaldo*. Oil on panel, *c.* 1477, 134 × 77 cm. Ducal Palace, Urbino.

3. Bernardo Pinturicchio. *Pope Alexander VI at Prayer*—detail from the *Resurrection*. Fresco, 1492–5. Sala dei misteri della Fede, Borgia Apartments, Vatican Palace, Rome.

ON 22 JULY 1444, at three in the morning, the Lord of Urbino, Oddantonio da Montefeltro, was assassinated by citizens outraged at his debaucheries. Federigo, the bastard half-brother of Oddantonio, then aged twenty-two, and a trained soldier, was soon at the city gates with an armed band. Having agreed to make no reprisals and to rule justly he was elected by popular voice to succeed his brother. For nearly forty years he governed with prudence and humanity. He was unanimously praised by contemporary chroniclers, and his reputation remains undented by modern historians.

Like the lords of many other fiefs in what were ostensibly the Papal States Federigo acted as a mercenary commander. His own territories lay between those of Venice, Florence and Rome, and his employment depended chiefly upon the friction between these states and those of Milan and Naples. Federigo served with great skill, and still more remarkable integrity, all these great powers at some time, but most of all he served the Popes. He was able to extend his own rugged Apennine territories into much of the fertile March of Ancona. Urbino enjoyed peace and benefited from the wars which Federigo waged elsewhere, and many of his subjects found employment in his army. The profits of war kept taxes low at home and also enabled Federigo to build one of the finest palaces, establish one of the most admired courts, and assemble one of the largest libraries of the period.[1] Beautifully represented in the marquetry panelling of the *studiolo* are his armour, his books, and his musical and scientific instruments. Above the panelling great writers and sages were painted, as if seen in a series of windows, conversing in pairs, each one, except Moses, holding a beautifully bound book. There were other paintings and some antique sculpture[2] at the court, but the greatest treasure, after the library, was the set of tapestries woven by a team of Flemings.

Raphael was born in Urbino on 28 March or 6 April, in 1483,[3] the year after Federigo's death. Under Duke Guidobaldo, Federigo's son and successor, Urbino retained much of its reputation and some of its splendour, but it was not secure from Cesare Borgia, the ambitious son of Pope Alexander VI, who in 1502 treacherously annexed the city, removing the books, the statues and the tapestries.[4]

Later in 1502 Guidobaldo managed to return briefly to Urbino, but it was only in the following year with the death of Alexander VI and the crumbling of his son's power, and the election of a relative of Guidobaldo as Pope Julius II, that the Duke was firmly re-established in Urbino and the court could flourish again. It was in these years that Guidobaldo's Duchess, Elisabetta Gonzaga, fostered the elegant literary circle described in *The Courtier*, the celebrated imaginary dialogues by Baldassare Castiglione (Plate 169) who was resident there together with Pietro

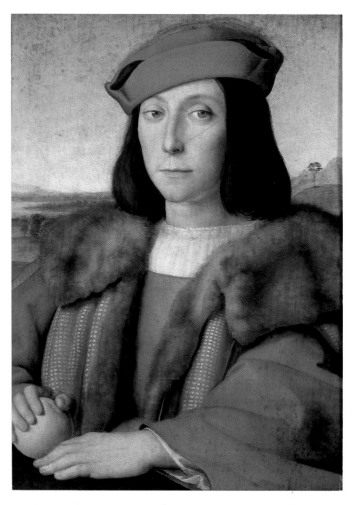

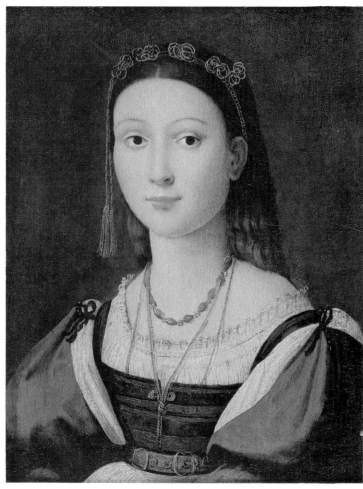

4. *Portrait probably of Francesco Maria della Rovere*. Oil on panel, *c.* 1505, 47 × 35 cm. Uffizi, Florence.

5. Perhaps Raphael. *Portrait of a Girl*. Oil on panel, *c.* 1505, 27 × 21.5 cm. (Undergoing restoration in Italy.)

6. *St George*. Oil on panel, *c.* 1505, 29 × 21 cm. National Gallery of Art, Washington, D.C.

Bembo and Bernardo Bibbiena (Plate 143)—all three were to become close friends of Raphael.

Guidobaldo, who was crippled and impotent, had adopted as his heir Francesco Maria della Rovere (Plate 4), his nephew who was also the nephew of Pope Julius II. The boy's father had been Prefect of Rome and Lord of Sinigaglia, and his mother, Giovanna, was known as the *Prefetessa*. At the birth of Francesco Maria in 1490 the *Prefetessa* commissioned for the church of S. Maria Maddalena in Sinigaglia an altarpiece of the Annunciation from Raphael's father, Giovanni Santi of Urbino,[5] a painter of whom she was especially fond. Santi is also recorded as painting portraits (and copying them) for the Duchess Elisabetta and for her brother Francesco Gonzaga's court at Mantua during the early 1490s.[6] He was a poet, the author of a rhymed chronicle of the life of Duke Federigo, as well as a painter, and this may well have helped him to establish himself at court, for he was responsible it seems for both the text and the decor of the masque (featuring a debate between Juno and Diana on matrimony) devised for the Duke's marriage celebrations in 1488,[7] and probably for other courtly entertainments of that period. His son, Raphael, must have spent his early years as he spent his final ones—at, or close to, a great court.

In his rhymed chronicle Santi takes Federigo's visit to Mantua in the last year of his life as the pretext for praise of the court painter there, Mantegna, whom he considers to be the greatest of all living artists. Then follows a discourse on the value of the visual arts in which he argues the by now familiar idea that painters should be esteemed like poets and historians. Santi also praises Van Eyck and Rogier van der Weyden as masters of oil painting, and supplies a long list of Italian masters including 'two young men equal in years and fame', Leonardo da Vinci and Pietro Perugino—a *divin pittore*.[8] When Santi came to consider his son's education Perugino would have been an obvious choice. He was active in both Perugia and Florence,

2

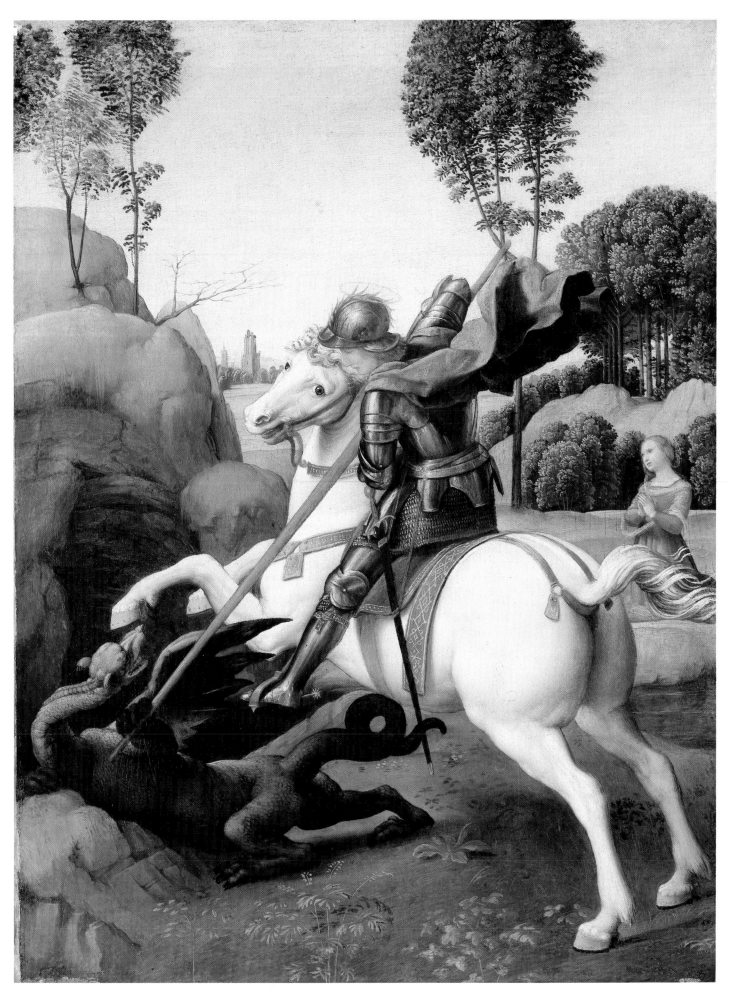

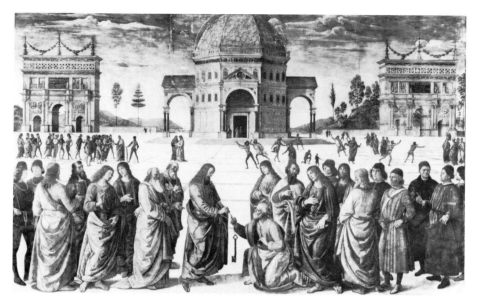
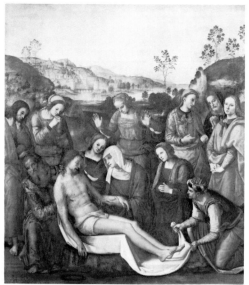

perhaps keeping assistants employed in both cities, and he had been employed in Rome in Sixtus IV's new chapel (the Sistine Chapel—Plate 7).

In 1500 the Sienese banker Mariano Chigi wrote to his son Agostino in Rome seemingly to check whether he was right in thinking that Perugino was the best artist for the altarpiece he wished to commission for the family chapel and to enquire whether there were promising pupils of his in Rome (he had it seems heard of Pinturicchio) whose services could be obtained more cheaply. Agostino replied that Perugino was considered the best.[9] A surer token of his high standing at that date is the fact that Isabella d'Este, the Marchioness of Mantua, an avid and exacting collector of works of art, began to pester him for a picture. In April 1504 she sent her protégé Lorenzo Leombruno to study with him.[10]

Perugino was one of the most proficient among the first generation in Italy to paint extensively in oil. As an example of his work in this medium we may consider his *Lamentation over the Dead Christ* (Plate 8) painted in 1495 for the nuns of S. Chiara, Florence, which was praised for its colour, its landscape and its sentiment. Like the majority of his paintings it provided 'a visible pattern to priests, attendants and worshippers of what the course of their invisible thoughts should be'.[11] Every expression and gesture is one of meek and tender piety, often with only slight differences between them—this is the 'angelic and most sweet air' especially admired in his work.[12] The figures, including the young males, seem incapable of strenuous activity. The mood is extended to the landscape, which is entirely free of distracting incidents. Into the spiritual world of such paintings there are fewer topical and secular interpolations than in the work of most of his contemporaries. Perugino's works enjoyed such a reputation that 'merchants began to traffic in them and exported them at no small profit', and one merchant offered the nuns three times as much for this picture as they had paid, but they would not part with it because Perugino declared himself uncertain that he could repeat it for them. The story is surprising because Perugino, although he did not duplicate this composition, certainly employed every pose, gesture and face elsewhere and was, ten years later, severely criticised by young Florentine artists for repeating himself.[13] Pressure of work and the production line of his very large workshop doubtless encouraged the reduction of his art to formulae.

Raphael, when still a child, was, according to Vasari, placed by Santi in Perugino's shop despite the tears of his mother.[14] Santi went to Perugia to arrange it but found Perugino away and had to wait. This gratuitous detail (which tallies with our impression of Perugino as constantly on the move) gives credibility to Vasari's account, which, however, is questionable for other reasons. Raphael's mother died

4

in 1491 when he was only eight. It was quite possible for apprenticeships to begin at seven or eight, but not probable that Raphael had at that age, as Vasari claims, already been of significant assistance to his father, who died on 1 August 1494. Raphael's guardian was his only paternal uncle, Bartolomeo, a priest, who during the following years was engaged in litigation with Raphael's stepmother—Raphael is mentioned in documents of 1495, 1497, 1499 and May 1500 relating to this, but only in the last of these is he described as absent from Urbino.[15] Most modern writers have therefore agreed that Raphael's association with Perugino began at about the turn of the century when Perugino was engaged in Perugia decorating the hall of the corporation of bankers (the Collegio del Cambio). At this age Raphael would have been an assistant rather than a pupil—he was anyway described as *magister* by 1501. But there is no evidence that he ever worked for Perugino except the word of Vasari.[16] However, Raphael's early style was so close to Perugino that some association is likely—as we shall see.

Raphael's early paintings may be divided into altarpieces made for Città di Castello and Perugia, and smaller works, both devotional and secular, many of them made for the court at Urbino. And although both categories of work were produced simultaneously it is convenient to consider them separately.

7. Pietro Perugino. *Christ giving the Keys to Peter*. Fresco, 1481–2. Sistine Chapel, Rome.

8. Pietro Perugino. *Lamentation over the Dead Christ*. Oil on panel, dated 1495, 214 × 195 cm. Pitti Palace, Florence.

⋆ ⋆ ⋆

Raphael seems to have travelled much during the first eight years of the new century, but he is recorded in Urbino in 1504 and 1506 and twice in 1507 and kept in contact with the court, which flourished after the troubles of 1502 and 1503. His patrons there were the patrons of his father. It was the Duchess, according to Serlio, who first fostered Raphael's genius,[17] and the *Prefetessa* was especially interested in him, as is demonstrated by her letter of recommendation of 1 October 1504 to Pietro Soderini, *Gonfaloniere* of the Florentine Republic:

> The bearer of this will be found to be Raffaele, painter of Urbino, who, being greatly gifted in his profession [*avendo buono ingegno nel suo esercizio*] has determined to spend some time in Florence to study. And because his father was most worthy and I was very attached to him, and the son is a sensible and well-mannered [*discreto, e gentile*] young man, on both accounts, I bear him great love . . .[18]

On 21 April 1508 we find Raphael writing to his maternal uncle Simone Ciarla with filial affection (*Carissimo quanto patre*):

> I have received your letter from which I learn of the death of our most illustrious Duke [Guidobaldo] on whose soul may God have mercy and in truth I cannot read your letter without tears but that which comes to pass we cannot change and we must submit with patience to the will of God. I wrote the other day to my uncle the priest [Bartolomeo] to get him to send me the small panel which was the cover for the *Prefetessa*'s Madonna. But he hasn't done so and I'd be grateful if you would remind him so that I can oblige the lady.[19]

From this it has been deduced that Raphael had painted a Madonna for the *Prefetessa* and was now working on a cover for it—which is very likely—but he might have been making (or revising or restoring) a cover for a Madonna by someone else.

Vasari records two Madonnas by Raphael in the possession of Duke Guidobaldo which were 'small but very beautiful', and also a *Christ in the Garden of Olives*, again quite small, and finished like a miniature.[20] This last seems in fact to have been commissioned by the Duchess to present to the Blessed Michele Fiorentino of the hermitage at Camaldoli. Bembo wrote to the latter on 6 May 1507 that the Duchess had determined to send him something of hers in return for the chaplet he had given

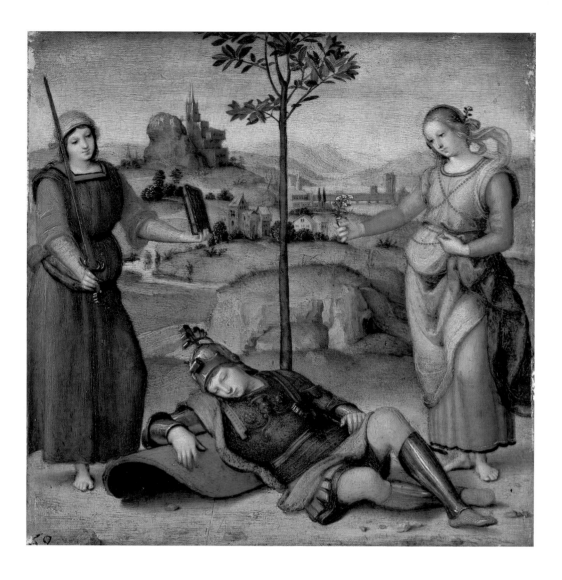

her but that 'because she could find no gift at the time which seemed worthy of your virtue she had ordered a picture from the hand of a great master of painting [to be made] with all possible speed'. It was nearly ready but had been delayed by the harsh winter which made painting difficult and also by the exquisite and highly finished character of the work—*sottile et minuto molto*.[21]

Raphael also executed a portrait of Bembo and at least one portrait of Guidobaldo which has not been traced.[22] Guidobaldo's heir, Francesco Maria, the *Prefetessa*'s son, the *Prefetino*, who was to succeed to the Duchy in 1508, may, however, be the subject of a small panel (Plate 4) generally agreed to be by Raphael and from the collection of the Dukes of Urbino which shows a youth, in winter dress with a fur collar and much gold thread, holding an apple. If the sitter is correctly identified and was studied in Urbino from the life and at the same time as his clothes (which, with court portraiture in this period, is not to be taken for granted), then this is likely to date from the winter of 1505/6.[23] An attractive portrait of a girl which was briefly in the Boston Museum of Fine Arts in the early 1970s was also perhaps by Raphael (Plate 5), and it has been persuasively proposed that the sitter might be Eleanora, eldest daughter of Isabella d'Este, whose betrothal by proxy to Francesco Maria was celebrated on 1 March 1505 in the Vatican. The Della Rovere in Rome had a drawing of the girl sent from Mantua but are known to have wanted a painting.[24] Betrothals were in any case a common pretext for small portable portraits.

Three other paintings by Raphael may be connected with the court of Urbino and these too are portable works. Two of them, one of St George slaying the dragon and

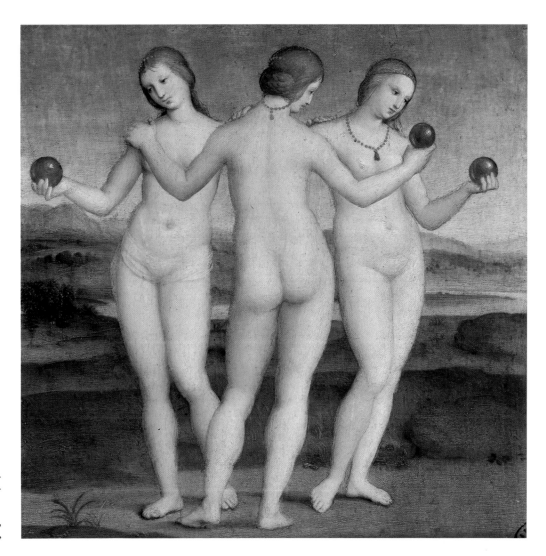

9. *Dream of Scipio* ('*Vision of a Knight*'). Oil on panel, *c.* 1504, 17 × 17 cm. National Gallery, London.

10. *The Three Graces.* Oil on panel, *c.* 1504, 17 × 17 cm. Musée Condé, Chantilly.

11. Hans Memling. *St John the Baptist.* Oil on panel, *c.* 1470, 32 × 24 cm. Alte Pinakothek, Munich.

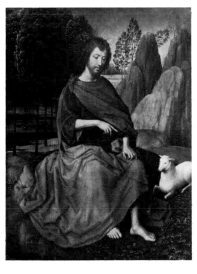

the other of St Michael pirouetting on top of a squashed demon, belong together although how exactly they were displayed is uncertain. Both saints were sometimes connected with knightly orders, St George being patron of the English Order of the Garter,[25] and St Michael of the French Ordre de Saint Michel,[25] and the *Prefetessa*'s father and brother 'were honoured with the first, her husband and son with the second', so that the pictures might have been commissioned by her, or for her.[26] It seems an odd commission all the same. St George is not necessarily to be connected with the Garter, and the possibility only arises here because of Raphael's other painting of St George in which the insignia of the Garter are actually featured. This double picture could equally have belonged to someone whose name saints or whose children's name saints were George and Michael.[27] It is of similar scale to a diptych by Memling which then belonged to a relative of Bembo, one shutter of which was painted with the Baptist (Plate 11).[28] Small Flemish devotional pictures of this sort seem to have been kept with jewellery and plate.

Federigo da Montefeltro had been elected to the Order of the Garter in 1474, and early in 1504 Henry VII of England sent ambassadors to Julius II to present the same honour to Federigo's son and successor Guidobaldo. It was an elaborately disguised bribe to persuade him to encourage Julius II to grant a dispensation for the marriage of the Prince of Wales to his brother's widow Catherine of Aragon. Castiglione was chosen to act as the Duke's substitute in the ceremony of installation at Windsor. Having been dubbed Knight of the Golden Spur, he eventually set out on 24 July 1506, taking with him falcons, horses and other presents. An old tradition connects a painting of *St George* by Raphael (Plate 6) with Castiglione's visit, and it is

tempting to believe that it was among the presents he brought. But it is more likely to be the *St George* Raphael painted on panel for the Duke of Urbino, which is mentioned by Lomazzo later in the sixteenth century.[29] In either case it is doubtless connected with the Duke's becoming a Knight of the Garter. The painting is remarkable for its miniature precision, and the flowers and the distant trees with their stippled highlights show that Raphael must have known Memling's diptych.

Another pair of paintings by Raphael surely belongs to this category of courtly pictures. The little panel traditionally known as the *Vision of a Knight* (Plate 9) is now believed to illustrate an episode in the Latin epic of the Punic Wars, the *Punica* of Silius Italicus: Scipio Africanus, resting beneath a bay tree has a dream in which he is presented with the choice which once faced Hercules—that is the choice between Virtue and Pleasure. Pleasure, as described by the poet, has fragrant hair and is loosely draped with a shining robe of Tyrian purple and gold. This would be the figure in the painting with a flower in her hair and wearing a flowing and shimmering dress. Virtue wears white in the poem (but not in the picture) and carries herself more soberly. She informs Scipio that her dwelling is on a hill reached by a steep and rocky path, and this can be seen behind her in the painting.[30] This painting was recorded in the Borghese collection in 1650 together with a panel of identical size adorned with the Three Graces (Plate 10).[31] The different scale of the figures suggests that they did not form a diptych, but one might have formed the lid of the other. It was conventional to liken a young knight to Scipio, as may be seen for instance in the opening page of Vespasiano da Bisticci's life of Federigo da Montefeltro,[32] and the pair would have made a flattering and edifying present at court.

The painting does surely represent Scipio, but the ladies do not seem to be in competition as they are in the poem, and the book, sword and flower they hold are not mentioned in it, although Pleasure does refer to the flower of the hero's youth. These attributes in the painting obviously represent the aspirations of the scholar, soldier and lover (or perhaps poet). That a young knight should be all these, but especially the first two, was a commonplace in courtly literature, and, to judge by *The Courtier* in which Lodovico Canossa and Bembo debate whether arms or letters should have priority in courtly education,[33] it was just the sort of subject the Duchess of Urbino most enjoyed hearing discussed. The *Three Graces* may also refer to the gifts possessed by—or thought to be appropriate for—the young knight to whom the pictures were perhaps addressed.

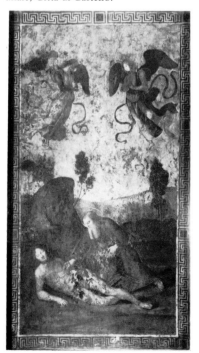

12. *The Holy Trinity with Sts Sebastian and Roch.* Oil on canvas, *c.* 1500, 166×94 cm. Pinacoteca Comunale, Città di Castello.

13. *The Creation of Eve.* Oil on canvas, *c.* 1500, 166×94 cm. Pinacoteca Comunale, Città di Castello.

★ ★ ★

Whatever the importance of Raphael's work for the court of Urbino, he was not attached to the court in the sense that his father may have been, or that Leonardo, Mantegna, or Costa were, or that he would himself be in the Rome of Leo X. He was not a salaried member of the household and he seems not to have been involved in painting frescoes for the palace or in making decor for court festivities. Timoteo Viti, after having worked for Francia in Bologna (a goldsmith and painter much admired by Guidobaldo),[34] returned to Urbino in 1495, surely not coincidentally, shortly after Santi's death and did, it seems, enjoy such a position, decorating a private room of the palace with an Apollo and two muses, providing other decorations there, fashioning important diplomatic gifts (such as horse armour for the King of France), making the scenery for the performance of Bibbiena's comedy *La Calandria* and the ephemeral triumphal arches for the wedding of Francesco Maria.[35]

Timoteo was also given, often no doubt on account of his connections at court, much work in the churches of Urbino and its neighbourhood. Raphael, who was fourteen years younger and may indeed have been Timoteo's pupil in the 1490s,

would not at first have been in a position to compete, and it is not surprising that Raphael's earliest large paintings were not executed for Urbino but for Città di Castello. This town, about a day's ride from Urbino, across the mountains on the road to Perugia, was ruled by the Vitelli, *condottieri*, sometimes rivals with the Dukes of Urbino.

Raphael's earliest surviving paintings may be the standards painted for the Confraternity of the Holy Trinity of Città di Castello, one of the oldest lay orders in the city. Such confraternities played an important part in the devotional and ceremonial life of Italian cities in this period and the standards when not employed in their processions were apparently displayed on either side of the high altar of their church (Plates 12–13).[36] On one of the long rectangles of cloth surrounded by a key-pattern border Sts Sebastian and Roch are depicted kneeling, as intercessors for suffering (and sinful) mankind, on each side of Christ on the Cross, supported by God the Father and accompanied by the Dove, thus forming the Trinity. Sebastian and Roche are plague saints and the standard was probably vowed during the plague that struck the city in 1499. On the other cloth, which is of the same size and has sometimes been thought to be the reverse of the same banner, angels hover over God the Father as he prepares to extract one of Adam's ribs. Although standards were not always considered as jobs for junior or journeymen painters (both Perugino and Signorelli were happy to accept such work at the height of their fame), this confraternity might

14. *Angel with Inscription* (from the altarpiece of St Nicholas of Tolentino). Oil on panel, 1501, 57 × 36 cm. Musée du Louvre, Paris (prior to cleaning).

15. *Drawing for the altarpiece of St Nicholas of Tolentino*. Grey chalk with white heightening over indications with the stylus, 1501, 39.5 × 25 cm. Musée Wicar, Lille.

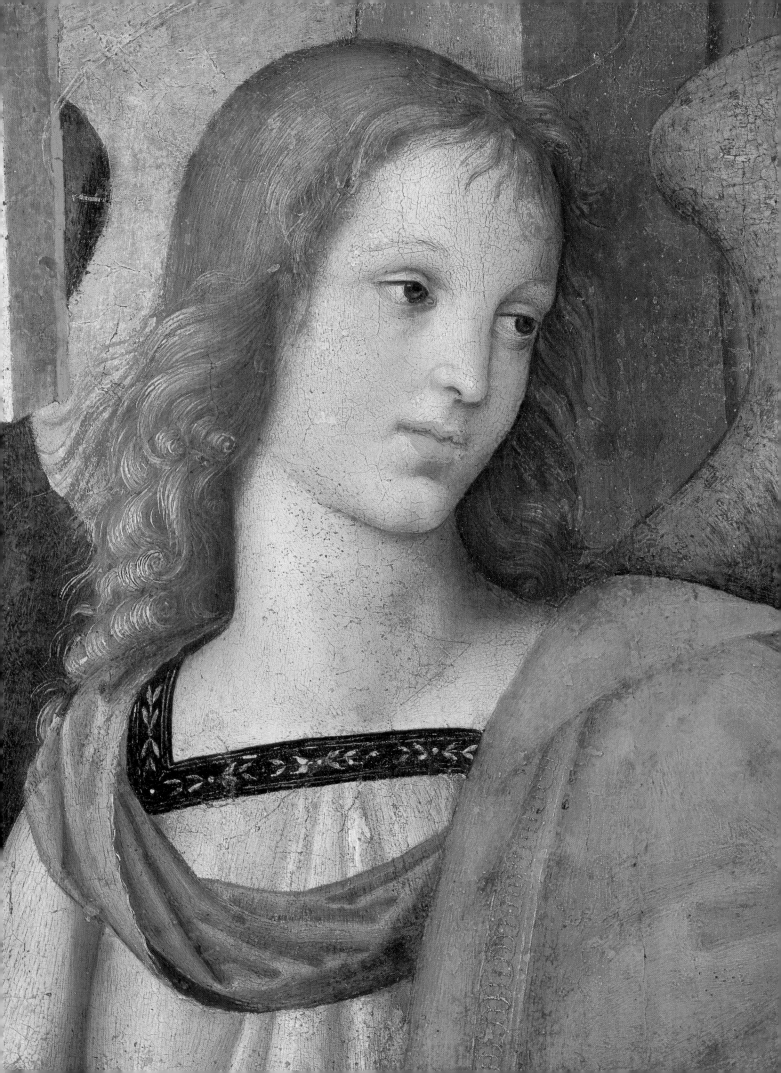

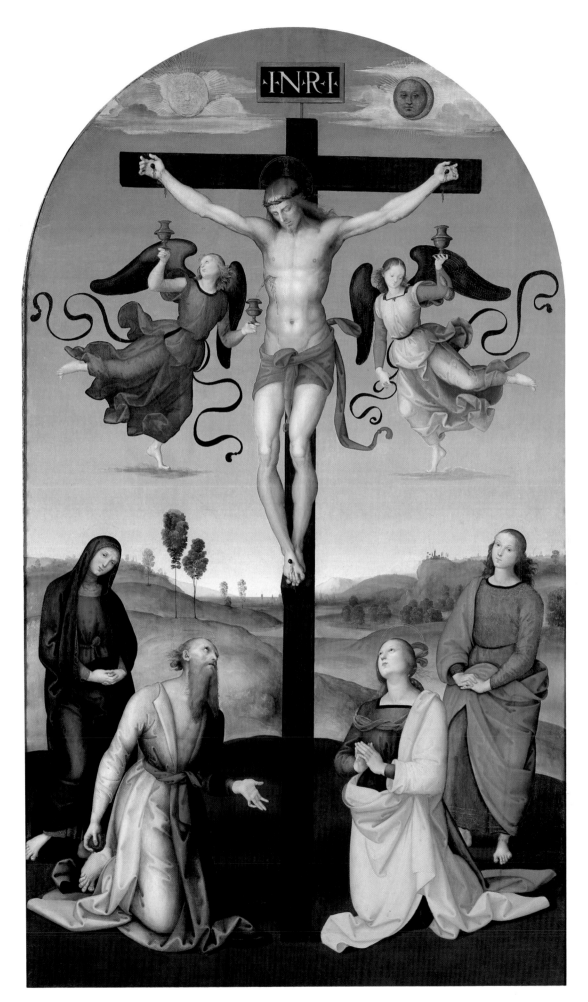

16. *Head of an Angel* (from the altarpiece of St Nicholas of Tolentino, edges trimmed). Oil on panel, 1501, 31 × 27 cm. Pinacoteca Tosio Martinego, Brescia.

17. *Crucifixion with Sts Mary Virgin, Mary Magdalene, John and Jerome*. Oil on panel, c. 1503, 280 × 165 cm. National Gallery, London.

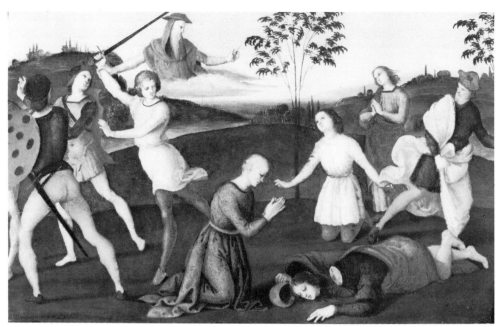

well have been looking for one who would not be expensive or keep them waiting.

The attribution of these almost ruined banners to Raphael is based on their style and on that of the preparatory drawings for them, but the altarpiece which Andrea di Tommaso Baroncio commissioned in 1500 for his chapel in Sant'Agostino in Città di Castello is documented by the contract he drew up on 10 December with the two masters (*magistri*), Raphael and Evangelista di Pian di Meleto, and there exists a receipt for the painting's delivery on 13 September 1501.[37] Evangelista is mentioned as a member of Santi's household in 1483. Later he worked for Timoteo Viti and other masters of Urbino.[38] Payment was as usual to be in three instalments: the first is specified as an advance for colours, the second for living expenses when work was under way, and the third to be given on completion.

The altarpiece was damaged in an earthquake and then cut into several pieces, three of them are in the museums of Brescia (Plate 16) and Naples. Another (Plate 14) has recently been acquired by the Louvre.[39] From a copy, from old descriptions and from one of Raphael's drawings (Plate 15) we can tell that St Nicholas of Tolentino—the second great saint of the Augustinian order—stood in the centre with his foot on the devil (portrayed, as Lanzi noted, not as a monster but as an Ethiopian),[40] the miraculous star on his black habit, the silver crucifix (containing a relic of the True Cross) in one hand and in the other the Gospel open at John 15:10.[41] There was a vaulted building with an arch opening onto a landscape behind St Nicholas. To either side of him were angels, and above, interrupting the cornice of the building, half-length figures of the Virgin and of St Augustine (to whom the church was dedicated) emerged from clouds extending crowns. Above them God the Father appeared in a mandorla, with a larger crown. This presentation of the saint was prescribed and it of course largely determined the composition. In the preparatory drawing Raphael seems to be both working this out and at the same time calculating the poses of individual figures. The figure of God the Father belongs to that category of drawing known as a *garzone* study, that is drawn from a youth in the studio (the earliest example of this practice in Raphael's *oeuvre*), whereas the angel is a preliminary sketch; and other angels have not even been indicated. Some of the changes the artist made were obviously needed (the lesser crowns, for instance, were made equidistant from the mandorla), others are unexpected (the devil was entirely reversed, perhaps in deference to ecclesiastical advice). A year or so later the artist would reject as archaic the convention of half-figures, and also the

18. *St Jerome saving Silvanus and punishing Sabinianus* (originally part of the predella of the *Crucifixion*—Plate 17). Oil on panel, *c.* 1503, 23 × 41 cm. North Carolina Museum of Art, Raleigh.

19. Carved stone frame originally around the *Crucifixion* (plate 17) and an altar table, now with a copy of the *Crucifixion*. S. Domenico, Città di Castello.

20. *Life drawing of a boy* (preparatory for the *Coronation of the Virgin*—Plate 23) Silverpoint heightened with white on a ground prepared grey, *c.* 1503, 19.1 × 12.7 cm. Ashmolean Museum, Oxford.

21. *Head of St James* (for the *Coronation of the Virgin*—Plate 23). Grey chalk, *c.* 1503, 27.4 × 21.6 cm. British Museum, London.

scrolls and mandorla, but his angels would still be slightly smaller in scale than the other figures. Above all, however, the way he worked out his compositions and separate poses would become more systematic than the method seen in this drawing.

Perhaps commissioned soon after this painting, but not completed until later and dedicated in 1503, is the *Crucifixion* (Plate 17) painted for Domenico Gavari for his chapel in S. Domenico, Città di Castello.[42] Angels nimbly tiptoe on tiny clouds and catch in vases the blood which drips and spurts from Christ's hands and side. Below, the Virgin and St John stand looking sweetly out at the worshipper while the Magdalene and St Jerome kneel in adoration. Above, as often in Umbrian representations of the Crucifixion, the sun and moon appear, in reference to the disruption of the cycle of night and day when Christ died. The carved stone frame (Plate 19) for this painting survives, prominently featuring, in the frieze above the capitals, the family device—it consisted, significantly, of a hand holding a crucifix. St Jerome, identifiable by the way his chest is exposed so that he can pound it with the rock held in his right hand, is the unexpected participant here, and no doubt reflects the special interests of the patron or of the Dominican order. Two of the panels from the predella or base of the altarpiece survive, and both of them concern St Jerome. In one (Plate 18) he comes out of a cloud to arrest the executioner about to behead Bishop Silvanus and, by 'will-power', simultaneously decapitates the heretical Sabinianus who was responsible for forgeries of his works.

Another altarpiece for Città di Castello, the *Sposalizio* (or *Betrothal of the Virgin*—Plate 24), is dated 1504. At the centre of the painting is the ring of the Virgin, the most precious relic of the city of Perugia which was then in close alliance with Città di Castello—the relic had been stolen from Chiusi only thirty years before and was, as

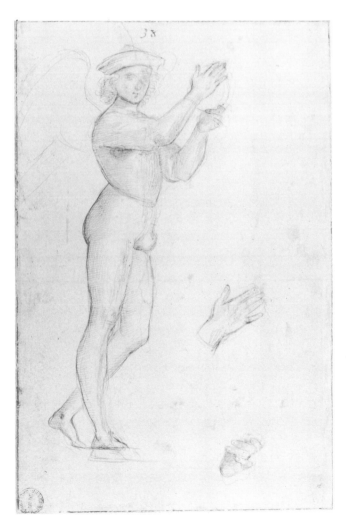

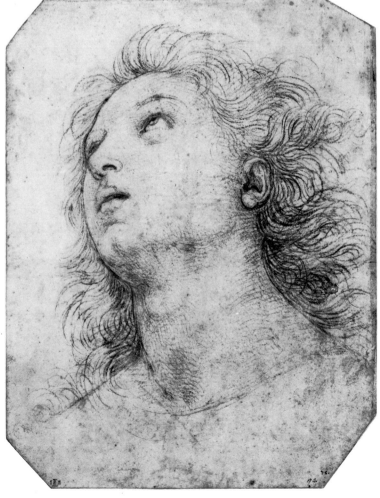

13

any contemporary looking at the altarpiece would have been aware, the subject of fierce political conflict. The altarpiece was commissioned for the Albizzini chapel in S. Francesco.[43] There were altarpieces by Raphael in the churches of the Augustinians and the Dominicans, and now there was one in the Franciscan church too. By this date Raphael was also in demand elsewhere. In fact he must have completed a major altarpiece for the Franciscan church in Perugia.

This was the altarpiece of the *Coronation of the Virgin* (Plate 23) probably commissioned by Maddalena degli Oddi (or perhaps by Leandra degli Oddi—or both) for the family chapel in S. Francesco al Prato. The Oddi were, during the 1480s and 1490s, involved in a series of street battles with the Baglioni, the other leading family in the town, and in 1495 they had been forced to seek exile. In the winter of 1502/3 the Lord of Perugia, Gianpaolo Baglioni, avoided the trap set at Sinigaglia by Cesare Borgia for his mercenary allies (including Vitellozzo Vitelli of Città di Castello), but he recognised that he could not defend Perugia, and the Baglioni quit the city. In February 1503 the Oddi were able to return,[44] and they would naturally have thought of adorning their chapel and honouring the burying place of members of their family who had been murdered in the previous twenty years.

The composition of the painting is divided rather sharply into two because the 'Coronation of the Virgin' is really only a proper description of the upper register, and

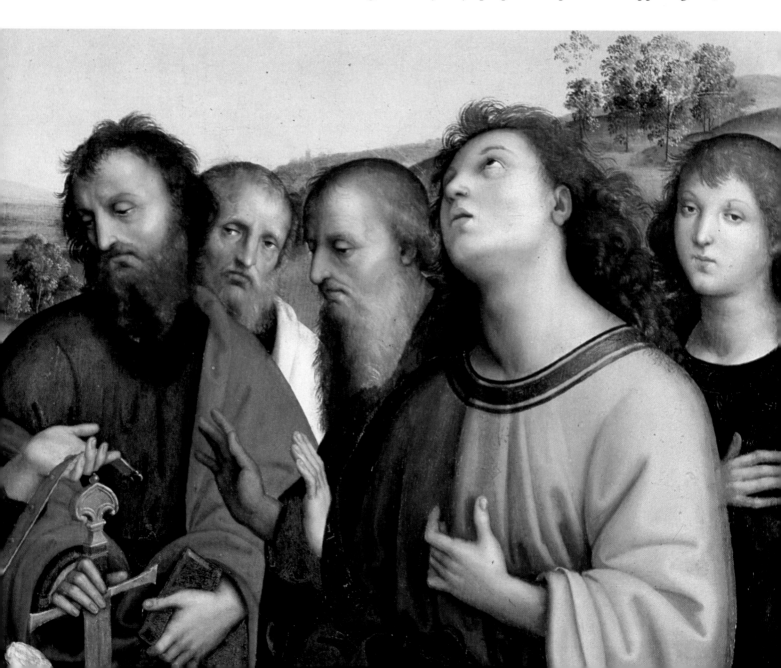

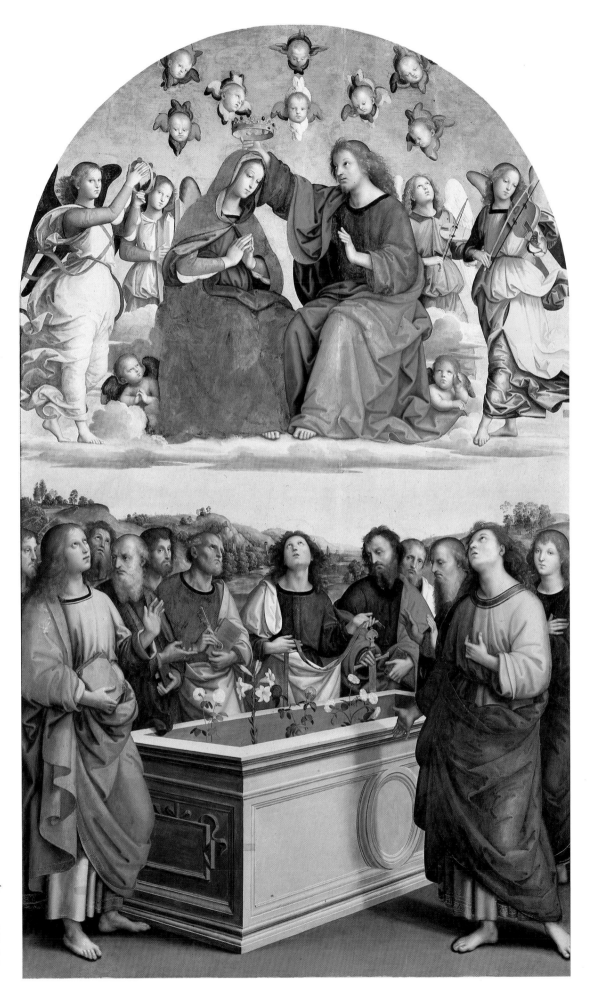

22. Detail of the *Coronation of the Virgin*.

23. *The Coronation of the Virgin*. Oil on canvas (transferred from panel), *c.* 1503, 267 × 163 cm. Vatican Museum, Rome.

below we see, instead of the customary saints and prophets who were believed to have foretold this event or whom the patrons wished to associate with it, the Apostles gathered around the empty tomb, some looking at roses and lilies which have miraculously sprung up inside it and some looking up at the coronation. The subject is really therefore the 'Assumption and Coronation of the Virgin'. This combination of subjects was most unusual[45] and would have required ecclesiastical approval. It also incorporates a third subject. At the centre of the painting between St Peter and St Paul stands St Thomas holding the girdle which the Virgin lowered to him as a tangible token of her assumption. At this date in paintings of this subject Thomas usually appeared as a latecomer catching the girdle in the distant landscape. These subjects, like the *Sposalizio*, were dear to the Franciscans who were then controversially promoting the theological standing of the Virgin Mary. They would have directed this painting very carefully, approving, if not suggesting, the priority of John and James in the foreground, or the way that the Madonna is seated on the same level as her son rather than on a slightly lower cloud.

This painting must have established Raphael as a rival to Perugino, and he soon received other commissions for altarpieces in Perugia, one from the nuns of S. Antonio,[46] one from the Baglioni when they returned to the city, and one from Bernardino Ansidei for the chapel of St Nicholas of Bari in the Servite church of S. Fiorenzo. In the Ansidei altarpiece, the *Virgin and Child enthroned with Saints* (Plate 25), the Baptist, holding a tall crystal cross, and St Nicholas, with his bishop's mitre and the three gold balls by his side, flank a high throne upon which the Madonna follows with her fingers her infant son's precocious literacy. Upon the hem of her mantle is the Latin date MDV followed by a few strokes which are probably merely decorative, but have sometimes been taken as part of the date (i.e. MDVI or MDVII). An old inscription below the fresco by Raphael in the sacristry of the Camaldolite community of S. Severo in Perugia assigns it to 1505 and Raphael may have finished the Ansidei altarpiece during the same period.

In Raphael's small courtly pictures Perugino's influence may often be detected—in the mannerisms of the little finger of Francesco Maria, for instance, or in the armour of the sleeping Scipio (Plates 4, 9). But in these larger paintings it is more obvious because the subject matter is very similar. There is nothing in the nature of Raphael's debt to Perugino in what remains of the St Nicholas of Tolentino altarpiece to suggest that he must have worked with Perugino, but the *Crucifixion* (Plate 17) is a different matter. Here he even seems to exaggerate the fragile physique, the 'angelic' sweetness of expression found in Perugino's work—and in the landscape behind, the rocks have been softened and smoothed, the trees refined into delicate stemmed specimens and the woods formalized as green bubbles. The colours also recall Perugino. In particular the robe worn by the Magdalene of pink, crimson in its shadows but with lemon yellow highlights, can be matched in Perugino's work—for instance in the sleeve of one of the figures in the S. Chiara *Lamentation* (Plate 8). In subsequent paintings Perugino's influence is quite as clear. The *Sposalizio* is remarkably close to Perugino's painting of the same subject. The general format of the Ansidei altarpiece with its vaulted architectural space opening onto a landscape and with a tall throne of gold-brown wood in front was also one which Perugino favoured. Here Raphael has created a 'cool, pearl-grey quiet place, where colour tells for double',[47] and the colour, the scarlet of the coral chaplet suspended from the baldacchino, found also in the lining of the rich deep green of St Nicholas's cape, the crimson of the Baptist's cloak, has the brilliance that Perugino achieved in his best work.

In a contract which Raphael (together with Berto di Giovanni of Perugia) made with the procurator of the Poor Clares of Monteluce (near Perugia) in December 1505[48] it is specified that the altarpiece he agreed to paint for them (but which was not supplied until after his death) should resemble in quality, size, colour, ornament and number of figures the very richly ornamented and crowded painting of the *Coronation of the Virgin* supplied twenty years earlier by Ghirlandaio for S. Girolamo

at Narni. (The painting was in fact virtually copied for other Franciscan churches.) In another contract Perugino agreed to copy features of Raphael's own *Coronation*.[49] Such conditions were more likely to be inserted in contracts by provincial religious communities than by leading families in a city like Perugia. However, it is easy to imagine that when given the commission for the *Sposalizio* he was asked that it should resemble Perugino's important altarpiece of the same subject begun in 1500 for the chapel dedicated to the relic of the Virgin's ring in the Duomo of Perugia,[50] and in the case of the Ansidei altarpiece we may suppose that if Raphael was not requested to work in Perugino's manner then he anticipated the expectation that he would paint in this way. The work by Perugino which it most resembles was in fact one easily available as a model to him—the altarpiece now in the Vatican completed for the magistrates of Perugia in 1495.[51]

The strongest argument for Raphael's having worked in Perugino's studio in some capacity is the fact that his technique is so similar. This is evident in his drawings[52] and still more so in his paintings. The deeper local colours and the shadows are thickly applied by both artists with an oil varnish as the vehicle. By contrast the flesh is 'almost invariably thin, and not infrequently exhibits the white ground underneath', appearing 'embedded' when next to the raised paint of the draperies. The flesh is also often marked by hatchings of the sort expected in tempera painting. The same applies to the light colours such as the grey worn by St Jerome in the *Crucifixion* (Plate 17). The excessive resin in the oil varnish, perhaps because of heat from sun or candles, caused cracking where the vehicle was most thickly applied in the darks and shadows.[53] This cracking was noted by Vasari as a defect of Perugino's works[54] and it may also be seen in Raphael's—for instance in the blue drapery of the Madonna in the Ansidei altarpiece.

Those qualities in Raphael's altarpieces of which we feel Perugino would not have been capable give an idea of what made Raphael already by 1505 one of the most impressive artists in Italy. The most remarkable of these is the lucid compositional geometry, shown not only in the beautiful lines of the flourishing ribbons of the angels in the *Crucifixion*, but also in the intervals between them. It is also evident in the oval frame provided by the curving legs of the musical angels in the *Coronation of the Virgin*. The disciples in this painting surround the sarcophagus much as the mourners in the S. Chiara *Lamentation* surround the dead body of Christ, but the sarcophagus with its sharply cut (and lit) edges provides a strong diagonal movement into space. The interest in linear perspective is far clearer in the *Sposalizio*, where there is no decisive break between foreground and the shadowy distance with its melting horizon. The perspectival geometry is, however, happily reconciled with the geometry of the surface pattern. The receding lines of the pavement, related to the inclined heads of the betrothed couple, converge on the gable of the triangular pediment of the open Temple door. Notable too is the way that the semicircular arch of the altarpiece, if continued, underlines the ring held by Joseph in the centre of the lower, square portion of the picture, and how in the Ansidei altarpiece the diminution of the throne steps is calculated to compensate for the arched top. Raphael's compositions like his figures at this date tend to be highly balanced.

Geometric idealisation may be detected also in the artist's treatment of the human face and body. In a drawing (Plate 21) of the head of St James in the *Coronation of the Virgin* (a type of drawing, perhaps pioneered by Raphael, known as an auxiliary cartoon, employed for important areas of the painting, and complementing the less-detailed cartoon for the entire painting) much of the contour of the left-hand side of the head consists of a single, almost segmental, curve which the chin fails to interrupt and which is continued in the line of the nose and then in the eyebrow. The impulse seems to have been in no way modified by the business of drawing from life. Thus in a silverpoint *garzone* study (Plate 20) for the angel with a tambourine to the left of the Madonna in the *Coronation* the upper torso is reduced to a simple and smooth shape like a pointed egg.

FOLLOWING PAGES

24. *The Betrothal of the Virgin ('Sposa-lizio').* Oil on panel, dated 1504, 170 × 118 cm. Brera, Milan.

25. *Virgin and Child enthroned with Sts John the Baptist and Nicholas of Bari* (the Ansidei altarpiece). Oil on panel, dated (apparently) 1505, 209 × 148 cm. National Gallery, London.

17

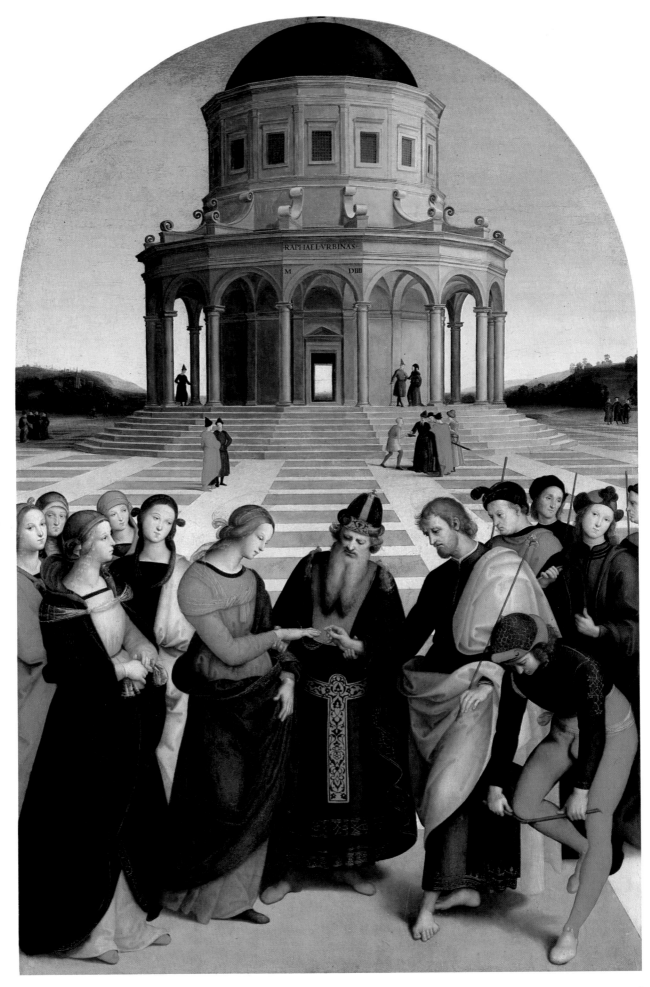

18

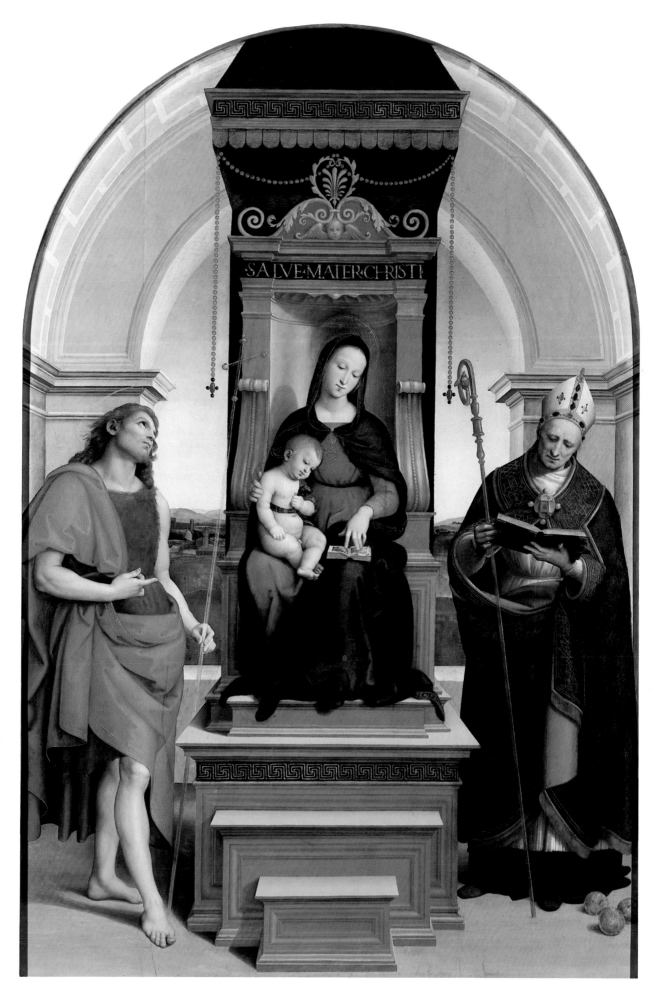

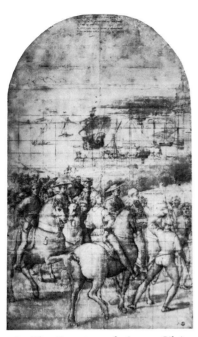

26. *The Departure of Aeneas Silvius Piccolomini for Basle* (preparatory for the fresco in the Piccolomini library, Siena, by Pinturicchio and his workshop). Grey chalk, pen and ink, squared for transfer, 1502–3, 70.5 × 41.5 cm. Uffizi, Florence.

Raphael obviously did not look only at Perugino. Memling has already been mentioned and there are echoes of Signorelli's work (which was well represented in Città di Castello and also to be seen in Urbino), but that artist's ungainly power is alien to the spirit of Raphael's art at this date. Pinturicchio must also be mentioned, for according to Vasari this successful former pupil of Perugino, 'being a friend of Raphael and knowing him to be a draughtsman of the finest quality', invited him to Siena to work with him on the frescoes he was commissioned to paint in 1502 of episodes in the life of Pope Pius II in the new Cathedral library founded by the Pope's nephew Cardinal Francesco Piccolomini (who was himself elected Pope after the death of Alexander VI, but who reigned, as Pius III, for only a month). Raphael may have travelled to Siena with Perugino, who was employed there in the second half of 1502 on the altarpiece for Mariano Chigi and on some lost frescoes[55]—and this was in any case a period when it was wise not to be in Urbino, Città di Castello or Perugia, where all lived in terror of Cesare Borgia.

The help Raphael provided for Pinturicchio took the form of 'drawings and cartoons', and he probably made the finished compositional drawing, squared for transfer and much reworked, which is preparatory for the fresco showing Aeneas Silvius Piccolomini (the future Pius II) setting off for the Council of Basle (Plate 26). Pinturicchio could not accept the empty space in the left foreground and filled it in the fresco with a greyhound, and the more elegant passages in the drawing are either clumsily redrawn or garishly coloured. The noisy vulgarity of the completed work would not, if Raphael ever saw it, have impressed him.

Raphael seems at this stage, however, to have had a rather limited notion of what narrative painting might be. He did not attempt to represent any of the conflict inherent in the story of Scipio, portraying seductive Pleasure and stern Virtue as benevolent sentinels over a passive sleeper. Action he did sometimes attempt, but the interrupted executioner and astounded bystanders in the predella of Jerome and Silvanus, or the disconsolate suitor in the *Sposalizio*, breaking his barren staff, appear to be engaged in a dainty ballet. St George's horse is careless of the venomous menace by its side and rolls its eyes at the beholder. On the other hand the detail of the woman in the *Sposalizio* who unconsciously feels her ring finger as she witnesses the ceremony is a remarkably effective narrative device.

It is clear if we imagine the sleeping knight as a nude or try in the Ansidei altarpiece to relate the Baptist's legs to his hips that Raphael could not always convincingly articulate the human body (and certainly had little understanding of anatomy). Moreover, despite his feeling for pictorial geometry, his linear perspective is not always proficient, for a plan of the throne in the Ansidei altarpiece shows that it is much too shallow to sit on. Raphael was well aware that he had much to learn, as is clear from the *Prefetessa*'s letter. He was attracted to Florence because of this, but above all because he wished to familiarise himself with the stupendous achievements of Leonardo and Michelangelo to be seen there, reports of which, Vasari assures us,[56] had reached him.

II. '. . . in Florence to study'

THE LETTER of recommendation to the *Gonfaloniere* of the Florentine Republic which the *Prefetessa* wrote for Raphael was dated 1 October 1504, and it is reasonable to assume that Raphael arrived in Florence soon afterwards. Since his intention was to study he would have stayed there for a few weeks at the least, but there is no reason to suppose that he was resident in the city for most of the time between then and 1508, when, on 21 April, he signed a letter to his uncle, 'your Raphael painter in Florence'.[1] He is recorded in Perugia in 1505 and 1507 and in Urbino twice in 1506 and again in 1507. There are also a number of clues that suggest he might have visited Rome in these years.[2] In 1505, when making the contract with the Poor Clares of Monteluce, he apparently did not consider himself as permanently resident anywhere, and Perugia, Assisi, Gubbio, Rome, Siena, Florence, Urbino and Venice are named in the contract as places where—it is implied—he might be found in the near future.[3] Nevertheless, it is clear that he was in Florence a good deal in these years.

Vasari noted that Raphael made friends with some young artists in Florence—he specifies Aristotile da Sangallo and Ridolfo Ghirlandaio—that he studied 'the old things by Masaccio', that what he saw of the works of Leonardo and Michelangelo spurred him on to make great improvements in his art, and also that he was greatly attached to Fra Bartolomeo of S. Marco and sought to imitate his colouring (*il suo colorire*—his way of handling paint as well as colour), in return 'teaching the good Frate the methods of perspective to which the latter had not until then attended'.[4]

Fra Bartolomeo had, in 1504, just resumed the profession he had abandoned in 1500 when he entered the monastery of S. Marco. Raphael would certainly have seen the fresco of the *Last Judgement* in S. Maria Nuova which he had been working on before he took vows. It is a ruin today but from a copy (Plate 27) we can see enough to wonder whether Vasari did not mean to say that Fra Bartolomeo had much to teach Raphael concerning perspective. In any case the linear perspective of the platform here upon which the dead rise is quite as sophisticated as that in Raphael's *Sposalizio* and the disposition of the seated saints in the clouds as a semicircle projected in space is more accomplished than the arrangement of the disciples around the sarcophagus in Raphael's *Coronation of the Virgin*.

The *Last Judgement* had been completed by Albertinelli,[5] an artist who acted, on and off, as Fra Bartolomeo's partner, sometimes executing parts of his friend's paintings and sometimes whole works to his friend's designs—among the latter is the *Visitation* of 1503 (Plate 28). This is a silent drama, subtly framed by architecture— something similar to, if simpler than, the *Sposalizio* (Plate 24). But in these two figures there is a gravity of carriage and grandeur of form which Raphael had not

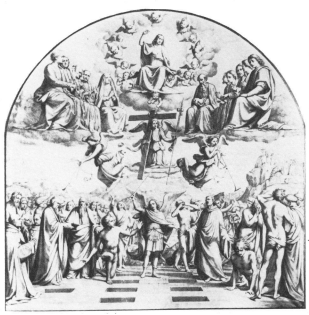
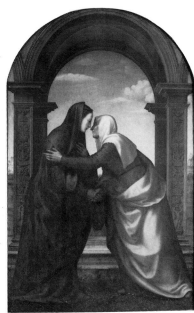
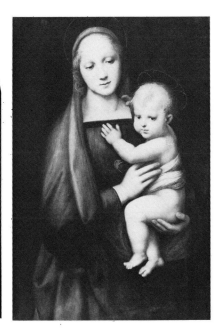

27. Raffaello Bonaiuti. *Full-scale copy of the Last Judgement by Fra Bartolomeo and Albertinelli.* Black chalk, 1871, 350 × 380 cm. Soprintendenza alle Gallerie (depot), Florence.

28. Mariotto Albertinelli (after Fra Bartolomeo). *The Visitation.* Oil on panel, dated 1503, 232.5 × 146 cm. Uffizi, Florence.

29. *Madonna del Granduca.* Oil on panel, *c.* 1505, 84 × 55 cm. Pitti Palace, Florence.

achieved—certainly not in his Virgin receiving the ring, moving daintily, light jointed, a scarf twisted round her, her little fingers curling.

The influence of paintings like these, although not reflected in the Ansidei altarpiece (Plate 25), which may have been well advanced before Raphael visited Florence, is apparent in the saints in the S. Severo fresco (Plate 30), also in Perugia and dated, by a later inscription, 1505. These saints are, as it were, inflated, with almost comically voluminous draperies, in an attempt to emulate the monumentality of Fra Bartolomeo's style, and the figures are seated in an arrangement which clearly derives from the *Last Judgement*.

It may have been easier at first for Raphael to absorb the ideals of Fra Bartolomeo in his female figures than in his heroic male saints. In the *Madonna del Granduca* (Plate 29) the mannerisms of Perugino have disappeared, and the weight, the few folds and continuous lines of the Madonna's robe, the reduction of ornament to the gold pattern in the yoke of her dress, the subordination of the two figures to a single oval scheme unbroken by any loop of drapery or flourish of ribbon would be unlikely without Fra Bartolomeo's example—and for this reason the picture might be dated 1505 or 1506. There must originally have been a stronger contrast between the blue (now very green) of her robe, its green lining and the crimson of her dress.

There is a suggestion of a distant landscape in a related drawing[6] in which the same group is sketched but within a circular frame, and with more curves in the drapery and with the Virgin's right arm lowered. This might have been a preparatory drawing for the *Madonna del Granduca*, but it could show Raphael working out a variation on the same artistic problem, as he did in a smaller panel, the *Small Cowper Madonna* (Plate 34), in which the Madonna has sat down, her robe has fallen around her waist, and the child, the same child, still supported in the same way, has climbed up—much of the appeal of the picture depending upon the proximity of the two tilted heads.

In both these paintings—and in others of this period by Raphael—the modesty of the Madonna is emphasised. She does not look at us, and her eyelids in the case of the *Madonna del Granduca* are lowered, as is the convention in modern soft-focus photographs of brides. George Eliot wondered whether they 'kept their placidity undisturbed when their strong-limbed, strong-willed boys got a little too old to do without clothing'.[7] Tranquillity rather than placidity, however, is what Raphael intended, and furthermore his Madonnas, although clear of brow, are thinking—thinking of matters beyond the immediate needs of the child they so effortlessly carry. Raphael, who carefully combined the humanly sympathetic with the

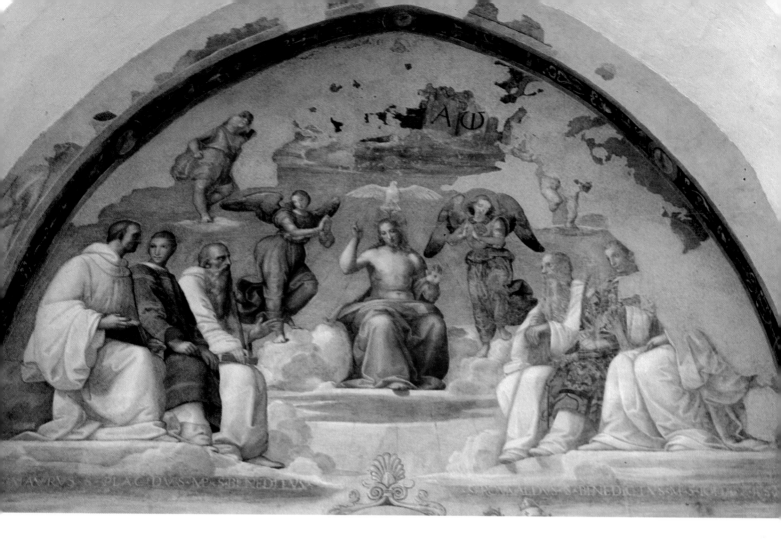

30. *The Holy Trinity flanked by Saints* (upper register of a wall, the lower completed later by Perugino). Fresco, *c.* 1505. S. Severo, Perugia.

appropriately divine, was working for patrons who had been made sensitive to the indecorous character of earlier representations of the Madonna by the sermons of Savonarola, who had also objected to the use of beautiful contemporaries as models in devotional art (so that people in the streets of Florence would say 'there goes the Magdalene').[8] No one could suspect that Raphael's Madonnas at this date were portraits. Their great merit is their decorum—a word which was entirely complimentary in Raphael's day, and for centuries after his death, but which now suggests imaginative timidity, compromise and an inhibiting concern to avoid offence.

★　　★　　★

In 1500 Leonardo da Vinci had returned to his native Florence. The artists of the city and many of its art lovers would not have forgotten the *Adoration of the Magi* (Plate 31) he had begun to paint nearly twenty years before for the monks of S. Donato, but which he had abandoned when he entered the service of the Duke of Milan. The panel had been kept, at first perhaps in the hope that the artist would return to finish it, but even when the monks had obtained another altarpiece by Filippino Lippi, Leonardo's work seems still to have been accessible. Raphael must have studied it diligently and it is worth considering here, although its influence on Raphael's own work is only apparent later.

The *Adoration* is an ambitious composition involving over forty figures which, although certainly planned in drawings, was also clearly developing as the artist worked on the panel, revisions being permitted by the oil medium. This was a new way of working out a composition, and the composition itself was of a novel character. The 'circle' of figures around the Madonna and Child is one of continuous

motion and protean form, such as Leonardo traced in the turbulence of water, and quite unlike the final geometry of architecture. Pictorial unity is achieved by dark shadows from which the figures seem only partially to emerge. The shadows give a remarkable relief and also contribute, along with the violent gestures and expressions, to the emotional excitement which is pitched higher than in any earlier painting of a comparable subject.

Many Florentines must also have heard something of Leonardo's achievements in Milan. His reputation was, in any case, sufficient for Filippino Lippi to surrender to him the commission for the high altar of the Servite church of SS Annunziata. 'In order that he could paint it', we read in Vasari,

> the Friars lodged him and paid his living expenses and those of his household; this continued for some time and he didn't even start the work. But eventually he made a cartoon, in which the Madonna, St Anne and Christ appeared, which was not only marvelled at by all artists, but, when it was completed, men and women, young and old, crowded continuously for two days into the room where it was exhibited, as if attending a solemn festival: and all were astonished at its excellence.[9]

The cartoon displayed in this most unusual exhibition of a work of art in progress is described in detail in a letter of 3 April 1501 written by Fra Pietro da Novellara to Isabella d'Este, as showing the Christ-child clutching a lamb, his mother rising from her mother's lap to draw him away, and her mother, St Anne, also rising, restraining her daughter from restraining the child. Novellara added that the action perhaps signified that the Church (represented by St Anne) would not wish to prevent the Passion (which the lamb as a sacrificial animal signified) although maternal instinct

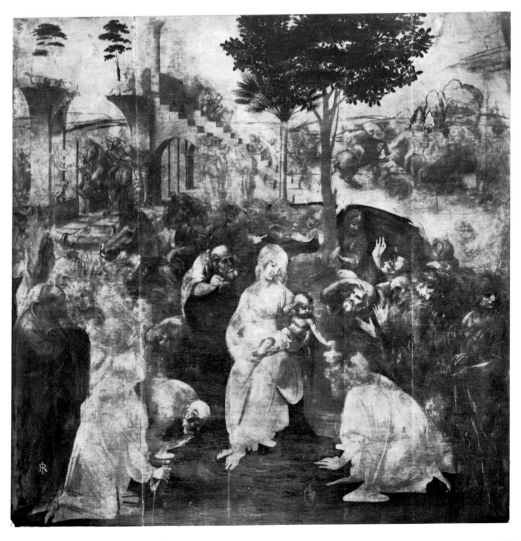

24

must be reluctant to accept it. The figures were placed one in front of the other to the left.[10]

This cartoon has been lost, but there are enough reflections of it in other works for us to be sure that Leonardo invested one of the most unnaturalistic conventions of devotional art (in which the Virgin with a child on her lap is seated upon her own mother's lap in a static and frontal composition) with a diagonal, and probably spiral, movement, portraying each participant in motion. Some action and sentiment had long been common in images of the Madonna and Child but narrative was less usual, and narrative of this complexity and subtlety was most original. It may have been a theological allegory, but it was only effective as such because of the artist's interest in human psychology.

The idea of the child with the lamb may have been suggested to Leonardo by

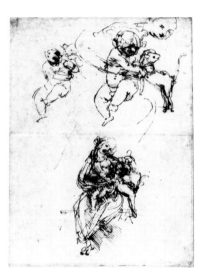

32. Leonardo da Vinci. *Studies for the Madonna of the Cat*. Pen and ink, *c.* 1480, 22.8 × 16·5 cm. Musée Bonnat, Bayonne.

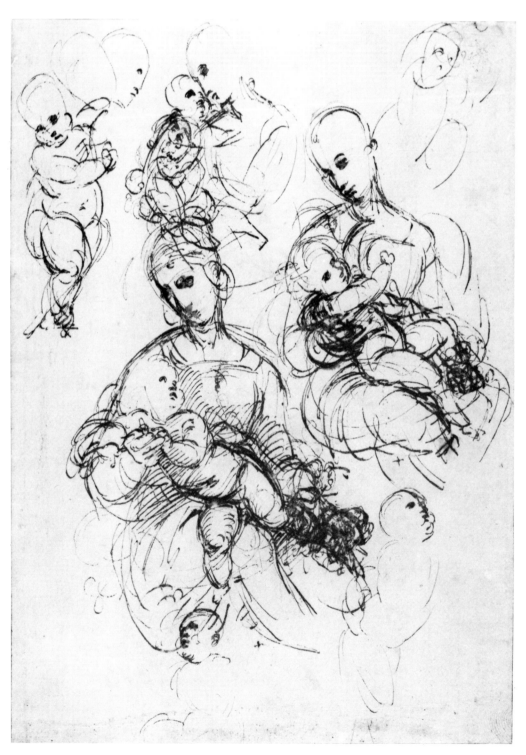

31. (left) Leonardo da Vinci. *Adoration of the Magi*. Tempera and oil on panel, 1481, 246 × 243 cm. Uffizi, Florence.

33. *Studies for the Virgin and Child*. Pen and brown ink with faint traces of red chalk, *c.* 1505, 25.4 × 18.4 cm. British Museum, London.

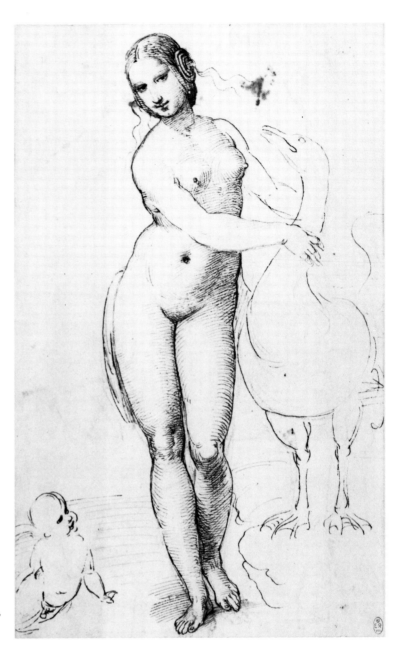

36. *Study of Leonardo's Leda*. Pen and ink over indications with the stylus, *c.* 1506, 30.8 × 19.2 cm. Royal Library, Windsor.

drawings he had made, long before, of children picking up cats (Plate 32).[11] These display very well what was one of Leonardo's most important innovations—his use of drawings not to define objects fixed before his eyes so much as to portray movement, and freely to explore a great variety of possibilities.[12] In some of his drawings groups of figures resemble at first glance nothing more legible than balls of hair.

A clear (and probably direct) reflection of Leonardo's cartoon is to be found in Raphael's *Holy Family with the Lamb*. There is a version of this painting in the Prado (Plate 35), and another in a private collection for which higher claims have been made, both as regards condition and authenticity, and which is inscribed 'Raphael Urbinas AD MDIV'.[13] These panels are similar in size and also style to the Washington *St George*. Leonardo would have made the lamb less heraldic and would have woven the figures more closely together, but this is clearly an attempt at a narrative of the type he had pioneered. Raphael's Christ is endeavouring to ride the lamb (which is less congenial to theological interpretation than is an attempt to embrace it), the Virgin here assists rather than resists, and St Joseph looks on with an intensity which reveals that he has grasped the significance of Christ's action—Christ, indeed, apparently explains it to him.

PRECEDING PAGES

34. *Small Cowper Madonna*. Oil on panel, *c.* 1505, 60 × 44 cm. National Gallery of Art, Washington, D.C.

35. *Holy Family with the Lamb*. Oil on panel, *c.* 1505, 32 × 22 cm. Prado, Madrid.

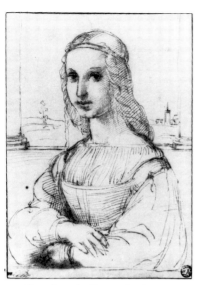

37. Portrait study. Pen and ink, *c.* 1506, 22 × 15.7 cm. Musée du Louvre, Paris.

Raphael seems also to have learnt from the way that Leonardo used drawings. In a sheet of pen studies of the Madonna and Child datable *c.* 1505[14] segmental and elliptical curves of the sort which are so conspicuous in his earlier drawings now consist of quick discontinuous and intersecting strokes of the pen, suggesting rather than delimiting (Plate 33).

A finished drawing, very different in subject and probably scale from the cartoon for the altar of SS Annunziata, seems to have been completed by Leonardo shortly before, or perhaps at the very moment of, Raphael's first visit to Florence. It was not, as far as we know, a commissioned work, and portrayed a nude Leda embracing and yet turning away from a swan—the twins, who were the fruit of their union, tumbling out of their eggshells in the dense vegetation at her feet. Raphael copied the figure of Leda in a drawing of his own (Plate 36), grasping with confidence the contrapposto. Here he has also imitated another characteristic of Leonardo's drawing—the use of lines which follow the curve of thigh or breast as well as of straight diagonal lines to indicate shade. This latter type of hatching would, in drawings by the left-handed Leonardo, have slanted in the opposite direction, so this is not a direct copy of a drawing by Leonardo. But we should not have been surprised if Raphael had made precise copies of another artist's drawing, since this was a standard studio practice at which even Michelangelo excelled.

Another of Raphael's pen drawings (Plate 37) to survive from this period is related to a different invention of Leonardo's—but this time to his celebrated painting, the *Mona Lisa*. Raphael makes his figure a girl rather than a woman of mysterious age, gives her a dress of contemporary fashion rather than winding veils around her, and replaces a distance of barren mountains with the sort of agreeable landscape he had painted in the *Small Cowper Madonna* (Plate 34). His figure, like Leonardo's, is separated from the landscape by a wall and the head is framed by columns (originally much more apparent in the *Mona Lisa*), but he has placed his wall higher than Leonardo and by aligning it with the girl's neckline he cuts the rectangle of the picture into equal parts. Most importantly, he has taken from Leonardo the idea of the half-length seated pose in which the arms provide the base for a pyramidal composition, which is given volume and animation by the contrasting axes of head, shoulders and hands. Raphael's earlier portrait, probably of Francesco Maria della Rovere (Plate 4), which may be quite close to this drawing in date, appears, as soon as it is compared with it, to be incoherent in design, the arms not concluding the pose, and the clothes inhibiting the articulation of the limbs and the continuity of the forms in space.

★ ★ ★

Only one Florentine portrait commission given to Raphael in these years is recorded by Vasari. Agnolo Doni, he informs us, 'although tight in other matters, spent willingly, although saving what he could, on pictures and statues, with which things he was much delighted', and he got Raphael to make a portrait of him and of his wife. He had married Maddalena, daughter of Giovanni Strozzi, who was ten years his junior, in 1503, and when Raphael painted her, even if he did so five years later, she was still in her teens.[15] It is hard to believe that the woman in the pair of portraits in the Pitti Palace in Florence could be so youthful, but these paintings did once belong to the Doni family, and the backs of them are decorated with allegories of fertility appropriate to the newly wed.[16]

The portraits (Plates 38–9) are painted on panels of identical dimensions. The male portrait would always have hung to the left of the female and each figure although looking straight out is turned inwards to complement the other—this is more noticeable in his case, her pose being closely related to that which Raphael had already studied in the *Mona Lisa*.

In both portraits the painting of the flesh is very accomplished, especially the representation of the veins below the skin in the hands of Agnolo Doni. His features are also recorded with greater particularity than those of his wife, as is so often the case. Both husband and wife show off their rings, her left hand hanging over a book, his over a stone ledge supported by scarlet balusters (his sleeves are crimson). Just as their hair is arranged to act as a foil for their faces, so the shadows ingeniously give relief to her jewellery—the pear-shaped pearl as big as an eye hanging from three stones, the uppermost of which is given a setting in the shape of a unicorn. (This beast was an emblem of virginity appropriate for a bride and appears as a pet in the lap of another girl perhaps painted by Raphael.)[17] One side of Agnolo's face is more darkly shadowed than any other in Raphael's work of this period, but these are not shadowy paintings like Leonardo's, and the clothes are not generalised in the way that the Mona Lisa's seem to be—the colours and textures are important to Raphael, as also doubtless to his sitters. The ribbed material of the doublet worn by Agnolo Doni must have made a textural as well as colouristic contrast with the sleeves. In the other portrait we can still appreciate the difference between the panels of orange-pink watered silk in her dress, the transparent veil passing over her shoulders, and the sleeves (separately attached as was then the mode) of blue damask.

Many paintings of similar character, format and size to the Doni portraits survive, apparently dating from the second half of the first decade of the sixteenth century, attributed variously to such Florentine artists as Bugiardini, Franciabigio, Granacci and Ridolfo Ghirlandaio. Two other portraits which have often, and with good reason, been accepted as by Raphael are of anonymous women, one known as *La*

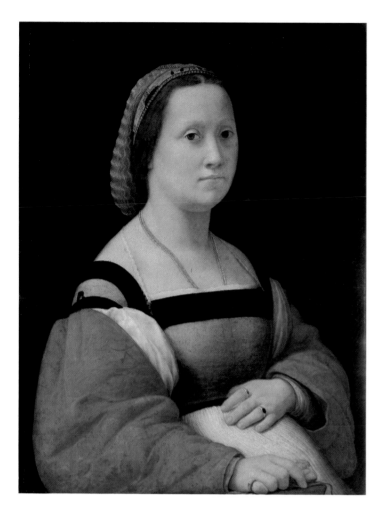

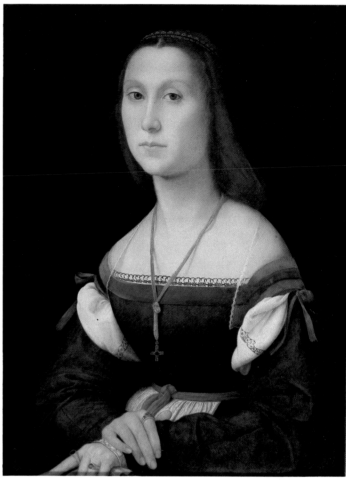

40. *La Gravida*. Oil on panel, *c*. 1507–8, 66 × 52 cm. Pitti Palace, Florence.

41. *La Muta*. Oil on panel, *c*. 1507–8, 64 × 48 cm. Ducal Palace, Urbino.

Gravida (the pregnant woman) and the other as *La Muta* (Plates 40–1). Both have uniformly dark backgrounds and in neither is there any flesh painting to compare with that in the portrait of Agnolo Doni (although there may once have been), nor is there the same interest in the stuffs worn (although this again may be due to the paintings' condition, for some traces of a damask pattern can be detected on *La Gravida*'s sleeve), but there are passages of comparable subtlety in design and optical precision, perhaps most notably the changing highlights on the twisted and knotted gold necklace of *La Muta*, the way its shadow is modified by the collar bone, and the way that the cross suspended from it has swivelled slightly away from the plane of her bosom, thus demonstrating that it hangs free and below it.

In his drawing of a girl (Plate 37), as also in his portrait probably of Francesco Maria della Rovere (Plate 4), Raphael adopted a convention found in much portraiture and in some intimate devotional pictures—that of placing a ledge across the bottom of the painting and resting the figure's forearm upon it. In both *La Gravida* and *La Muta* this ledge has been lowered to become the frame of the painting against which the sitters rest their arms both holding what appear to be gloves. *La Muta* actually extends her index finger and presses it against the frame. This is an arresting device which reinforces the fiction that the painting is akin to a window, an extension of the space occupied by the beholder. The pressing index finger, perhaps as much as the sitter's sealed lips, accounts for her being called '*La Muta*', the silent one. The name acknowledges that she could, if she wished, speak to us—which is not something we could suppose of the profile portraits which had until recently been conventional in Italy. The fiction is thus that she not only occupies an extension of our space but also responds or could respond to us. And here, in this implication of the beholder, as in the form of his portraiture, Raphael follows the lead of Leonardo.

38. *Agnolo Doni*. Oil on panel, *c*. 1507–8, 63 × 45 cm. Pitti Palace, Florence.

39. *Maddalena Doni*. Oil on panel, *c*. 1507–8, 63 × 45 cm. Pitti Palace, Florence.

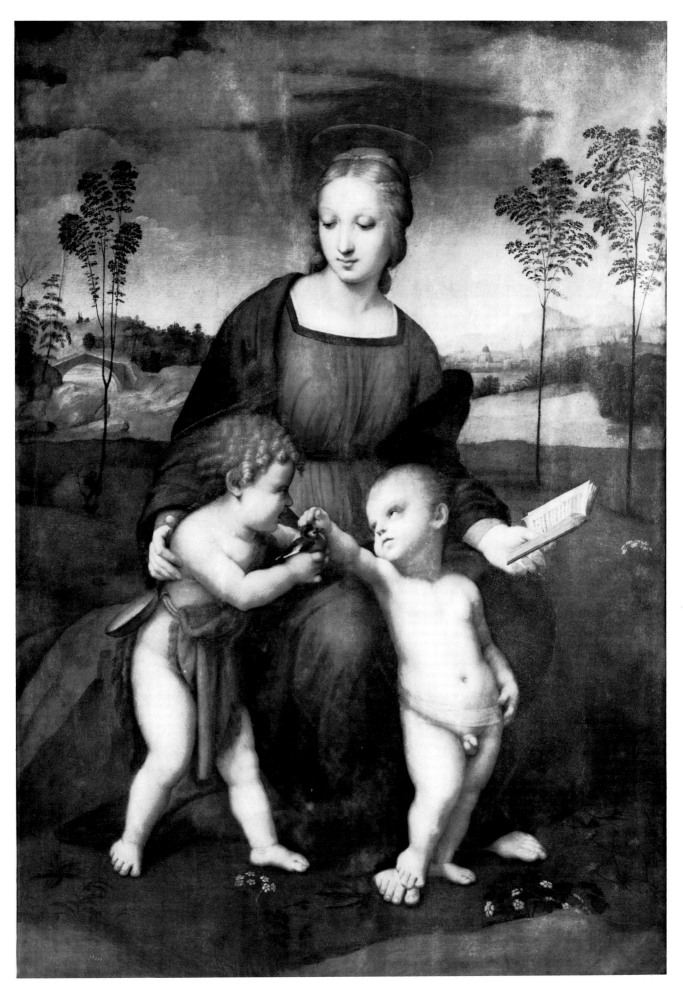

Leonardo had devised the pyramidal composition for the Holy Family as well as for the half-length portrait. And several surviving panels by Raphael show him exploring the idea himself, each one being a narrative with a variation on the theme of the child Baptist's legendary visit to his younger cousin to discuss the mystery of the Passion. In the *Madonna of the Meadow* (Plate 43) he brings a bamboo cross which Christ eagerly accepts (some have thought that Christ gives it to the Baptist, or even that they dispute over it).[18] In the *Madonna del Cardellino* (Plate 42) the Baptist presents a goldfinch (*cardellino*), a symbol of the Passion, to his solemn cousin. In *La Belle Jardinière* (Plate 44) the Baptist kneels before Christ who seems to explain why he does so to his mother.

Of these panels, the *Madonna of the Meadow*, so-called from the fields surrounding her, once much greener, was in the Taddei collection in the seventeenth century[19] and thus was probably one of the paintings Raphael made for Taddeo Taddei, a Florentine merchant and art lover, to whom he was perhaps introduced by his friend Bembo.[20] Taddei, according to Vasari, made the artist welcome in his house and at his table, and 'Raphael, who was courtesy personified, not to be outdone in kindness, made him two pictures'.[21] The letters *MCV* appear on the neckline of the Madonna's dress, followed by a circular ornament and then another *I*, but MCV (1505) seems perfectly possible. Vasari implies that Taddei extended his hospitality to Raphael during the artist's first visit to the city. It continued, however, and in his letter to his uncle Simone Ciarla in April 1508 Raphael alerted his relatives to Taddei's forthcoming visit to Urbino, urging them to receive him well for his sake, for he was 'certainly as much obliged to him as to any other living man'.[22]

Vasari also mentions what must be the *Madonna del Cardellino*.

Raphael also had great friendship for Lorenzo Nasi, [and] for the latter, who had taken a wife at that time, he painted a panel in which Our Lady held a child between her legs to whom a little St John, totally delighted, is offering a bird, with much reverence and pleasure in one and the other, and in the attitudes of both a certain childish and entirely lovable simplicity; while it is so well coloured and so carefully finished that they seem living flesh.[23]

The account shows how it was later possible to value the sentiment without giving much attention to the symbolism. It also emphasises qualities in the painting which are now much less evident. The blue in particular has deteriorated and the painting has generally darkened. Vasari himself records that it was extensively restored after Nasi's house collapsed in the winter of 1548. The three figures are more closely integrated than those in the *Madonna of the Meadow* and there is a greater sense of volume in the group, but nothing so gracious as the line in the *Madonna of the Meadow* which extends from the Madonna's toes through her curved arm and sloping shoulder and which may be imagined as concluding by curling round into her halo or the equally clean lines of her hair.

La Belle Jardinière is almost certainly the latest of these three paintings and differs from the other two in having an arched top, but the relationship with the *Madonna of the Meadow* in particular is very strong—its starting point indeed was perhaps that composition in reverse. There is a more complex silhouette, however, and, as in the *Madonna del Cardellino*, a greater sense of volume—although much of this is lost by the ruin of the Madonna's blue mantle. The painting has sometimes been identified as the Madonna Raphael painted for some 'Sienese gentlemen' but which on his departure from Florence he left to Ridolfo Ghirlandaio 'to finish some blue drapery in it' and some other things.[24] Since Raphael did not leave Florence for Rome until 1508 the Sienese painting should be dated to that year, but this picture is signed and dated 1507 on the hem of the Madonna's mantle. The pose of the Christ-child in *La Belle Jardinière* is more complex than any Raphael had, as far as we know, yet given to any adult in a painting. It is reminiscent of the Leda drawing (Plate 36) and may be compared with the equally twisted but more active child in the *Bridgewater Madonna* (Plate 45), a ruined painting with a compelling design.

42. *Madonna del Cardellino*. Oil on panel, *c*. 1506, 107 × 77 cm. Uffizi, Florence.

FOLLOWING PAGES

43. *Madonna of the Meadow*. Oil on panel, dated (apparently) 1505, 113 × 88 cm. Kunsthistorisches Museum, Vienna.

44. *La Belle Jardinière*. Oil on panel, dated 1507, 122 × 80 cm. Musée du Louvre, Paris.

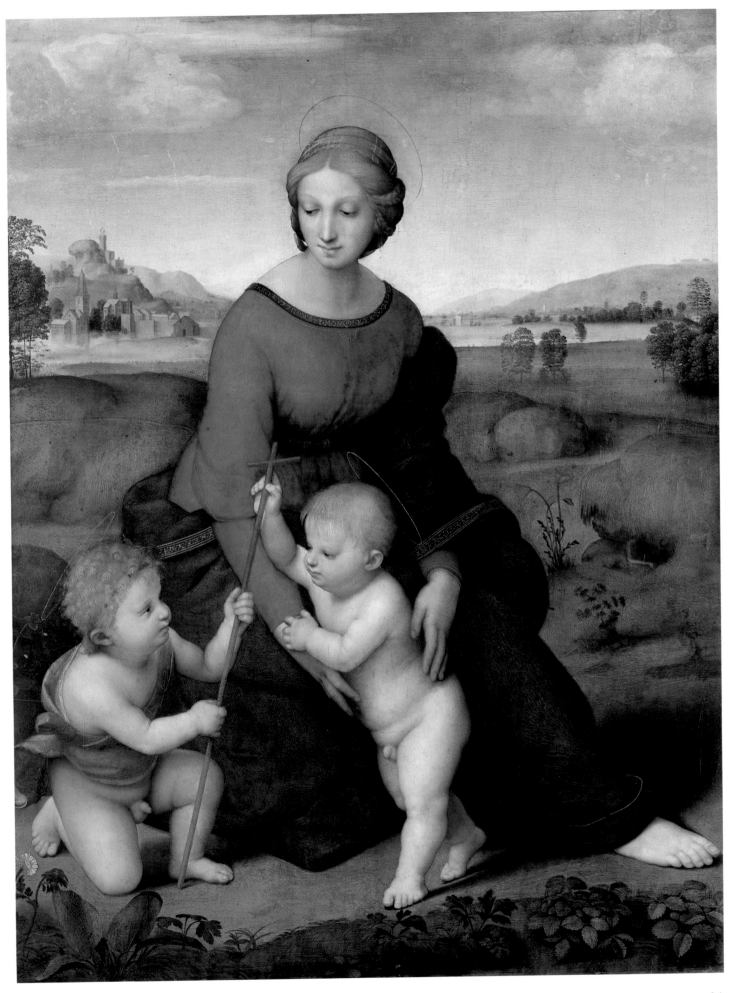

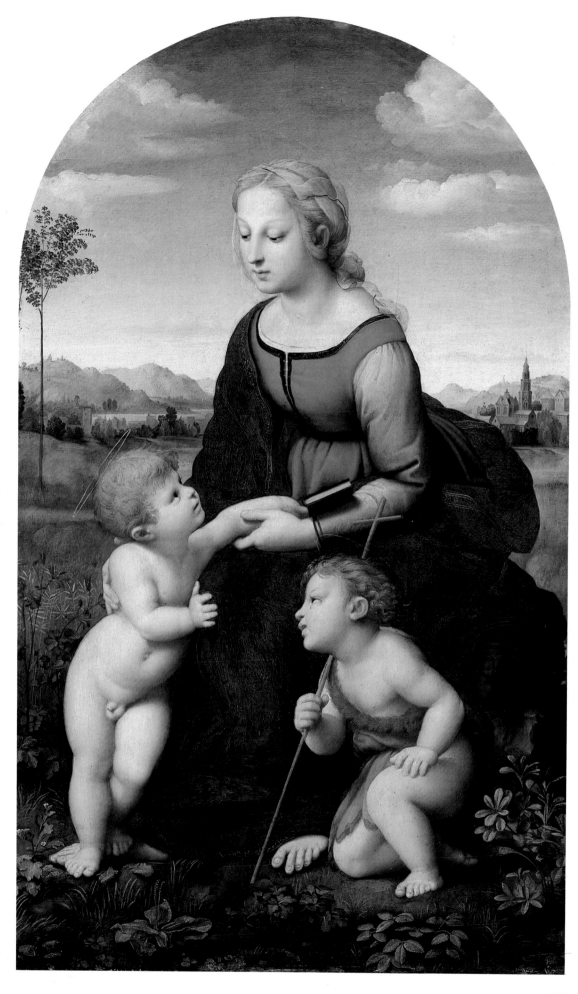

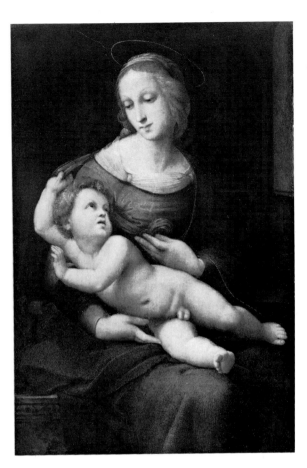

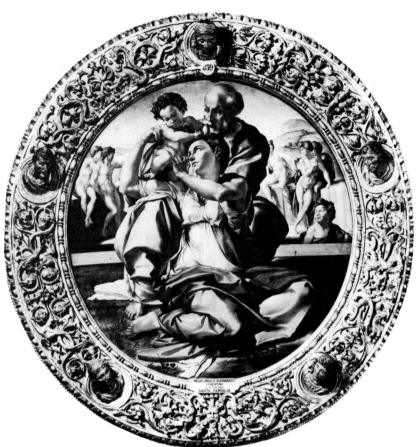

The origin of the Madonna's pose here may be the *Madonna of the Meadow*, only with the reversed *S*-line drawn rather higher, and the origin of the wriggling pose of Christ may be found in a series of very free sketches (Plate 33) in a style related to that of preparatory studies for that painting. The attitude of the child cannot simply be explained as a formal experiment (although it may first have suggested itself to the artist in this way), but must have a motive. The child appears to have woken, having perhaps dreamt of the Passion. This would make the painting a dynamic version of the convention of the Madonna portrayed with a sleeping child as an allusion to the time when she would cradle his dead body.

The idea of a waking child, and this particular pose (as is clear if it is reversed), must be indebted to the marble tondo Michelangelo began to carve for Taddeo Taddei.[25] But it is not the only evidence of Raphael's interest in Michelangelo's art at this time. The pose of the Christ-child in the *Madonna del Cardellino*, with his foot placed upon his mother's, derives even more clearly from the Madonna and Child which Michelangelo had by 1506 carved for display in Bruges.[26] Nevertheless the very different ideals of these two artists may be demonstrated dramatically by comparing these Holy Families by Raphael with Michelangelo's tondo painted, perhaps in 1504 or 1505, according to Vasari to celebrate the marriage of Agnolo Doni (Plate 46).

The meaning of Michelangelo's painting—why Joseph chooses such a peculiar, if formally fascinating, way of passing Christ to his mother; what, indeed, he has been doing with the child; whether there is any significance in the way the child plays with his mother's hair; even the identity of the athletic nudes in the distance—is all uncertain, whereas Raphael's narratives are more obviously accessible. Our sentiments are also more easily engaged by Raphael's Holy Families. And he has taken more trouble than Michelangelo with the painting of nature, not only flowers and trees, but light and air. Michelangelo's draperies appear to be fashioned out of metal or coloured marble, and his ideal landscape is made of stone only. He was nursed by a stonemason's wife, imbibing, he claimed, a love of marble with her

milk. (Raphael on the other hand was said to have been nursed by his own mother so as never to be exposed to the rough manners of the lower orders.)[27]

The culmination of Raphael's Florentine Holy Families, the largest, the busiest, and the most ambitious, is that which he was commissioned to paint by Domenico Canigiani (Plate 48). To the Virgin, Child and infant Baptist are now added an older woman and St Joseph (in an attitude reminiscent of the *Holy Family with the Lamb*— Plate 35); also, originally, as is revealed by X-rays, clusters of cherubim in the sky top left and right. Again Vasari provides useful evidence of what the sixteenth-century beholder valued in such a work:

> He also made for Domenico Canigiani Our Lady in a picture with the child Jesus who plays with a young St John held by St Elizabeth, who whilst she supports him looks with a most vivid quickness [*prontezza vivissimia*] at St Joseph, who, leaning with both hands upon a staff, inclines his head towards this old woman, as if marvelling and praising the greatness of God that someone so old should have so young a child, and all seem astonished to see with what sagacity the two cousins, of that tender age, are playing, one venerating the other.[28]

Since he is so enthralled by the narrative it is curious that Vasari does not mention the scroll inscribed 'ECCE AGNUS DEI' (Behold the Lamb of God) which John has brought and which Christ reads and expounds with reference to his destiny. The old woman (perhaps St Anne rather than St Elizabeth) turns to Joseph to relay their exposition and it is surely by this rather than by her fertility that he is engrossed.

<div align="center">★ ★ ★</div>

In addition to the works by Leonardo and Michelangelo which have already been mentioned, the large cartoons prepared by both artists for paintings in the Hall of the Great Council were certainly studied by Raphael, as his drawings show, although we may doubt Vasari's claim that it was to make such studies that Raphael first came to Florence. Leonardo's subject was the Battle of Anghiari. In 1505 he executed in some sort of oil medium on the wall the central portion—a group of warriors, some on horses and some rolling on the ground, tightly locked in violent contention for a standard. Michelangelo's subject was the Battle of Cascina, a Florentine victory, like the Battle at Anghiari, which would inspire the leading citizens of the

45. *The Bridgewater Madonna*. Oil on canvas (transferred from panel), *c.* 1506, 81 × 56 cm. Duke of Sutherland Collection (on loan to the National Gallery of Scotland, Edinburgh).

46. Michelangelo. *The Doni Tondo*. Tempera (?) on panel, *c.* 1504, 120 cm diameter. Uffizi, Florence.

47. Aristotile da Sangallo. *The Battle of Cascina* (copy of an earlier drawing of Michelangelo's cartoon of this subject). Oil on panel, 1542, 76.4 × 130.2 cm. Holkham Hall, Norfolk.

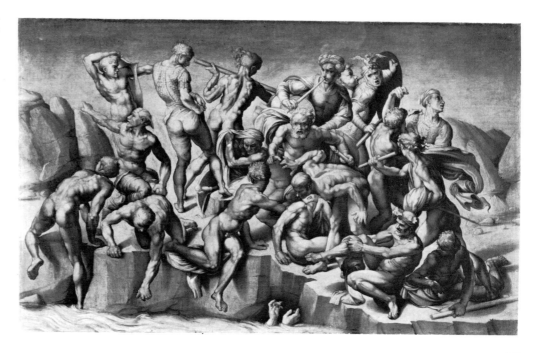

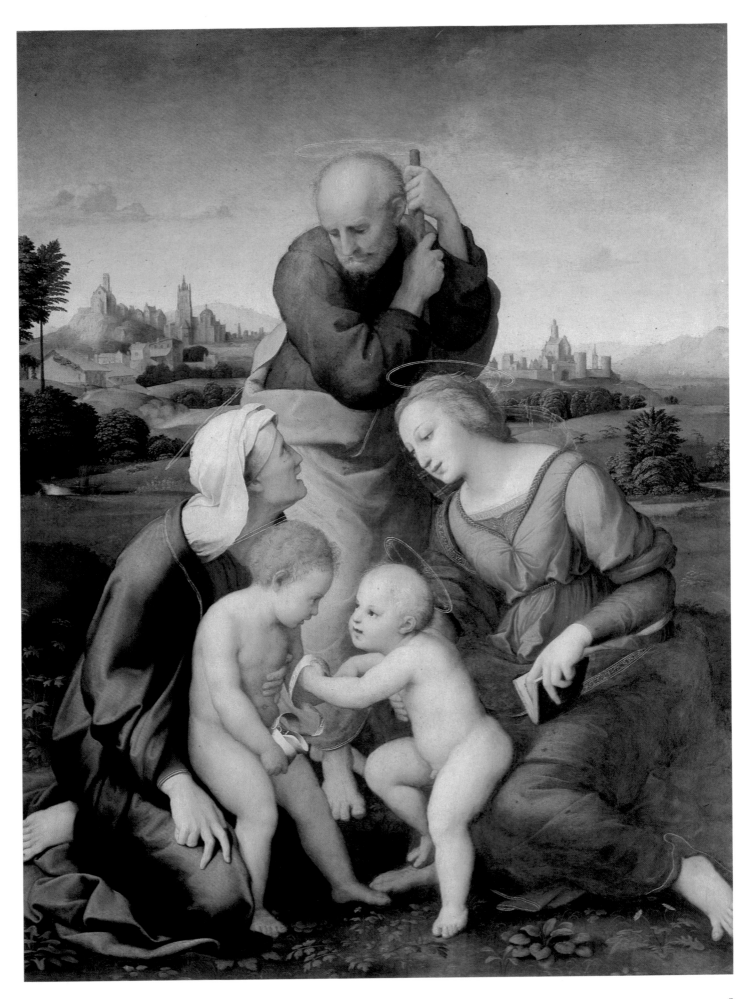

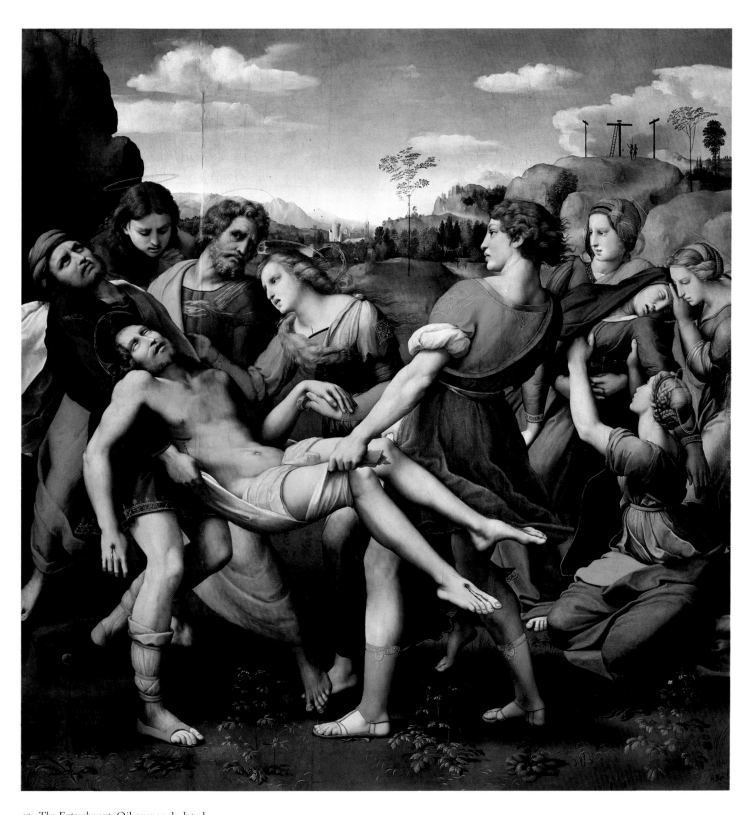

49. *The Entombment*. Oil on panel, dated
1507, 184 × 176 cm. Borghese Gallery,
Rome.

48. (left) *Canigiani Holy Family*. Oil on
panel, *c.* 1507, 131 × 107 cm. Alte Pin-
akothek, Munich.

Republic who assembled in this room to give priority to questions of defence. Instead of the thick of battle Michelangelo, in his principal group, which he never painted, showed soldiers alarmed while bathing (Plate 47).[29]

Heroic violence as an ideal in art must have been one of the things which most struck Raphael in Florence: there is nothing like it in his own earlier work. However, he would have encountered it not only in these cartoons, but in the work of Pollaiuolo (Plate 51) or in Bertoldo's bronze relief of a battle, and it is such works quite as much as the *Battles of Anghiari* or *Cascina* which may come to mind when we look at Raphael's drawings of twisting and shouting, fighting and struggling male nudes (Plate 50) which must date from the years between 1504 and 1507.

Violent hand-to-hand combat, glamourised in such works of art by the antique nudity of the participants, was not then uncommon in the streets of Florence, and was endemic to those of Perugia. The conflict between the Baglioni and Oddi clans

50. *Nude Male Warriors.* Pen and brown ink over traces of black chalk, *c.* 1506, 26.8 × 41.7 cm. Ashmolean Museum, Oxford.

51. Antonio Pollaiuolo, *Battle of Nude Men.* Engraving (2nd state), *c.* 1470–5, 40 × 61 cm (sheet). Whitworth Art Gallery, Manchester.

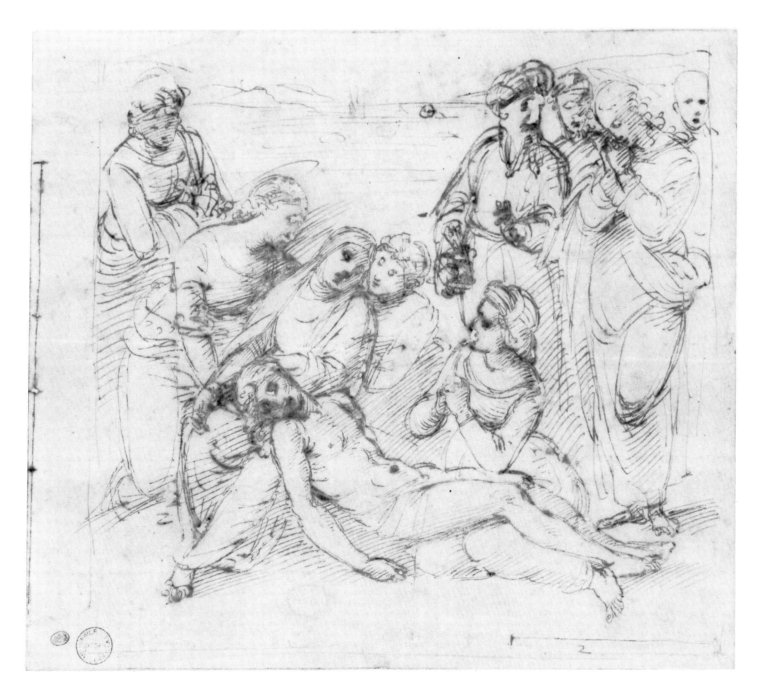

52. *Lamentation over the Body of Christ* (preliminary idea for the *Entombment*—Plate 49). Pen and brown ink, *c.* 1506, 17.9 × 20.6 cm. Ashmolean Museum, Oxford.

FOLLOWING PAGES

53–5. Details from the *Entombment* (Plate 49).

in Perugia has already been mentioned in the first chapter. But the Baglioni also killed each other. An especially bloody episode involved the attempt made by Grifonetto Baglioni and some junior members and discontented followers of the family during wedding celebrations in 1500 to murder all the rest of the Baglioni in their beds. After the carnage Grifonetto's mother Atalanta refused her son refuge in her villa. When he returned to the city, repentant, he was met by Gianpaolo Baglioni, who had survived the night by escaping over the roof tops and had rallied his men. They now butchered the boy. As he lay dying his mother arrived and bade him forgive his assassins. Stretching out his right hand to her, he died, and Matarazzo, the chronicler of the family, describes how she left the scene, smirched by her son's blood, revered by all. Although forced to quit the city in January 1503 by the Borgia, Gianpaolo Baglioni and his followers returned in September with the usual bloodshed.[30] When Pope Julius II marched out of Rome in the summer of 1506 Gianpaolo submitted to him on his knees at Orvieto and swore to be a loyal vassal of the Church. Soon afterwards he escorted the Pope in Perugia itself where he said Mass in S. Francesco—Machiavelli thought it surprising that he didn't take the opportunity to assassinate him.[31]

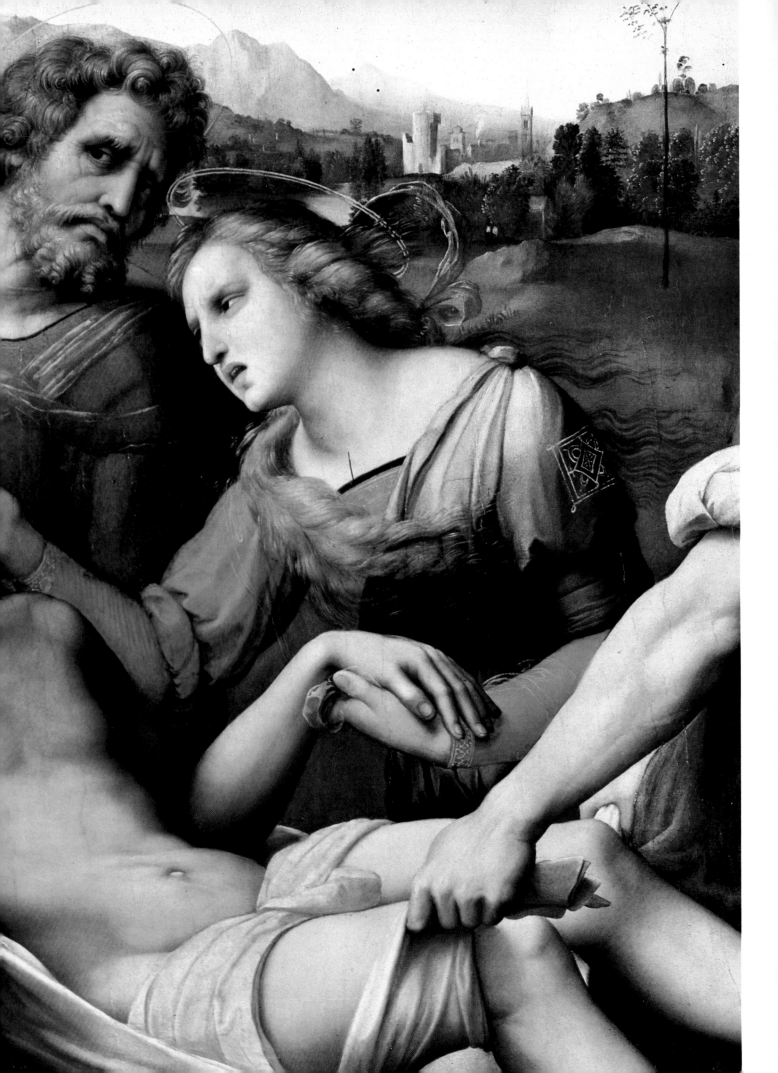

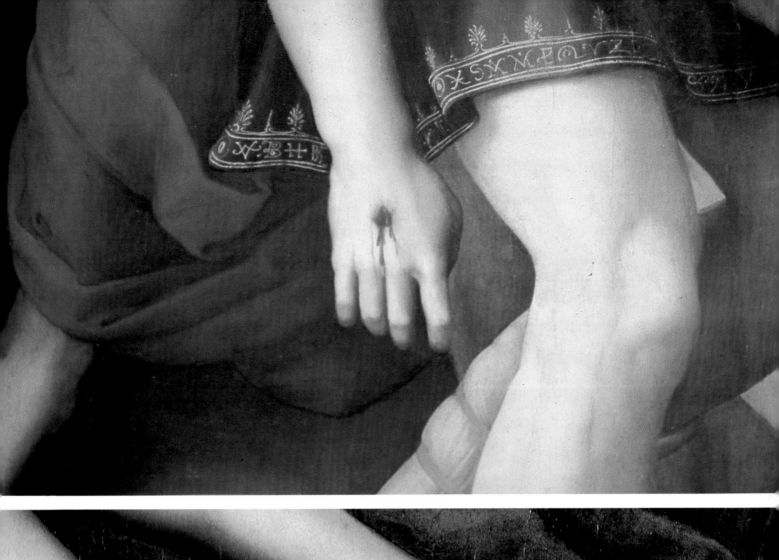

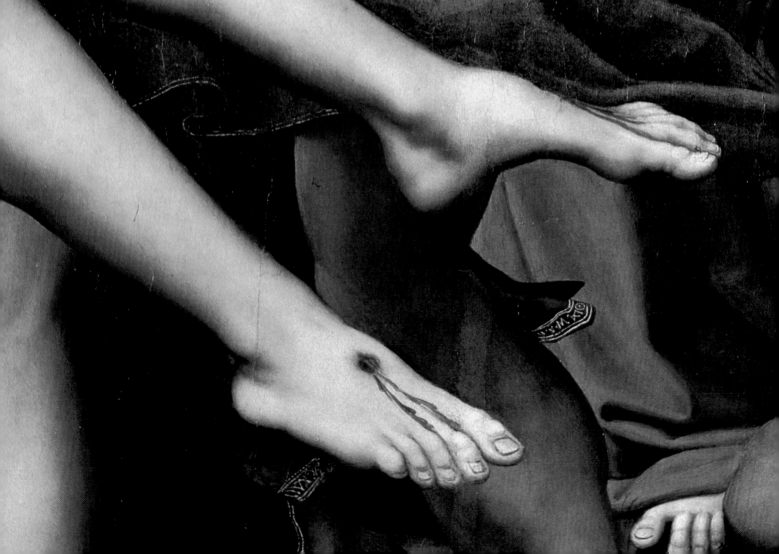

Atalanta Baglioni commissioned from Raphael an altarpiece for her chapel in S. Francesco. Her sister-in-law was Leandra degli Oddi (the families had sometimes intermarried) who may have commissioned Raphael's *Coronation* for the same church.[32] Vasari says that Raphael promised he would execute the work, but had first to return to Florence where he had business. 'At Florence he devoted incredible pains to the study of his art, and did the cartoon for the chapel, intending to carry it out as soon as he had the opportunity . . . he was recalled to Perugia, where first of all he finished the work for Atalanta Baglioni.'[33] Then he returned to Florence. The painting (Plates 49, 53–5) is dated 1507 and the commission may have been given when Raphael was in Perugia in 1505.

What may be Raphael's first idea for Atalanta Baglioni's altarpiece is represented in a drawing (Plate 52).[34] The subject is the Lamentation of the Marys over the dead Christ. Raphael's composition is not unlike that of Perugino's famous painting for S. Chiara (Plate 8), although the body of Christ is here placed across the laps of the mourners, his head cradled by his mother, who swoons. The last episode introduces more action than Perugino had allowed, but Raphael evidently wanted still more and accordingly changed the subject to an Entombment, perhaps inspired by the painting by Michelangelo and the print by Mantegna of the same subject.[35]

In the finished picture the action takes place from right to left. To the right a group of women attend to the swooning Virgin from whom Christ has been taken. The theme is carried over from the first idea for the altarpiece, and the kneeling figure may be a development of the figure there over whose lap Christ's legs were draped, but now given an extreme torsion, monumental build and sharply cut drapery inspired by the example of Michelangelo's *Doni Tondo*. In the foreground two men without haloes carry the body, the one at the head backing up the steps cut in the rock leading to a sepulchre similar to the cave in the *St George* (Plate 6); the other youthful one placed in the very centre of the painting has been proposed, sentimentally, as an ideal portrait of Grifonetto.[36] As they begin to wheel around, the Magdalene rushes to kiss Christ's hand and to look for the last time at his face.

This last motif may derive from a type of ancient sarcophagus relief showing the burial of Meleager, such as the one cited by Alberti in his treatise on painting, the text of which informed the most sophisticated thinking about painting in Raphael's day. In Rome, Alberti wrote, an *historia*, a narrative, was praised 'which shows the dead Meleager carried away, and those who carry the weight appear grieved and straining in all their limbs, while in the dead man no member appears that is not completely dead, all hang down, hands, fingers, neck . . .'[37] Woven in with the more or less equal balance of strong reds, yellows, greens and blues are Raphael's flesh tones, with a careful contrast between the living and the dead, most poignant where the Magdalene holds Christ's hand. Her loose tresses, blown round her shoulder, brush over Christ's hand and a thin veil, at first hardly apparent, accompanies them and is gathered in her hand holding his—fine details such as these, or the tears on the cheeks and reflections in the distant water, which must have been hard to appreciate when the painting hung above an altar, testify to its excellent condition. In this respect it is matched by a three-quarter length *St Catherine* (Plate 57) which must be of similar date—both works 'signed', curiously, by a dandelion in the left corner. The *St Catherine* is a highly unusual painting showing a saint as an exemplar of, rather than an object for, devotion. She turns enraptured towards a heavenly light—it is as if Raphael wished to represent, metaphorically, the episode of her mystic marriage to Christ.[38] The torsion attempted in the kneeling woman on the right of the *Entombment* is no more remarkable than the pose of this saint, which derives, however, from Leonardo's *Leda* rather than from Michelangelo. The expression of St Catherine is stronger than Raphael had attempted in any other work except the *Entombment* and the *Canigiani Holy Family* (Plate 48). Women now open their mouths: the teeth of St Catherine and of the Magdalene in the *Entombment* are visible; St Anne (or Elizabeth) in the *Canigiani Holy Family* lets us see that she has none.

56. Commenced by Raphael (completed and modified, posthumously). *The Madonna del Baldacchino*. Oil on panel, probably begun, certainly abandoned 1508, 277 × 224 cm. Pitti Palace, Florence.

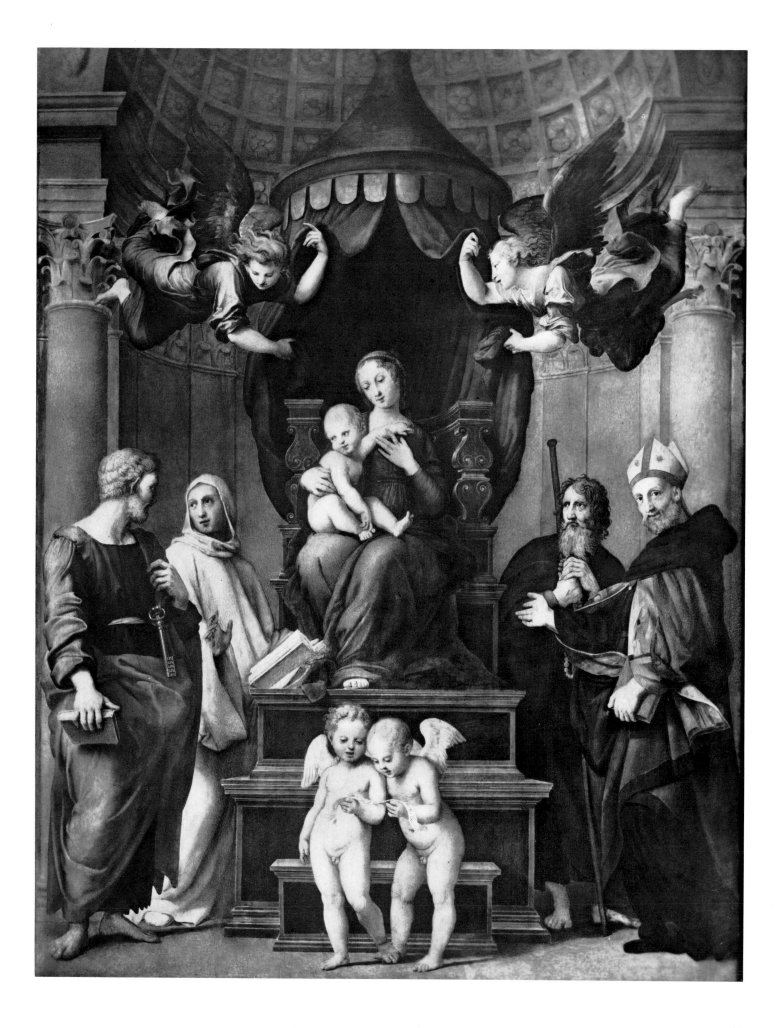

45

As a composition the *Entombment* may be compared with Raphael's drawings of struggling nudes (in fact in some of the preparatory studies[39] the figures are portrayed nude). He avoids an inappropriately graceful arrangement of the figures and seeks to convey the consternation of the participants by means of a composition which seems at first to be confused. The numerous preparatory drawings for this work show how much attention Raphael paid to the composition, but the division into two groups is not as dramatically effective as Raphael must have intended, perhaps because the figures appear to belong to a continuous frieze, despite the way they are placed on different planes. On the left of the painting the legs of St John and of the bearded Nicodemus present a distracting problem, and it is not clear what the latter is doing, or at what he looks. The painting had a frame, parts of which survive, decorated with griffins (the family crest was a griffin's head, and the name of Atalanta's husband and son was Grifone) being crowned and fed by winged putti seated on rams' heads, all of yellow-bronze colour against a blue ground.[40] The frame also incorporated small grisaille paintings below of Faith, Hope and Charity, and, above, a panel of God the Father, in a glory of cherubim, blessing his son (designed by Raphael but executed by Domenico Alfani),[41] which must have been calculated in relation with the open *V* in the composition of the principal panel below.

On his return to Florence in 1507 or early 1508 Raphael began work on an altarpiece for the Dei chapel in S. Spirito which had been provided for in a will dated 20 July 1506 made by Rinieri di Bernardo Dei.[42] It is probably to this work that Raphael refers in his letter to his uncle Simone Ciarla of 21 April 1508 as something he had not put a price on because he thought he would do better to have it valued. This picture, known as the *Madonna del Baldacchino* (Plate 56), Raphael's only Florentine altarpiece, was left incomplete when Raphael went to Rome later in that year. The Dei family later commissioned a replacement from another artist and the panel was acquired by Raphael's friend and executor Baldassare Turini and completed for him as the altarpiece of his new chapel in the Duomo at Pescia.[43]

When Raphael's painting was completed a strip was added to the top of the panel above the rim of the baldacchino, the figures were all worked over and the angels, which are unintelligently adapted from a later one of Raphael's (Plate 115), and the architectural setting, were added. Raphael certainly intended the baldacchino, but he may have planned to place it in the open air.[44] The composition is nevertheless essentially his, as preparatory drawings testify, and it is a truly architectural one, that is monumentally and coherently conceived in fully spatial terms, with the four saints establishing a semicircle around the throne and the deep curve of the throne itself projecting back, and that of the baldacchino forward, in space.

While the two child angels sing from the score, St Peter and St Bernard (the latter specified in Dei's will) debate, the Christ-child apparently listens, keeping note of the points on his toes, St James looks on in adoration, and the worshipper is invited to participate by St Augustine, patron of the order whose church S. Spirito was. There is thus a dramatic, if not an explicitly narrative, dimension uniting these figures and the beholder.

In 1508 when Raphael was working on this painting he must have appeared the heir to Leonardo. In Rome he was to be given the chance, and the room, to undertake the great works to which Leonardo now seemed incapable of committing himself. Michelangelo was already there.

57. *St Catherine*. Oil on panel, *c.* 1507, 71 × 56 cm. National Gallery, London.

III. The Private Library of Julius II

ON 26 NOVEMBER 1507 Pope Julius II had vigorously expressed his disgust with the apartments on the second floor of the Vatican Palace decorated for the Borgia Pope Alexander VI (Plate 3) by Pinturicchio.[1] His family had been keen patrons of the artist and he himself continued to employ him.[2] What irked him was not the style of decoration but the likeness and the ubiquitous insignia of his great enemy—'an apostate and an uncircumcised Jew' (a description of Alexander which some members of his entourage rashly took to be a joke). Julius had already on occasion occupied the floor above[3] and this outburst probably marks a decision to make a definitive move and decorate his own rival suite of apartments there. Among the team of artists employed were Perugino, Bramantino and Sodoma.[4] Bramante is said to have recommended that Raphael, a fellow countryman and distant kinsman,[5] join them. Julius may already have known Raphael's name, if not his work, through his close relations with the court of Urbino.

The circumstances in which Raphael joined the team and subsequently took over the decoration are not fully documented. In April 1508 he was in Florence, intending to paint what was probably the *Madonna del Baldacchino* and angling for a public commission there. When we next hear of him he had already been some time in Rome, where he was paid 100 ducats on 13 January 1509 for painting in one of the Pope's vaulted rooms.[6]

This room was the one which Vasari indelibly named the Stanza della Segnatura (Plate 58)—that is the room in which sat the *Signatura gratiae* (a division of the supreme tribunal of the Curia over which the Pope presided). The room was in fact employed for this purpose when Vasari wrote, but there is overwhelming evidence that it must have been intended by Julius as a library—the Bibliotheca Iulia.[7]

Recognition of its original purpose is inhibited by our modern idea of a library as invariably furnished with tall shelves. But this was not the case in the libraries of the period that have survived. In the Piccolomini library for instance most of the wall space is occupied by paintings. Here there would have been either book presses placed in front of the wall, or shelves up to shoulder height (that is up to the height at which the principal scenes are painted). Unlike the adjacent rooms, there is no fireplace here which would put books at risk from fire and dirt—and, it was believed, bugs.

It may seem surprising that Julius gave priority to the decoration of such a room, for he is not now noted for his devotion to literature.[8] Vasari reports that when, in Bologna in the winter of 1506/7, Michelangelo consulted him concerning the appropriate attribute for his statue he declared that he should hold a sword not a book, for he was no scholar.[9] The story, even if apocryphal, reflects the Pope's

58. General view of the private library of Pope Julius II (the Stanza della Segnatura), Vatican Palace, Rome.

reputation. When Raphael was painting this room Julius was campaigning in the north, braving the hardships of camp in an exceptional winter, directing cannon, shouting at his men, and swearing like a trooper—he was reported to have declared as he left Bologna early in January 1511 for the siege of Mirandola, 'I'll see if I've balls as big as those of the King of France'.[10] A military 'image' was, however, more compatible with a liking for libraries than it has since become—a mercenary could indeed be a bibliophile, as is borne out by the portrait of Federigo da Montefeltro wearing his armour at his reading desk (Plate 2).

Julius's military activity in defence of the temporal authority of the papacy was a continuation of the policies of his uncle, Pope Sixtus IV. There is continuity in other fields. He was a munificent patron of S. Maria del Popolo, which his uncle had founded; he laid out the Via Giulia which connected with his uncle's new bridge, the Ponte Sisto; he commissioned Michelangelo to paint the ceiling of his uncle's Sistine Chapel; and in founding a library in the new Vatican apartments he was again following his uncle's example, for Sixtus had founded the main Vatican library, extending and housing the collection of Nicholas V—this would be a smaller complementary collection for the personal use of the Pope, a kind of grand papal *studiolo*.

Predictably but outrageously, Julius's foundation was likened to those of antiquity at Pergamon and Alexandria[11]—outrageously because a list made after the Pope's death records the modest total of some 220 books.[12] There can never have been a close relationship between the books in the list and the many authors and their books that Raphael was to paint in the library. Homer and Sappho are among the most conspicuous authors represented on one wall, Plato and Aristotle on another, but Julius read no Greek and there is no record of any Greek text owned by him.

It was well known that the Romans had furnished their libraries with portraits of great poets. Equivalent practices were revived in fifteenth-century Italy—sequences of ancient heroes had indeed become a popular form of palace decoration since the days of Petrarch,[13] and were sometimes found in libraries. The Duke's *studiolo* at Urbino comes again to mind.

But Raphael was to revolutionise this tradition. He had had little experience of painting large frescoes, perhaps no more than the *Trinity and Saints* which he had left unfinished in Perugia. There is little in his work to prepare us for the classic monumentality of the solutions he was to formulate in Rome for the problems of coherently orchestrating large groups of people in unified, but varied and grand spatial compositions. What is even more impressive, since he seems to have received little formal education, is the way in which he was able to come to terms with, and offer highly persuasive visual forms for, the abstract world of literature and learning that he was set to represent, in what has been called a *Summa* of contemporary thought. So persuasive was it, indeed, that scholars have assumed that the intellectual content of the original programme he was given was as distinguished, complex and coherent as the artistic form in which it was finally expressed, and must have been thought out in all its detail before Raphael started work. In what follows, we will try to show that the original programme may have been simpler than what we now see, and that it is likely that Raphael himself had much to do with its expansion and unification.

The basic scheme of the decoration can be simply described. It starts on the ceiling (Plate 59), where in four tondi the abstract notions of Theology, Poetry, Philosophy and Jurisprudence are personified by beautiful women. Below them, pictures occupying the major part of each wall amplify the personified abstractions by showing literary heroes from the distant and more recent past engaged in forms of activity, and accompanied by large numbers of books, appropriate to each of the disciplines. Thus, under *Theology* we see the *Disputa* (Plate 68), in which theologians contemplate the mystery of the sacrament. Under *Poetry* we see the poets assembled on Parnassus (Plate 79). Under *Philosophy* ancient sages are gathered with their pupils in a scene which has for over three hundred years been called the *School of Athens*

59. Raphael, but some small sections by Sodoma and others. Ceiling of the Stanza della Segnatura. Fresco, c. 1508–9. Vatican Palace, Rome.

(Plate 87). On the fourth wall, below the tondo of *Jurisprudence*, are more personifications, of Fortitude, Prudence and Temperance, the Cardinal Virtues crucial to the proper exercise of justice, and, below these, two episodes illustrating the establishment in book form of historically significant codes of law: *The Emperor Justinian handing the Pandects to Trebonianus* and *Pope Gregory IX handing the Decretals to St Raimund* (Plate 88).

Described thus, the mechanics of the programme are similar to those of schemes recently painted by Perugino and Pinturicchio.[14] In the former's decoration of the Collegio del Cambio in Perugia, female personifications of virtues, accompanied by winged putti holding inscribed tablets, sit in the clouds above ancient heroes who stand as exemplars of the virtues on earth (Plate 60). Perugino's heroes, though, are simply lined up in a way that does little to express visually the abstract ideals they represent. Some purposeful animation is to be found in Pinturicchio's decorations of the Borgia apartments, where women personify the Liberal Arts in thrones set above groups of people who are shown appropriately employed (Plate 61). But to compare his scenes with those of Raphael is only to underline how visually articulate and intellectually authoritative Raphael had become. His early years in Rome must have been accompanied by a marked broadening of his mental horizons, and perhaps personal experience was a factor in his ability to convey authentically the 'curiosity and breathless desire to find the truth about what is in doubt' which Vasari praised in the *Disputa*.[15]

The fourfold classification of literary and learned activity that we find in the decoration corresponds with the way in which books were classified in libraries of the day, by the faculties. A reductive view of the programme would be that it does no more than give visual form to the catalogue of an ideal library. Certainly it has not been demonstrated how the four parts of the decoration might be seen as a systematic proposition that amounts to more than a general assertion of the unitary purpose of all human thought. There are, however, undeniable signs of intellectual as well as artistic synthesis, particularly in the ceiling and to some extent on the walls below. In the rectangular pictures on the ceiling are subjects related to the female personifications in the tondi on either side of them. Thus *Adam and Eve on the Brink of Disobedience* deals with a subject which has an obvious relationship with both *Theology* and *Jurisprudence*. The *Judgement of Solomon* involves a wise man making a legal decision. *Apollo and Marsyas* connects *Poetry* with an albeit pre-Christian divinity. In the fourth panel, *Urania*, the Muse of Astronomy presides over a sphere that represents the harmony of the universe, something of which is reflected in the

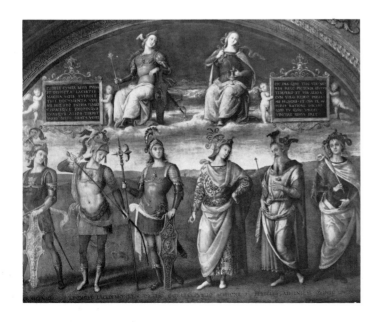

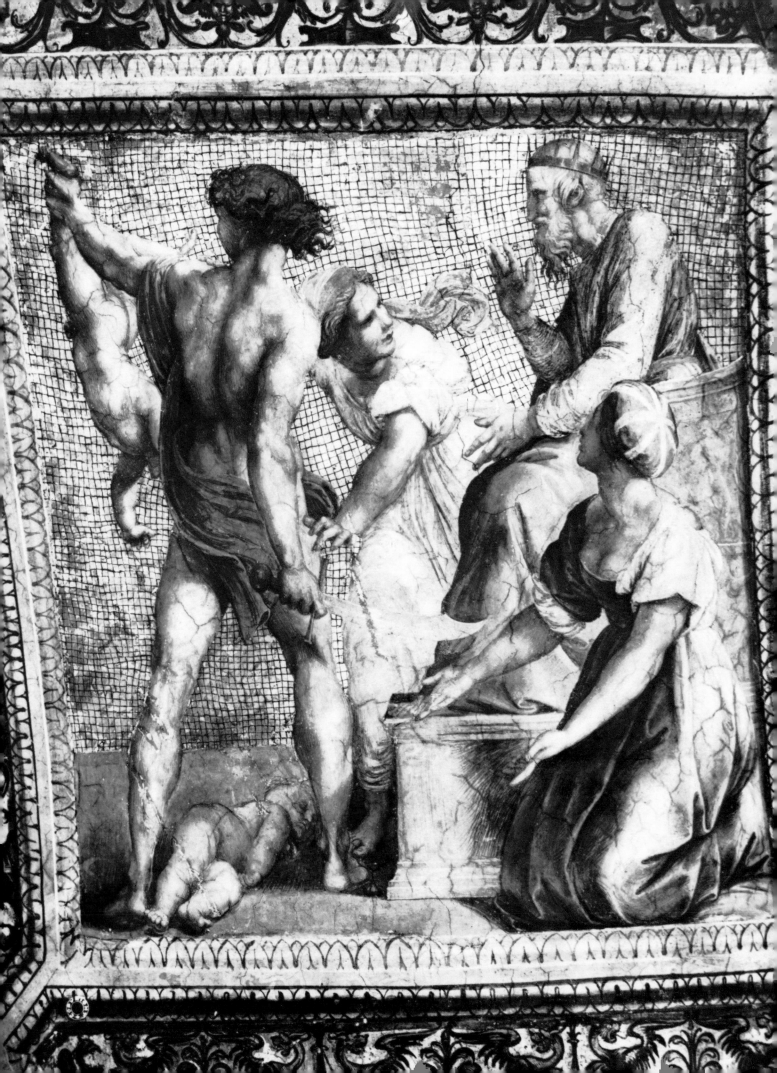

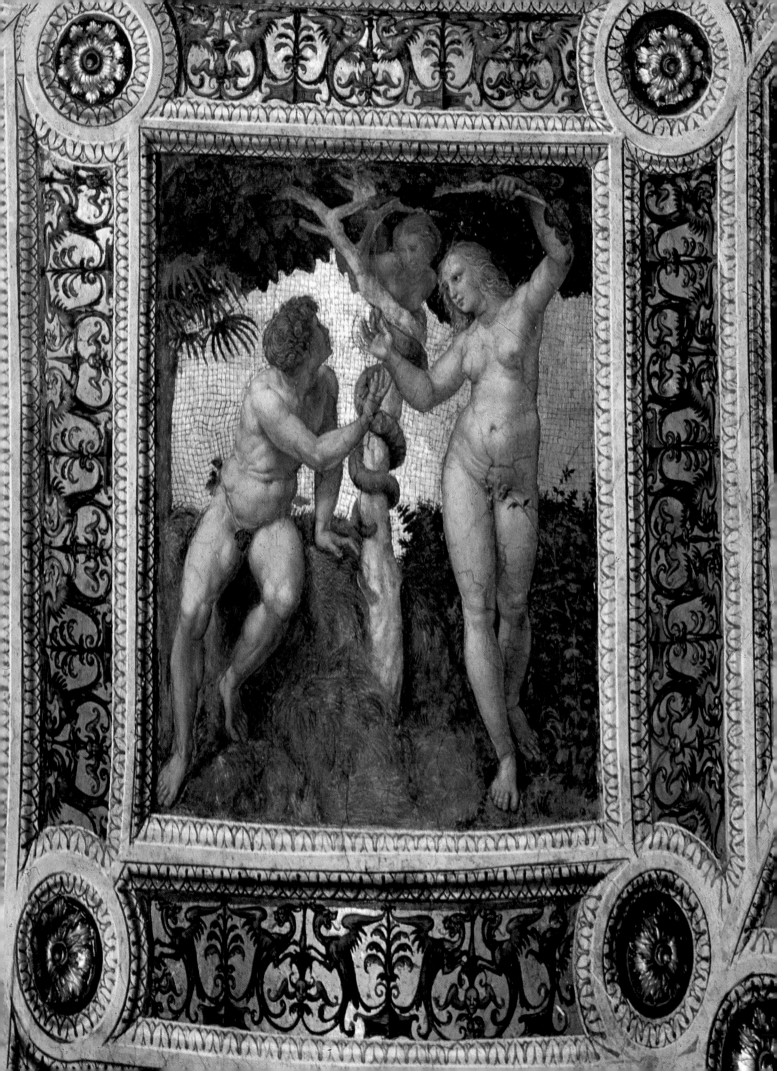

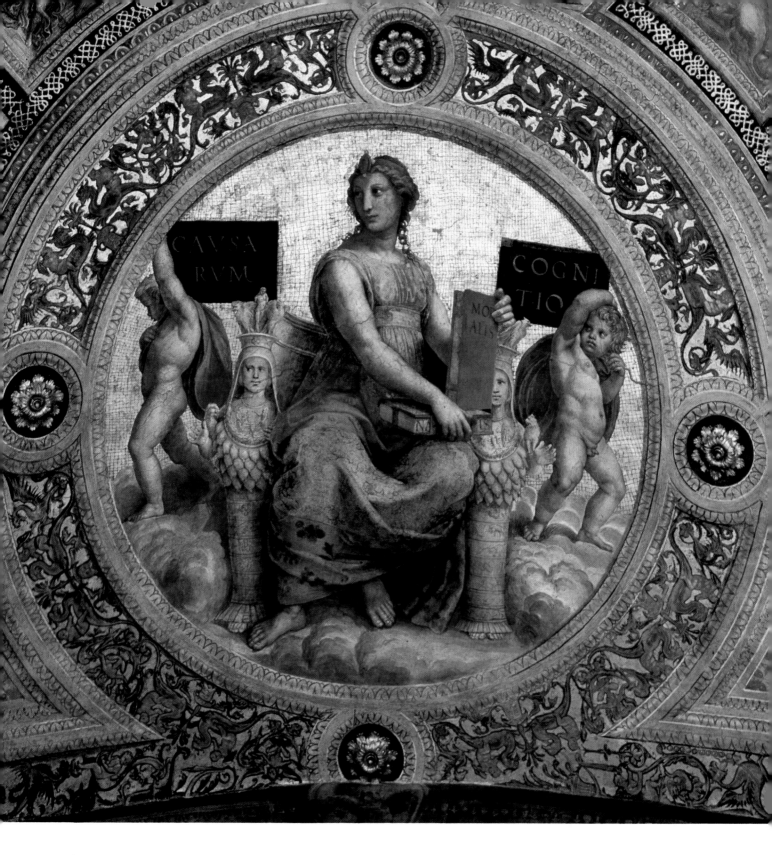

64. *Philosophy* (from the ceiling of the Stanza della Segnatura—Plate 59).

63. *Adam and Eve on the Brink of Disobedience* (from the ceiling of the Stanza della Segnatura—Plate 59).

beauty of poetry (which here includes music) and which can be understood by philosophers also. These links of content were given visual reinforcement by Raphael. The composition in each panel has bold diagonal movements which relate the upper corners to the adjacent tondi.[16] In the case of the *Judgement of Solomon* (Plate 62), diagonals are established by the movements of the figures, and the drama depends upon the point at which the diagonals cross.

The way the decoration of the ceiling is organised in tondi and rectangles around a central octagon, with smaller scenes paired between them, links it with other ceiling decorations of the day that had begun to imitate ancient Roman models. Like Pinturicchio's ceiling in the choir chapel in S. Maria del Popolo, it recalls stucco

65–6. Francesco Bartoli. *Stucco Vaults from Hadrian's Villa*. Watercolour, *c*. 1725, 32.4 × 32.4 cm and 34.6 × 34.6 cm. Eton College Library (Topham Collection).

vaults to be found at Hadrian's Villa (Plates 65–6).[17] But whereas Pinturicchio's ceiling is high enough to be considered as a whole, and can therefore be given a centre which is the focus of the design, the library vault is comparatively low (and already had a sculpted coat of arms at the centre), and there is instead a shifting hierarchy of parts perfectly adapted to both the curvature of the surface and the size of the room. A sketch by Raphael (at the bottom left of Plate 73) shows him to have been thinking about the problems of decorating a ceiling like this one (a quarter of a vault is shown), but Vasari indicates that the basic layout had already been established by Sodoma, one of the artists working in the apartments in late 1508,[18] before Raphael took over. Vasari's story that Raphael preserved the ceiling divisions and the grotesque decoration around them but repainted the principal picture fields is confirmed by technical analysis of the plaster.[19]

The smaller pictures by Sodoma remain. His fashionable idea of replacing the sky in them with simulated gold mosaic was retained by Raphael in the larger ones and contributes to the striking material richness of the ceiling, rivalling that of Pinturicchio's decoration in the Borgia apartments. It is enhanced by the fictive marble mouldings inset with gold-backed spiky grotesque ornament. The latter was probably executed by Johannes Ruysch, a decorative specialist—possibly the 'Fleming called John' who subsequently resided with Raphael.[20]

The subjects of the four tiny sets of paired historical and mythological pictures that Sodoma painted allude to the four elements which constituted the physical world as then understood, Fire, Air, Earth and Water.[21] It is not entirely clear how they relate to the rest of the decoration, but they are not incompatible with it and one cannot say whether Raphael's repainting of Sodoma's bigger pictures involved a change of programme or an aesthetic preference.

The four women he painted to represent the faculties are a development of his seated Madonnas. Here, however, the infants hop about on neighbouring clouds holding heavy tablets inscribed with Latin tags, and, where the character of their mistress's concerns calls for them, sporting wings. To express the ideas that the women embody by their physical deportment and beauty alone would be a tall order, and Raphael has had to rely on symbolic attributes and colours to amplify the inscriptions. Thus, Theology is dressed in white, green and red, which are the colours of the Theological Virtues. Like Beatrice, Dante's guide in Purgatory and Paradise, she wears, in addition to these colours, an olive crown and veil.[22] Philosophy (Plate 64), as the titles of her books indicate, had two spheres of interest, one *moralis*, the other *naturalis*. The latter covers what we would now call science, and it is this aspect which is amplified in her ornament. As Vasari vaguely remembered, the colours of her dress are those of the four elements. Its embroidery elaborates the theme by showing stars, marine creatures and plant forms at appropriate places. The point is taken further, and given ancient authority, by her remarkable throne, which is supported by two figures of the many-breasted Diana of Ephesus. They are very closely based on a celebrated type of antique sculpture, perhaps specifically on an example then interpreted as the goddess of nature, in which the seven circles binding her legs supposedly denoted the system of the planets.[23] The irrational but controlled fantasy of the figure is typical of an aspect of antique sculpture that had for some time (since Donatello) been imitated and developed for ornamental purposes by artists. But perhaps only in the work of Mantegna had such ornament been so thoroughly related to a work of art's meaning as here. Raphael's archaeological knowledge, as we shall see, probably developed as rapidly as his artistic style, but we may doubt whether at this stage he knew enough to interpret the figure himself. Its appropriateness here may have had to be pointed out to him.

In the picture of Adam and Eve, Raphael was able to paint the female nude for the first time, as far as we know, since the *Three Graces*. Here, and in two of the other rectangular pictures, he also had a chance to paint for the first time the heroic male nude. Of these, the most powerful is the executioner in the *Judgement of Solomon* (Plate 62). It is often said that the figure derives from an invention of Leonardo's, but

a similarly posed figure had already been modelled by the sculptor Bertoldo in his bronze relief of a battle. The relief was, in its turn, an ideal restoration of a damaged Roman battle sarcophagus which is still to be seen in Pisa.[24] This is confusing, but it illustrates some of the problems we face when trying to identify the sources of Raphael's inspiration. In at least one of the figures on the ceiling, however—that of the hanging Marsyas[25]—the direct derivation from an antique statue is clear, and Raphael must surely have expected the many admirers of ancient sculpture of his day to appreciate it.

The picture of Urania may contain an allusion which few beholders would have had the astronomical knowledge to grasp. In his preliminary drawing, Raphael provided her with an orrery, that is a model of the universe, rather than the actual universe over which she now presides. In the painting, the translucent cosmos (we can see her leg through it) shows the constellations in a specific configuration. It is one which can be seen in Rome for a few days each year and, significantly, would have been visible shortly after Julius's coronation, on 31 October 1503.[26]

It is impossible to say whether this change of plan arose from Raphael's desire to pay the Pope a compliment or whether the Pope himself suggested it. The change here has only a marginal effect, adding a little ornament to the meaning of the room, but if we turn now to the *Disputa* (Plates 68–9, 74), probably the first of the wall paintings to be executed, we will find that much more radical changes occurred during the process of making preparatory drawings, which suggests either that the person who devised the programme was not very firm of purpose or, more likely, that it had not been definitively specified in the first place.

<p style="text-align:center">★ ★ ★</p>

In its final form the *Disputa* is an ambitious orchestration of nearly life-size figures in space which when seen in the room occupies most of the field of vision, so that the experience must originally have been as overwhelming as that to be had in the cinema. Just as the special effects of modern films dispel our incredulity before impossible fictions, so here Raphael made the central mysteries of the Catholic faith more intensely real than ever before.

In the golden sphere of the vault of heaven, angels, many only barely discernible, attend on God the Father. He gives venerable backing to his white-robed son, who sits enthroned against a disc of gold, displaying the wounds of his sacrifice. At his side sit Mary and St John the Baptist, while behind him are arrayed figures from, alternately, the Old and New Testaments, seated on a heavenly cloudbank teeming

67. Piero della Francesca. *Victory of Constantine over Maxentius*. Fresco, c. 1455. Choir chapel, S. Francesco, Arezzo.

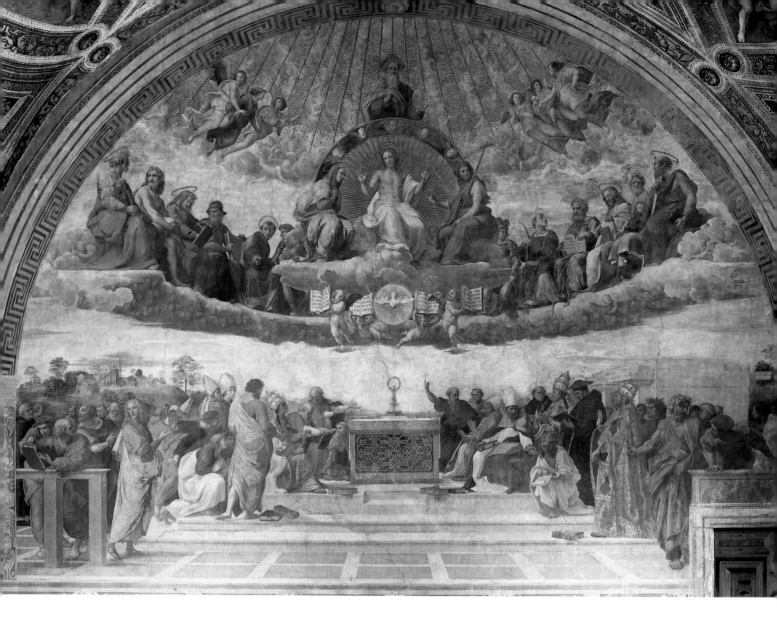

68. *The Disputa*. Fresco, *c.* 1509–10. Stanza della Segnatura, Vatican Palace, Rome.

with seraphim. Below, the white Dove of the Holy Spirit flies down, it too set against a smaller disc of gold. The focus of this downward movement, implied also by the diminution of the discs, is the tiny white circle of the Host (in which the body of Christ is 'really present') set in the golden ring of a monstrance on a simple rectangular altar, inscribed discreetly (but twice) with the name of Julius II. The monstrance is also literally the focus of the elaborate terrestrial scene, since the vanishing point of the earthly perspective is at its base. This is like Piero della Francesca's use of perspective in his fresco cycle of the legend of the True Cross at Arezzo, and, in particular, the way in which the small white disc of the Host is at the optical and spiritual heart of a rich display of colour and movement may be compared with the role of the minute white cross which is the central source of power in Constantine's victory in Piero's painting of that subject (Plate 67).

The *Disputa* is the work of Raphael's for which more preparatory drawings survive than for any other; over forty are known.[27] This is probably not an accident, given the scope of the work and his lack of experience of working on such a scale. Even those drawings that survive can be only a fraction of what he made. It is more than a little surprising to find that the altar and Host which are so crucial to the design and meaning of the picture were not envisaged when Raphael set about composing it. They are not to be seen in what is probably the earliest of them (Plate 70), an economical half-drawing of what was evidently intended to be a symmetrical composition. The cast of characters here is much smaller in number. Some of them are also different, or placed differently in the heavenly hierarchy.

69. Detail from the *Disputa*.

58

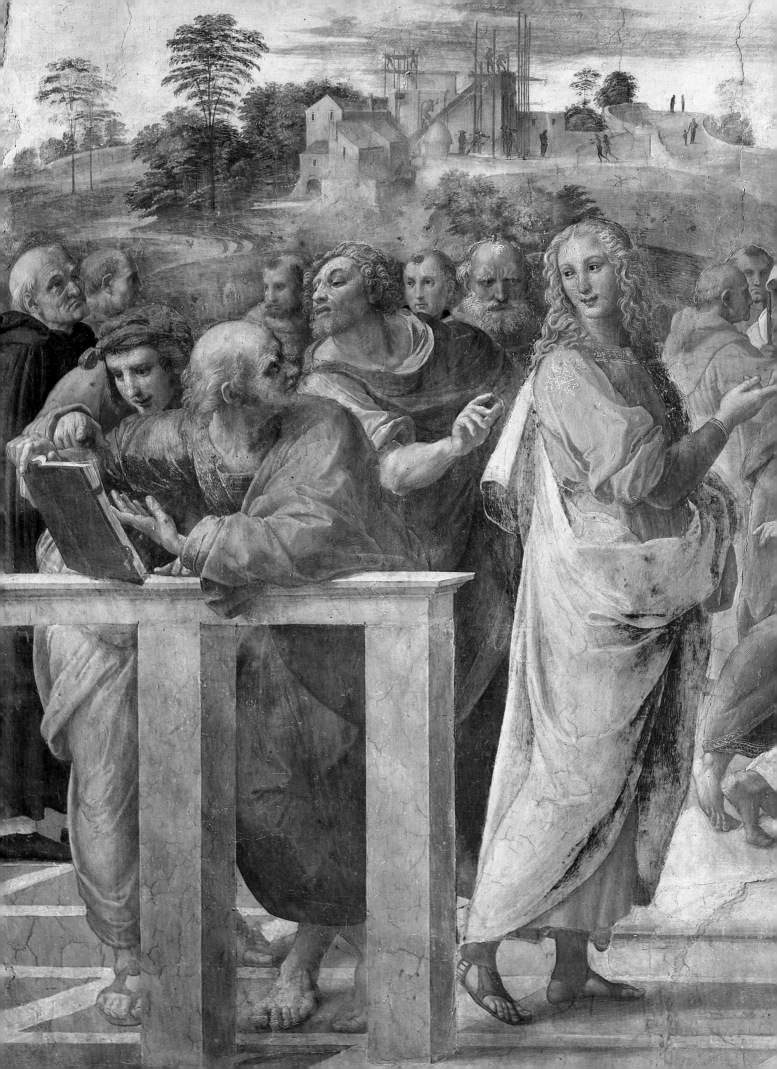

Thus the Evangelists who sit on the cloudbank closest to the ground in the drawing do not appear in the painting (instead, angels present books of their writings) and St Peter and St Paul, who sit below Christ, later end up at the sides of the semicircular group that stretches out behind him. These changes, too, suggest that Raphael's theological instructions were not inflexible.

The starting point for his ideas here was his own earlier, smaller-scale version of the *Trinity and Saints* at Perugia (Plate 30). The compositional nucleus of that painting had been inspired by Fra Bartolomeo's fresco of the *Last Judgement* in Florence (Plate 27), and his continuing memory of it may have led him to adopt here the grouping of interrelated figures at the bottom, where Perugino might simply have lined them up (as he was to do when he completed Raphael's Perugia fresco). But the chief source of Raphael's increasing interest in animation and narrative, such as we have already seen in his Florentine work, was Leonardo, and nowhere can this be better appreciated than in this early version of the *Disputa*. The drawings in Plates 71 and 72, originally perhaps one sheet, give a fuller account of this version, the brush drawing and white heightening used with much greater fullness and precision to study the volumes of the figures and their chiaroscuro illumination. The lower section is astonishingly close to the group around the Virgin in Leonardo's unfinished *Adoration of the Magi* (Plate 31), not only in some of the poses but even in details of facial type.

Leonardo's picture has a strong central focus, and to use only his supporting figures like this must have made it clear to Raphael that his own composition lacked a centre of attention in the lower part. His introduction of an altar with the sacrament (just visible in Plates 77 and 78) brilliantly solved the formal problem, while at the same time making the religious content more coherent. The sacrament is the miraculous manifestation of God in material form, and its mysterious nature sufficiently justifies the number of theologians present who strive to understand and explain it. To focus attention on the material object also underlines the way in which man's perception of God is not direct. Very few of the earthly participants are privileged to look up.

The link between the Host and God is direct, however, and this was emphasised by Raphael's changes to the upper part of the design. In Plate 70 Christ looks more like the Christ of the Last Judgement (and in Plate 75 Mary looks more like the Mary who intercedes at the Last Judgement), but in the painting he more mercifully alludes to the sacrifice embodied in the Host below and is placed at the centre of a vertical line which is now visually uninterrupted by the drawing's heavenly row of lesser beings—like St Peter and St Paul, who were moved to the sides. As we have seen, this central vertical was also emphasised by the concentration of the colours white and gold.

Raphael's ideas for the figures arranged horizontally around this centre were also considerably amplified. In Plate 70 they do not reach to the sides of the lunette and are placed in an architectural setting which acts as a unifying frame. Some of the spatial ambiguity of the S. Severo fresco is also present in Plates 71 and 72, where it is not clear whether the top row of figures are arranged in a line or a semicircle. All this is gone in the painting, where the figures occupy the entire width of the picture field in a spatial construction of architectonic simplicity and grandeur. The vault of heaven, with its studded rays of gold leaf, now looks like the apse of a church, and the whole assembly may be thought of as an illustration of the idea (which was familiar from the New Testament) that the true Church should be understood as a building composed of living members. The other half of this thought, that actual buildings are important to the Church as well, is perhaps alluded to in the background. At the left, in the distance, is a structure which has been related to Bramante's work at the Vatican Palace, while on the right can be seen the bases of a huge architectural order, like the one he was then building for the crossing of new St Peter's.[28]

Architectural elements are not quite absent from the foreground, where

70. *Compositional study for the Disputa.* Pen and wash with white heightening, over indications with a stylus, *c.* 1508–9, 28 × 28.5 cm. Royal Library, Windsor.

71. *Compositional study for the Disputa.* Pen and ink, with white heightening, *c.* 1508–9, 23.3 × 40 cm. Ashmolean Museum, Oxford.

72. *Compositional study for the Disputa* (perhaps formerly attached to Plate 71). Pen and ink, with white heightening, *c.* 1508–9, 23.2 × 40.6 cm. Musée Condé, Chantilly.

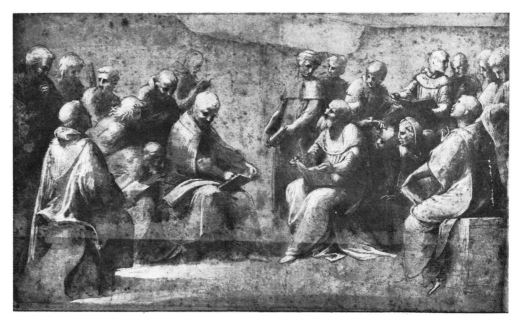

61

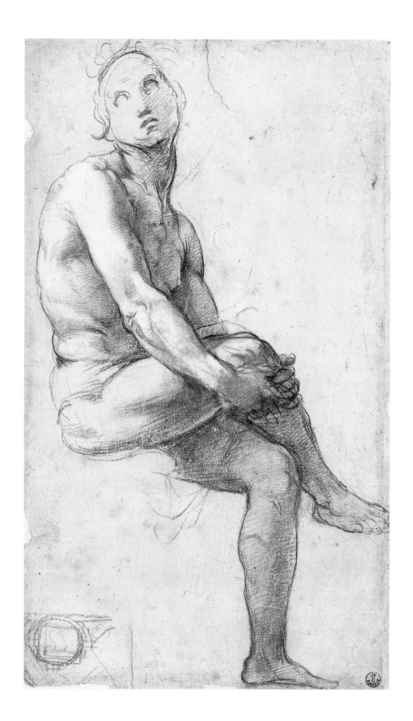

73. *Nude study for Adam in the Disputa.* Grey chalk, with ink and white heightening, *c.* 1508–9, 35.7 × 21 cm. Uffizi, Florence.

74. Detail from the *Disputa* (Plate 68).

Raphael has ingeniously used them for two purposes. The balustrade on the left balances a similar feature on the right, introduced to disguise the presence of the real door frame which upsets the regularity of the picture space. The device is rendered less obtrusive and at the same time more dramatic by the way foreshortened figures lean over the barriers, as if crossing the boundary of the picture frame and entering the world of the viewer. This kind of play with the division between beholder and picture has its immediate sources in recent work of Filippino Lippi and Pinturicchio, though its effectiveness here is more comparable with the use made of it by Mantegna in his frescoes of the life of St James in Padua.[29] As we shall see, Raphael was to make an even more astounding demonstration of this kind of virtuoso foreshortening in the *Parnassus* to deal with an even bigger interruption caused by a window. In both cases these devices seem to have been introduced at a late stage in the design, perhaps when Raphael finally had to face up to the realities of the site.

We have so far looked at the evolution of the main features of the design. The surviving drawings permit us to study in more detail the gradual elaboration of one of the major figure groups, that at the bottom left. After establishing its basic

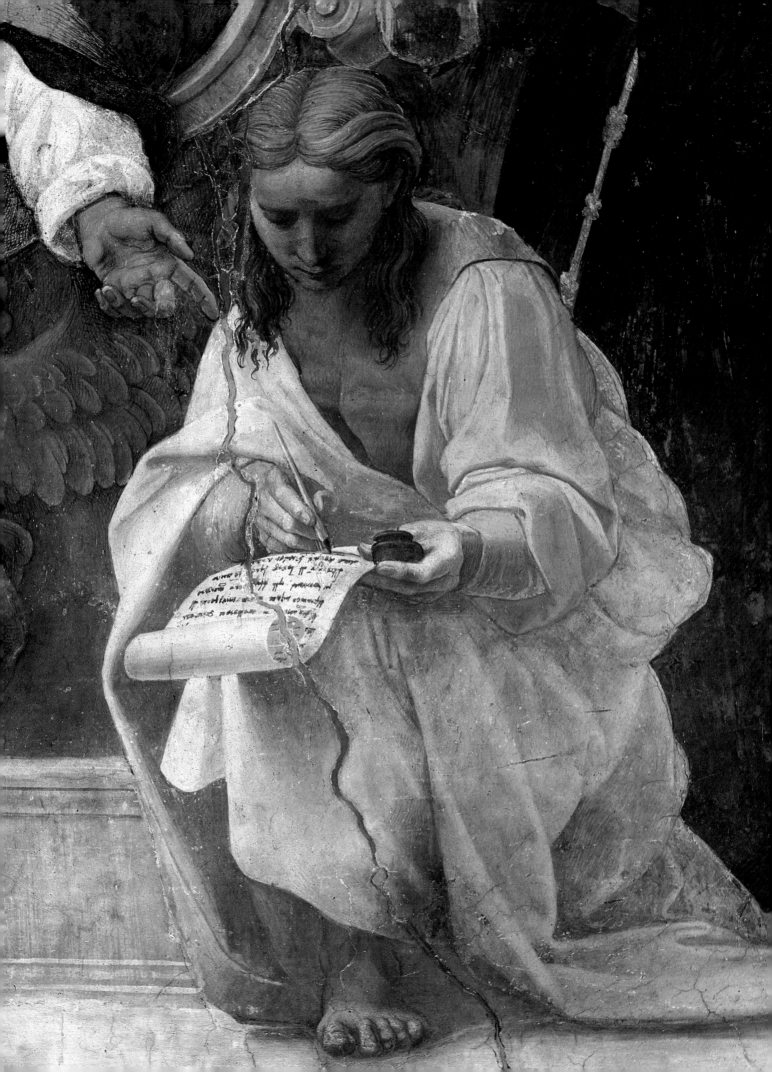

organisation in Plates 71 and 72, Raphael expanded it, seating the two principal Church Fathers on thrones rather than stools, and enlarging their entourage. This is shown by Plate 77, which also shows that the poses of the figures have been studied with reference to the nude model. This drawing, like the more schematic Plate 75, probably represents a stocktaking synthesis of a number of individual nude studies, many of which may have been as impressively descriptive as the black chalk drawing for the figure of Adam in the group above (Plate 73), though it must be remembered that Adam deserved special study, as he was to appear almost nude in the final picture. Despite the work that has evidently gone into the project at this stage, Raphael was still not satisfied with the arrangement, as we can tell from Plate 78, which is closer to the fresco, where he has introduced another vertical caesura to articulate the general movement, conveyed by gesture and expression, towards the altar, reinstating at the same time the Beatrice-like figure which had momentarily appeared, on a cloud, in Plate 70. The main purpose of Plate 78 was to clarify the contribution made to this compositional movement by the pattern of the draperies. The lights on them are provided by white heightening, applied with the point of a brush over the black ink and chalk beneath, in a way that helps to unite the figures dynamically, an effect which was disrupted in the painting, where the clothes of each of the major characters are of two different colours. The draperies assembled here may also be a synthesis of separate studies from studio props, like the one which survives for Christ's garments (Plate 76).

The exact identities of all the earthly participants have not been definitively established, despite intensive speculation.[30] The four Fathers of the early Church, seated on either side of the altar in unobtrusively, but again meaningfully, figured thrones,[31] are identified by inscriptions in their haloes, and by the books at their feet, as St Gregory the Great and St Jerome on the left and on the right St Ambrose and St Augustine. On the right, two further figures, St Thomas Aquinas and St Bonaventure, the leading writers of the Dominican and Franciscan orders, are identified by inscribed haloes, while two more were certainly intended to be recognised by their facial features: Dante, whose poetry Julius II especially admired, appearing in his role as poetic theologian on the side of the picture next to the *Parnassus*, and the towering figure of Sixtus IV, who was not only Julius's uncle, but also the author of a treatise on, significantly, the Blood of Christ, presumably the book he grasps. Behind Dante may be lurking the hooded face of Savonarola,

79. *Parnassus*. Fresco, *c.* 1509–11. Stanza della Segnatura, Vatican Palace, Rome.

80. *Sappho*—detail from the *Parnassus*.

towards whom Julius was not unsympathetic. Among the other heads are certainly some, but only some, faces which look as if they might be portraits, but we should not necessarily assume that they were all intended to be recognised.

Thus, Raphael seems to have used his friend Bramante's features for the person leaning over the balustrade, but this is likely to have been a private compliment. The figure does not *represent* the historical Bramante, who was of course not a theologian. Nor was he a heretic. This has to be said because the groups at the sides of the picture, and those in classical dress, have sometimes been interpreted as heretics or pagans being shown the truth by angelic or heroic figures pointing to the altar. This may be right, but Raphael's subject is an unusual one, and there is room for difference of opinion. Vasari, indeed, had two opinions, at one point saying that 'the Holy Fathers arrange [*ordinano*] the Mass' and at another that 'the infinite numbers of saints . . . write the Mass . . . and debate [*disputano sopra*] the Host on the altar'.[32] The use of the latter verb seems to be the origin of the picture's current title, the *Disputa*. Vasari does not mention any heretics, however, and the ideas entertained by Raphael's participants need not be seen as in the direct conflict that we find in Filippino Lippi's *Triumph of St Thomas Aquinas*, where Vasari names the vanquished heretics (and calls the picture a *disputa*).[33] Perhaps we should simply see these subsidiary figures as the less enlightened, in the process of being enlightened, a process most vividly and freshly caught in the air of the young man leaning over the arm of 'Bramante' (Plate 69). By their proximity to us, we are invited to participate.

Raphael's first biographer, Paolo Giovio, says that he painted this room 'to the prescription' of Julius II,[34] and there is no reason why we should not credit him with the basic themes of the decoration. It has frequently, and reasonably, been supposed

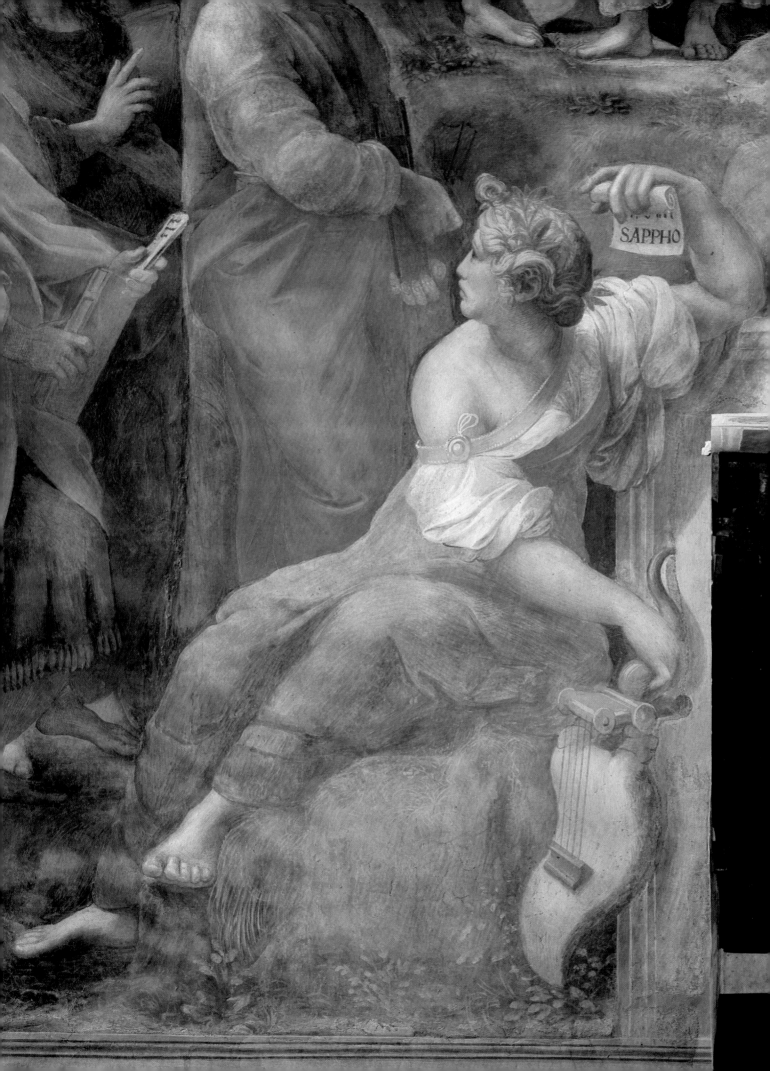

that expert advice was sought, and a number of names have been suggested for the authorship of the programme. But given what we know about how the designs evolved it is most likely that such advice was given *ad hoc* for details of the amplification, and Raphael may have shown considerable initiative in seeking it. He apparently consulted the poet Ariosto about the appropriate 'airs' for some of the figures,[35] and his research for the portraits, according to Vasari, included the study of 'statues, medals and old paintings', as well as life studies of contemporaries. Julius was not a pedantic patron, nor one to stifle the initiative of his artists. One has only to think of the way Michelangelo in these very years was permitted to enrich the ceiling of the Sistine Chapel with something far more elaborate than what he called the 'poor' programme of twelve Apostles Julius had suggested.[36]

★　　　★　　　★

Probably after painting the *Disputa*, Raphael depicted on the wall to the right of it his poets' paradise, the *Parnassus* (Plate 79), where Apollo has the central place of honour which Christ enjoys in the *Disputa*. The *Disputa* wall was interrupted by a door, this one by the embrasure of a large window. The window itself, like the others on this side of the apartment, was an important one in the Pope's plans for the Vatican. It looked out on the terraces that Bramante was arranging in a perspective view on the ascending slope of the Vatican hill (Plate 258). The more learned of the Pope's visitors would have been aware that the hill was sacred to Apollo in antiquity, and its name, Mons Vaticanus, was thought to be etymologically related to the idea of *vaticinium*, which embraced prophecy and poetical song. Indeed, contemporary poets, in flattering accounts of life in the age of Julius II, entertained the fancy that Apollo had left his home in Greece and had found a new one on the Mons Vaticanus.[37] They doubtless particularly had in mind the famous antique statue, the Apollo Belvedere, which had a prominent place in Julius's new sculpture garden there,[38] but one can see why this wall would be appropriate for the *Parnassus*.

To the painter, however, it presented problems—the distant view from the window would compete with any extensive fictional distance in the painting, and until the advent of electric light, the glare from it made enjoyment of the painting difficult.[39] The shape of the picture field was not very promising either, but, as one would expect from a great artist, the difficulties seem to have stimulated Raphael's powers of invention.

In the painting, the laurel trees of Parnassus (the source of the poets' wreaths) are cut off by the curve of the frame, suggesting, but not defining, a space beyond the wall. In the front plane, the limitations of the frame are defied, more aggressively than in the *Disputa*, by boldly foreshortened figures which apparently project forward, beyond the fictive moulding Raphael painted around the top of the window embrasure. Contemporaries would have been particularly impressed by the skill of the foreshortening—one of the features most admired in Michelangelo's figure of Jonah on the Sistine ceiling was the way its apparent recession contradicted the outward curvature of the actual vault.[40] It is hard to think of a precedent for the way the powerful figure to the right of the *Parnassus* window actually points out into our space. Antonello da Messina and Leonardo had used the device to enhance the beholder's psychological involvement with the half-length figures of small devotional pictures, but not on this monumental scale.

If we consider the content of the picture, we see Apollo playing the fiddle, surrounded by his followers, the muses, and attended by a selection of poets. Considering their proximity to him, it is remarkable that none of the poets seem to be looking at Apollo, or at his beautiful escorts. The Richardsons considered this a fault.[41] Perhaps the idea is that they are not visible to the eyes of the mortals in the picture. However, at least one and perhaps two of the mortals at the left point

81. After Marcantonio Raimondi (after Raphael). *Project for the Parnassus.* Engraving, after 1510, 35.8 × 48 cm (sheet). Whitworth Art Gallery, Manchester.

towards him, as if they could at least hear the music, but those on the right pay more attention, by their looks and gestures, to our world, as if drawn by a rival music, that of Julius II's court.

If Raphael wished the learned in his audience to exercise their minds and display their erudition in the task of identifying the participants, he was amply rewarded. The task has become a parlour game which no one is likely to win. The days when figures were given inscriptions to identify them were nearly past, and he offers visual clues of varying degrees of difficulty. Everyone who could read would identify Sappho in the foreground, whose visiting-card scroll ensures her admission to the company. Given the number of famous women poets, it may seem surprising that she had to be identified at all, but it was perhaps their very rarity that made it necessary—otherwise she might have been taken for a stray tenth muse. As it is, she is the only historical female in the room.

Students of the classics would be able to identify the muse with the comic mask as Thalia, and the one with the tragic mask (not easily detected) as Melpomene. But after that there are difficulties. The book might identify Clio as the Muse of History, the trumpet Calliope and the lute Terpsichore, who sang hymns to the gods. Of the others, are we to take the upward gaze of one of them as a sign that she is Urania, Muse of Astronomy, and the gesturing hand of another for the pantomime of Polyhymnia?[42] Or was Raphael not concerned with the exact specification of all nine of them? There had after all been no consensus in antiquity about the proper attributes and attitudes for each of them, and there was none in Raphael's day.

Turning to the poets, those familiar with the 'old paintings' Vasari mentions as one of Raphael's sources would be able to recognise Dante (to the right of the seated youth on the left), Petrarch (third from the left) and Boccaccio (the most distant figure on the right). Those familiar with the living would have been in a better position than we are to be sure whether Tebaldeo and other moderns are represented, as Vasari later claimed. The face at the extreme right looking out, at any rate, does resemble the portrait medal of Sannazaro.[43] A fairly elementary knowledge of literature would identify Homer as the old blind poet who sang his

FOLLOWING PAGES

82. *Muses*—detail from the *Parnassus* (Plate 79).

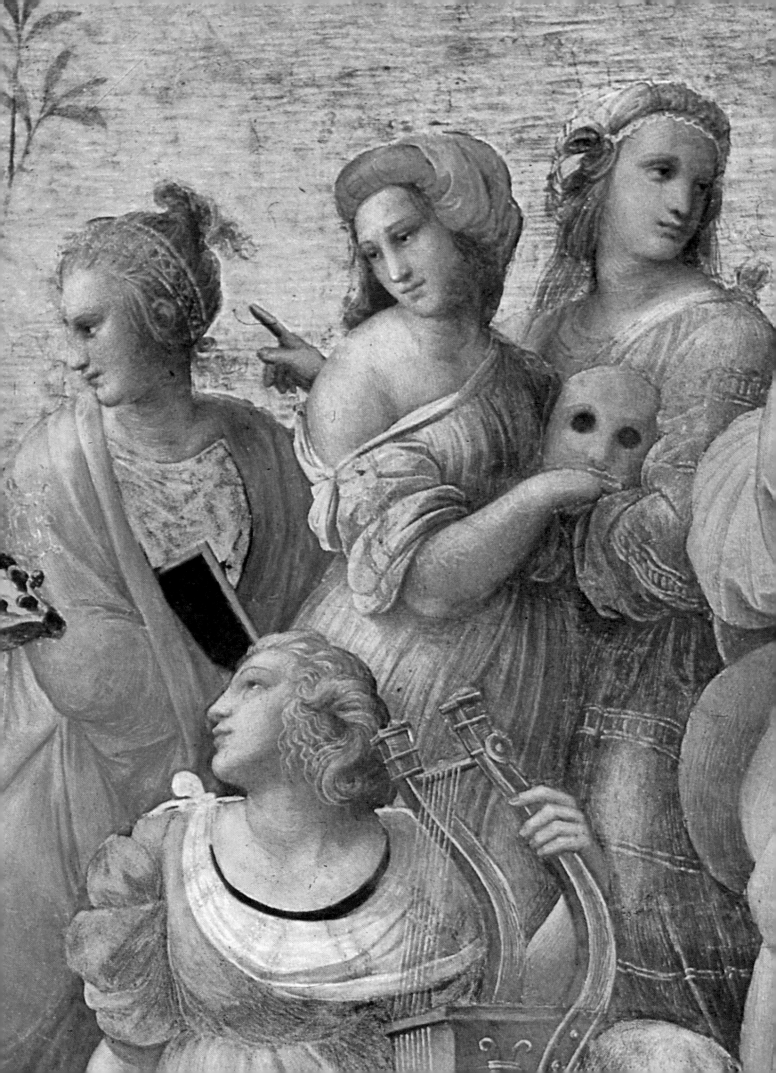

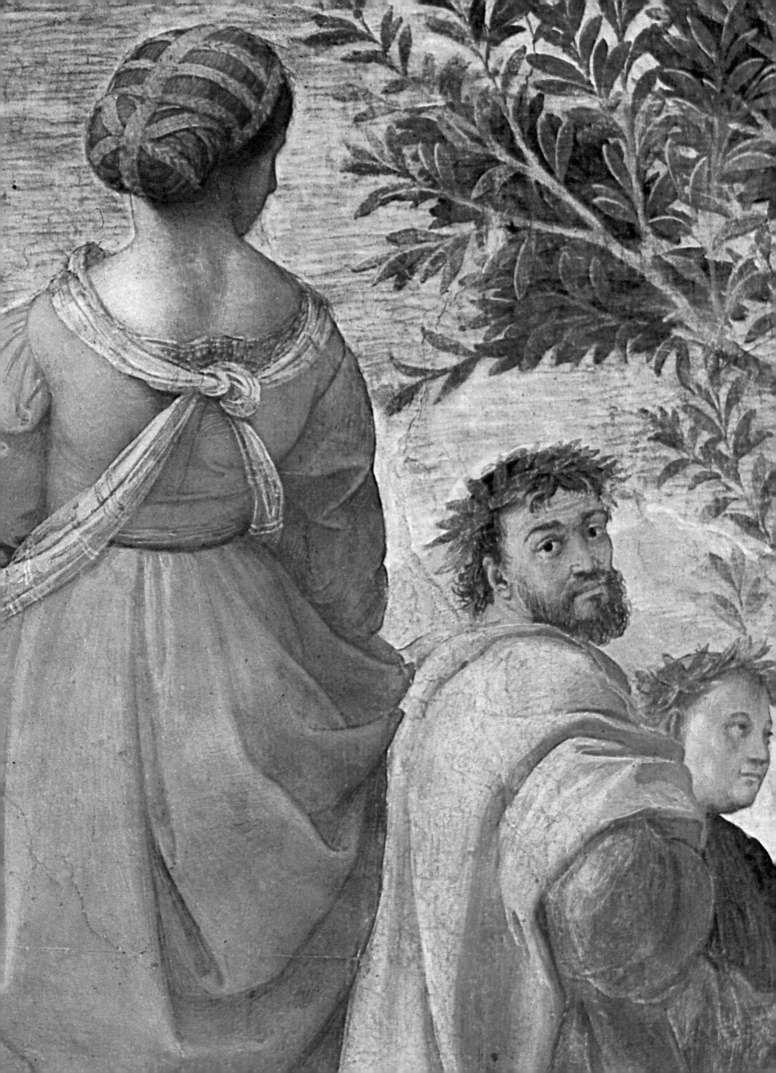

verses while others wrote them down. Behind him Dante's attention is being directed by his guide in the *Divine Comedy*, Virgil. Only specialist scholars would have known that the Roman epic poet Ennius regarded himself as a second Homer, his work dictated to him by the ghost of Homer which appeared to him in a dream. Should we assume that he is represented by the seated youth, who writes down Homer's words?[44] Or is this figure intended as an anonymous, unwreathed scribe whose role is simply to denote the fact that Homer did not himself write?

Having realised that the epic poets, Homer, Virgil and Dante, are grouped together, the beholder given to classification might have thought of looking for groups representing the other three genres of poetry—lyric, bucolic and dramatic. The grouping of Sappho and Petrarch might suggest that their companions are also lyric poets, and the name of Horace has been suggested for the monumental but stylish figure in egg-yolk yellow. But Petrarch also wrote an epic. Is that the reason why he is the closest in his group to the epic poets, or are we on the wrong track? For it is difficult to see the poets on the right as forming the two other distinct groups we need, and while the three Greek tragedians Aeschylus, Sophocles and Euripides might be shown as old, middle-aged and young, this distinction alone could surely not have been sufficient as a way of identifying the three foreground figures as tragic poets.[45] A document could turn up which might answer all these questions, but there is good reason to doubt that Raphael wished to give an exclusive finality to the assembly. This conclusion may seem rather casual and convenient, but it is one which accords best with what we know of the picture's evolution.

The principal evidence is a print (Plate 81). It is inscribed 'Painted by Raphael in the Vatican', but it is clearly not a copy of the fresco and records rather a fully worked out, earlier idea for it which Raphael thought worth publishing (or not unworthy of preservation).[46] The trees were doubtless completed, and the putti perhaps added, to suit the rectangular format of a print. Much may be learned from it. As in the early stage of the *Disputa*, the number of participants is smaller, and if Raphael did intend the foreground group on the right as the tragic poets, he has curiously included only two of them. We may notice also that the poses of the muses are mostly the same as in the fresco, but that only one of their attributes is the same, and no more than three of them have them. The water from the Castalian spring has not yet started to refresh the delicate mountain plants, and the man to the right of the window gestures to the view outside it rather than into the room. Only rocks overlap the frame, and the bold projections of all the figures in the front plane of the painting have yet to be developed.

The figure of Sappho is a completely new arrival (Plate 80). She is given more complex torsion than any of Raphael's earlier creations. He has enjoyed making the movement and the shape of her body more interesting by concealing part of it in soft convolutions of linen and restricting it with gilded bands which not only restrain her upper arm but also cut into her bosom. Such a posture and such devices were further developed not by Raphael but by Michelangelo and later artists like Francesco Salviati (Plate 83)—at the expense of much else that Raphael valued.

Turning again to the project recorded in prints it will be noticed that Apollo plays an antique lyre and not, as in the fresco, a contemporary fiddle. This must surprise us. Bellori supposed that it was a compliment to a court musician,[47] and given the importance for Raphael's contemporaries of costumed entertainment this does make sense. In September 1506, for instance, Julius was entertained in Orvieto by a poet dressed as Orpheus reciting beneath an oak tree filled with children disguised as acorns,[48] and in September 1512 Vincenzo Pimpinello, also dressed as Orpheus, sang in the Belvedere gardens for the benefit of the Pope's guest, the Bishop of Gurk, ambassador of the Holy Roman Emperor. According to one account there was also a comedy, in the middle of which Apollo and the muses appeared and praised the Pope and Emperor.[49]

This latter entertainment is of interest for another reason. During the course of it, the Pope and the bishop crowned Francesco Maria Grapaldi of Parma with laurels

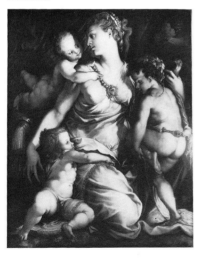

83. Francesco Salviati. *Charity*. Oil on panel, *c.* 1550, 156 × 122 cm. Uffizi, Florence.

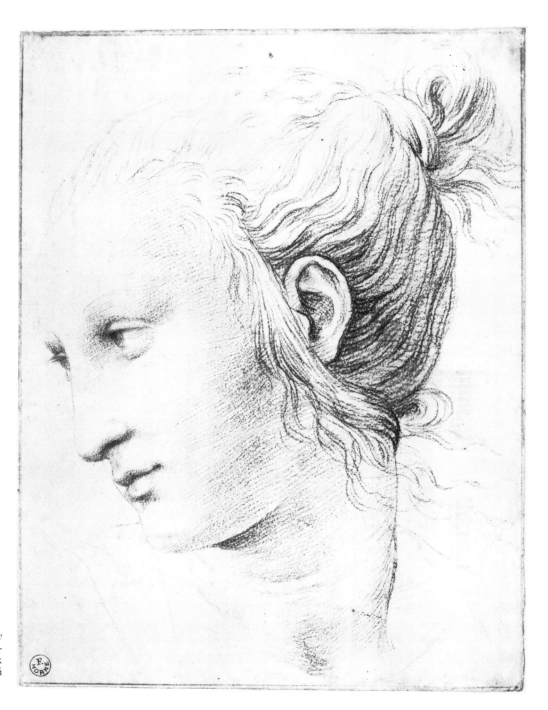

84. *Study for the head of a muse in the Parnassus* (perhaps re-used for the *Healing of the Lame Man*—Plate 149). Black chalk, *c.* 1510, 26.2 × 20.7 cm. Uffizi (Horne collection), Florence.

after he had recited fulsome Latin verses.[50] Paris de Grassis, the Pope's highly conservative master of ceremonies, had expressed his strong disapproval of the pagan custom.[51] However, the laurels were supplied (and perhaps the whole affair proposed) by Tommaso Inghirami (Plate 165). Given his position as prefect of the Vatican library and his subsequent reputation as an impresario, organising paintings, scenery and floats for ceremonial occasions,[52] Inghirami is a likely candidate for one of Raphael's advisers in his decoration of this room. Parnassus with its laurel trees would clearly have been an attractive subject for him. Paris's reaction on the other hand suggests that a system of decoration which gave to Apollo an eminence almost equal to that of Christ might not have been considered appropriate by all at court.

To have changed Apollo's antique lyre to a fiddle (which necessitated recasting the pose of the figure) is surprising, because all the other changes made to the musical instruments and attributes between print and painting are in the direction of greater archaeological accuracy. In the interval Raphael had evidently paid attention to a

sarcophagus of the muses which was then in the Casa Mattei.[53] From it he borrowed the idea of the tragic and comic masks for the muses and gave Sappho an instrument which, if he was really anxious to give all the muses the attributes they had in antiquity, should have been given to a muse.

These antique details lend authority to Raphael's picture, though the real reason why it has been so much admired is not the detail, or the literary taste shown by the programme, but more general considerations of its appropriately elevated but attractive style. This has more to do with his ability to use figures and gestures expressively. Here too the antique had much to offer. The drapery and folded legs of the muse reclining to the left of Apollo in the fresco seem to have been adjusted between print and painting with reference to the antique *Ariadne* which may have been discovered when the fresco was being prepared.[54] It was taken to the Belvedere statue garden as was the *Laocoon* group, discovered in 1506—one of the most heroic examples of Hellenistic sculpture to be seen in Rome, which provided inspiration for the powerful facial expression of Homer. This element in his style was controlled by constant recourse to the living model, and with an artist like Raphael a sculptural source may always be enlivened by the imagination and by recollections of living models—thus the smooth simplified features of one ravishing chalk study look like marble, but the hair has a freedom unlikely in sculpture (Plate 84). Likewise in imitating ancient statues of Diana of Ephesus (Plate 64) he supplied the goddess with nipples, which are not found in any antique example. Raphael had particular reason to be familiar with the *Laocoon*. Shortly after his arrival in Rome, Bramante had appealed to him to judge a competition he had organised between four sculptors who were to make small wax models of it, presumably to show how the damaged parts might most effectively be restored.[55]

The classicising character of the Parnassus wall was, probably somewhat later, reinforced by two grisaille paintings below the main scene on either side of the window (Plate 58), which imitate, in their colour and narrative style, Roman relief sculpture. They show two episodes illustrating the importance attached to literature by great rulers (like the imperially named Julius II)—on the left *Alexander the Great places Homer's 'Iliad' in Safe Keeping* and on the right *Augustus prevents the Burning of Virgil's 'Aeneid'*.[56]

Finally, it is worth noting that at this time Raphael himself was trying his hand at writing poetry. Drafts of amorous Petrarchan sonnets are to be found, intriguingly, on sheets of studies for the *Disputa*.[57] Their quality would scarcely justify his inclusion in the *Parnassus*, but his features do seem to be, rather impudently, included in the picture, immediately to the left of the muses.[58]

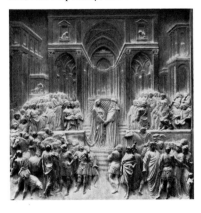

85. Giambologna. *Apollo*. Bronze, 1573–5, 88 cm. Studiolo, Palazzo Vecchio, Florence.

★ ★ ★

86. Lorenzo Ghiberti. *The Meeting of Solomon and Sheba*. Gilt bronze, c. 1430, 79.5 × 79.5 cm. From the *Porta del Paradiso*, The Baptistery, Florence.

The execution of the *School of Athens* (Plate 87) probably followed that of the *Parnassus*. We should not, though, conclude that because the frescoes were painted in this sequence they were not initially designed together. We sometimes find Raphael transferring ideas developed for one picture to another context. The pose of the man to the right of the window in the early design for the *Parnassus*, for example, was actually used, in reverse, for the man to the left of the altar in the *Disputa*; and a figure group from a drawing for the *Disputa* (Plate 72) found its way into the *School of Athens*.

The painting of the latter, however, can hardly have been completed before 1511. On 14 August of that year the first section of the Sistine ceiling that Michelangelo had completed was available for inspection—Vasari reports that Bramante had arranged for clandestine visits beforehand, but now it could be properly studied.[59] One figure in the *School of Athens*, the brooding figure wearing boots and seated beside a block in the foreground, who was, it is clear from the plaster, an

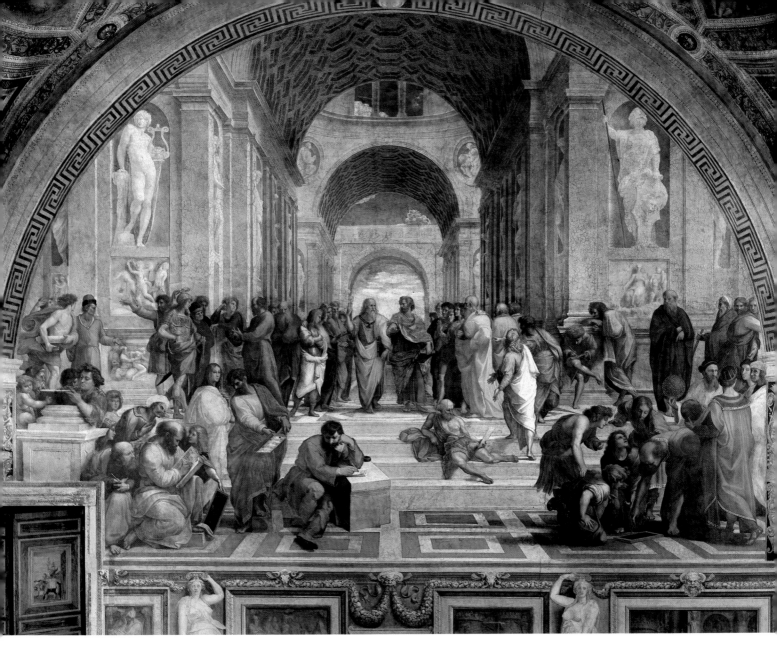

87. *School of Athens*. Fresco, *c.* 1510–12.
Stanza della Segnatura, Vatican Palace,
Rome.

afterthought, is probably Raphael's first attempt to appropriate some of the heavyweight power of Michelangelo's Sistine prophets and sibyls.

When the *School of Athens* was itself inspected, this debt must have been obvious, but it could have been said that Raphael's fresco also possessed merits which Michelangelo did not seek to equal. Michelangelo had developed his interest in foreshortening the human body without developing an overall interest in linear perspective for his compositions. He had no inclination to arrange numerous figures harmoniously in a deep, mathematically constructed space. This had been an ambition central to the work of such great masters of the fifteenth century as Masaccio and Ghiberti (Plate 86), and Raphael appears, above all here, as their heir.

The architecture Raphael painted here is far more massive than that which he created seven years earlier for the *Sposalizio*. We will discuss it in more detail later. Its scale is enhanced and its angularity softened by the colossal statues that fill, indeed by conventional standards overfill, the unusually high niches. The two statues which preside over the assembly of mortals are Minerva, who is placed, appropriately, on the right, nearest to the wall which illustrates Jurisprudence, and Apollo on the left nearest to the *Parnassus*. The latter has a sinuous pose which anticipates, even if it did not influence, the Apollo made by Jacopo Sansovino for the Loggetta in Venice and the statuette of Apollo, with a similarly effeminate build but yet more narcissistic contrapposto, created by Giambologna (Plate 85)—there is a type of beauty

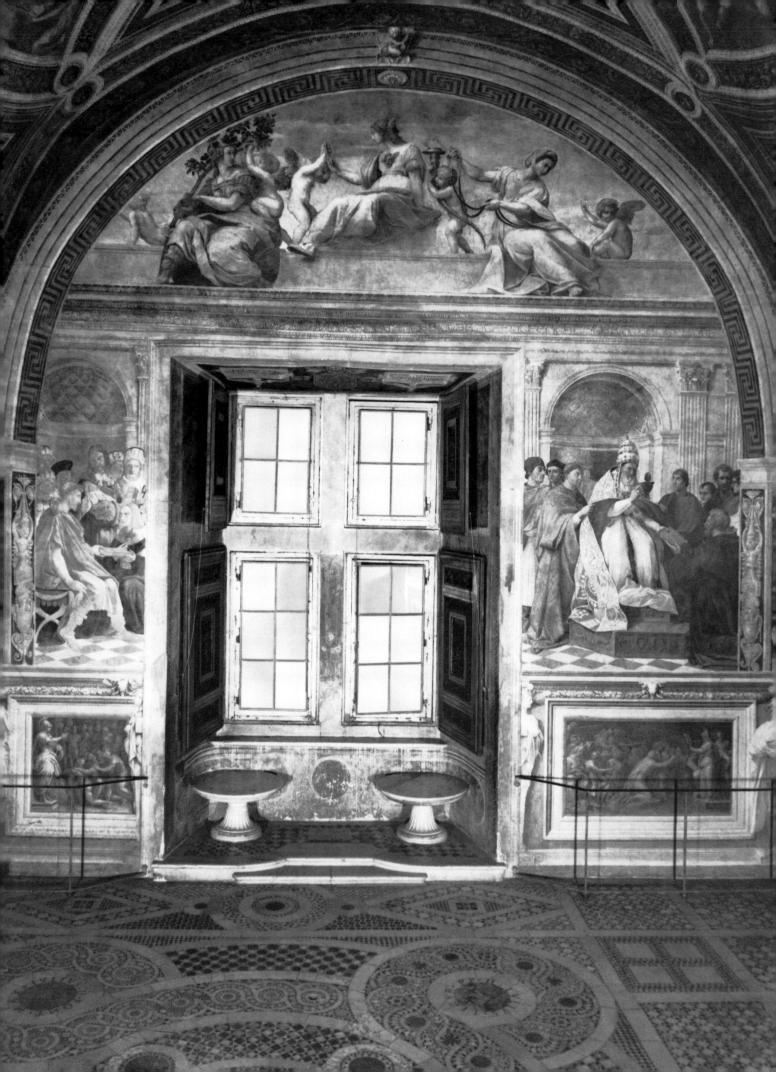

proposed here, just as there was in the Sappho, which would increasingly attract the leading artists in Italy over the following century.

The arches frame the central figures of Plato, holding his *Timaeus*, and Aristotle with his *Ethics*. Their heads are among the smallest in the painting, but are the only ones with the sky behind. The eloquence of their gestures, economically characterising their different philosophies, is enhanced by the architecture. The arch if completed as a circle would underline the extended hand of Aristotle. This is the same sort of finely calculated geometry that had helped to organise the *Sposalizio*.

To the left of Plato, Socrates can be recognised, partly by his features, for which Raphael was able to use an antique portrait head as a model,[60] and, very tellingly, by the gestures he makes to his students—'Even the Manner of the Reasoning of *Socrates* is Express'd: he holds the Fore-finger of his left hand between that, and the Thumb of his Right, and seems as if he was saying, You grant me This and This.'[61] Amongst the disciples is a young soldier who must surely be his friend Alcibiades. Another disciple seems to wave away a skinny librarian who has ushered in a muscular slave laden with the literary authorities of the sort the Socratic method has no need of.

In the foreground to the right of the door which projects into the picture space is Pythagoras seated with a book and, precariously, an inkwell. A young disciple holds a slate tablet upon which are noted the harmonic relations. In the equivalent position on the right Euclid bends down to demonstrate with his compasses. The four youths around him variously appeal for assistance, struggle to follow the proposition, grasp it for the first time and delight in its reiteration.

Another figure which can be certainly identified is the cynic Diogenes sprawled ungraciously on the steps with the bowl which was his only possession by his side. The crowned figure in a yellow robe with his back to us on the right, holding a terrestrial globe, is likely to be the geographer Ptolemy and the bearded sage in front of him holding a celestial one the astronomer Zoroaster.[62]

Although the magnificent full-scale cartoon for the figures in the picture survives,[63] we know less about the evolution of the design than with the previous pictures. But we have already seen that the programme was flexible enough to admit a last-minute newcomer to the scene—the seated figure in the foreground with his elbow on a block, who was not included in the cartoon. More than anyone else in the fresco he powerfully does what one expects philosophers to do—sit and think—but

89. After Raphael. *Project possibly for the Stanza della Segnatura.* Pen and wash, probably copying a drawing of *c.* 1509. Musée du Louvre, Paris.

88. (left) Wall of the Stanza della Segnatura illustrating Jurisprudence. Fresco, *c.* 1511–12. Vatican Palace, Rome.

77

90. *Study of two youths and of the head of Medusa on the Shield of Minerva* (preparatory for the *School of Athens*—Plate 87). Silverpoint with white heightening, on paper prepared pink, *c.* 1509–12, 27.8 × 20 cm. Ashmolean Museum, Oxford.

91. *Fortitude* (from the wall illustrating Jurisprudence—Plate 88).

his identity has not been established. (His features have, implausibly, been seen as those of Michelangelo.)

We might have expected some modern philosophers of the Christian era to be included, but none can be detected. Bramante was a highly skilled geometrical perspectivist, and the use of his features for Euclid was pointed, but we must presume that he is not here in his own right, any more than Raphael himself, who used his own features for the young student looking out at us at the extreme right.[64]

As in the *Disputa* and *Parnassus*, there are figures who appear to be important but cannot be identified (and we do not have the many helpful hats, tiaras, mitres, tonsures and haloes of the *Disputa*), and Raphael seems again to have used a combination of the precisely specified and labelled, and the suggestively vague, with

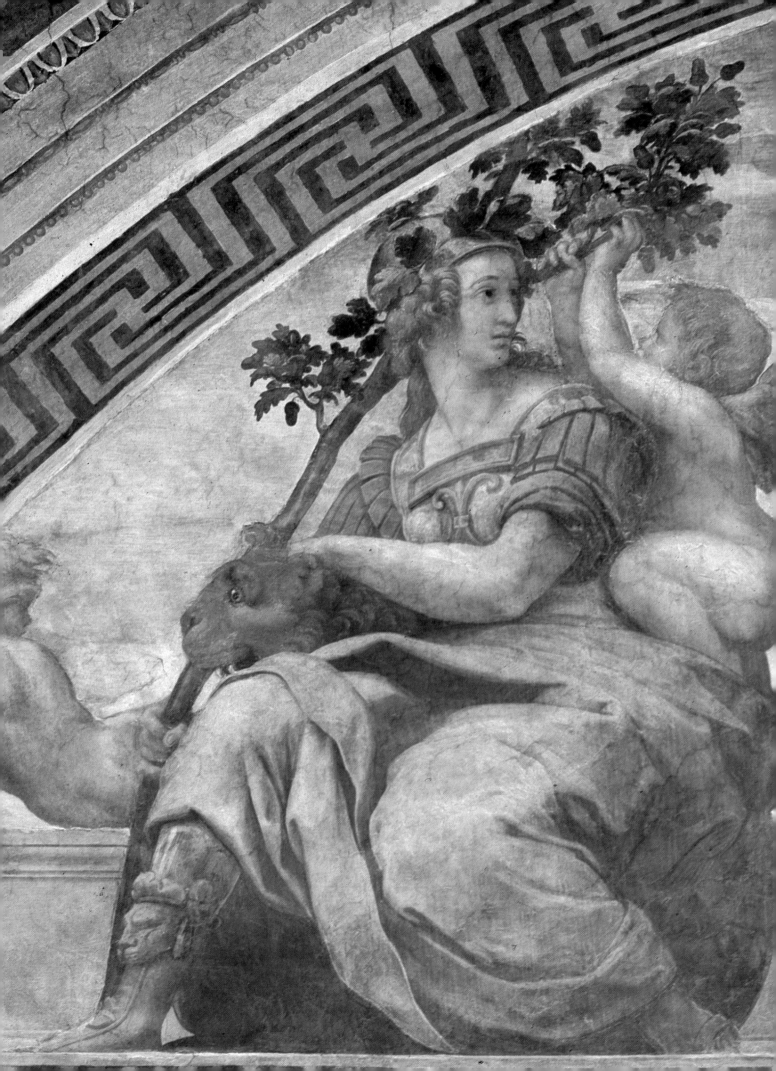

the border between them hard to draw—as we saw with the 'Ennius' of the *Parnassus*. Here, the two elegant youths on the steps (studied together by Raphael in an exquisite silverpoint drawing—Plate 90) present a similar problem. Are they anonymous participants, or might they be Epicurus and Aristippus?[65]

<div align="center">★ ★ ★</div>

On the Jurisprudence wall (Plate 88), we have another instance of a contemporary's features being pointedly used for the face of an historical person, and this was more than a private compliment. Pope Gregory IX delivering the Decretals is a portrait of Julius II, and both his pontifical robes and throne bear Della Rovere emblems. Julius had returned to Rome, making his first appearance there with his new beard on 26 June 1511. A portrait of him bearded is mentioned as already in the palace by August[66]—this is likely to be a reference to this fresco.

It is possible that a quite different scheme had initially been envisaged for the wall, recorded in a copy (Plate 89).[67] Evidently intended for a site like this, it shows a view of Mount Patmos—a sacred complement to Mount Parnassus opposite—with St John recording his vision there, and the (as yet unbearded) Pope on his knees opposite, while God the Father in the sky dispenses to the seven angels the awful trumpets that will announce the Last Judgement. However, although the subject is not inappropriate for Jurisprudence, it is not so bookish as the present decoration, and lacks the distinction between canon and civil law made by the two historical scenes that were actually painted, a distinction already implied by the tondo above, where two of the putti have wings and two do not.

These scenes (if we except the vividness of the portrait heads) have not attracted the same praise as the rest of the decoration, partly because of their condition (the one on the left is unfinished), but also because the compositions, particularly that depicting Justinian, are not as impressive. The architectural backgrounds work well as a way of unifying the scheme around the window but less successfully as locales for the action, and there is a painful lack of relationship between the pattern of the marble pavement and the dais of Pope Gregory's throne.

This may be due to their having been designed in a hurry, and partly executed by assistants, but no such excuses are needed for the Virtues who sit on the platform above them. They may be contrasted with the personifications in the ceiling tondi, which now seem relatively meagre in their forms and inhibited in movement. The Sappho and the seated muses of the *Parnassus* prepare us for the monumentality of Prudence and Temperance here, but Fortitude (Plate 91) is given not only a pet lion and a leonine boot ornament and an oak branch with acorns (which was also the emblem of Julius II) but also more impressive proportions than her two companions—in fact a massive grandeur which again suggests the influence of the Sistine ceiling (Plate 241), and which is unprecedented in Raphael's females.

As in the ceiling tondi with which we began, we may ask these women's companions for meaning as well as charm. Their actions allude to the other Virtues, the theological ones of, from right to left, Hope, Faith and Charity.[68]

IV. The Early Years in Rome

WHILE the decoration of the private library of Julius II established Raphael as one of the leading artists in Rome, his reputation was still more enhanced and his fortune doubtless increased by the prints after his designs which began to appear in the same period. Among earlier Italian artists only Mantegna had obtained a comparable fame by this means, but it has been persuasively argued that he had never sought to mass-produce images and that this was achieved by former employees who stole and reworked his plates.[1] Mass-production was, however, the aim of the leading printmaker in Europe, Albrecht Dürer. Raphael, unlike Mantegna and Dürer, did not, as far as we know, work on the metal himself. He let Marcantonio Raimondi engrave his work. It is unlikely that any artist before Raphael so profited from the reproduction of his work by another hand in another medium.

Patrons and collectors in this period were increasingly attaching a high value to work by the artist's own hand. They wanted a 'Leonardo' or a 'Raphael'. This may be connected with a new and exalted notion of artistic genius. But as the modern conception of the autograph original came into being, so too did the reproduction — that is, the self-declared un-original work of art. As the 'original genius' arose, so too did his shadow, the 'mere craftsman'. So much reproductive art exists today that we take it for granted. Yet when Raphael was born there was hardly any art of this character. The revolution occurred in Raphael's lifetime and he, and Marcantonio, played an important part in it.

Marcantonio, who came from Bologna, made his name in Venice during the first decade of the century as an exact imitator, and on occasion forger, of Dürer's prints. These were remarkable technical achievements, but one of his later Venetian prints was more ambitious (Plate 92). It is traditionally, but for no good reason, known as 'Raphael's Dream', and has been supposed to be a record of a lost nocturne, a 'fire with several figures' painted by Giorgione.

If so, it is the first attempt to reproduce a painting as an engraving. At the same period (Vasari says 1508)[2] a leading Venetian painter, Titian, took the step of organising printmakers to execute a large woodcut of the *Triumph of Christ* to his designs. So we may also trace the division between the artist-creator and craftsman-executor to this moment in Venice. In 1510 Marcantonio signed a print of several figures from Michelangelo's Florentine cartoon of the *Battle of Cascina* placing them against a background from a print by Lucas van Leyden.

In Rome Marcantonio does not seem to have approached Michelangelo. Instead, as Vasari tells us, 'when he came to Rome [Marcantonio] engraved on copper a beautiful sheet by Raphael of Urbino, on which was the Roman Lucretia who killed herself, in such a careful and beautiful manner, that when some of his friends then

92. Marcantonio Raimondi (perhaps after Giorgione). *Nocturne with Nudes* ('*Raphael's Dream*'). Engraving, *c.* 1507–8, 23.8 × 33.5 cm (sheet). Whitworth Art Gallery, Manchester.

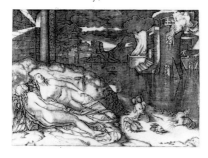

93. *Compositional sketch for the Madonna Alba, with other studies.* Red chalk, pen and brown ink, *c.* 1511, 41 × 26.4 cm. Musée Wicar, Lille.

94. *Life drawing of a boy* (verso of Plate 93—preparatory for the *Madonna Alba*). Red chalk, *c.* 1511, 41 × 26.4 cm. Musée Wicar, Lille.

took it to Raphael, he [Raphael] determined to issue as prints some designs of his things'.[3] This sentence (which is no more elegant in Italian) suggests that the first initiative was Marcantonio's.

At some point a talented youth who had 'for some years' ground Raphael's colours was put in charge of printing and marketing the engravings made by Marcantonio after Raphael's designs. We know this youth only as 'il Baviera'. Vasari also tells us that he had looked after a woman whom Raphael loved. If he was Bavarian, as his name suggests, it is significant, for many Roman printers at that date were of German extraction,[4] and it would have helped him to survive the Sack of Rome in 1527 which ruined Marcantonio.

Vasari attributed Baviera's prosperity after the Sack to the fact that he had the *stampe*—literally the prints, but presumably the plates—of Raphael's work. However, Vasari also mentions that the German soldiers carried off a plate from Marcantonio, who must therefore also have had some.[5] The character of the partnership is in fact entirely mysterious. But it certainly flourished, and before Raphael's death other engravers, notably Marco Dente of Ravenna, Agostino de' Musi from Venice and Jacopo Caraglio, were involved.

The words *Raphael pinxit in Vaticano* appeared on the prints Marcantonio and his school made of the *Parnassus* (Plate 81)—or were at least added to the plate at an early stage. In fact, as we have seen, what Raphael painted was quite different. There

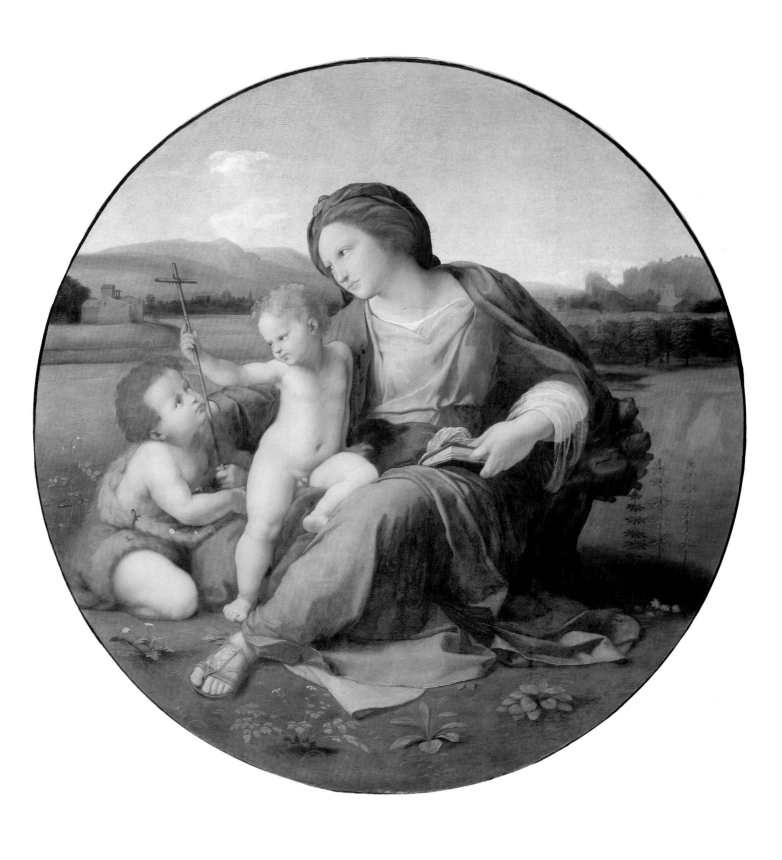

95. *The Madonna Alba*. Oil on canvas (transferred from panel), *c.* 1511, 95 cm diameter. National Gallery of Art, Washington, D.C.

are other examples of Raphael passing on to Marcantonio finished drawings which had been developed for paintings but never used. To Marcantonio it would have made little difference, for when the paintings *were* reproduced he would still have worked from the same sort of drawing. Raphael may have adapted drawings for Marcantonio, but only in a few cases does it seem to us likely that Raphael made original designs specifically for a print. The earliest of these prints (Plate 97) must date from early in their association.

An interest in scenes of violent movement and passion involving the heroic nude male is evident in Raphael's drawings prior to his work for Julius II and found further expression in the ceiling picture of the *Judgement of Solomon*. On the same sheets upon which he drew studies for this there appear others for another narrative also involving men about to cut up children—the *Massacre of the Innocents*. A pen and chalk drawing in which all the figures including the women are nude shows the composition nearly worked out (Plate 96). However, the warriors who pull back fleeing women by the hair in the second plane on the right are sketchily drawn when compared with the other densely hatched figures. The man and woman moving to the right do not appear in the final print; but the other pair, who do, are in fact the same two figures turned round.

As he executed this drawing Raphael seems to have conceived of the action as rotating around the central figure. This, above all, gives compelling unity to the design. By contrast Michelangelo's *Cascina* cartoon (Plate 47) appears to be a compilation rather than a composition. This comparison suggests itself because of the number of male nudes in Marcantonio's print. There is in fact no rational explanation for this as there is for the nudes by Michelangelo. In earlier large representations of the *Massacre* (of which the fresco by Ghirlandaio in S. Maria Novella would certainly have been known to Raphael) the soldiers are all dressed. Raphael has adopted a convention of classical art well represented by the *Laocoon* group, in which the Trojan priest is portrayed without the sacerdotal robes he would certainly have been wearing. A notable precedent for the portrayal of the active nude male in a print is provided by Mantegna and by the enormously popular *Battle of Nude Men* by Pollaiuolo (Plate 51). The idea of repeating a pose from different viewpoints in a single design is also one that might have been suggested by Pollaiuolo's practice here and elsewhere.

The outlines of the more finished of the figures in the drawing are pricked to facilitate transfer—a characteristically precise economy in his drawing procedure. These outlines were in fact probably transferred to a sheet now at Windsor which is drawn in red chalk. From this, or a similar drawing in this medium, a counter-proof could be obtained by wetting the sheet and pressing another against it. This would provide a reverse cartoon for the engraver.

The background appears in none of the surviving drawings and might therefore be supposed to have been adapted by Marcantonio, as was his usual practice, from a Northern print. However, the bridge in it is one of the ancient ones to have survived in Rome and the whole scene derives from a source (perhaps a drawing by Raphael himself) which was also copied in a sketchbook of Roman antiquities, certainly completed before Marcantonio came to Rome.[6] It is unlikely anyway that Raphael would on this occasion have left anything to Marcantonio's invention, and the bridge plays a decisive part in binding the figures together, whereas distant buildings when designed by Marcantonio tend to have no interesting relation to the foreground.

There were two plates made of the *Massacre*. They were very similar but were not intended to be mistaken, for a fir tree is added to the corner of one of them. The differences have been taken to indicate another artist's style but may equally well be due to the use of a different set of engraving tools. It has never been established which was made first. Was one a copy made as a studio exercise? Had the original plates been so worn that subtle refinements of delicate hatching and stipple could not be effectively strengthened and so another version was required?—Vasari is quite

96. *Massacre of the Innocents* (study preparatory for Plate 97). Pen and brown ink, with some figures in red chalk, *c.* 1511, 23.2 × 37.7 cm. British Museum, London.

97. Marcantonio Raimondi or imitator (after Raphael). *Massacre of the Innocents.* Engraving, *c.* 1511, 28.3 × 43.4 cm (sheet). Whitworth Art Gallery, Manchester.

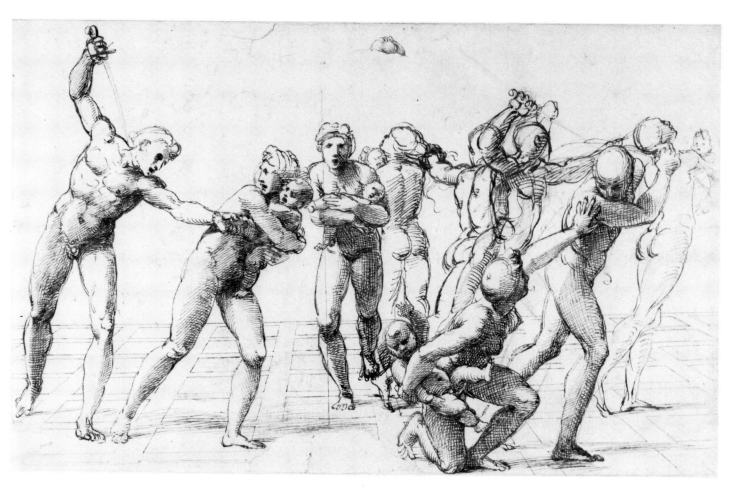

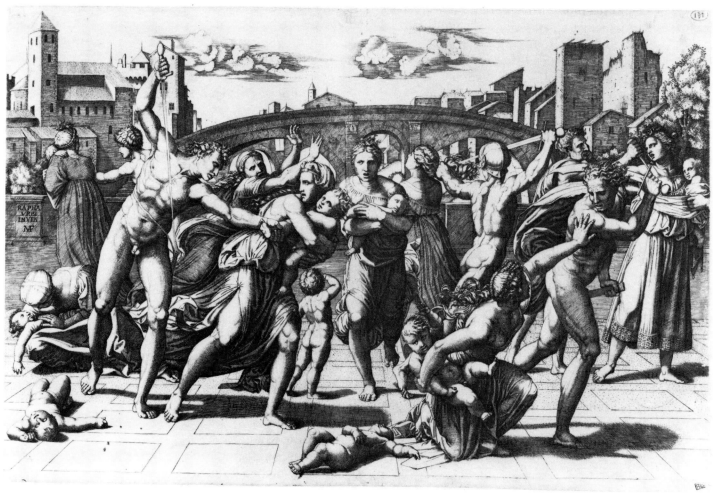

85

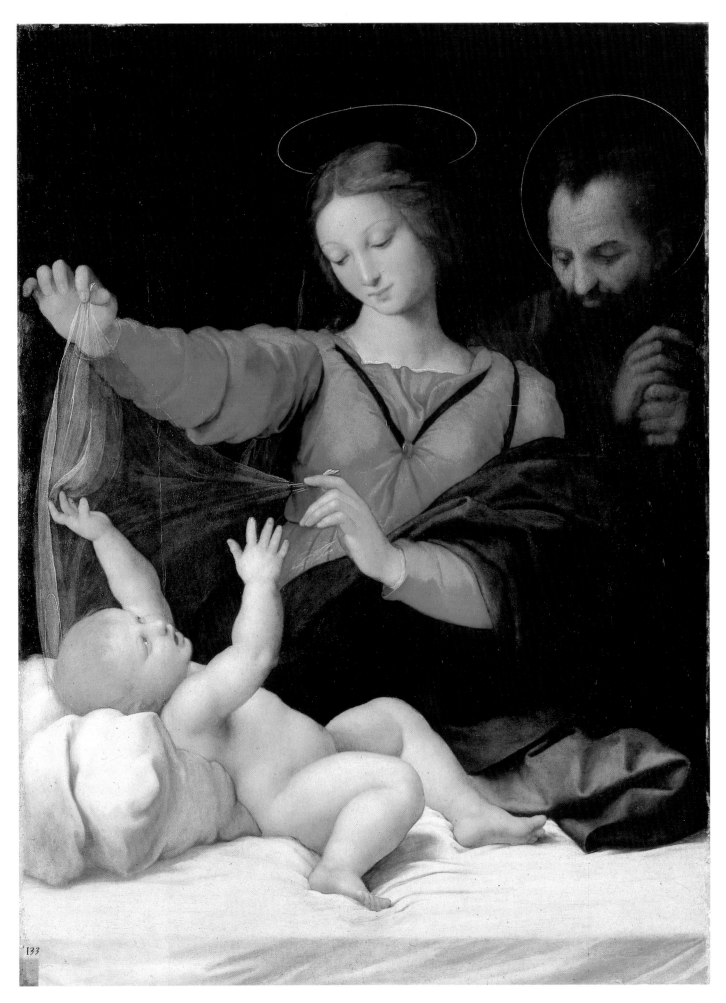

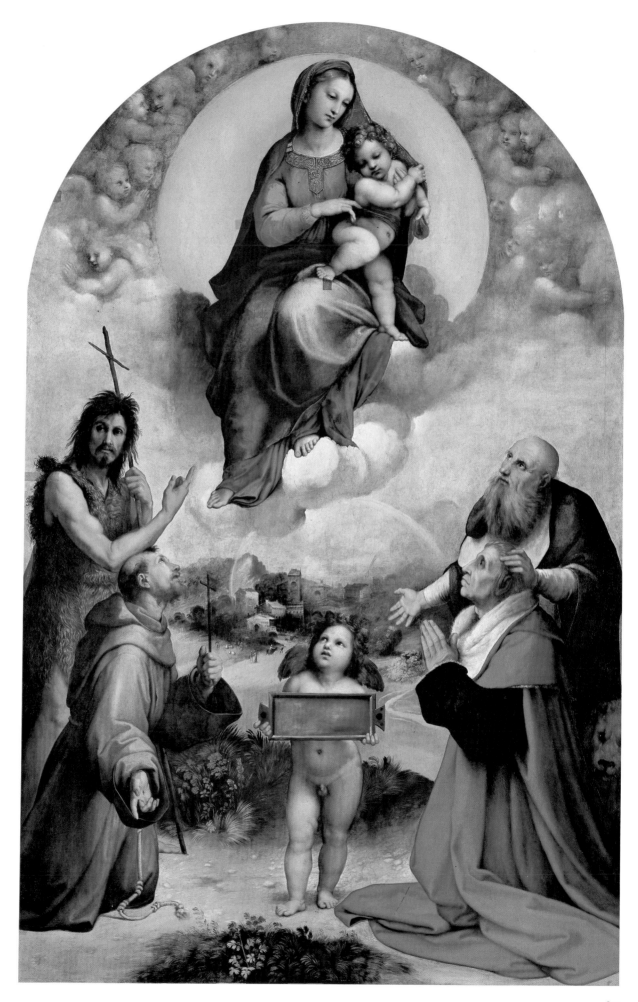

98. *Madonna di Loreto*. Oil on panel, *c*. 1511, 120 × 90 cm. Musée Condé, Chantilly.

99. *Madonna di Foligno*. Oil on canvas (transferred from panel), *c*. 1512, 301 × 198 cm. Vatican Museum, Rome.

explicit that this was the case with another of Marcantonio's plates.[7] Was the first plate stolen during the Sack? Or did Marcantonio and Baviera perhaps divide their assets and agree that both should retain the means of profiting from this immensely popular image?

★ ★ ★

One great opportunity presented to the artist by engraving was that of choosing his own subject matter, but there is no evidence that Raphael felt himself to be inhibited by the requirements of commissions. He continued in this period to be in demand as a painter of Madonnas and he invented new and beautiful variations on the themes he had earlier employed in such works for Florentine patrons. In the *Madonna Alba* (Plate 95) the Virgin is clearly seated on the ground, and is, more obviously than in his earlier work, a 'Madonna of Humility'. She welcomes the young Baptist who presents the Christ-child on her lap flowers held in the fold of his goatskin loincloth and a cross upon which they all gaze. The Virgin's pose is related to the panel's circular shape—far more than had been the case with the figures in the tondi in the ceiling of the Pope's library (Plate 59). A compositional sketch (Plate 93) shows the Baptist presenting Christ with a bowl or basket, but the idea of raising Christ's arm, if not the motive for doing so, seems to have occurred to Raphael as he drew. The Virgin's pose, with its repeated diagonals meeting at right angles, as well as its sweep, a compelling geometrical idea not easily reconciled with anatomy, must have originated in drawings of this sort, but on the other side of the same sheet (Plate 94) there is a *garzone* study in which a boy models the pose. In the painting the strain in the leg and the torsion in the shoulders are replaced by perfect grace.

The *Madonna Alba* was probably painted not for a church but for private devotional use, but size alone is no certain guarantee of this, and on occasion such panels could be displayed in public. Thus the *Madonna di Loreto* (Plate 98), another devotional painting by Raphael of similar dimensions (but rectangular format), is recorded as having been hung on a pillar in S. Maria del Popolo during festivals in the early sixteenth century,[8] as was Raphael's portrait of Julius II (Plate 164). It is unlikely that either picture was made for the church, but clearly neither was considered as unsuitable for it. Vasari stressed both the beauty of the Christ-child and the decorum and expression of his mother 'in whose countenance are revealed, in addition to the highest beauty, her joy and her sorrow'—her tilted head and lowered eyelids resemble those of the figure of Justice on the ceiling of the Pope's library (Plate 59). Only recently has one of the many versions been identified as the original,[9] and although cleaning has revealed some attractive passages (especially in the foreshortened arm) the thinly painted flesh has been rubbed and parts of the veil where it passes over the Virgin's left shoulder have been lost. Replicas of the picture were much in demand from an early date perhaps because it was accessible to a larger public than were those of similar character in private possession. And the portability of the panel may also have facilitated copying. The popularity of the painting is not only reflected in these copies. The action of the Madonna was also much imitated— most beautifully by Sebastiano del Piombo.[10]

The theme of the waking child playing with his mother's veil is also found in Raphael's *Bridgewater Madonna* (Plate 45), and although the pose of Christ here is very different it does appear in a series of studies apparently made in preparation for the *Madonna di Loreto* (Plate 100). It is unlikely that Raphael when he made these studies was working from a moving model. Rather he was turning ideas over in his head, seeking new poses by revising former ones.

Raphael's earliest altarpiece for a Roman church was probably completed after both the *Madonna Alba* and the *Madonna di Loreto*. This was the *Madonna di Foligno* (Plate 92), so-called because it was taken to Foligno later in the sixteenth century. It

100. *Compositional sketch for the Madonna di Loreto and other works*. Metal point on pink prepared surface, *c*. 1511, 16.7 × 11.9 cm. Musée Wicar, Lille.

was originally commissioned for the high altar of the church of S. Maria in Aracoeli on the Capitol in Rome by Sigismondo de' Conti, an historian and poet, and a close friend and private chamberlain (*cameriere segreto*) of Julius II, who died on 18 February 1512 and was buried in the choir of the church. The portrait of the kneeling donor certainly has the sunken features characteristic of a deathmask, and the altarpiece can probably be dated to the year of his death.

Conti is supported and presented to the Christ-child by St Jerome, and opposite him, also kneeling, is St Francis (this was a Franciscan church) with St John the Baptist standing beside him. They adore—or, in the case of St John, exhort us to adore—the Virgin and Child who appear seated upon the clouds (composed of accumulated putti like those in the *Disputa*), rather than upon a throne as in earlier altarpieces by Raphael. The Virgin does not, however, float weightlessly and the infant Christ firmly presses his right foot down on the cloud, pulling his mother's skirt across as he does so. In a beautiful preparatory drawing on bluish-green paper of a sort popular with Venetian artists (Plate 103)[11] the child's foot has not assumed this position and the group is slightly closer to its source in the Madonna and Child in Leonardo's *Adoration* (Plate 31). The torsion of the group is important for the meaning of Raphael's painting; the Madonna and Child must not be related to Sigismondo only, but also to St Francis.

A narrative unity in the *Madonna del Baldacchino* (Plate 56) was established by the saints debating around the Madonna and Child. Here it is established by the saints and the donor sharing a vision of the Madonna and Child. The emotional character of their devotion is strongly emphasised by Vasari in his description of the expressions of St John, all 'sincerity of soul and passionate conviction', and St Francis 'burning with love . . . form and colour showing how he is consumed by passion, receiving comfort and life from her beauty and the liveliness and loveliness of the Christ-child'.[12] The melting profile and feverish colour of St Francis were so exaggerated in the work of subsequent painters such as Barocci that their impact has been considerably diminished.

In place of the mandorla which was conventional for a visionary apparition, Raphael has placed a gold disk behind the Madonna—not unlike those behind Christ and the Dove in the *Disputa* but more suggestive of the sun. It was in fact perhaps inspired by Pietro Cavallini's now lost fresco, in the apse behind the altar, of the legendary Vision of Augustus from which the church derived its name. According to Vasari, the Virgin appeared here 'surrounded by a circle of sun'.[13] Instead of the conventional crescent moon below her feet, Raphael depicted an arc of light which could be taken for a natural phenomenon. In the distance a red flash in the sky, sometimes identified as a meteor, sometimes as a ball of lightning, may be connected with the occasion (some portent or narrow escape) which prompted Conti to vow to dedicate this altarpiece[14]—a reference to this would presumably have been made in the 'epitaph' held by the child angel.

The grass and flowers in the foreground and middle distance are painted with the same confidence and freedom that Raphael devoted to human hair, and as patches rather than as a few sparse specimens. The distant hills are not only blue but bluer as they meet the sky, and the same blue predominates in the distant building, thus local colour has been more altered by aerial perspective than is the case in his earlier distances. Also, whereas in the *Entombment* or the *Canigiani Holy Family* separate objects remain distinct, the foliage here cannot be related to particular trees and it is not clear where one building ends and another begins. The brushwork is very obvious, with dabs for sheep, tremulous stipple for leaves, and vertical strokes for the buildings. The experience of working in fresco where the wet plaster draws the paint from the brush may have encouraged this quickness of touch. So too might the example of the small landscapes which occur in small ancient Roman mural decorations.

If this painting was completed in 1512 then it is approximately contemporary with Raphael's fresco *Isaiah* (Plate 104). The putti behind the prophet are similar to

FOLLOWING PAGES

101. Detail from the *Madonna di Foligno* (Plate 99).

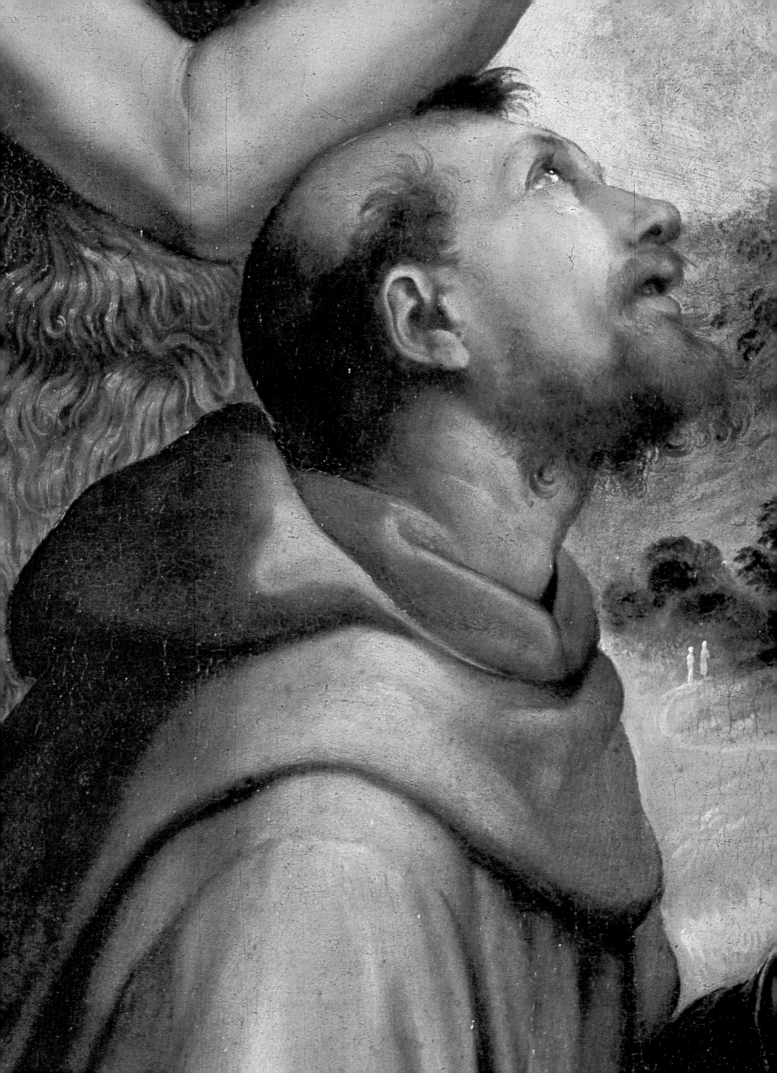

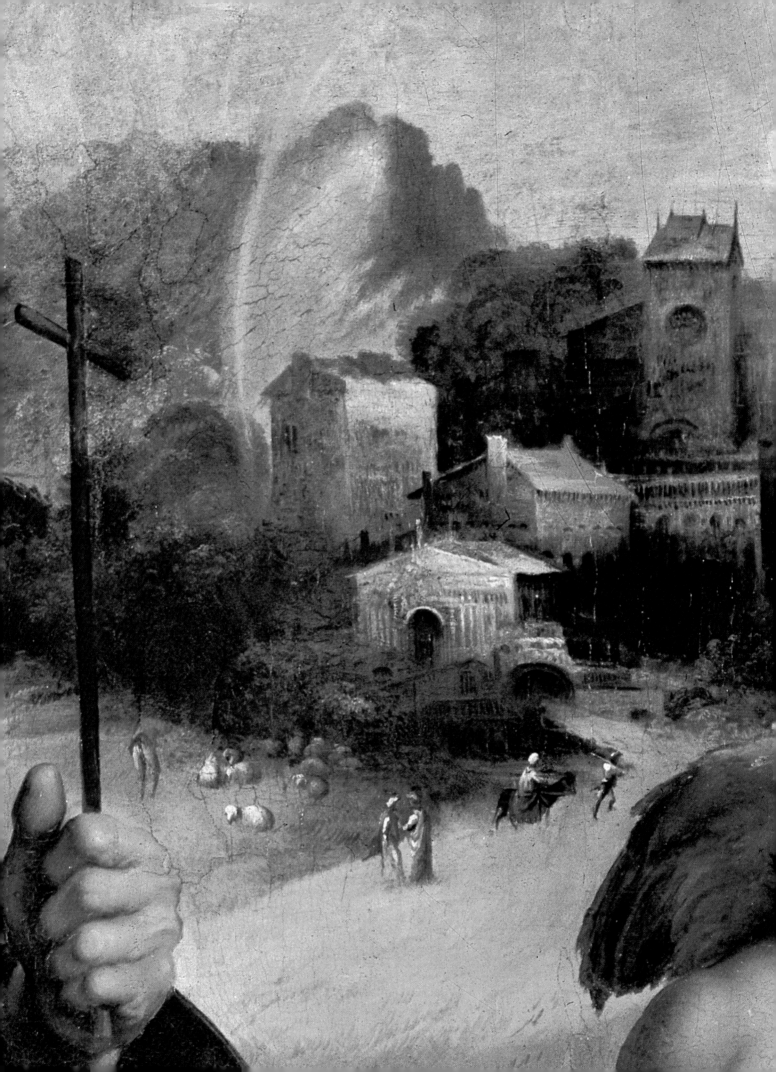

the one in the *Madonna di Foligno* and the prophet's expression is not unlike that of the Baptist in that altarpiece—but the differences are more striking and are entirely due to the influence of Michelangelo's Sistine prophets and sibyls. Given this subject Raphael's attempt to emulate Michelangelo's example here is understandable, but it must be admitted that at this moment he came close to being overwhelmed by it. The *Isaiah* was painted on one of the piers of S. Agostino in Rome for Johann Goritz, apostolic protonotary and philologist. It was unveiled on 26 July 1512.[15] After that date there was less chance for men such as Conti or Goritz to obtain work on this scale from Raphael. Raphael had already begun to work for the richest man in Italy.

<div align="center">★ ★ ★</div>

When Julius II was crowned in 1503 the rubies in his tiara were only there thanks to Agostino Chigi, a Sienese banker who had been active in Rome for a decade funding the Borgias, accumulating privileges and sinecures, and extending his financial empire. His bank, which at one point had a hundred offices in Italy and branches as far away as Cairo and London, supported, and was supported by, extensive industrial and trading interests.[16]

Julius II not only found Chigi's services indispensable, but became a close and trusted friend as well, granting him the right to quarter the Della Rovere arms with his own. Leo X, who succeeded Julius, had been a friend of Chigi's as a cardinal, so the banker's pre-eminence was secure. He erected a particularly lavish and elaborate temporary festival arch for Leo's *Possesso* (the procession of the newly crowned Pope to the Lateran) and invited him to an exceptionally expensive supper party soon afterwards.[17]

This astute millionaire was not devoted entirely to business. His domestic life was ostentatiously irregular and his hospitality was far more lavish than was required to endear him to his papal clients. As with so many patrons of this period it is not clear how much he valued art as distinct from luxury—there is nothing in the letter he wrote in 1500 to his father about Perugino which we have cited to suggest that he was particularly knowledgeable about painting at that date.[18] Nor is it clear how learned he was, although it was under his auspices, indeed in the basement of his villa, that the first Greek texts were printed in Rome (by the Cretan Zacharias Callierges), and he owned ancient inscriptions (as well as some, but not it seems many, statues); so it appears that he valued a reputation, at least, as a friend of scholarship.

Raphael's arrival in Rome coincided with the completion of Chigi's *suburbanum*, a palatial villa outside the city walls (Plate 228, b). This building, now known as the Farnesina after the Farnese family who eventually acquired it and combined it with their own earlier villa of similar character adjacent, was not originally the severe building it now appears, for the architect Peruzzi (like Chigi, a native of Siena) decorated the exterior with figures in grisaille.[19] Chigi's town palace was contiguous with his bank in the Corte de' Chigi, part of the commercial quarter on the other side of the Tiber;[20] his villa was used chiefly for entertainment. Its gardens extended to the river where there was a grotto and dining loggia. Here Chigi gave the banquet for Leo X at which his servants are said to have astounded the guests by tossing the priceless plate used for each course into the river. (It was discreetly retrieved by other servants, with nets.)[21]

Raphael is, as it happens, first recorded as working for Chigi as a designer of plate. He is mentioned in a contract of 10 November 1510 in which the goldsmith Cesarino agreed to produce in six months and for 25 gold ducats two bronze tondi which Raphael had designed, and these are likely to have been salvers.[22] Two drawings of friezes by Raphael apparently for the rims of such vessels, and both

102. Garden loggia of Agostino Chigi's villa (the Farnesina) showing the frescoes of *Polyphemus* and *Galatea*.

involving the combat of libidinous marine gods of the sort found on Roman sarcophagi, survive (Plate 162), but the contract mentions no figurative designs and specifies only that they were to be adorned *cum pluribus floribus*. No flowers appear in either of the drawings. Raphael doubtless made designs for many works of this class—two silver basins by him were offered to Isabella d'Este in 1516.[23]

At the Farnesina, Peruzzi's decoration of its exterior has perished. The garden setting has changed, too—the Tiber has been embanked; a thick barrier wall protects the building from the rumble, but not the roar, of traffic; the fish ponds and orange trees have mostly disappeared. The loggias which Raphael helped decorate were once airy spaces filled with the sounds of bird song and fountains and with fragrance. They are now sealed off and of course they no longer serve for banquets, masques and concerts.

Raphael's work in the entrance loggia belongs to a later period. Here we are concerned with his first painting for Chigi, which occupies a section of the wall of the loggia facing the river. It shows the nymph Galatea riding upon a shell and circled by amorini, mermen, hippocamps and nereids (Plate 106). The symmetry of the composition both as a two-dimensional pattern and as a three-dimensional design suggests the studied choreography of the *Massacre of the Innocents*, while the pose of the foreground putto recalls that of the infant Christ in an earlier work—the *Bridgewater Madonna*.

In January 1512 the poet Blosio Palladio published a Latin poem in praise of the *suburbanum*.[24] In it he refers to the decoration of the vault of the loggia (which had been painted by Peruzzi with mythological scenes alluding to the patron's horoscope)[25] and of the lunettes below (the work of Sebastiano del Piombo who had come from Venice in August 1511 to serve Chigi). But he does not mention a picture of Galatea, or the *Polyphemus* which Sebastiano painted on the wall next to Raphael's picture (Plate 102), so both must have been executed after the poem was written.

Raphael did no further work on the decoration of the loggia, and if his painting precedes Sebastiano's, as Vasari says, then Sebastiano may have taken over the decoration of the wall when it became clear that Raphael's other engagements were too great. It is possible, though, that Chigi, like other villa patrons before him, wanted a series of paintings by different artists working in concert.[26]

The scale of the figures in the two pictures is quite different, but Polyphemus after all was a giant. Far odder is the fact that the horizon lines do not match. This was unlikely to have been because one artist was careless of the other's work. A symmetrical relationship between the two frescoes may never have been intended. In recent cleaning traces of a painted frame were discovered around the *Galatea* but not the *Polyphemus*.[27] Perhaps then the *Galatea* was to be seen as a painting within a painting, with the giant contemplating a work of art rather than his beloved in person.

Raphael in his *Galatea*, remarks Aretino in a dialogue by Dolce, 'competes with the beautiful poetry of Poliziano',[28] and it is certainly the case that both he and Sebastiano took as their text Poliziano's highly popular *Stanzas for the Joust of Giuliano de' Medici*. The second half of the first book consists of a detailed description of the Palace of Venus which is entirely constructed of precious materials and the doors of which are set with gems engraved with amorous subjects each of which is described stanza by stanza.

The grotesque figure of Polyphemus, with a big nose and a single eye, with acorns shading his shaggy temples, is described as seated in the shade with his sheepdog between his feet and his reeds under his arm serenading Galatea. Sebastiano follows this, using a profile view to make the single eye less offensive. Then Galatea is described. She rides upon the sea in a chariot pulled by two stout snorting dolphins whose reins she holds herself, and around about her circle a still more spirited crowd (of what is not specified) spouting out the foam and playing amorously. The beautiful nymph and her sisters laugh at Polyphemus's rustic song.[29] Raphael has added to this (the amorini in the sky for instance and the rather silly paddle wheel),

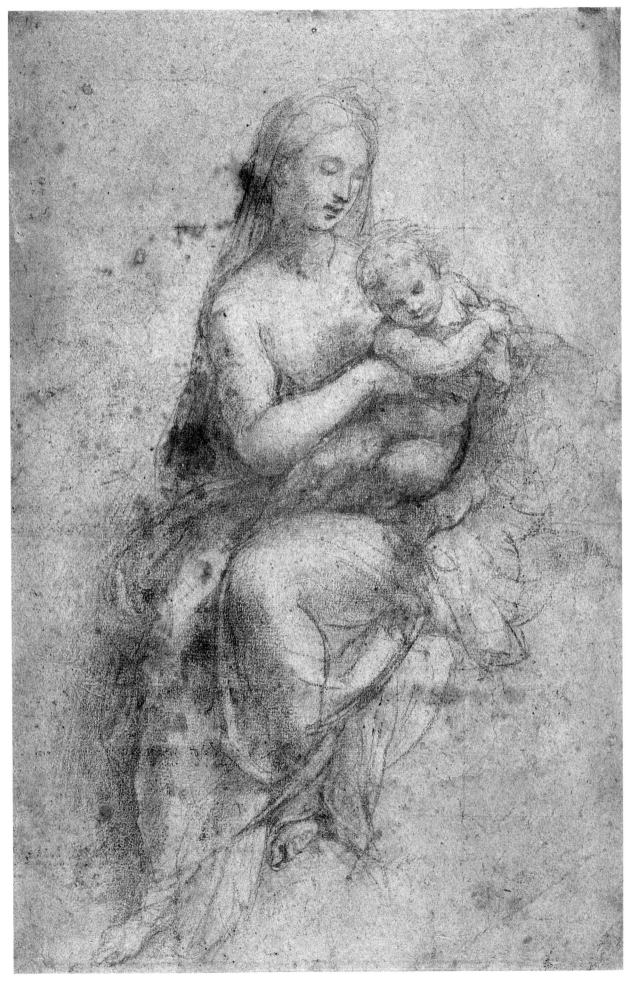

94

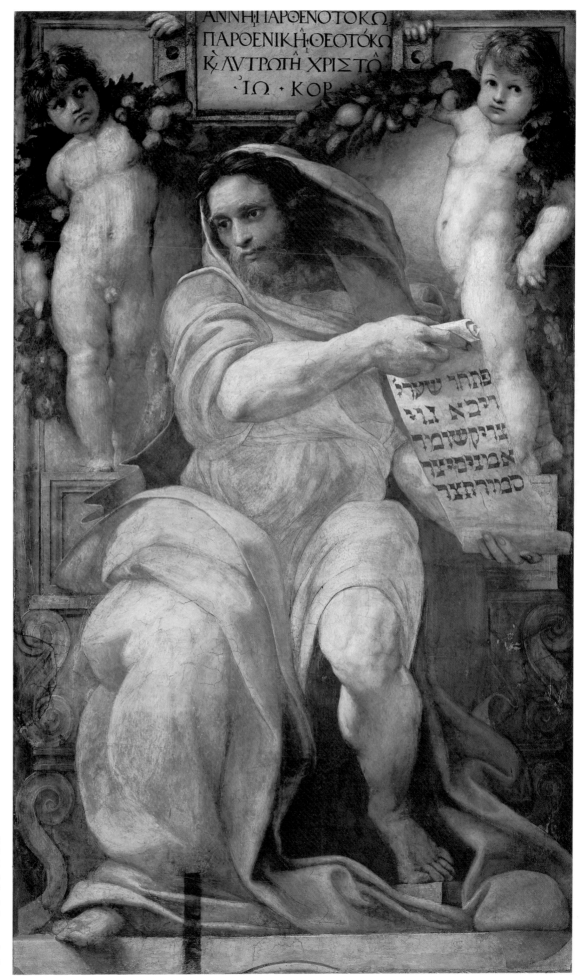

103. *Preparatory study for the Madonna and Child in the Madonna di Foligno.* Black chalk on grey-green paper, faintly squared, over indications with the stylus, c. 1512, 40.2 × 26.8 cm. British Museum, London.

104. *Isaiah.* Fresco, completed 1512. S. Agostino, Rome.

but he has omitted very little except the laughter. The reins Galatea holds were obviously designed with an eye for pleasing pattern rather than practical utility.

It is tempting to speculate on the other subjects planned for the loggia. Poliziano's poem offers a number, including two which would have made an attractive counterpart to *Polyphemus* and *Galatea*, if placed at the other end of the wall. His memorable description of the birth of Venus is followed by one of Vulcan rude and shaggy beside his forge. This would have placed another solitary grotesque lover next to another (possibly framed?) marine idyll.

An hypothesis is also needed to explain the fact that the scheme was abandoned. Chigi may have been disappointed with Sebastiano's work as a mural painter, and Raphael too busy; but there may be a practical explanation. The severe flood of the Tiber in 1514 may not only have rendered the villa's walls too wet for new fresco painting for a while but also have served as a warning against painting the ground-floor walls at all.[30] The condition of this painting is, however, excellent and the only significant change is to Galatea's deep crimson mantle which was originally shot through with silvery grey such as is now only pronounced in the projecting knee.[31]

The technique of pure fresco painting involves the application of pigment to an area of fresh wet plaster prepared the same day. The actual execution can be bold and spontaneous but must also be decisive and thus carefully prepared, even though additions can be made to the plaster after it is dried, as they had been in Julius's library. It is also advantageous if the design takes account of the areas which can be covered in a day's painting. Each day's work can usually be seen if a fresco is examined closely.

In the *Galatea* the colour of the sky on either side of the bow held by the right-hand amorino does not match. This bow marks the edge of a day's work. The problem of matching exactly the tone of blue is one Raphael tried to dodge by painting it with irregular but approximately parallel brush strokes to avoid uniformity, but it remained a problem. Another edge may be detected between the raised arm of the hippocamp and the same amorino's bow. Here Raphael has conveniently invented a cloud. Galatea's drapery is designed so that it can be painted in two parts (we are reminded of the way drapery is disposed in some antique sculpture to conceal the use of two blocks). The edge in this case passes along the fold crossing her belly.[32]

This makes us acutely aware of the limitations of fresco as distinct from oil painting. With the latter medium there would be no question of the clouds being placed or the draperies shaped for this sort of reason. Thus, in comparing the flying drapery in, for example, Titian's *Bacchus and Ariadne* (Plate 105) with that in this fresco, we should take account of the advantage of a simplified contour at this point for Raphael. Nevertheless that does not seem an adequate explanation of the character of the drapery. It is derived from Roman relief sculpture rather than from the observation of how cloth behaves in the wind. The horse's head on the left is also marmoreal (as well as white), and Raphael may never have seen a real dolphin. The cheetahs and dog in the Titian on the other hand are studied from life.[33] In some respects in fact the *Galatea* is an archaeological work in the sense that some of Poussin's were at a much later date (in particular his nautical Triumph painted for Richelieu, which owes so much to the *Galatea*). This is not to deny the artist's interest in sunlight and sea breeze. The gold in the streaming hair of the surf-riding boy, the light on the tip of his nose and the glimpse of his teeth are superbly painted, and Raphael has also tried to paint reflections in the water and to make the water seem wet.

On the other hand the head of the nymph in the foreground in the fresco is uncertainly placed on her neck, her upper arm is unrelated to her torso, and her breasts are not well drawn. It is hard to believe that Galatea has two breasts. How much are these figures, like the dolphins, creations of the imagination, aided by the antique but not by nature? We have seen that Raphael in this period did not, or sometimes did not, use female models for the figures of his Madonnas. Did he use

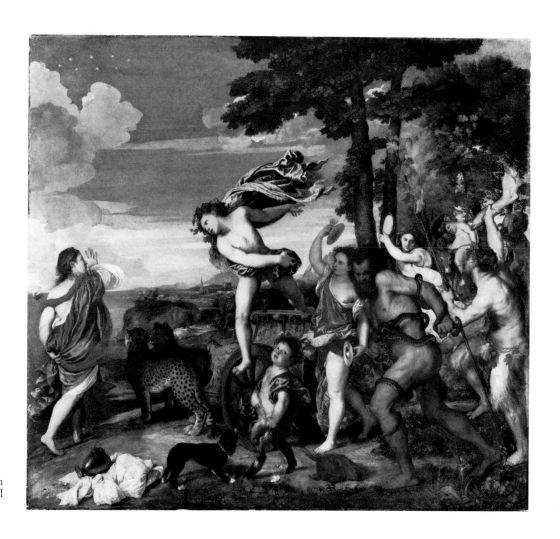

105. Titian. *Bacchus and Ariadne*. Oil on canvas, 1520–3, 175 × 190 cm. National Gallery, London.

one here? Replying to a letter from Castiglione, in 1514, he announced that the Pope had honoured him with the great responsibility of the design for St Peter's. He wished to excel even the model that had already been made by Bramante by discovering 'the beautiful forms of the ancient buildings'. Vitruvius, he found, supplied some light on the matter but not enough. As for the *Galatea*, Castiglione had praised it in the highest terms, and Raphael wrote:

> but in your words I recognise the love that you bear me, and I tell you that to paint a beauty, I must see more beautiful women, with this condition, that your Grace assists in selecting the best. But being deprived of good judges and of beautiful women I make do with a certain idea [*certa idea*] which comes into my head. Whether this has in it some artistic excellence I know not; certainly I toil to acquire it. At your Grace's command. From Rome.[34]

The brevity of this letter is studied: this is not a note dashed off to a friend. Raphael is careful to appear modest, certainly not to appear pretentious, and yet to display his familiarity with sophisticated aesthetic theory. He alludes to the stories of ancient artists who composed a perfect beauty out of a selection of the parts of mortal models. Above all he refers to the imagination. The *certa idea* he mentions is not just something that comes into the head but a reference to Platonic prototypes, the perfect abstract models that can be apprehended by the mind. It has been proposed that the letter was written for Raphael by Aretino (who later performed services of this kind for Titian), and a contemporary letter by Raphael to his uncle is certainly in a very different manner.

Since Raphael was interested in the literary evidence concerning ancient architecture we may imagine he was similarly curious concerning ancient painting. Very little had survived, but much had been described, above all in the *Imagines* of

FOLLOWING PAGES

106. *Galatea*. Fresco, *c.* 1512. Farnesina, Rome.

107. Unknown artist (17th century, perhaps Flemish). *Raphael's fresco of the prophets in the Chigi chapel, S. Maria della Pace*. Pen and brown ink with white heightening, 41 × 58 cm. Victoria and Albert Museum, London.

108. *Sibyls*. Fresco, *c.* 1512–13. Chigi chapel, S. Maria della Pace, Rome.

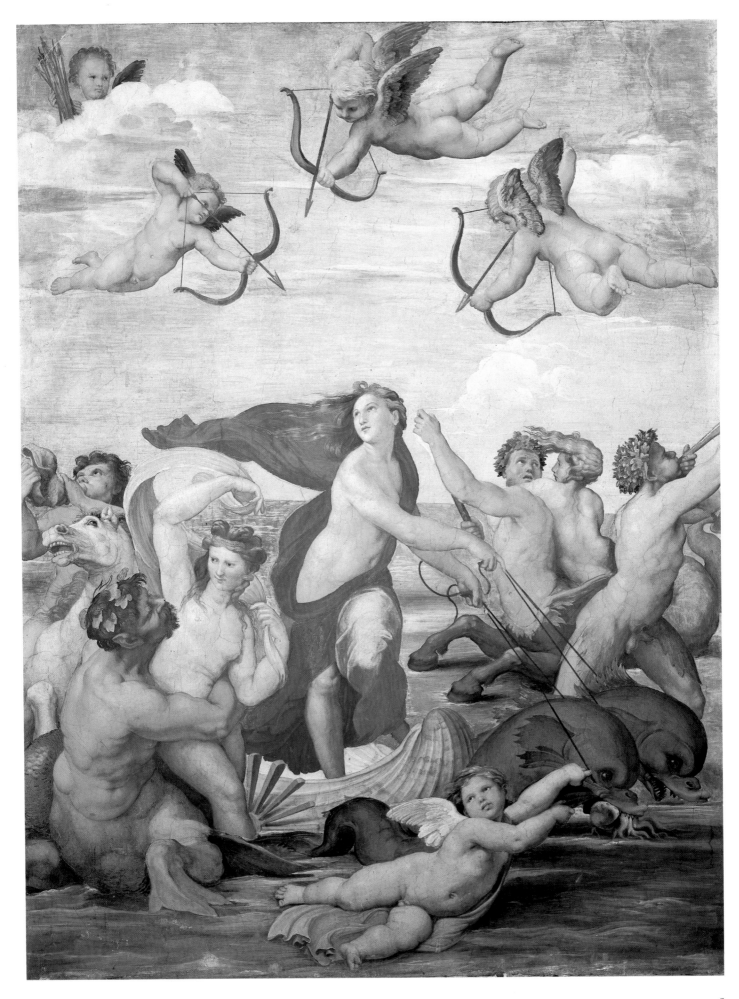

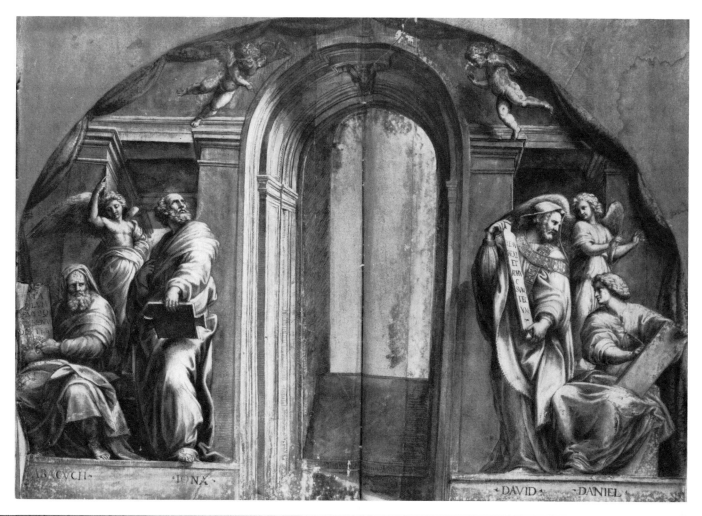

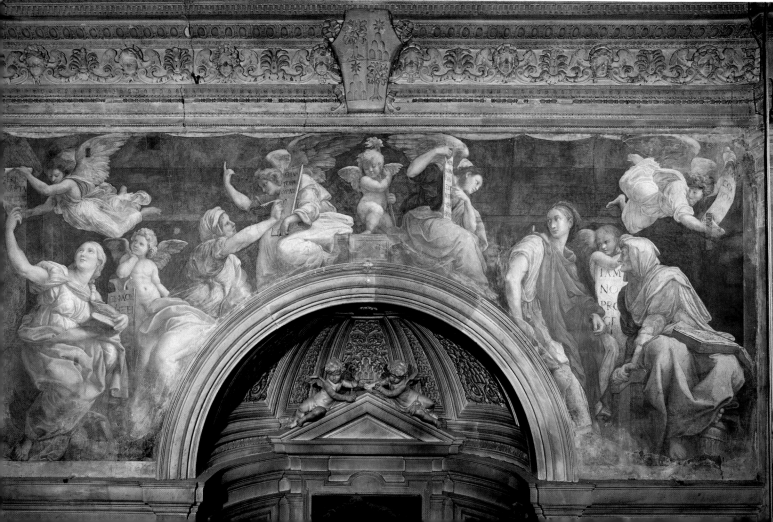

the elder Philostratus, who flourished in the early third century A.D. Philostratus had been a source for Poliziano's poem, and the idea that Raphael, like Mantegna and Botticelli before him, was engaged in a conscious attempt to emulate a famous lost work of antiquity is attractive. Blosio Palladio's reaction to the loggia even before Raphael worked there was that artists had 'here repainted what Ovid had painted in his verse'.[35]

<p style="text-align:center">★ ★ ★</p>

109. Chigi chapel, S. Maria della Pace, Rome.

At his villa, Chigi had shown his allegiance to Julius II by having an impressive Della Rovere coat of arms set in the middle of the entrance loggia (Plate 193). In his patronage of religious art, his choice of the churches in which Raphael was to orchestrate chapel projects must also have been calculated to please the Pope. S. Maria della Pace and S. Maria del Popolo were both Augustinian churches, a fact no doubt satisfactory to a man named Agostino, but they had also been rebuilt by Julius's uncle and, particularly in the case of S. Maria del Popolo, continued to attract Della Rovere attention.

At S. Maria della Pace the stained-glass window (now lost) of the chapel (Plate 109) was divided by a marble column, which separated two escutcheons quartering the Chigi and Della Rovere arms.[36] Here the chapel had already been built before Raphael was called in to decorate it. As often was the case in churches of the time, it was not a properly enclosed space, but simply the wall surface of a bay of the right-hand nave wall, with an apsed niche for an altar.

Vasari recorded and tacitly endorsed the view that the sibyls Raphael painted here (Plates 108, 115) were 'the most rare and excellent work he did in his whole life',[37] and

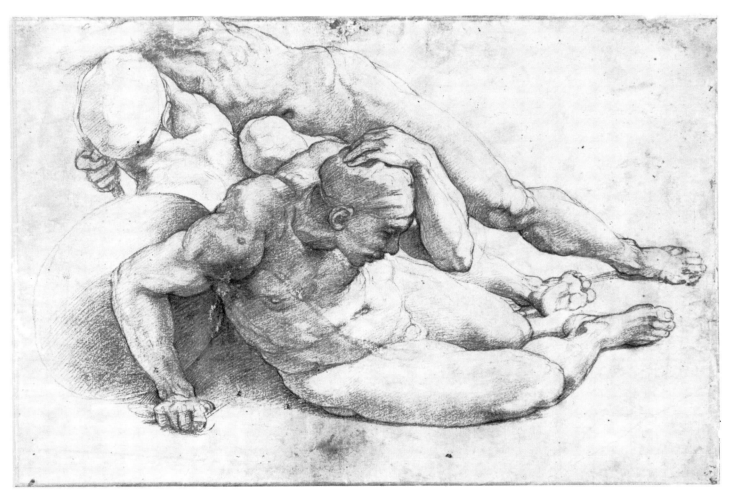

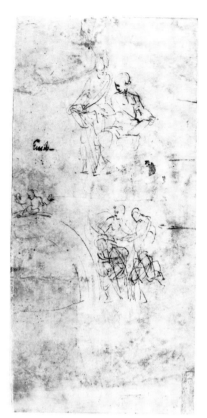

111. Detail from a sheet showing a *Preparatory sketch for the Chigi chapel.* Pen and ink, *c.* 1512–13, 24.7 × 32.6 cm (whole sheet). Ashmolean Museum, Oxford.

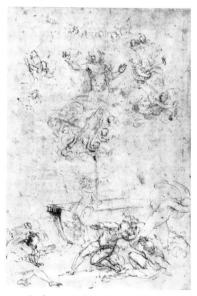

112. *Preliminary sketch for the Resurrection.* Pen and brown ink, *c.* 1512–13, 40.5 × 27.5 cm. Musée Bonnat, Bayonne.

110. (left) *Nude studies for the Resurrection.* Black chalk, *c.* 1512–13, 23.4 × 36.5 cm. Chatsworth, Derbyshire.

there are passages that strike us as more accomplished and beautiful than any which have survived in his earlier frescoes—the transparent drapery around the legs of the flying angel on the left, or the pink highlights to the pale greenish grey drapery of the other, seated, angel on the left for example. But when considering the chapel's frescoes it should be remembered that they are only a poorly preserved fragment of a programme which was never fully realised by Raphael.[38] The prophets flanking the window (Hosea, Jonah, David and Daniel) and the four sibyls below them (who cannot, and should not, be individually identified)[39] all hold, study or write inscriptions that allude to the theme of the Resurrection, and it seems that their role was to add their authority to a dramatic narrative representation of the Resurrection, which Raphael designed, but did not in the end paint, for an altarpiece in the niche below. For the wall space beside the altarpiece were intended two bronze tondi of subjects related to the Resurrection, the *Incredulity of St Thomas* and, for the right side, *Christ in Limbo* (Plate 116). These were actually cast to Raphael's designs but may never have been installed, and what we now see below the sibyls is of much later date. To visualise Raphael's intentions for the altarpiece requires an effort of the imagination, but it is amply rewarded, for there exists a striking series of drawings, ranging from the rough compositional study of the whole (Plate 112) to individual nude studies of extraordinary power (Plate 110).

As the decoration of the Pope's library would lead us to expect, Raphael sought to make a formal unity of this elaborate programme. His early idea for the project (Plate 111), an almost scribbled version of the type of half-drawing he produced for the *Disputa* (Plate 70), shows him thinking of both registers of figures in relation to the central niche. In the actual painting he united them by adopting a single point of view, and a common architectural framework, which has since been largely painted out or damaged and can only be appreciated with the assistance of copies (Plate 107).

The sibyls seem unaware that the dramatic event they foretell is actually taking place below—only the central putto with a lighted torch, perhaps symbolic of eternal life, looks benignly down. But the more sharply foreshortened, and smaller-scale, figures of the prophets would have complemented the upward movement of the altarpiece, a movement Jonah continues by gazing heroically, as if at a redeeming vision of heavenly light. As he turns to do so, he faces the oculus of the church facade, the actual light from which provides the notional illumination for the whole painted scheme.

To match the real lighting conditions of the site with the notional light in the painting in this way was by now a standard device to enhance the plasticity—the *rilievo*—of the representation. Raphael had done this in his earlier altarpieces, and when requested in 1515 by Castiglione, acting on behalf of Isabella d'Este, to make a small picture, he enquired as to its intended size and illumination (*la mesura del quadro et il lume*), and his reason was immediately understood.[40]

In Chigi's chapel the impression of physical immediacy in the figures is fortified by the way in which the knee of the writing sibyl appears to project in front of the frame of the arch. To judge from drawn copies of the fresco,[41] which show her draperies overlapping it, the original frame may have been less of a barrier than the present one and more like the one on which Sappho leans in the *Parnassus* (Plate 80), that is to say painted rather than real.

To compare the sibyl with the figure of Sappho is also instructive in another way. The spiralling of the forms and axes in both the figures may be seen in part as a determined attempt to minimise, by a distracting complexity of form, the awkwardness of the picture shape in which they are set. The torsion of Sappho is complex enough, but this sibyl is even more supple. The elaboration of design in both the parts and the whole of the lunette can be particularly appreciated from a study of the drawings, which show how Raphael tried out a variety of poses in a very fluid approach to the problem (Plates 113–14). The final result owes much to Michelangelo, in particular to the wealth of solutions offered by him in the Sistine Chapel lunettes to the difficulties presented by this kind of picture shape.

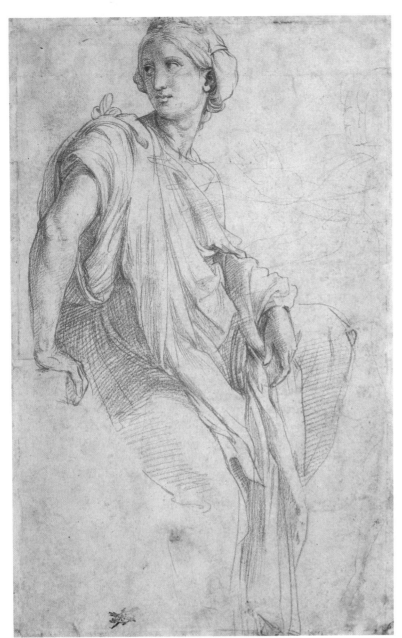

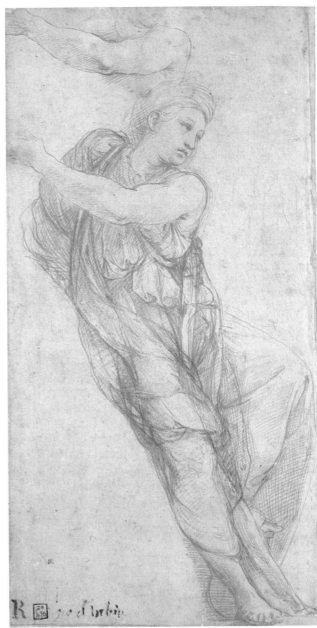

113. *Study of a Sibyl for the Chigi chapel.* Red chalk over indications with the stylus, *c.* 1512–13, 26.2 × 16.7 cm. British Museum, London.

114. *Study of a Sibyl for the Chigi chapel.* Red and some black chalk over indications with the stylus, *c.* 1512–13, 36.3 × 18.9 cm. Ashmolean Museum, Oxford.

115. Detail of the *Sibyls* (Plate 108).

Vasari repeatedly drew attention to Raphael's debt to Michelangelo here,[42] but no one could possibly mistake these sibyls for Michelangelo's own work, and Vasari uses them as a 'perfect' illustration of how Raphael was able to absorb what others had to offer and synthesise it into something all his own. The comment occurs in the middle of a long and remarkable passage he inserted in the second edition of the Life to describe the development of his successive styles—his *maniere.* In the interval between the two editions, Vasari had become increasingly aware of the baneful influence exerted on some artists by Michelangelo's example; he did not exclude Raphael from this but saw the sibyls as an optimal response to the master. They certainly do represent something of a high point in his work, with freshness, monumentality and sophistication held in fine balance.

If the fresco can be seen, then, as a response to Michelangelo, it is interesting to find a favourable reaction of Michelangelo himself to the work, reported in a guidebook of 1591.[43] The anecdote, printed seventy years after Raphael's death, may well be apocryphal, but is worth retelling. Raphael had received the large sum of 500 *scudi* on account for the sibyls, and when the work was finished he went to Agostino Chigi's cashier to ask for the rest of the money. The astonished reply was that he had already been handsomely remunerated. Raphael suggested that they get

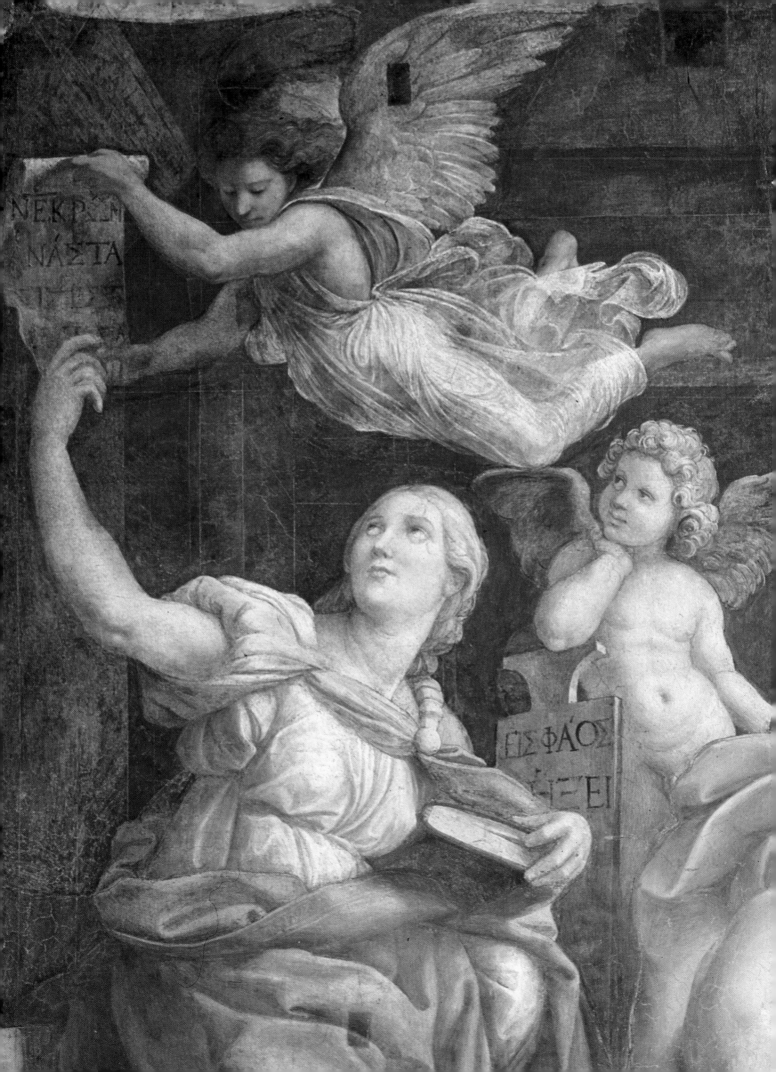

an expert to value the work. Michelangelo was called in and after standing for a long time silent in front of the fresco said, pointing to one of the sibyls, 'That head is worth 100 *scudi*.' The cashier asked, 'And the other heads?' 'The same', replied Michelangelo. When Agostino heard of this he told his cashier to make up the sum so that Raphael would receive 100 *scudi* for each head in the picture, and instructed him, when making the payment to 'be polite and keep him happy, because we'll be ruined if he makes us pay for the draperies'.

Pictures at this time might indeed be valued by taking a head count of the figures they contained—Sebastiano del Piombo intended to present his bill for the *Raising of Lazarus* (Plate 261) in this way.[44] And earlier in his career, in the case of the *Madonna del Baldacchino*, Raphael had calculated that an expert valuation might bring a better reward than his own unaided negotiation with the patron. By 1514, however, the increasingly successful artist boasted that he could name his own price—'I am paid for my work what I see fit to ask.'[45]

It is impossible to pin down the dates of Raphael's work at S. Maria della Pace. But in the light of this story Vasari's view that the sibyls follow closely on the *Galatea*, and predate the unveiling of the Sistine ceiling (which took place in two stages, in August 1511 and October 1512), deserves to be taken more seriously. One of the early drawings had almost certainly been made no later than 1512.[46] The sibyls themselves can be related not only to the *Galatea* but also to some of the figures in the Pope's library (especially the lunette of the Virtues) and could have been painted in 1512. The altarpiece drawings, where the growing influence of Michelangelo, and particularly the *Cascina* cartoon, on the male nudes is more obvious, may be a little later. At any rate, the closest comparison for the dramatic action of the Resurrection drawings is provided by the narratives Raphael painted in a room in the Vatican, which, although started in 1511, was not finished until 1514—the Stanza d'Eliodoro. Indeed, more than one of the figures in the Resurrection series recur, with small variations, in that room.

At S. Maria della Pace, Raphael was assisted by others. We must assume that he was advised by a theologian on the, in some cases, obscure texts, to which the figures in the painting pay so much attention. At the artistic level, Vasari rather confusingly states in his life of Timoteo Viti that this artist designed and painted the sibyls on the right.[47] He must have been listening to someone who had known Viti and had formed an exaggerated view of his true role in the workshop. But we can be fairly sure that the bronze roundels were (rather weakly) modelled and cast by the sculptor Lorenzetto on the basis of drawings provided by Raphael. Two of the surviving drawings are complete studies of the whole composition,[48] but a third, a *garzone* study for the figure of Christ in Limbo (Plate 117),[49] shows the thorough preparation Raphael might bring even to comparatively minor elements in a project.

With its emphasis on the theme of Resurrection, we might have expected this chapel to be Agostino's intended burial place. But his body was to rest in S. Maria del Popolo, in a mausoleum chapel designed by Raphael which quite eclipses it in physical splendour and in the elaboration of its thematic programme.

<p style="text-align:center">★ ★ ★</p>

116. Perhaps Lorenzetto (after Raphael). *Christ in Limbo*. Bronze, *c.* 1512–13. Abbey Church, Chiaravalle.

117. *Life drawing of a boy* (preparatory for the *Christ in Limbo*). Pen and ink over indications with the stylus, *c.* 1512–13, 40.1 × 26 cm. Musée Wicar, Lille.

118. *Section and half-plan of the left-hand side of the Chigi chapel, S. Maria del Popolo, Rome*. Engraving, 41.3 × 19.5 cm. From G.G. Dei Rossi, *Disegni di Vari Altari e Cappelle nelle Chiese di Roma . . .*, Rome 1713.

Chigi had acquired the site, which adjoins the left aisle of the church, as early as 1507, when Julius II issued a Bull stating that the chapel should be jointly dedicated to the Blessed Virgin of Loreto, St Augustine and St Sebastian. The building itself was finished, and mosaics were in place in the cupola, by 1516. Some time before this an overall scheme for the chapel's decoration must have been worked out, but, as at S. Maria della Pace, it was incomplete when both Raphael and Chigi died in 1520, and we have to use our imagination in envisaging their full intentions.[50]

It is worth emphasising initially the exceptional lavishness and range of materials that greets the visitor—a variety of polychrome and white marbles, bronze, gold, paint and mosaics (Plates 119–23). Chigi is reported to have spent the magnificent sum of 22,000 *scudi* on it before he died, a fact which may have impressed more contemporaries than we may care to imagine. For the art historian one of the other most striking features is the orchestration by one artist of all the different parts of a family chapel that would normally have been allocated by the patron to a number of different artists, as was the case, for example, in the chapel that Julius II was organising for the choir of the church, where Bramante, Andrea Sansovino, Pinturicchio and others were involved. Raphael here designed the architecture of the building, the mosaics in the cupola, the marble and bronze tombs on the side walls, the marble sculpture in the niches and, we must presume, an altarpiece. We will consider the totality here but return to the architecture in a later chapter.

Looking up at the cupola (Plate 123), we are invited to believe that the gilt coffered dome is open to the heavens. Outside the space of the dome, in mosaic, God the Father gestures down, accompanied by angels, some of whose hands grasp the rim of the central oculus. In the eight compartments below, more substantial angels keep in motion the seven planets and the stars, which are identified by zodiacal figures and accompanied by their respective gods (Mars, Mercury, Diana and so on). In a way which unifies the compartmentalised scheme, and articulates it with the rest of the decoration, some of these angels, including the one above the entrance, look up at God, while the one above the altar looks down.

For the spaces between the windows of the drum below, Raphael intended further mosaics, but we do not know if he actually designed them all,[51] or what the subjects were to be. Later, these spaces were painted with scenes of the Creation, and the tondi in the pendentives which support the drum acquired paintings of the four seasons, all by Salviati.

Below this, on either side of the altar, the sumptuous marble tombs of Agostino and his brother Sigismondo face each other (Plate 121). They are now simpler and

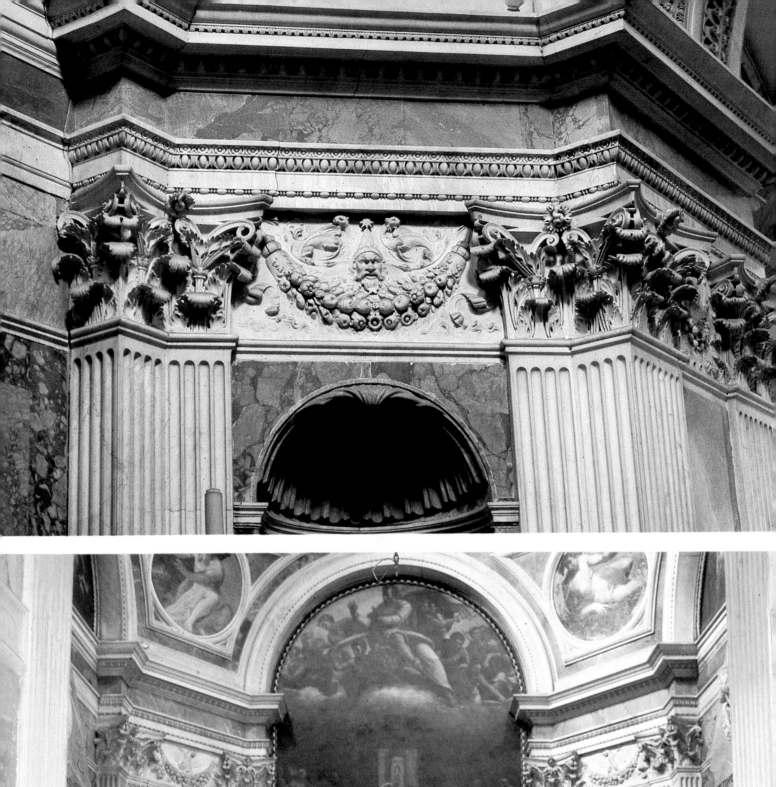

less rich than Raphael intended and lack the planned bronze ornament, which was to include portrait medallions and narrative reliefs. One of the latter (illustrating the story of Christ and the woman of Samaria) was in fact executed and has since been installed on the altar front. The central part of each of the tombs consists of a sarcophagus on which rests what looks like a cross between a pyramid and an obelisk, both of which forms were then thought to have funerary connotations. The niches framing this central section must also be considered as part of the tombs, which can thus be seen as a development of the fashionable idea of using triumphal arch motifs for more self-contained tombs—exemplified by Andrea Sansovino's pair of tombs in the choir of the church. Of the marble sculptures (Plate 122), only two were made to Raphael's designs—the *Jonah* (who should be in the niche on the other side of the altar) and the *Elijah*. The sculptures in the other niches are part of Bernini's later completion of the project. The programme of the tombs as Raphael designed them is therefore incomplete. Perhaps figures of St Augustine and St

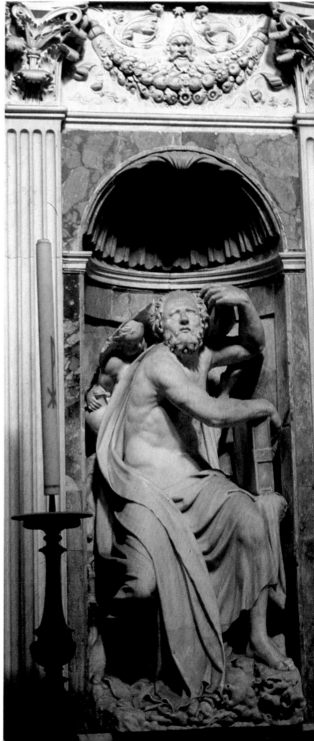

Sebastian (to whom the chapel was dedicated) were to have appeared in the other niches, but, as it is, the emphasis is on hopes for the after life, as Jonah was associated with the Resurrection, and Elijah with the Ascension, of Christ. Elijah looks up toward the altarpiece, while Jonah concerns himself with the floor.

The present marble paving of the chapel is another of Bernini's contributions. We can only guess whether Raphael too had intended to match the pattern of the cupola in the floor, but we can visualise a striking focus of interest here. Originally there was a rectangular opening just in front of the altar, which allowed the visitor to descend to, or look down on, another pyramid, set below the altar, in the crypt.[52] It was carefully designed to receive light from the cupola above, and from two angled windows in the crypt. A similar conceit (but without the illuminated pyramid) is to be found in Bramante's memorial chapel to St Peter, the Tempietto.

The pyramids in the chapel proper rise above the level of the frieze of the architecture behind them. This may be a formal metaphor for the direction in which it was hoped the resurrected bodies of Agostino and his brother would travel on the Day of Judgement—upwards, towards the celestial spheres of the cupola, where God's ambiguous, if authoritative, gesture has been seen as one of welcome.

With our knowledge of Chigi's other chapel, we might have expected the altarpiece to play a more formally and thematically related role in this scheme than does the existing picture of the *Nativity of the Virgin*, painted later by Sebastiano del Piombo and Salviati, where God is shown again, apparently repeating his gesture. It may be that Raphael had originally conceived a dramatically soaring representation of the Assumption of the Virgin, which was studied in a group of his drawings whose purpose is otherwise unexplained. The main theme of the funerary chapel would then have been a dynamic, multi-media, three-dimensional illustration of God receiving the Virgin, and, in her slipstream, the Chigi, into heaven.

The interaction of form and meaning implied by such a reconstruction is unprecedentedly complex and articulate, but it is one whose roots could be traced. In 1512, for example, Raphael himself had contributed to an ensemble which placed a painting of his in an active narrative relation with a work of sculpture. His figure of Isaiah (Plate 104) holds a text above Andrea Sansovino's sculpted Christ-child in the Holy Family below, for him to read it. More generally, for the use of lavish materials, as well as for the unifying animation of the different elements of the decoration, one may think particularly of a royal mausoleum in Florence, the Cardinal of Portugal's chapel in S. Miniato al Monte, finished in the 1460s, where the central saint in the painted altarpiece gestures towards the tomb of the cardinal. Here too the elements of the tomb had been integrated into the architecture of the chapel, and involved the illusion of a heavenly figure, the Virgin, appearing at a window to bless the proceedings.[53]

If we look at the individual parts of the scheme in more detail, that of the cupola is particularly interesting. From the point of view of its meaning, it should be remembered that the idea of decorating a room's ceiling with a view of the heavens was a venerable one, the gold stars on a blue sky of Giotto's Arena Chapel in Padua being only one of many earlier instances. More particular views, of precise astrological configurations, had been painted in the cupolas of Brunelleschi's Pazzi and Medici chapels, and, more recently, the seven planetary deities had appeared with zodiacal devices in compartments on the ceiling of the Collegio del Cambio in Perugia. It is not necessary, then, to appeal to Chigi's special interest in astrology to account for the basic idea, and nothing more than a general allusion to the idea of the cosmos, found in Dante, in which the planets are governed by angels, need be detected.[54]

From a formal point of view, the decoration of the cupola develops, enriches and synthesises two contemporary trends which we have seen most recently exemplified in Sodoma's design for the ceiling of the Pope's private library (Plate 59). There we were offered, in the central compartment, the visual conceit that the ceiling was open to the sky and that putti were flying around outside and entering the room—a

device that can be traced back to Mantegna's Camera degli Sposi. The illusion was not sustained in the rest of the ceiling, however, where the taste for antique schemes resulted in a pattern of different-sized pictures whose notional space was unrelated. In the Chigi chapel, Raphael amplified the conceit so that all the figures in the separate compartments of the cupola can be thought of as existing in one coherent space outside the chapel—something which called for some of the most extreme perspectival foreshortening he was ever to attempt. He may have adopted the practice of suspending wax models from the ceiling, but for drawings like Plate 124 may have found it convenient to have his living models lie down on the floor to be sketched.[55]

At the same time the scheme also has a strong antique character, and the allusion to the open oculus of the Pantheon made by Mantegna was extended so that we are reminded too of the pattern and the gradual diminution of the coffering in the great temple's dome. Raphael may also have had in mind other Roman ceiling types, in particular one which showed zodiacal signs and half-length figures of planetary deities in its coffers.[56]

The choice of the medium of mosaic can also be seen as a revival, since it is most naturally associated with its great flowerings in antiquity and in the middle ages. It had become virtually extinct by the fifteenth century, perhaps in part on account of its great cost. The gold leaf backing of the pieces, whose light-reflecting properties give the medium much of its brilliance, was of course expensive, but so too at this date was the glass. The expertise required was also in short supply, as Lorenzo il Magnifico found out when he tried to sponsor the revival of the medium in Florence. Since money was available, he thought there would be no problem, but he was pointedly told 'Money does not make masters'.[57] Some mosaicists were still to be found in the glass-making city of Venice, where work was still being done in the church of S. Marco, and it is likely that the very few mosaic decorations of the late fifteenth century in Florence and Rome (like the splendid ceiling in S. Croce in Gerusalemme) were executed by masters whose knowledge stemmed from Venice. At any rate, Chigi had been to Venice and his mosaics were put up by a Venetian specialist, Luigi de Pace.

Compared with the fictive mosaics which had appeared in many recent decorations, they are undeniably impressive in their authenticity. However, they also suggest a reason why this magnificent experiment was not repeated by Raphael or other central Italian artists of the day, since it is clear that the medium was not really congenial for the figurative ideals which preoccupied them. The complexities of the pose of, say, God the Father do not translate well into mosaic—so little so, in fact, that we hardly think of comparing this figure, as Raphael must have hoped we would, with Michelangelo's versions of the Creator on the ceiling of the Sistine Chapel, in particular in the *Separation of Light from Dark*, where the medium of paint had been so brilliantly exploited.

Only a few of the drawings Raphael prepared for the mosaicist survive, all of them in red chalk. Plate 124 is clearly a study from a clothed model, while Plate 125 is an elaboration of it, in reverse, which is closer to the final image. The most precise way of translating designs on paper into mosaics is first to stick the little pieces face down onto the paper drawing, then to stick the assembled group onto the wall and subsequently to peel off the paper. This reverses the original image. Alternatively, and more conveniently when the wall surface is curved, the artist can draw directly on the wall for the mosaicist to apply the tiles directly. Some of the surviving drawings are in reverse, and perhaps Raphael intended that the first method be used.

For the sculptures down below, Raphael could give more substantial assistance to the executant artist than two-dimensional drawings, but we can only guess at the nature of his collaboration with the principal maker of them, the same Lorenzetto who may have modelled the reliefs in S. Maria della Pace. It is very likely that, for the fully three-dimensional figures, it did not stop with the preparation of drawings. In 1516 a friend of Michelangelo's wrote to him in Florence to say that Raphael had

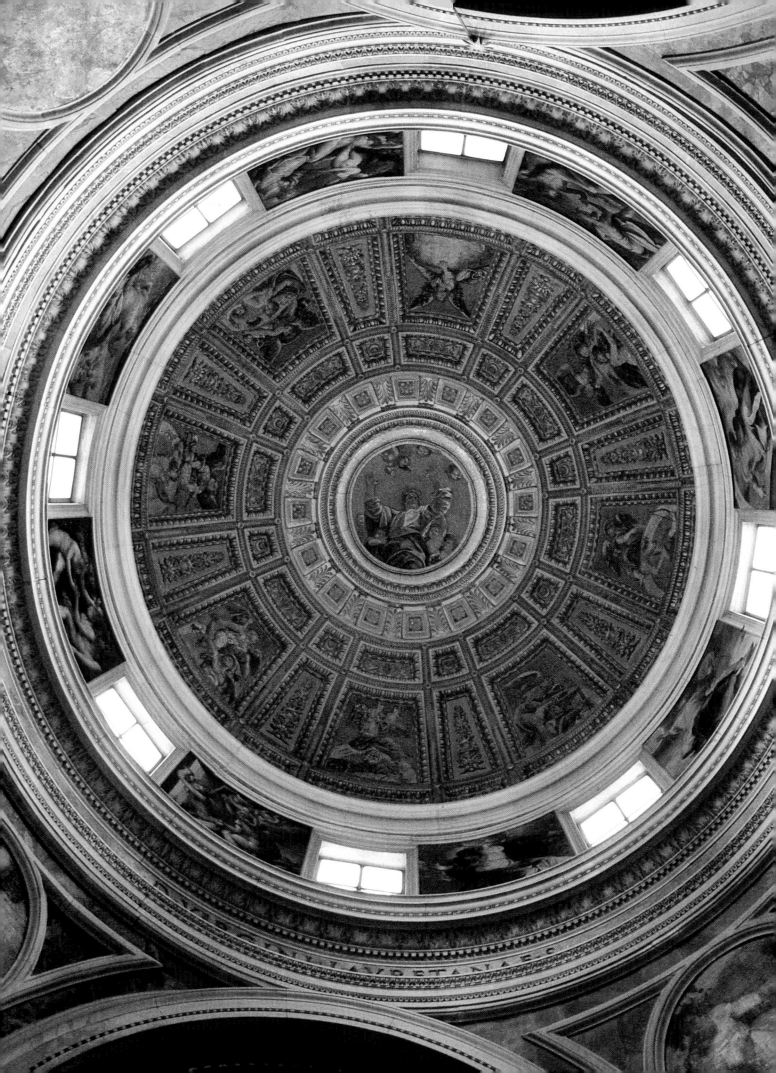

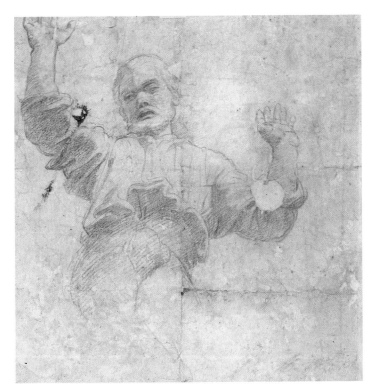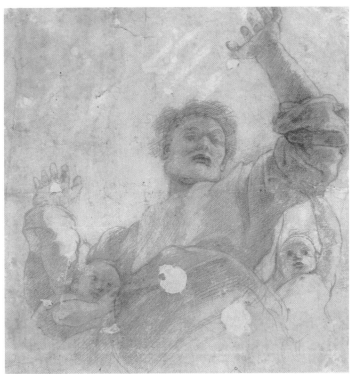

made a terracotta model of a little putto to be executed in marble by Pietro d'Ancona.[58] And in 1523 his own friend Baldassare Castiglione, who should have known what he was talking about, described what may have been the same little marble putto as being actually 'by the hand of' Raphael.[59]

Too little is known of Lorenzetto's own independent work for us to judge what is his own invention in the sculptures, but there are elements which have suggested that they were designed by someone trained, like Raphael, as a painter rather than as a sculptor. For example, Elijah's setting (with an angel, plants, a treetrunk, a water jug, etc.) is more fully described than was normal with sculptures in niches. Also noticeable is the way in which antique sculptural prototypes were followed closely in the design.[60] We might have expected this from a sculptor whose main claim to fame (according to Vasari) was the trend-setting garden display he arranged for the antique sculpture collection of the Della Valle family,[61] but Raphael may himself at times have come close to this kind of quotation—for instance in the paintings he designed for the Loggia of Psyche, the entrance loggia of Chigi's villa, to which we will return in a later chapter.

Even before much progress had been made on the decoration of the chapel, the church of S. Maria del Popolo was said, in a guidebook of 1517, to 'surpass all the others in Rome in the beauty of its paintings and sculpture'.[62] It is a measure of the significance of the Chigi mausoleum for future generations that in 1627, before Bernini put the finishing touches to it, a member of the family was able to say that it had the 'grandest reputation' and was 'the most visited in Rome by connoisseurs [*gli intendenti*]'.[63]

V. The Stanza d'Eliodoro

RAPHAEL's work in the papal apartments of the Vatican Palace did not stop with the completion of the decoration of Julius II's library. The Ferrarese ambassador reported to Isabella d'Este on 12 July 1511 that the Pope 'is having Raphael paint two rooms'.[1] The other of these, the room now known as the Stanza d'Eliodoro, seems likely to have served originally as an audience chamber.[2] The letter to Isabella does not imply that Raphael was already painting here, but he is likely to have made preparations to do so in that year. Slightly later inscriptions in the window embrasures indicate that it was certainly being painted in 1512 and 1514, payments suggest it was completed in the latter year, and, as we shall see, on 1 July 1514 Raphael was able to tell his uncle that he had started work in another room.[3]

The four walls are painted with narratives taken from the Apocrypha, from the Acts of the Apostles and from early and relatively recent Church history, united by the common theme of divine intervention on behalf of the Church. More obviously than the decoration of the library, they relate to the particular preoccupations of Pope Julius II but should not be taken simply as topical, and hence ephemeral, propaganda, for it could be maintained that these preoccupations were perennial to the papacy. Indeed the decoration of this room was completed by a very different Pope, Leo X, and the ceiling which was painted during his pontificate reinforces the themes of the wall decorations and makes them more general.

Had Julius wished to paint the triumphs of his own life, there were plenty of precedents for this. Pinturicchio had painted the *istorie di Papa Alessandro*, narratives of the Borgia, for a room in Castel S. Angelo, which included up-to-date pictures of the French invasion of Italy.[4] The slightly later frescoes in the Piccolomini library give an idea of their character (Plate 26). There are also frescoes of the life of Sixtus IV in the hospital of S. Spirito. What Julius commissioned was something more like the great battlepieces ordered for the Council Hall of the Florentine Republic from Michelangelo and Leonardo in that these were records of glorious, but also urgently significant, historical episodes. Into the paintings, however, Julius and his court are inserted, as participants or witnesses. This is suggestive of the role of the donor in an altarpiece such as the *Madonna di Foligno* or of the possible early project for the Jurisprudence wall in Julius's library. It is also instructive to compare it with the way the court of Sixtus IV had been portrayed in the biblical narratives on the Sistine Chapel walls, mingling with the Apostles, for instance, as Christ gives the keys to St Peter (Plate 7). As we will see, however, Raphael makes the insertion of the modern world into the old both less confusing and more dramatic.

The narratives Raphael painted on the two window walls are the *Deliverance of St Peter from Prison* and the *Miracle of the Mass at Bolsena*. The second of these (Plate 129)

126. Ceiling of the Stanza d'Eliodoro. Fresco, c. 1514. Vatican Palace, Rome.

FOLLOWING PAGES

127. Detail from the *Mass at Bolsena* (Plate 129).

128. Pope Julius II—detail from the *Mass at Bolsena*.

113

129. *The Miracle of the Mass at Bolsena*. Fresco, c. 1512–13, Stanza d'Eliodoro, Vatican Palace, Rome.

130. After Raphael. *Project for the Mass at Bolsena*. Pen and brown ink with grey wash and some body colour, 26.5 × 41 cm. Ashmolean Museum, Oxford.

concerns the miracle which occurred in the thirteenth century at S. Cristina, Bolsena, near Orvieto, when blood issued from the communion wafer held by a German priest, then on his way to Rome, who had prayed for his doubts concerning transubstantiation to be removed. Each time he folded the corporal (the linen cloth upon which the consecrated elements rest during the celebration of the Mass and by which they are subsequently covered) the stain showed. Pope Urban IV had instituted the Feast of Corpus Christi partly on account of this miracle. In order to promote the building of the Cathedral of Orvieto, Sixtus IV had in 1477 granted indulgences to those who venerated the relic of the stained corporal, which was preserved in a silver tabernacle above the Cathedral's high altar.[5] On 7 September 1506 Julius stopped in Orvieto on his march against Bologna and in the evening after Vespers adored the relic, blessing the crowds gathered in the piazza outside to whom it was also exhibited.[6]

In this case it would hardly have been appropriate for Julius II to be the chief actor in the painting. He appears rather as a witness—completely bareheaded (even without a silk skull cap) as the Pope was only at the most solemn moments in the Mass. He is accompanied by four prelates, clearly all portraits, among whom Vasari identified only Julius's cousin, Cardinal Riario, whose arms are crossed. Still closer to us are a few of the two hundred strong Swiss Guard formed by Julius in May 1510, thirty years after his uncle had first introduced Swiss mercenaries into Italy.[7]

The narratives on the other walls of the room are the *Expulsion of Heliodorus* and the *Repulse of Attila*. The first of these (Plate 132) comes from the second book of Maccabees, and shows how Heliodorus, the Syrian usurper, in response to the fervent prayers of the high priest, is flogged by angels and expelled by an angelic rider from the Temple of Jerusalem which he had intended to plunder of its treasure. Julius again appears as a witness, this time carried on a litter, but he impresses us so much as an agent that we can easily understand Vasari, who wrote from memory, claiming that he is shown driving avarice out of the Church. Vasari is also surely at least partly right about this being the theme of the painting, although it probably refers more generally to the Church's right to temporal possessions.

Within the first year of his pontificate Julius II had publicly condemned the way Alexander VI had fraudulently enriched his own family. Soon afterwards he prepared his Bill against simony.[8] On the other hand Julius kept the Vatican treasury full,[9] and although lavish in public works he tried to restrict his private expenditure. Temporal possessions, however, meant more than a full treasury. Julius insisted also on the Church's right to the Papal States, and to proper dues from his 'Vicars' there (such as the Baglioni of Perugia).

The second narrative portrays the encounter between Pope Leo I and Attila, King of the Huns, which took place in A.D. 452 (Plate 133). The barbarians were repulsed by the miraculous appearance of Peter and Paul.[10] The significance of this episode is obvious. By the time Julius II was elected Pope the struggle for ascendency in Europe between the great powers of France, Spain and the house of Hapsburg was centred on Italy, and the Pope as a secular ruler was obliged to participate. Having used the French to help humiliate Venice, Julius felt threatened by them. The thought of freeing Italy from the French and punishing their ally the Duke of Ferrara, he told the Venetian envoy on 14 May 1510, 'puts me off my food and keeps me from sleep and last night I got up and paced the room unable to rest'.[11] The matter gave him little rest for two years. He never succeeded in taking Ferrara as he intended in his campaign over the hard winter of 1510/11, and in April 1512 the French won the Battle of Ravenna, occupied the Romagna, and, but for the loss of their own generals, would have advanced on Rome. By the following month, however, Julius had engineered a new league against them and within a few weeks they had abandoned Milan and were retreating across the Alps. By the end of the year Julius had retaken Bologna and won Parma and Piacenza (but not Ferrara) for the Holy See. It would, however, be quite wrong to consider this fresco simply as a topical allegory with Huns as the French—although the term 'barbarians' *was*

132 *The Expulsion of Heliodorus*. Fresco, c. 1512–13. Stanza d'Eliodoro, Vatican Palace, Rome.

133. *The Repulse of Attila*. Fresco, c. 1513–14. Stanza d'Eliodoro, Vatican Palace, Rome.

frequently used of them.[12] It illustrates divine sanction for the participation of the Pope in the defence of Italy against foreign aggressors.

The *Deliverance of St Peter from Prison* (Plate 137), opposite the *Miracle of the Mass at Bolsena*, was a subject which would remind those having audience of the futility of the force used against the first Vicar of Christ. They might also have thought of the recent delivery of the papacy from military threats. Julius's titular church as cardinal had been S. Pietro in Vincoli (St Peter in chains); his successors as cardinals there were his nephews Galeotto and Sisto della Rovere; and he retained a palace at S. Pietro. As soon as he had received the news on 22 July 1512 of the expulsion of the French from Italy he announced his intention of going to this basilica to give thanks for what he regarded as an instance of divine intervention. Despite his ill health he was carried there on a litter the next day and prayed at length before the high altar, that is before the chains of St Peter, the chief relic of the church, contained behind gilt bronze doors which he had himself commissioned from Caradosso. His return procession to the Vatican was lit by hundreds of torches, and then on 27 July there were fireworks and the entire city was lit in celebration of the liberation of the Pope's native city of Genoa.[13] Raphael himself in this fresco contrived a spectacular illumination.

Raphael had not completed these paintings when, on 20 February 1513, Julius died. His successor Leo X was notoriously averse to Julius's belligerent attitudes. Pallas has succeeded to Mars (Julius) and Venus (the lecherous Alexander VI) was the claim made on the triumphal arch erected by Chigi for his *Possesso*. But Leo would not have considered denying the principle represented by the *Repulse of Attila*. And as it happened he had chosen the name of the Pope who was represented in it. There exists a superb drawing (Plate 131) clearly recording a composition which had been fully worked out, in which the Pope and his entourage are in the distance. The foreground action is less divided than in the fresco and more heroic because free of

131. By or after Raphael. *Modello of a project for the Repulse of Attila*. Metalpoint, ink, white heightening (retouched), over indications with the stylus, on vellum, c. 1513, 36.2 × 59.2 cm. Musée du Louvre, Paris.

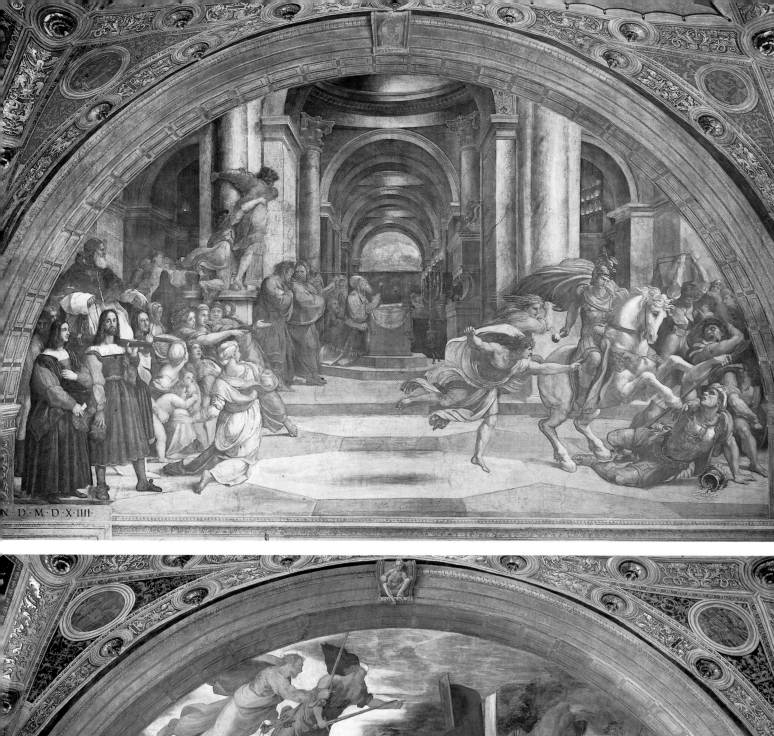
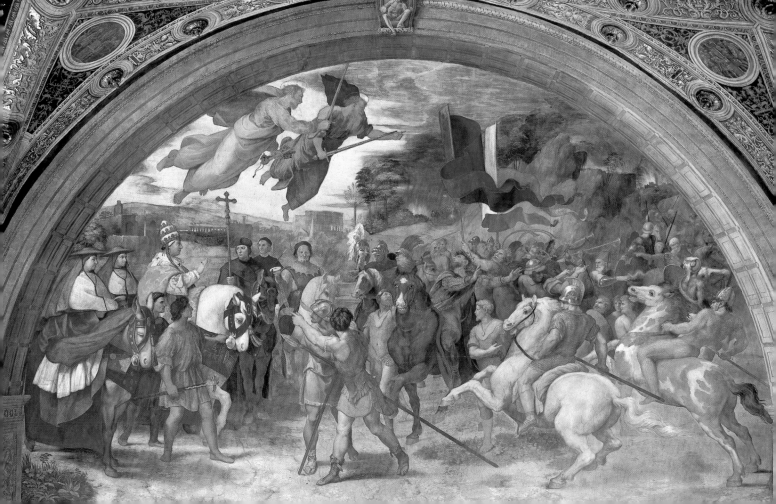

the prose of portraiture. The barbarian warriors are thrown back in all directions by the apparition, forming a centrifugal composition with some similarities to the projected Resurrection for S. Maria della Pace. This may represent Raphael's preferred idea for the fresco which when it was rejected he converted to a rectangular format, perhaps with the idea of having it engraved.[14] Leo I was eventually put in the foreground, given the likeness of the new Pope, and placed upon the white horse on which, when acting as papal legate, he was taken prisoner by the French at the Battle of Ravenna. Superstitiously anxious to associate the triumphs with the disasters of his life, Leo also rode this mount in his *Possesso*.[15] The tumult on the right is contrasted with the quiet procession conducted by Leo on the left rather as the fresco of the *Victory of Constantine* by Piero (Plate 67) is divided into order and confusion.

The *Repulse of Attila* was not the only painting in this room to be executed under the new pontiff. The painted *basamento* of caryatids supporting an entablature (which cuts rather uncomfortably across the ornamental piers from which the arch framing each narrative springs) must have been painted after the narratives and so too must much of the ceiling. The latter had in fact been decorated before Raphael was involved in the room, and the dividing ribs, filled with fictional stone reliefs of grotesque candelabra against a gold field, survive from the original scheme. Four of the original eight ribs were, however, removed to make space for four Old Testament narratives which we are to imagine as awnings hooked to the ribs that remain (Plate 126).

These narratives show God's instructions to Noah prior to the flood (above the *Repulse of Attila*), God's intervention in the sacrifice of Abraham (above the *Mass at Bolsena*), God's message to Moses in the Burning Bush (above the *Expulsion of Heliodorus*), the ladder and angels appearing to Jacob in a dream (above the *Deliverance of St Peter*). In each case a specific relationship is intended with the narrative below (for instance the flood is analogous with the invasion of Huns). In a general sense all these episodes illustrate heavenly intervention at a critical moment on earth. The condition of these frescoes is poor, and they have been much restored. All the same the character of Raphael's work here is unexpectedly stylised, perhaps because he was representing painted cloth (or perhaps tapestries).[16] The areas of paint that survive from the earlier decorative scheme are in better condition. It is not clear to what extent they can be related to the parts Raphael painted. The chalice and Host, however, which appear below the *Sacrifice of Isaac* on the keystone of the arch framing the *Mass at Bolsena*, are obviously appropriate.

In the frescoes of Julius's library the poses of almost every figure appeared to have been calculated separately, however well they were grouped, and it is not likely that Raphael could have painted a crowd effectively at that date. In the congregations behind the priest at Bolsena and to the left of the *Expulsion of Heliodorus* are particularly impressive examples of crowds—densely packed and animated groups, designed coherently and yet successfully conveying the idea of confusion. Those in the *Expulsion* were ingeniously and attractively explained by the Richardsons as widows and orphans dependent on the Church for support and placed so that they seem to be under Julius's protection.[17] If so, with the exception of one who appears by his right hand, the widows are remarkable for their youth, and the youths climbing the columns belong to another category. In these areas the colours are designed so as to unite rather than distinguish the separate figures. The twisting, kneeling woman who creates so powerful a sense of movement into the space on the left (an invention which has been compared, ingeniously, with Titian's Ariadne—Plate 105)[18] is studied on a separate sheet (Plate 134), as is also the case with the woman to her left, but we doubt whether this was the case with each of the figures behind.

To the right of the *Expulsion* and still more strikingly to the right of the *Repulse* the groups of soldiers are united by dark shadows, a device already found in Leonardo which Titian would take further a few years later in his *Assunta* for the

134. *Study for a kneeling woman in the Expulsion of Heliodorus.* Black chalk, c. 1512–13, 39.5 × 25.9 cm. Ashmolean Museum, Oxford.

FOLLOWING PAGES

135. Detail from the *Repulse of Attila* (Plate 133).

136. Detail from the *Deliverance of St Peter* (Plate 137).

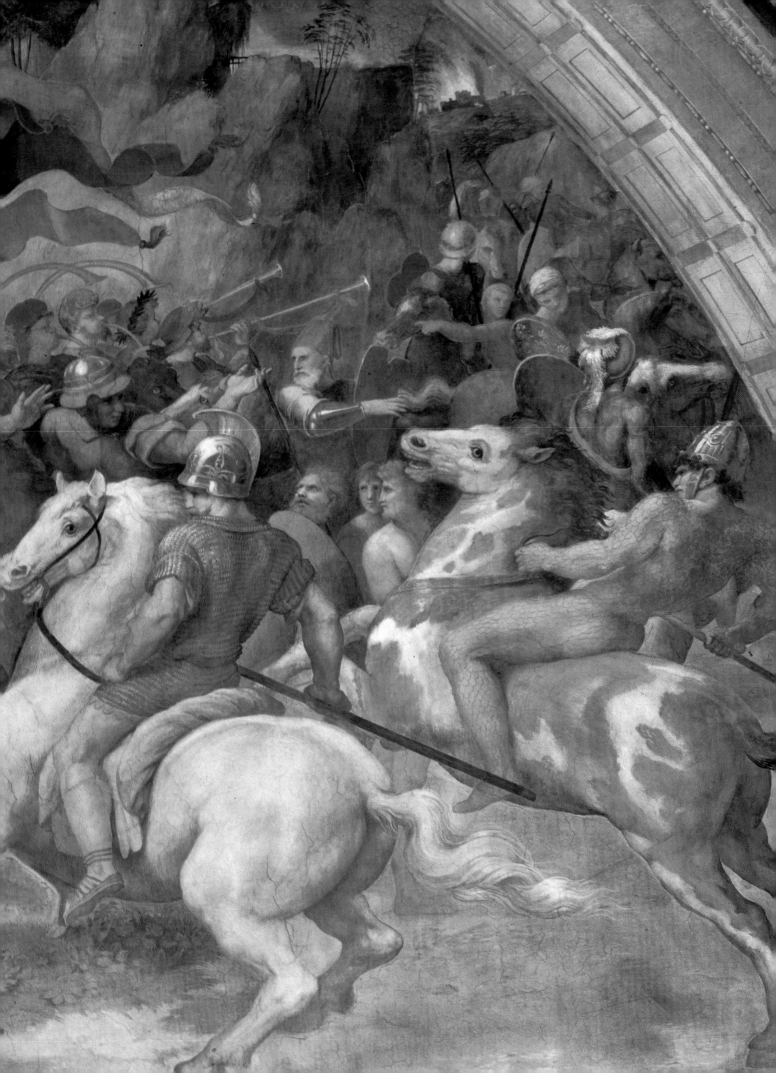

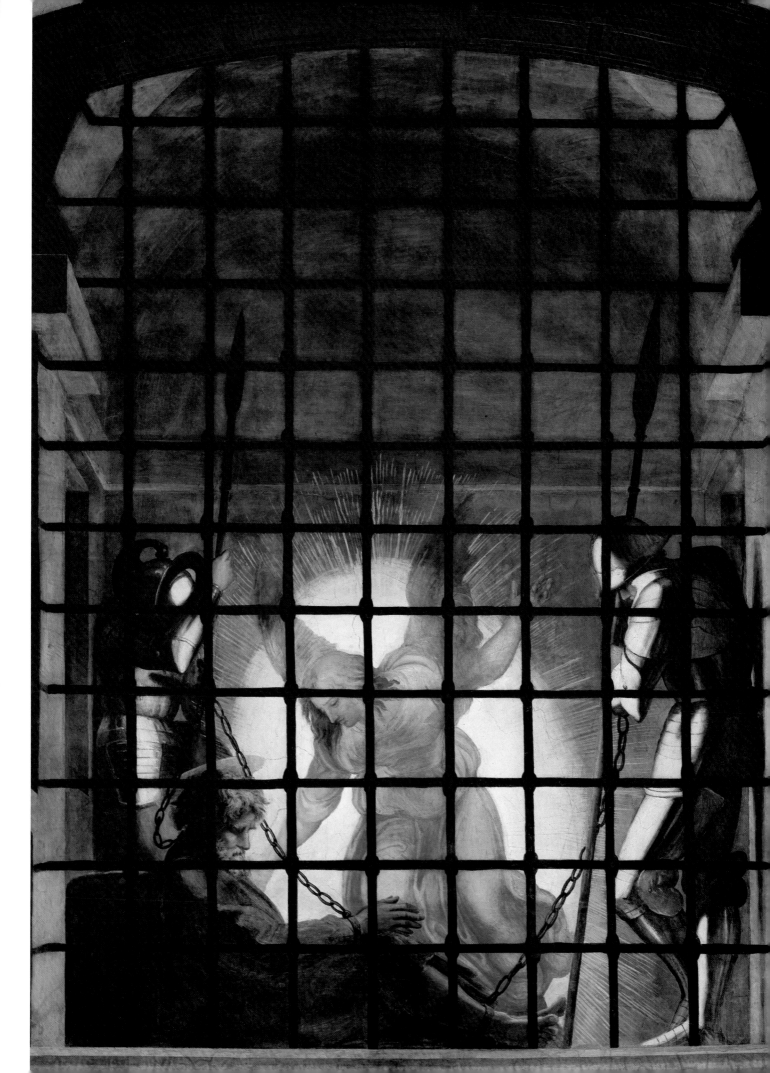

137. *Deliverance of St Peter from Prison*. Fresco, *c*. 1512–13. Stanza d'Eliodoro, Vatican Palace, Rome.

138. *Project for the Deliverance of St Peter*. Pen and wash, *c*. 1512–13, 25.7 × 41.7 cm. Uffizi, Florence.

Frari in Venice. In these areas of the painting Raphael's study of ancient art is particularly obvious. Details such as barbarian fish-scale armour or curly trumpets are taken, as Vasari pointed out, from Trajan's Column, and the horseman attacking Heliodorus resembles the relief of Trajan riding into the Dacian ranks on the Arch of Constantine. But it is equally obvious that the expressions of violence and desperation on the right of the *Expulsion*, the white rearing horse and its companions and the pennants above them in the *Repulse*, all recall the *Battle of Anghiari*.[19] Leonardo, interestingly, was in Rome when Raphael was completing these frescoes, living in the Belvedere, taming lizards and experimenting with varnishes.

Raphel has not permitted the door frames to interrupt the painted areas as they did in the decoration of Julius's library. The windows, however, do break into the shorter walls. In the case of the *Mass at Bolsena* the window is inconveniently off centre. Drawings show that at first Raphael contemplated placing the altar above the mullion of the window, not to the right of it. In his first idea (Plate 130) Raphael also proposed that the Pope and his entourage should occupy the smaller of the two areas but in the painting they occupy the larger, and the element of portraiture, as so often in the evolution of narrative paintings in which it plays a part, becomes more prominent, doubtless in deference to the patron's self-importance. The subject executed might in fact be more properly described as 'Julius II testifying to his Faith in the Miracle at Bolsena'.

The preliminary *modello* (Plate 138) for the *Deliverance of St Peter* is also different from the executed fresco. The poses of many figures have been changed and so has the architecture, and above all there seems to be only one source of light, whereas in the final painting there are several—the moon and the torches as well as the heavenly light emanating from the angel.

The interest in varieties of light is found in all the frescoes—in the *Expulsion of Heliodorus* there are the lamps burning in the dim recesses of the Temple, the tapers in the seven-branched candlesticks and the reflections from the gilt arches and domes; in the *Mass at Bolsena* there are the tapers held by the acolytes; and even in the *Repulse of Attila*, which takes place entirely outside, it is dawn and there are the fires made by the pillaging army in the distance.

Both light and colour must have played a large part in Raphael's original conception of this painting. This is also most obviously the case with the radiant angel in the *Deliverance of St Peter*, an invention of astonishing originality and enormous influence beautifully described by Bellori as *composto di aria, e di luce, senza mortal peso* (compounded of air and light, without mortal weight).[20] But we may also think of the priest in the *Mass at Bolsena* whose confusion is, as Vasari observed, conveyed as much by the colour of his face as by his hands.[21] In Raphael's earlier frescoes, by contrast, colour and light were less essential. The heavens in the *Disputa* are ablaze with glory, but figures below, it has been justly observed, 'partake of the Common Day-light just as if none of that Brightness had proceeded from those Sacred Persons'.[22] It is also noteworthy that whereas in the earlier room gold had been represented by gold leaf here it is represented by yellow and white pigments.

In considering the use of light in the *Deliverance of St Peter*, we may recall Raphael's ideas for a Resurrection altarpiece in the Chigi chapel of S. Maria della Pace. The subject, since it involves guards awakened from sleep, is in some respects similar and it has been suggested that Raphael conceived it, unusually, as a nocturne. The idea is prompted partly by the heightened chiaroscuro of the drawings for it and partly by reflections of the work in later paintings by other artists.[23] Of the *Deliverance* itself the Richardsons wrote that it was 'incontestably the finest Night-Piece in the World' preferring it even to the *Notte* of Correggio and to Rembrandt's 'Fine, and surprising Management of lights' on account of the variety and the harmony—'Here all is Night, but all Shines, with such a due subordination however, that One does not hurt Another, or torment the Eye in the least, which at ease can consider the Whole, and every Part, and not at Ease only, but with Delight.' But they were also struck forcibly by the horror of the prison: 'The Iron Gate thro'

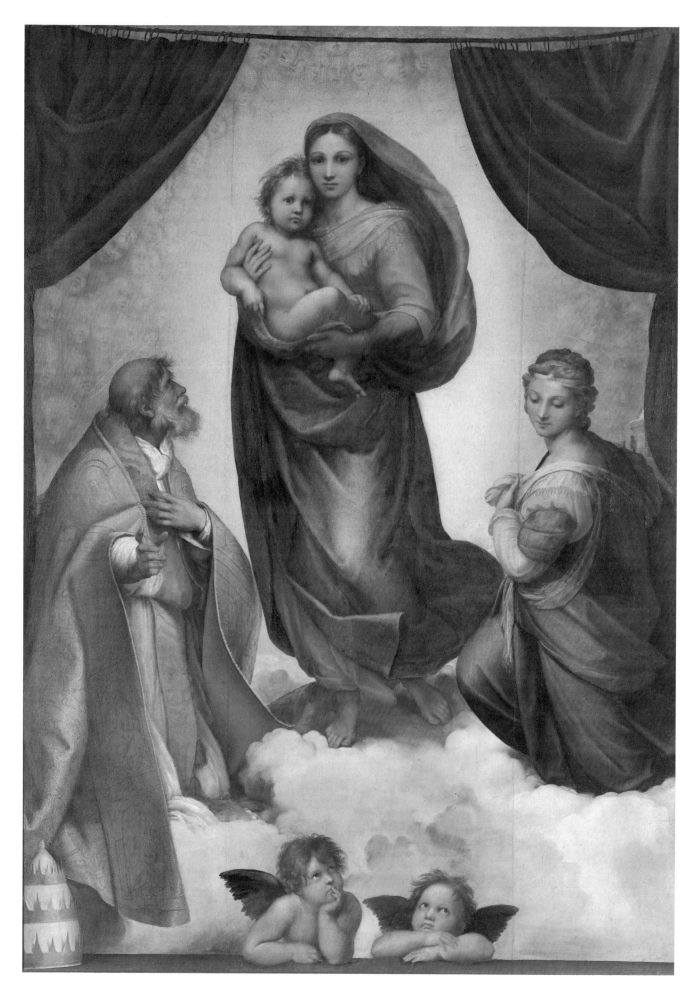

which those Figures appear is plac'd there very Artfully, it immediately gives you the Idea of a Jail, and those Dark Lines cutting the Brightness behind into so many small parts gives a Flickering and a Dazzle that nothing Else could possibly have done.'[24]

The slumped figure of St Peter, whom the dazzling angel liberates, has been thought not only to allude, as we saw, to his successor Pope Julius II but also to resemble him physically. When compared with actual portraits of the Pope (e.g. Plates 128, 164), St Peter, with the full head of hair and bushy moustached beard that pictorial tradition required, is hardly an exact likeness. However, Raphael also painted an altarpiece in which another successor of St Peter, the canonised Pope Sixtus II, looks, again only generically, like Julius, but the kind of identification proposed is, in this case, strengthened by the appearance of Della Rovere emblems on his cope and tiara (Plates 139–40).

The picture, the *Sistine Madonna*, was painted for the high altar of the newly rebuilt church of St Sixtus in distant Piacenza. Julius had already taken an interest in the rebuilding when a cardinal, but this commission may reasonably be regarded as a gesture of goodwill towards a city which had in 1512 become part of the Papal States, and it may have been prompted by a visit to Rome of a delegation from Piacenza in June 1512. The altarpiece was presumably in progress before Julius died and was possibly ready for the reconsecration ceremony in 1514. In it, the Julian figure of St Sixtus, resplendent with heavenly light, kneels on a cloudbank before the Virgin with one hand on his heart, interceding with her on behalf of the congregation of Piacentine worshippers which he draws to her attention with the other. Opposite him, with her tower just discernible behind her, St Barbara genuflects to Christ and looks elegantly down at the impish angels below. She was the patron saint of soldiers, but was probably included here because the church possessed not only a relic of St Sixtus, but also one of her.[25]

In terms of function, setting and scale, the *Sistine Madonna* is comparable to the *Madonna di Foligno* (Plate 99). They are almost exactly the same width, and must also have been painted within a couple of years of each other. But it is a sign of the rapid development of Raphael's art, and of the flexibility of his approach, that they are such different pictures. In both, subsidiary figures intervene between the beholder and the Madonna, but the Foligno Madonna is a distant vision in the heavens, while the Sistine Madonna walks, and looks, directly towards us, in a vision of an immediacy unparalleled in earlier altarpieces. The sense of physical proximity is paradoxically enhanced by the device, common in portraits, narrative frescoes and small devotional pictures, of a ledge at the bottom of the picture which, like the curtains at the top, defines the frame as a window and the vision as something separate from our world—but also able to enter it. The ledge, on which the reassuringly regular form of the Pope's tiara and irreverent relatives of the angels in the Chigi heaven (Plate 123) firmly rest, also stabilises a composition of figures which, from a distance, might appear to be floating freely in the air. The figures are on a much larger scale than those of the *Madonna di Foligno*, and the Madonna, uniquely in Raphael's altarpieces, is a full-length standing figure, over five feet tall. Raphael spent more time working on ideas for half-length Madonnas, and it is significant that a circle drawn around the Madonna's veil and the Christ-child would enclose an admirably designed tondo, like the approximately contemporary *Madonna della Sedia* (Plate 188).[26] It is in this circular area of the composition that the celestial light irradiating the picture is at its most golden.

The light in the *Sistine Madonna* plays an important part in its effectiveness as a vision. It is a pure light and offers none of the strong contrasts of light and shade that make the frescoes in the Stanza d'Eliodoro so dramatic. If we consider the variety of light effects Raphael used in these frescoes, it is interesting that moonlight, dawn light, flames, and reflections on dark armour are specified by Castiglione (together with blond hair, thunder storms and dancing highlights in the eye) as among the special achievements of painting.[27] We associate these subjects especially with oil

141. Marcantonio Raimondi (after Raphael). *The Morbetto*. Engraving, *c.* 1512–13, 19.5 × 24.8 cm. British Museum, London.

painting, in particular in Venice, rather than with fresco. But it is hard to think of an oil painting Raphael might have seen where equivalent lighting effects were attempted, whereas he could have seen the nocturnal fresco of the *Dream of Constantine* by Piero della Francesca at Arezzo. He would also have known Marcantonio's mysterious print, the first engraved nocturne and perhaps, as we have mentioned, a record of a painting by Giorgione (Plate 92). The theory is attractive because the print is such an unusual attempt to re-create pictorial atmosphere and light. Marcantonio has been defeated by the effort of finding an equivalent in black and white lines for a sky and water painted in colour. But Raphael now designed a nocturne of his own, for Marcantonio, who produced an engraving which is entirely successful as a representation of enveloping atmosphere and which set a standard for the portrayal of light effects in this medium surpassed only in the fantastic candlelight banquets by Jan Sadeler and Jan Muller at the end of the century.

This print (Plate 141), which is known as the *Morbetto*, illustrates an episode in Book III of Virgil's *Aeneid* when Aeneas and his Trojan followers are struck by a plague in their new settlement in Crete. The fortress had been built and new houses were being allotted when it came. 'Men gave up the sweet breath of life or dragged their bodies along'—*Linquebant dulces animas aut aegra trahebant/Corpora* (the text we read here)[28]—'the fields were parched and barren, the crops diseased.' This is clearly illustrated on the right-hand side of the print. *Nox erat*, Aeneas recalls. 'It was night and all creatures slept, when the holy images of the gods, the house-hold gods of Troy'—*Effigies sacrae divum Phrygiique Penates* (the text added in abbreviated form to the moonlight in the print to clarify the meaning)—appeared in the moonlight and bade the hero abandon Crete and continue his travels to the west.[29]

The arch in which the sleeping Aeneas is visited, the steps and the openings in the masonry to one side of it, the torchlight, and some of the poses all connect this with the *Deliverance of St Peter*. The print is divided by the terminal figure into day and night scenes. There is also a division of action in the fresco, for Peter appears there twice, awakened by the angel and escorted by him. It may be that Aeneas does so

FOLLOWING PAGES

142. Detail from the *Sistine Madonna* (Plate 140).

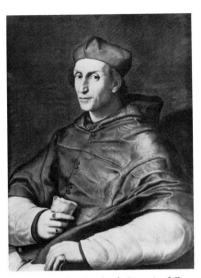

143. By or after Raphael. *Portrait of Cardinal Bibbiena*. Oil on canvas, *c.* 1516, 86 × 65 cm. Pitti Palace, Florence.

too. In any case the bearded figure looking over his shoulder at the tragic episode in the right foreground bears a close resemblance to the figure sleeping on the left. The composition is more effective in reverse and makes more sense, night following day. The beautiful metalpoint drawing which Raphael used for the daylight landscape (Plate 216) and the drawing, probably by him, of the whole composition, in pen and wash with white highlights,[30] are both in reverse.

<center>★ ★ ★</center>

On 1 July 1514 shortly after he had completed work in the Stanza d'Eliodoro, and probably on the *Sistine Madonna*, Raphael wrote to his uncle Simone Ciarla in Urbino, addressing him still with filial affection (*Carissimo in locho di Patre*), begging to be excused for not keeping in touch, chiding his uncle for not having written either and then breathlessly keeping him up to date:

> I find my personal estate in Rome to be worth three thousand gold ducats, with an income of fifty *scudi* per annum, and as architect of St Peters [an appointment made three months earlier] another three hundred gold ducats, and on top of this am paid for my work what I see fit to ask, and have begun another room for the Pope which will bring in one thousand two hundred gold ducats.

This, he continues, does honour to his uncle, to all his relatives and to his homeland. And then he comes to the point: 'you should know that Santa Maria in Portico [that is Cardinal Bibbiena] wishes to give me his niece as a wife and with your permission and that of my uncle the Priest I have promised to take her when the cardinal wishes.'[31] The girl in fact died before the wedding.

Raphael was clearly anxious not to offend someone like Bibbiena (Plate 143). The two men probably first met when Bibbiena was attached to the exiled Medici at the court of Urbino. He features as 'Bel Bernardo' in his friend Castiglione's *Courtier*, an expert lady's man exceedingly pleased with his appearance but a shade anxious as to the perfection of his legs.[32] His racy vernacular imitation of a Roman comedy, *La Calandria*, was probably composed in this period. By 1508 he had entered into a successful diplomatic career at Rome securing the favour of Julius II, from which his patron and boyhood friend Cardinal Giovanni de' Medici also benefited.[33] At the conclave of 1513 Bibbiena ensured his patron's election as Leo X[34] and was quickly rewarded with a cardinal's hat, the office of papal treasurer and responsibility for the *Segretario Intimo*. He was known as the 'other Pope' and it was observed that for Leo he was everything (*il tutto*).[35] He was indeed one of the most powerful men in Europe and it is unlikely that any earlier artist had ever come close to making an alliance of a comparable kind. But, according to Vasari, Raphael was given reason to hope that he would be made a cardinal himself and this was a motive for delaying the marriage. Leo was greatly indebted to Raphael and was compulsively generous. The court was, moreover, frequently buzzing with rumours of the Pope's plans to create new cardinals as a financial expedient. A relatively humble family background and utter lack of religious qualifications had not stood in Bibbiena's way.

VI. Papal Majesty

ON EASTER Monday, 1518, Paris de Grassis had an interview with Leo X in which he pointed out that the Sistine Chapel was full of cobwebs. The Pope agreed to appoint a couple of cleaners. Paris then went on to suggest that the Chapel's wooden lectern was really unworthy of such a place. The Pope replied that it should go and enquired what sort of new lectern Paris would propose. The cardinals, perhaps thinking of how the treasury had been exhausted by the recent war with Urbino, suggested that gilt wood with silk or velvet would do, at which Paris laughed, saying that even he had one like that at home. No, it should be solid silver and gilt. The Pope thought this a good idea and also agreed to other suggestions for improving the vestments, furniture and plate.[1] In the chapel of the papal palace, the principal chapel in Christendom (as St Peter's was the principal basilica), where the *Maiestas Papalis*, the majesty appropriate for the Vicar of Christ, to say nothing of the majesty appropriate for the Medici, was conspicuously displayed, excellence of design could not compensate for ordinary materials, and no skilful imitation (gilt wood) could be equivalent to the real thing (precious metal).

When, five years before, Leo X was elected Pope he found the Sistine Chapel with a vault newly decorated by Michelangelo and with walls earlier frescoed by a team of artists including Perugino. His first major improvement was to provide the Chapel with superior choral music.[2] His next was to commission Raphael to design tapestries to hang on the lower register of the Chapel wall which had been painted with hangings of gold and silver. It is easy to imagine someone like Paris de Grassis suggesting that mere paintings were not good enough, or, more likely, regretting that the real hangings which were on occasion employed there were inappropriate. In any case what Leo had made were tapestries woven with silk and with gold and silver thread. The metal would originally have been obvious—as it is now in the tapestries which have been restored (Plate 144)—and would have been particularly so by candlelight. Looting soldiers burnt at least one later set of tapestries in order to extract it.

The famous tapestries made for Duke Federigo da Montefeltro's palace at Urbino were, like the oil paintings in his *studiolo*, made by Flemish artists. Now, over twenty-five years later, the Italians, although they had mastered the secrets of oil painting, could still not rival Flemish technology in weaving. Leo, however, instead of inviting Flemings to Italy, sent ten full-scale coloured 'cartoons' by Raphael to the leading workshop in Brussels, run by Pieter Van Aelst.

Of these ten cartoons, eight survive, and if we consider that they have travelled extensively and are painted in a medium which can be described as a type of gouache (with pigments bound in animal glue) on large supports composed of numerous

134

145. *Cartoon for the Tapestry of the Charge to Peter.* Gouache on paper, *c.* 1515–16, 343 × 532 cm. Her Majesty the Queen (on loan to the Victoria and Albert Museum, London).

144. Workshop of Pieter van Aelst (after Raphael). *The Miraculous Draught of Fishes.* Tapestry, *c.* 1516–19, 492 × 512 cm (including a lateral border not shown in this plate). Vatican Museum, Rome.

sheets of paper, their condition is remarkably good, but many of the colours have faded or changed, not always agreeably. Because the weavers worked at the back of the tapestries looking at the cartoons through the horizontal warp,[3] the images on the finished tapestries were the reverse of those on the cartoons. Thus Raphael had to ensure that some of the figures acted as if left-handed, and also, since there was strong movement and narrative direction in each episode, he calculated this from right to left so that it would appear in the tapestry in reverse, that being the expected direction, and, especially when repeated in a series of images, the more satisfactory. Here no doubt Raphael benefited from his experience of making designs in reverse for engravers and mosaicists.

The first recorded payment to Raphael for this work was made on 15 June 1515 and the last on 20 December 1516. Impressive progress had been made on the tapestries by July 1517 and seven of them were put on display in Rome on 26 December 1519.[4] It is not known when the complete set were first hung in the Chapel—perhaps not in Raphael's lifetime. Raphael received 1,000 ducats for his work. The tapestries cost 15,000 ducats.[5] They were rumoured to have cost more and also to have been paid for out of funds collected for the Crusade or the rebuilding of St Peter's[6]—rumours which show how much attention this particular extravagance attracted.

The *Maiestas Papalis* was not only reflected in the costly materials of which the tapestries were woven but was also given biblical authority by the narratives portrayed in them. The ceiling frescoes in the chapel represented episodes from the earliest books of the Old Testament together with the prophets and sibyls. The wall frescoes illustrated in parallel sequences episodes from the Old and New Testaments involving Moses and Christ. It therefore comes as no surprise to find that the tapestries, which were meant to be closest to us, are mostly devoted to the part of the

146. *Cartoon for the Tapestry of the Miraculous Draught of Fishes*. Gouache on paper, *c.* 1515–16, 319 × 399 cm. Her Majesty the Queen (on loan to the Victoria and Albert Museum, London).

147. Detail from the *Charge to Peter* (Plate 145).

Bible nearest to us in time—the Acts of the Apostles. At least some of the episodes selected had a theological and political significance which no educated person could at that date have missed.

The authority of the Pope rested on the doctrines of the Apostolic Succession and the Primacy of Peter. Like all priests he was invested with spiritual authority transmitted from the Apostles, but his supreme authority, spiritual and temporal, was transmitted from Peter who was chosen by Christ as his Vicar on Earth. It was in Peter's boat that Christ performed the miracle of the draught of fishes. Peter fell on his knees and Christ explained to him that he would make him a fisher of men (Plate 146).[7]

To Peter, who had recognised him as 'Christ, the Son of the living God', Jesus also declared in front of the other disciples, 'thou art Peter, and upon this rock I will build my church; and the gates of hell shall not prevail against it. And I will give unto thee the keys of the kingdom of heaven.'[8] After the Resurrection Christ showed himself to his disciples at the Sea of Tiberias and again enabled them to make a remarkable catch. When they had dined he made Peter declare three times his special love for him, and in reply bade him 'Feed my sheep', that is take charge of all his followers.[9] In portraying this scene (Plate 145) Raphael reinforced its significance by referring back by means of the keys to the earlier episode. Here we may easily imagine the intervention of an adviser, but it must have been Raphael who emphasised the

136

148. *Cartoon for the Tapestry of the Healing of the Lame Man.* Gouache on paper, *c.* 1515–16, 342 × 536 cm. Her Majesty the Queen (on loan to the Victoria and Albert Museum, London).

miraculous character of Christ's appearance by placing, in the centre of the group of disciples who press forward to witness the scene, Thomas, bolt upright, his mouth open and his cloak fallen from him. In fact the Gospels make it clear that his doubts had been resolved at a former appearance, but it is a legitimate liberty.

The power which Peter thereafter exercised in his charities is illustrated by the miracle he performed at the Beautiful Gate of the Temple, healing a lame man who was asking for alms. In a tapestry of silver and gold he is shown at the moment when he is recorded to have said, 'Silver and gold have I none, but such as I have give I thee: In the name of Jesus Christ of Nazareth rise up and walk. And he took him by the right hand, and lifted him up.'[10] (He takes him by the right hand in the cartoon, by the left in the tapestry, but this may have been because Raphael wished to show him blessing the man simultaneously—an act which could not be performed by the left hand.) The healed man then entered the Temple and the disciples (Peter and his companion John) were mobbed 'in the porch that is called Solomon's'. Raphael looks forward to this by placing the miracle itself in a vestibule composed of enlarged silver versions of the twisted late antique columns in St Peter's. These were supposed to have come from the Temple of Solomon and one of them was credited with miraculous healing power.[11]

Authority of an opposite kind is illustrated when the Apostles redistribute the wealth of the Church and Ananias is struck down dead after Peter accuses him of cheating.[12] There is no mystery as to why these last two episodes were selected: they demonstrate the power of Peter to give and take life, and, in both, his power, rather than that of the Apostles collectively, is emphasised.

By taking into account the sizes of the tapestries (which are not uniform), the lighting in them (which was presumably intended to relate to that in the Chapel itself), and the obstacles on the wall (screen, cantoria, and back of the papal throne)

149. Detail from the *Healing of the Lame Man.*

138

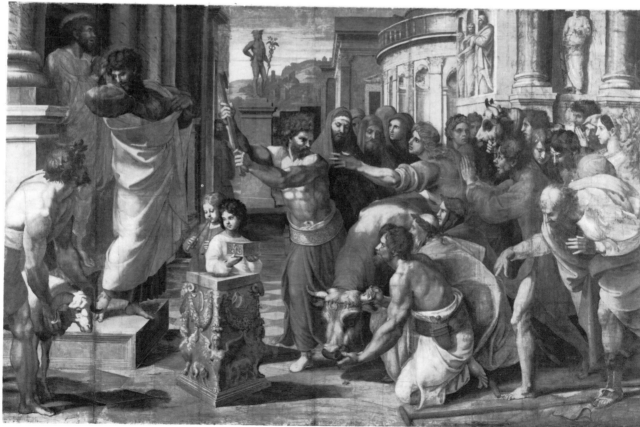

the order in which the tapestries were intended to hang has been plausibly reconstructed.[13] The four episodes from the life of St Peter just described would have hung in that order the first on the altar wall to our right, the others along the wall of the area of the Chapel enclosed by the marble screen. 'Whoever recollects the deep humility and devotion in the expression and attitude of Peter kneeling in the boat before Christ, may now also call to mind, that, at the distance of a few paces, the "Head of the Church" contemplated this scene from the highest of earthly thrones.'[14] Episodes from Leo's own life were portrayed in a small frieze beneath the principal narratives. Thus below the *Miraculous Draught* we see him arriving in Rome for the conclave of 1513 and his election as Pope. The moment when he was chosen is thus placed below that when Peter was 'called'.

Parallel with this series and again commencing on the altar wall were tapestries adorned with scenes from the life of St Paul. These were below the frescoes recording the life of Moses, whereas those devoted to Peter (the Vicar of Christ) were placed below the frescoes of the life of Christ. The first portrayed the stoning of Stephen, and the moment when, kneeling, he 'cried out with a loud voice, Lord, lay not this sin to their charge'. Saul (Paul), a young man who was a violent persecutor of the Christians, is mentioned as present and Raphael places him so that Stephen's speech seems directed specifically at him.[15]

In the next tapestry Saul is shown temporarily blinded on the way to Damascus[16]—an episode involving terrified, wheeling horses derived from ideas for the *Repulse of Attila*. Having been tended by Christians and converted, Paul was summoned to expound the Faith to Sergius Paulus, Proconsul of Asia.[17] Paul converted the Proconsul by blinding a sorceror who attempted to impede him— 'behold, the hand of the Lord is upon thee, and thou shalt be blind, not seeing the sun for a season. And immediately there fell on him a mist and a darkness; and he went about seeking some to lead him by the hand' (Plate 150).

Paul is represented in the next tapestry rending his clothes and 'crying out' when the people of Lystra endeavoured to sacrifice to him and Barnabas, supposing them to be Mercury and Jove after Paul had healed a cripple (included by Raphael staggering on the right of the cartoon—Plate 151).[18]

There was next a narrow strip of tapestry representing Paul's miraculous release from prison and then the last tapestry showed Paul preaching at Athens, introducing a philosophical public to the doctrine of the Resurrection. Some mocked, some wanted to know more and 'certain men', notably Dionysius the Areopagite, and 'a woman named Damaris'—the enthusiastic pair to the right of the cartoon—'clave unto him, and believed' (Plate 152).[19]

These subjects were perhaps intended simply to reinforce the Church's mission to those in power, to the superstitious populace and to the educated, by reference to the works of its most active early minister. There is no good reason to suspect any arcane or complex significance in them. A problem is presented by the last tapestry which must have hung outside the screen and in the main body of the chapel. The subject, Paul preaching at Athens, may have been considered appropriate for the lay public who were for the most part assembled there, but it must have looked odd, even if it was in part balanced by the cantoria on the opposite wall. Further tapestries may have been planned.

The cartoons must have been designed more or less together, even if they were executed one by one, and a stylistic development is not obviously apparent in them. The contrasts between contiguous tapestries were evidently calculated: so too were elements of continuity, of which the most obvious is the landscape shared by the *Miraculous Draught* and the *Charge to Peter* although the events are described in the Gospels as occurring in different locations. The vertical borders with which the tapestries were supplied do correspond with the pilasters painted between the frescoes above, but Raphael has made no more of an attempt to match what he must have considered as an outdated style than Michelangelo had when painting the ceiling. The difference in style is neatly demonstrated by comparing Raphael's

150. *Cartoon for the Tapestry of the Blinding of Elymas*. Gouache on paper, *c.* 1515–16, 342 × 446 cm. Her Majesty the Queen (on loan to the Victoria and Albert Museum, London).

151. *Cartoon for the Tapestry of St Paul at Lystra*. Gouache on paper, *c.* 1515–16, 347 × 542 cm. Her Majesty the Queen (on loan to the Victoria and Albert Museum, London).

cartoon of the *Charge to Peter* with Perugino's fresco of the *Donation of the Keys* (Plates 7, 145).

Like the small pieces of glass which make up a mosaic, the weave of a tapestry is always evident to remind us of the two-dimensional character of the work of art. The surface will also never be as flat as a wall, a panel or a stretched canvas. For these reasons it may be considered unwise to encourage the fiction that we are looking through an opening into space. It is also impossible in weaving to emulate the subtle and continuous tonal transitions possible in painting and so it may be argued that it is wiser to avoid the imitation of aerial perspective and even chiaroscuro. Raphael, however, was not at all inclined to accept the limitations of this medium. The reflection in the water in the *Miraculous Draught* is not the only example of an extremely pictorial effect which he hoped Pieter Van Aelst would achieve. Vasari was sure that he did achieve it—the tapestries looked as if they were paintings (paintings, however, he praised for looking like the real world).[20]

Furthermore, as if in defiance of the flexible surface of the tapestry, Raphael designed frames for the pictorial narratives which imitate porphyry (a stone of proverbial hardness) carved in a guilloche pattern, and the reliefs below are imitations of bronze reliefs, mimicking all the mannerisms of Roman relief sculpture—with no perspectival space, the landscape reduced to squat, simplified trees, and reclining gods used to signify rivers.

There is, however, at least one aspect of the cartoons in which Raphael may have been influenced by the fact that they were, even if works of art to be appreciated in their own right, primarily works of art to be reproduced in a different medium by craftsmen who were not working under his own eye. Raphael may have felt himself to be in the position of a writer who knows that his work is to appear before the world in translation and who is therefore concerned to avoid refined and subtle language. Certainly Raphael has taken care that the compositions, the expressions and the gestures are clear and forceful.

It has been remarked that the 'actors' here are 'less beautiful in person' and they are less gracious in movement than those in the frescoes of the Stanze.[21] This must have been in large measure a response to the simplicity of the texts illustrated, in which dignity and power counted more than elegance. More than any of his paintings since the *Entombment* the cartoons correspond with the highest type of painting as it had been defined by Alberti and by Leonardo—the *historia*, the narrative painting akin to ancient tragedy. And in the most elevated examples of this type of painting Alberti counselled a limited number of actors in accordance with the prescriptions of ancient drama.[22]

In this case almost all the actors are men and only in one cartoon, the *Healing of the Lame Man*, is feminine beauty allowed. Far more characteristic than the flowing forms of the woman bearing a basket to the left of this cartoon is the compact and massive form of St Paul preaching. He stands squarely, with feet flat on the ground, but seems superbly elevated by the step and by the arches springing above his head, while the force of his gesture is emphasised by the enfilade of pilasters behind. This is a man 'engaged in real action, unsolicitous of grace', as Joshua Reynolds observed. Reynolds also suggested that Raphael derived this and some of the other poses in the cartoons from Masaccio.[23] Raphael may well have had the chance to re-examine Masaccio's frescoes of the life of St Peter during a visit to Florence in the suite of Leo X in the winter of 1515.[24]

The style of the tapestry cartoons seems to have exerted no significant influence on any artist until, well over a century after they had been painted, Nicholas Poussin, using the tapestries and prints (the cartoons had by then been taken to England) drew from them as much strength as Raphael had drawn from Masaccio. Poussin indeed exaggerated Raphael's style—or rather concentrated it, for he was working on a far smaller scale (Plate 153). He did not permit himself any redundant felicities in the distances, made the draperies stiffer, the outlines harder, the local colours still more obviously contrasted, the expressions more like masks, the gestures more

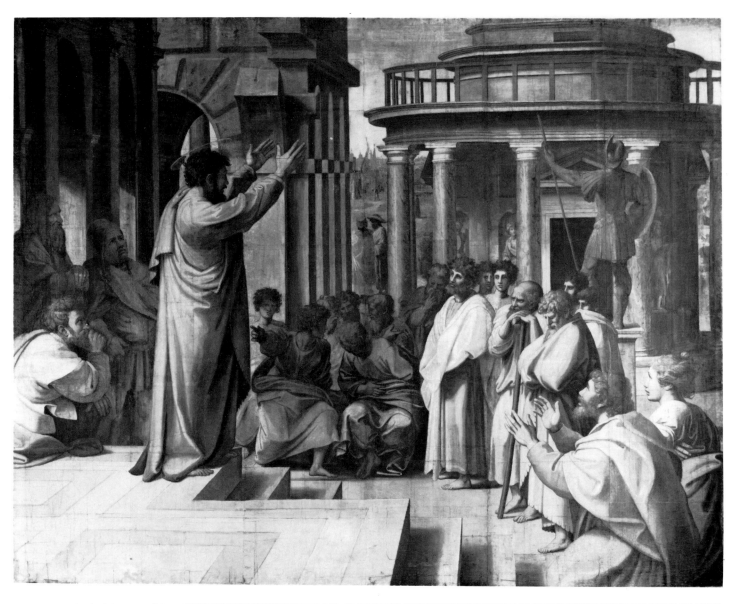

152. *Cartoon for the Tapestry of St Paul at Athens.* Gouache on paper, *c.* 1515–16, 343 × 442 cm. Her Majesty the Queen (on loan to the Victoria and Albert Museum, London).

153. Nicholas Poussin. *The Donation of the Keys ('Ordination').* Oil on canvas, 1647, 117 × 178 cm. The Duke of Sutherland Collection (on loan to the National Gallery of Scotland, Edinburgh).

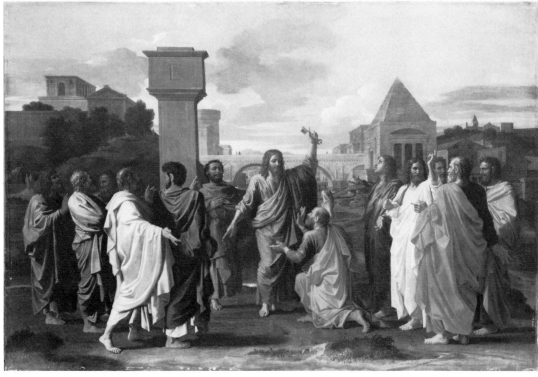

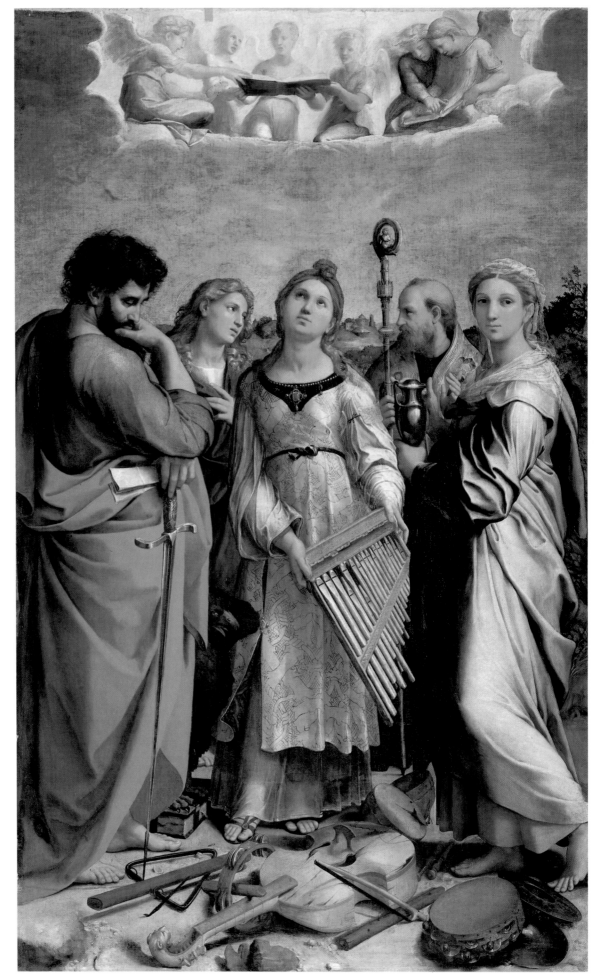

154. *St Cecilia with Sts Paul, John Evangelist, Augustine and Mary Magdalene*. Oil on canvas (transferred from panel), *c.* 1513–16, 238 × 150 cm. Pinacoteca, Bologna.

155. Detail from the St Cecilia altarpiece.

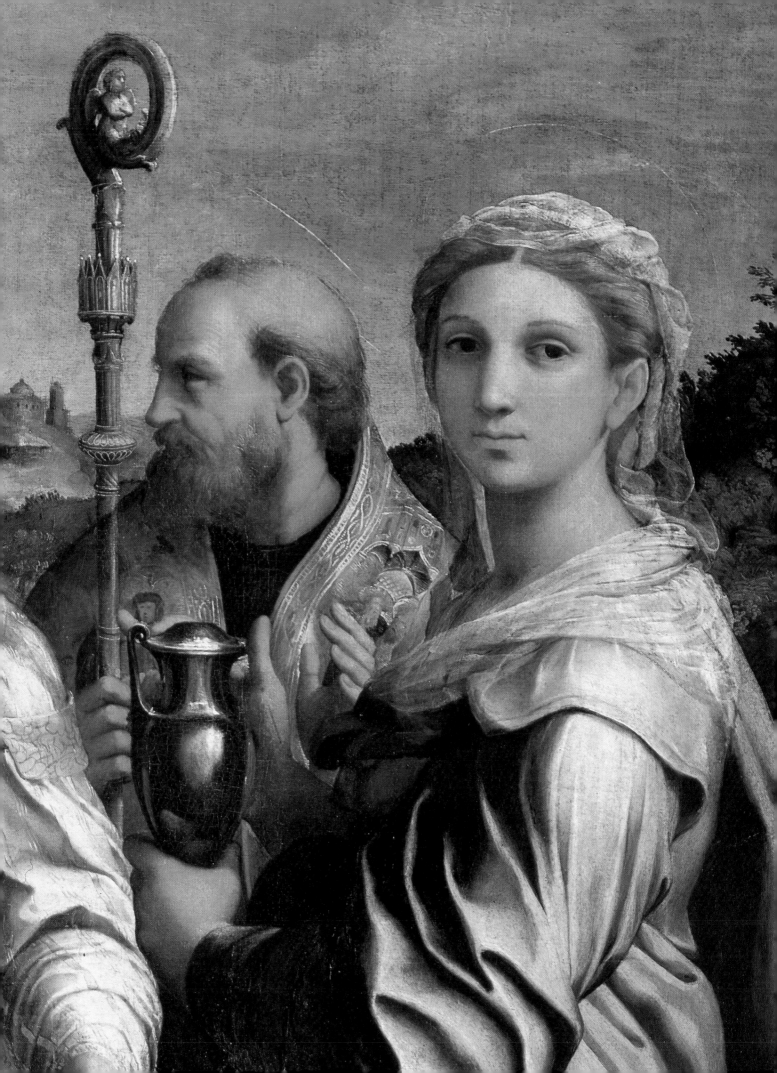

156. The St Cecilia altarpiece (Plate 154) including the replica of its original frame. Pinacoteca, Bologna.

rigid, and the groups still more easily divided into separate units. In place of compositions which possess 'the beauty of an organism held in complex equilibrium',[25] Raphael in the cartoons, and Poussin in his imitation of them, provide us with figures locked into an enduring geometrical formula. Hence their power over the memory: they are as memorable as the texts they illustrate and indeed make these texts more memorable. It is not surprising that they came to be considered as exemplary by the eighteenth-century proponents of edifying history painting. But this has the unfortunate consequence for us that, looking at the cartoons today, it is sometimes hard not to be reminded of routine competition pieces based on the prescriptions parodied by Ruskin: 'whenever you admire anybody, you open your mouth and eyes wide; when you wish to show him to someone else, you point at him vigorously with one arm . . .'[26]

The tapestry cartoons impress themselves so deeply in the memory that it is disappointing to rediscover that they are not entirely agreeable to look at. The idea (first proposed, it seems, by the great connoisseur Richard Payne Knight)[27] that the cartoons were in large part not executed by Raphael is hard to resist when they are compared with an oil painting on which he was working in the same period. This was an altarpiece for the chapel which had been founded by Elena Duglioli dall'Olio in her local church, S. Giovanni in Monte in Bologna (Plate 154).

Elena gradually attracted ecclesiastical attention during the early years of the century on account of her visions, her great virtues, and her successful struggle, assisted by St John the Evangelist (patron of Virginity), to persuade her husband not to consummate their marriage. Her model in this scheme was St Cecilia of whom she made a special cult. Cardinal Alidosi, who was legate in Bologna and probably the most influential of her promoters, presented her with a small knucklebone from the arm of St Cecilia which Henry VII of England had sent to Julius II. Her chapel was dedicated to St Cecilia who is also the chief subject of Raphael's altarpiece and is represented there with abandoned instruments of secular music, and with an *organetto* slipping from her hands as she is transported by the superior music of a heavenly choir. St Cecilia is surrounded by saints who were associated with divine love, celibacy and the renunciation of carnal pleasure, among them St John of course (not only because he was her special protector but because the church was dedicated to him) and also St Augustine, patron of the Canons Regular whose church this was.[28] It is an unusual altarpiece in that it has as its centre an act of devotion rather than the object of devotion,[29] and the manner of representing St Cecilia and the metaphorical use of music was also novel and would have required the sanction of high authority. The commission came in fact from another of Elena's admirers and promoters, the Florentine canon Antonio Pucci (later Bishop of Pistoia), who subsequently also presented the church with a silver reliquary for the knucklebone. He was able to obtain Raphael's service through the agency of his uncle Cardinal Lorenzo Pucci, one of the most powerful members of the Curia, who may well have met Elena himself when he accompanied Leo X to Bologna in the winter of 1515/16.[30]

We would not expect to be able to match in the broader handling of the cartoons any of the fine precision found in the details here—the light on the miniature ornaments of St Augustine's silver crozier, on the golden curls of St John the Evangelist, on the steel blade of the sword upon which St Paul leans, on the shimmering garments of Cecilia herself, or in the vase in which the Magdalene's hand is so beautifully reflected. But the conviction and care found in every part of the altarpiece are for the most part lacking in the cartoons.

There is a delicacy of touch, as for instance in the sunlight on the tree-clad hills behind Christ in the *Charge to Peter*, and there is also much fluent boldness of handling, but there are some passages (the hands behind the blinded Elymas for example) which are clumsy, and some which are dull. Vasari, although he says in his life of Raphael that the cartoons were painted by Raphael, in his life of Gianfrancesco Penni says that Penni assisted in the execution.[31] So too perhaps did Giulio Pippi

(Giulio Romano), although he may only have been sixteen at the time. These two *garzoni* were soon established as Raphael's principal assistants, but we do not know exactly when they joined him.

It is worth remembering that since becoming an independent master Raphael must always have been helped by boys who would grind pigments, prepare panels with gesso, and also pose for life drawings. Furthermore, in the earliest surviving contract involving Raphael an associate is mentioned. This may have been a legal convenience, but Raphael certainly proposed to work in collaboration with another painter on the altarpiece he agreed to make for Monteluce, and parts (certainly God the Father who can hardly be considered subordinate) of the altarpiece for Atalanta Baglioni were the work of another artist. It is reasonable to assume that Raphael did not execute his large frescoes single handed. As he painted the heads, the accomplished boys in his studio could be trusted to paint the sky, and the most accomplished perhaps some of the drapery. Penni and Giulio had doubtless begun by working in this way. Raphael, who had earlier welcomed collaborators, gave them more to do as soon as they were ready.

Since in true fresco painting the pigment must be applied with decision and speed and cannot be effectively revised, provided the condition of the fresco is good it should not be too hard to determine any important area where a junior assistant has worked—far less hard, in any case, than it is in the tapestry cartoons where the technique permitted Raphael to leave much of the preliminary 'blocking in' to assistants and then to correct it before the uppermost layer of paint was applied by him—or by the assistants (all possible permutations are suggested by X-ray photographs).

Oil painting is a gradual process and Raphael could intervene at several stages. It has even been suggested that the more solid execution of many of his oil paintings after he came to Rome was related to his use of assistants.[32] Certainly the operation of more than one hand on the relatively thinly painted flesh in his early work would be hard to disguise. In a major altarpiece it would be important for Raphael to ensure that it was finished with uniform excellence. It is not possible to detect the work of different hands in the St Cecilia altarpiece. Vasari, however, wrote that the broken instruments discarded by the saint were painted by Giovanni da Udine,[33] an assistant who was, as we shall see, more of a specialist and who had more independent status than either Giulio or Penni.

★ ★ ★

On 1 July 1514 Raphael had started work on 'another room for His Holiness'.[34] This must be the room now known as the Stanza dell'Incendio which connects with the Stanza della Segnatura (which Leo probably continued to use as a *studiolo* although it was no longer a library) on the opposite side to the Stanza d'Eliodoro. Progress on the room was delayed by Raphael's numerous commitments. The date 1517 on an inscription indicates the year in which work was completed. Raphael was said to have had only a couple of days' more work to do in the *camera del Papa* on 16 June 1517.[35] On 1 July his *garzoni* were paid 20 ducats for work in the 'room before the secret treasury'—certainly this one.[36] On 19 July Bembo wrote to Cardinal Bibbiena who was in France that 'the rooms of His Holiness that Raphael has painted, both on account of the singular and excellent pictures but also because they are almost always well furnished with cardinals, are most beautiful'.[37] This would only have been news if a new room was among them—it may also mean that the decoration and redecoration of subordinate parts of the other Stanze had been completed.

Bembo's letter tells us that the room was in use, and we may think of the long hours spent even by the greatest dignitaries in waiting for an audience, but we are

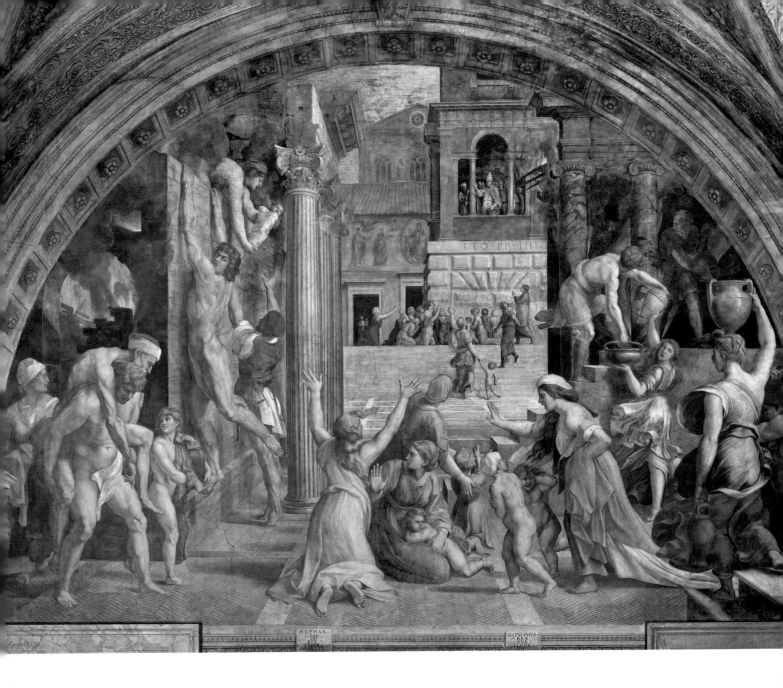

157. *The Fire in the Borgo*. Fresco, *c.* 1516–17. Stanza dell'Incendio, Vatican Palace, Rome.

given no precise information as to the exact function of this particular room. The other contemporary references already mentioned are only to a room or a chamber, and that State rooms such as this were designed for a variety of functions should be remembered. Paolo Giovio, however, who was very familiar with the court (Leo, who knighted him, enjoyed hearing him read his history) and who wrote his life of Raphael not long after the artist's death, does say that this was the room where the Pope dined in private,[38] and this is given support by the exterior balcony passage built during Leo's pontificate to connect this room with what was, at least at a later date, a kitchen.[39]

Dining, even private dining, in the palace was governed by rigid etiquette with the Pope eating separately at a high table. Nevertheless it could be entertaining. There are reports of gross clowning and fantastic gluttony, of poetry recited and improvised, and above all of music performed on these occasions—music which sometimes so moved Leo that he seemed entirely transported by it. He closed his eyes, his head sunk on his breast, and he murmured in accompaniment.[40] However, if Leo sometimes forgot himself at dinner, the decoration of his private dining room did not encourage this. He was surrounded by reminders of the acts of his predecessors, after whom he was named and with whom he was constantly compared.

158. Detail from the *Fire in the Borgo*.

148

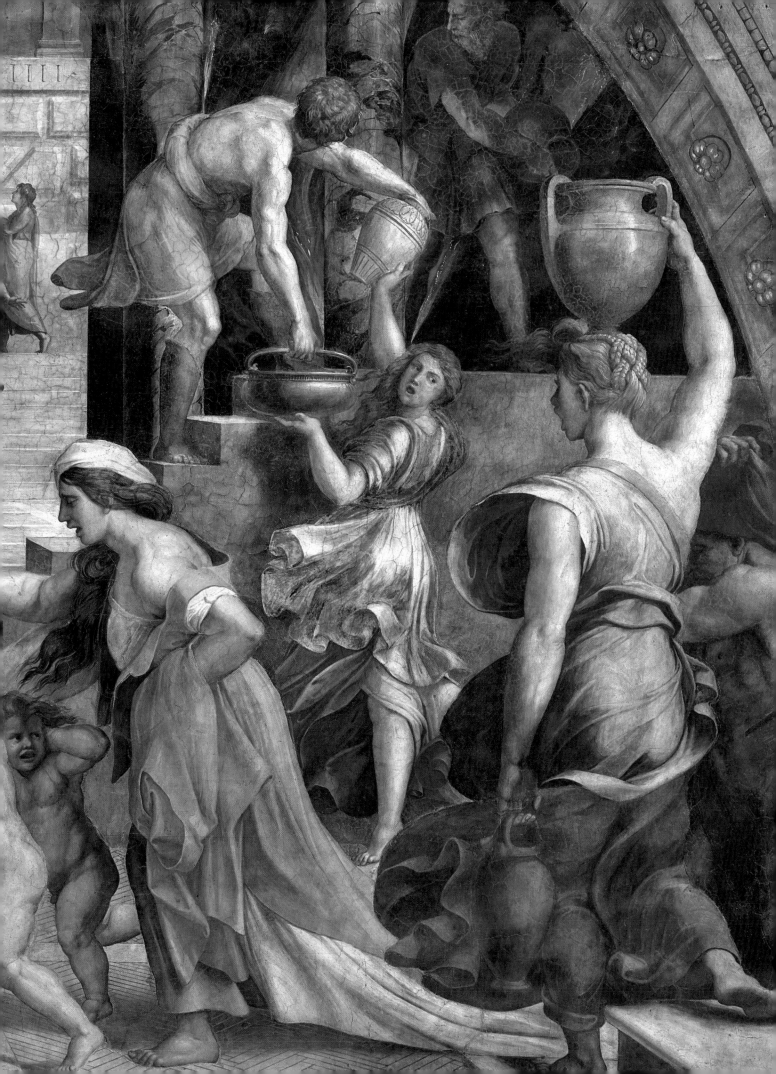

The frescoes show Leo III (795–816) taking the oath in St Peter's and crowning Charlemagne Holy Roman Emperor in the same basilica, and Leo IV (847–855) thanking God for the victory of the allied fleets of Christian Italy over the Saracens at Ostia, the Port of Rome (Plate 159), and extinguishing 'by the sign of the Cross a great fire, which had burn'd down the quarter where *Saracens* and *Lombards* liv'd, and reach'd very near S. Peter's Church' (Plate 157).[41] The source in each case is likely to be the most obvious one, the popular and official lives of the Popes written by Sixtus IV's librarian Platina which gives prominence to all four episodes.[42] The ceiling had already been decorated by Perugino, but Raphael has not adapted the style of the new paintings, any more than he adapted the style of the Sistine tapestries, to suit the earlier work.[43] The contrast is not agreeable.

Since both Leo III and Leo IV are given the features of Leo X, some topical relevance for Leo X may be expected in the narratives. Platina explains the circumstance in which Leo III made his oath. Not only had there been military attempts against the Pope, but many slanders against him were circulated, and when Charlemagne, who was protecting him, arrived in Rome he enquired of the assembled ecclesiastics in St Peter's concerning the conduct of the Pope. The unanimous reply was 'that the Apostolick see, the Head of all Churches, ought to be judged by none, especially not by a laick', after which Leo voluntarily declared his innocence upon the Bible.[44]

A Latin inscription spells out the message: 'God, and not Man, is the Judge of Bishops'. The great threat to papal authority which Leo X inherited was the Schismatic Council of Pisa established by the French King Louis XII to censure Julius II. At the sixth session of the Lateran Council in December 1513, when the decoration of this room was perhaps being planned, envoys of Louis XII solemnly dissociated the King from the Schismatic Council.[45] The parallel is obvious.

The *Coronation of Charlemagne* represented the proper relationship between the temporal and spiritual powers. Charlemagne was, as the Latin inscription declares, 'supporter and protector of the Roman Church'. By December 1515 (when the fresco had still not been executed) the subject had become particularly relevant owing to the benign attitude which the new French King, Francis I, seemed to be assuming towards the papacy which had every reason to fear humiliation at his hands. In the tough bargaining which accompanied the deferential ceremonial meetings between Pope and King at Bologna, he agreed not only to protect the Papal States but to abolish the royal ordinances limiting papal authority in France (the 'Pragmatic Sanction').[46]

As well as reasserting the authority of the papacy and entering into a harmonious relationship with the King of France, Leo X would put out the flames of war, as Leo IV extinguished the fire in the Borgo, bringing peace—to Christians, that is. For Leo also hoped to combine the rival powers of Christendom in a Crusade against the infidel Turk, as Leo IV had led a united Christian campaign against the Saracens. The Turks were a serious menace in Eastern Europe (Leo had wept in public on 13 June 1513 at the distressing reports from Poland) and in the Mediterranean (Leo himself had nearly been captured by raiding Corsairs at the end of April 1516 when he was hunting near the mouth of the Tiber). The idea of a Crusade, to which lipservice had long been paid, was pressed very seriously by him.[47]

The *Battle of Ostia* (Plate 159) should perhaps really be described as the 'Saracen Prisoners brought before the Pope'. The Roman citizens, Platina tells us,

> would have some of them hang'd without the City for a terror to the rest, very much against the mind of *Leo*, who was very remarkable for Gentleness and Clemency, but it was not for him to oppose the rage of a multitude. Those that were sav'd alive Leo made use of in re-edifying those Churches which the *Saracens* had heretofore ruin'd and burnt, and in building the wall about the Vatican, which from his own name he call'd Urbs *Leonina*. This he did lest the Enemy should with one slight assault take and sack the Church of S. Peter, as heretofore they were wont.[48]

Thus this fresco concerns St Peter's as directly as does the *Fire in the Borgo* and the two scenes of the *Oath* and the *Coronation*. Leo X was of course engaged in rebuilding St Peter's and so was Raphael, who was, as has been mentioned, appointed architect of the basilica in succession to Bramante.

Because of his duties as architect of St Peter's—to say nothing of other obligations—Raphael could not give full attention to all the frescoes in this room. The *Fire in the Borgo*, however, appears to us to be entirely his design and in all important parts painted by him. Of the four subjects it was the one which had least restrictions, its principal participants being the common people, anonymous and unencumbered by official dress. It may be compared with the earlier *Massacre of the Innocents* (Plate 97) in which half-dressed women also run in panic or crouch in supplication accompanied by children and athletic male nudes. The foreground paving is no less clearly defined but it is broken up here by architectural elements, and there is an opening in the centre of the composition so that the orthogonals run without interruption towards old St Peter's and the figure of the Pope to whom the women appeal. He appears at a loggia in what may be intended for the lower register of the campanile of St Peter's which he erected.[49] The principal action is thus made at right angles to the wall surface—a daring innovation, spectacularly developed by Tintoretto, above all in his *Presentation of the Virgin*.

The painting of fire is something Raphael had already attempted in the Stanza d'Eliodoro, but 'calamity itself is seen more by the Distress of the People, Variously, and Finely express'd, than by the Flames themselves',[50] as the Richardsons remarked, noting that it was the preference of the ancients to portray events through the human figure wherever possible. It is hard to imagine a way in which the flames could be shown to respond to the Pope, whereas the people could be shown amazed at how they did so. Despite the distress nothing horrid is shown, so our sympathy is unobstructed by revulsion. This again was certainly in accordance with the ideals of ancient art. The same applies to the nudity, although it has been pointed out that the fire must have occurred during the siesta and that the people had been surprised in bed.[51] A difference between this fresco and those Raphael had painted in the Stanza d'Eliodoro is that Raphael shows no interest here in painting a crowd. None of the figures in the foreground react collectively, their distress is indeed 'variously express'd', the range of reactions increasing on scrutiny.

It is tempting to wonder whether Raphael after the *Morbetto* planned to make a print of Aeneas's escape from the flames of Troy. The group to the left of this painting was either derived from or converted into a study of Aeneas carrying his father Anchises and escorted by his son Ascanius, a very similar but more heroic group, known from an engraving by Caraglio[52] which, however, gives no idea of the dramatic setting and displays none of the fine burin work we would expect if it was one to which Raphael gave special attention.

If this group is inspired by ancient poetry, the woman to the right, stopping on the steps and gaping wide-eyed with astonishment at the miracle as she hastens carrying water to the men fighting the fire, is a monumental development of a type of figure adapted in fifteenth-century Florentine painting from antique sculpture. The wind which blows her dress about contributes to the sense of agitation and hurry but also, by defining her buttocks and calf, emphasises her poise. In that she directs us into the picture space and pushes back the rest of the figures she invites comparison with the kneeling woman in the *Expulsion of Heliodorus* (Plates 132, 134). She is also closely related to the woman floating forward to one side left of the *Healing of the Lame Man* and her elaborate hairstyle is found elsewhere in the same cartoon. But unlike these women the watercarrier in this fresco is dressed in the cool greys and greens of metal or stone, and the size of her head is reduced and her limbs are expanded and elongated. The sensuous vitality and mental energy conveyed by the figure are astonishing: she was surely in Giovio's mind when he wrote that Raphael had painted this scene with a 'wanton brush'.[53] Bellori considered it impossible to imagine a figure in the grand manner more beautifully conceived.[54]

Even more startling evidence of a new feminine ideal in Raphael's art is provided by the St Cecilia altarpiece painted for Elena Duglioli. A print by Marcantonio and a careful drawing probably by Penni (which perhaps served as a *modello* for the print) record an earlier idea for the painting. This was probably made by 1514, by when the commission had, it seems, been given to Raphael.[55] The painting itself may, however, not have been sent until 1516 since, according to Vasari, Francia, the leading local artist, who agreed to install it, and no doubt place it in the gold and blue frame which still survives, died shortly after doing so. (Vasari claims that he never recovered from the blow of seeing how superior it was to his own art[56]—which is obviously an hyperbole, but he might well have been deeply depressed by the sudden blow to his reputation from the exhibition of this work.)

Of the many differences between the early project and the completed painting, the changes to the Magdalene are most remarkable. The volume of her drapery is greater than is now immediately obvious, owing to the paint having darkened in the shadows. It falls vertically from her hands, cutting across the smaller pipes of the organ that Cecilia is letting slip. Her drapery is in dark blue-grey which, where its sharp folds catch the light, is a pale, slightly rose, stone colour—the same colour as the highlights of the pink drapery over her shoulder. The pose has a self-conscious elegance with the weight placed on one leg: her figure is twisted, but not because she

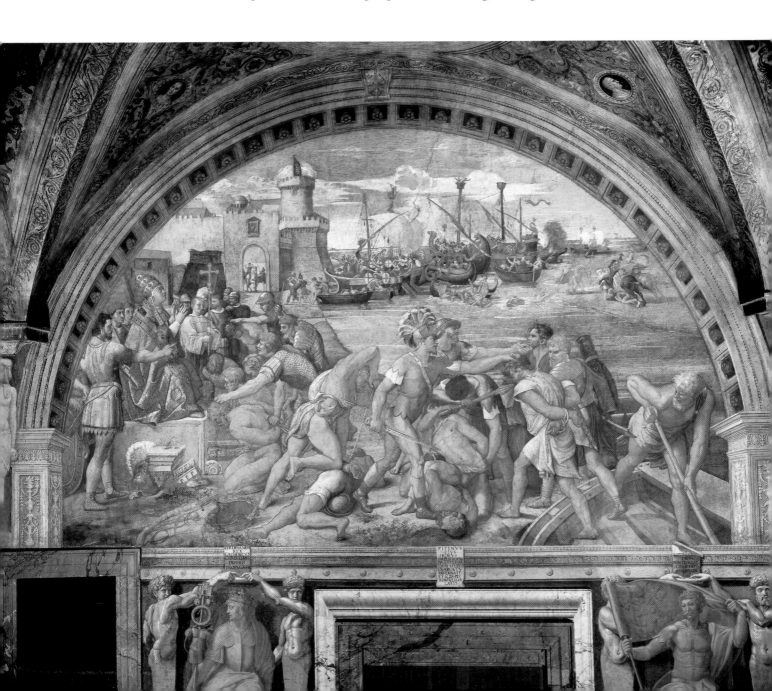

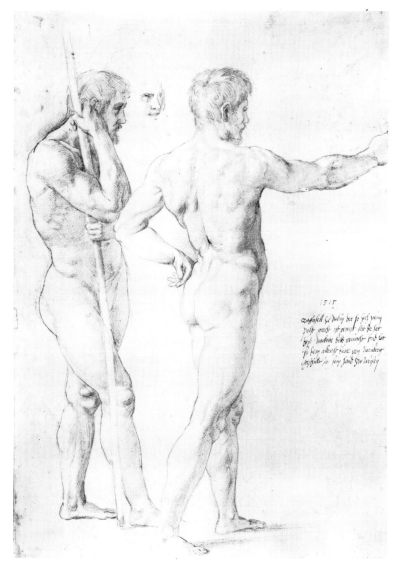

159. (left) Raphael workshop. *The Battle of Ostia* (including part of the basamento, interrupted by a later chimney piece). Fresco, *c*. 1515–17. Stanza dell'Incendio, Vatican Palace, Rome.

160. *Life drawing of a nude youth in two poses* (preparatory for the *Battle of Ostia*). Red chalk, inscribed 1515, 40.1 × 28.1 cm. Albertina, Vienna.

161. (below) Parmigianino (Francesco Mazzuoli). Detail from the vault of S. Maria della Steccata, Parma. Fresco, 1531–9.

is moving. Instead of looking up to the heavens, as in the earlier composition, she turns her small head to us. She has the slightest smile, controlled rather than passively responsive, and wide immobile eyes, more penetrating than inviting.

This new type of beauty was much imitated in the years after Raphael's death, but only one artist fully understood what Raphael had achieved here—Parmigianino, the reincarnation of Raphael as he was considered, on account of both his courtly manners and his manner of painting.[57] His women (Plate 161) have still longer legs and smaller heads, a still more unearthly elegance, and often carry vessels which seem to be metaphors of their own perfect bodily form, an idea which perhaps occurred to Raphael as he contrived the small silver and the large marble vases held by the Magdalene in this altarpiece and carried by the woman in the *Fire in the Borgo*.

Looking at the other frescoes in the Stanza dell'Incendio is disappointing. Gallant attempts have been made to detect merits in the design of the *Oath of Leo III* and the *Coronation of Charlemagne*[58]—there is obviously none in their execution—but it seems to us that these might be cases in which an assistant was rashly permitted to produce a work that was a lame imitation of what Raphael had executed in the Stanza d'Eliodoro.

The *Battle of Ostia* (Plate 159) does not look as if it was executed by Raphael, and the composition is too clumsy to be entirely his, but it incorporates some figures Raphael had invented and for which he completed beautiful *garzone* studies on a sheet which he sent to Dürer (Plate 160). It is inscribed in German, perhaps by Dürer himself: '1515. Raffahell de Urbin who is so highly esteemed by the Pope made this

162. Probably Raphael. *Design for a salver*. Pen and brown ink with some red chalk, *c.* 1516, 23.2 × 36.9 cm. Ashmolean Museum, Oxford.

naked figure and sent it to Albrecht Dürer in Nuremberg to show him a work by his hand.' (Dürer had sent Raphael his self-portrait.) The fresco also develops ideas for frieze-like compositions of captives forced to their knees, bound with ropes and pulled by the hair such as are found in Raphael's own earlier drawings (Plate 50). What perhaps happened is that Raphael provided both a compositional sketch and at least some detailed studies of separate figures, but an assistant, most probably Giulio, made modifications and added elements of his own, and was responsible both for the full-scale cartoon and for the execution in fresco. Raphael designed a similarly compact and energetic frieze of amorous rather than martial character at about the same date for the rim of a vessel (Plate 162).

The *basamento* below the narrative paintings in the Stanza d'Eliodoro consisted of paintings of stone caryatids with bronze reliefs between them, here there are term figures flanking seated representations of secular princes who gave notable support to the papacy. Chiaroscuro painting of this sort was still more prominent in the Camera del Papagallo where, however, the decorations only survive in part. The room was completed earlier in 1517 than the Stanza dell'Incendio[59] and must be one of those new rooms to which Bembo referred in his letter to Bibbiena. Here Vasari records that Raphael 'made in certain niches some Apostles in chiaroscuro as large as life and most beautiful'.[60] In fact there were some saints as well as Apostles and the work may have been executed by assistants. The room served as the Secret Consistory, and so the Apostles who had assisted St Peter looked down at the cardinals assisting Peter's successor.[61] When the Pope and the cardinals looked higher up, however, they saw painted upon the cornice by Giovanni da Udine portraits of 'parrots of varied colours which his Holiness then owned, and also *babuini, gattimamoni, zibetti* and other exotic animals'[62]—altogether, a combination of solemnity and entertainment typical of Leo's court, and an intriguing example of the division of labour within Raphael's studio. This studio had been turned into something that could almost be called a firm, and circumstances as much as ambition had turned Raphael into an entrepreneur whose name on a work of art was often now a seal of his approval rather than an autograph, although the demand for works 'by his hand' meanwhile increased.

VII. 'More like him than he is himself'

RAPHAEL, who asks respectfully to be remembered to you, has made a portrait of our friend Tebaldeo which is so lifelike that the painting is more like him than he is himself. For my part I have never seen a likeness more perfect. You can judge for yourself what Messer Antonio [Tebaldeo] is saying and thinking about it—and he is quite right. The portrait of Messer Baldassare Castiglione, or the one of our Duke of hallowed memory [the recently deceased Duke Giuliano de' Medici], to whom may God grant peace—these would seem to be by the hand of one of Raphael's *garzoni*, if they are compared in point of likeness with that of Tebaldeo. I am most envious and think I, too, will have my own portrait painted one day.

So wrote Pietro Bembo on 19 April 1516 to Cardinal Bibbiena.[1] Bembo had in fact already, as a young man at the court of Urbino, been the subject of a small portrait by Raphael,[2] and his letter is an index of the remarkable growth of Raphael's skill as a portraitist in Rome. The way he praises the picture is striking, but also conventional. To say that a portrait was lifelike was the standard response and even to say that it was more true to life than the sitter himself was an idea with a literary pedigree.[3] Nevertheless it is a fair comment on the vitality of Raphael's portraits.

As we have seen, Raphael had had some experience of portrait painting before coming to Rome, but at the papal court much more extensive demands were made on his talents and they elicited a remarkably inventive and, as it turned out, influential response.

Most of these portraits were not independent pictures but parts of larger works. The decorations of the Stanze are full of them and Vasari thought that the poet Tebaldeo had earlier found a place in the *Parnassus*.[4] Vasari's evidence on these matters is, however, not always reliable (he was not born until 1511) and many heads in the Stanze which look like portraits cannot now be identified. This is the case, for example, with the younger bishop on the left of the altar in the *Disputa* (Plate 68), whose features may have been based on those of a cardinal, also, as yet, anonymous, of whom Raphael painted an impressive independent portrait not long afterwards (Plate 163). The latter is deceptively simple in construction, dominated by the scarlet expanse of the cardinal's watered silk *mozzetta*, and showing less of the figure than the Doni portraits or *La Muta* (Plates 38–9, 41) but creating more successfully a sense of physical presence. Apparently renouncing here the opportunity to convey character by showing the hands (which he took in his otherwise similar portrait of Cardinal Bibbiena—Plate 143), Raphael devised a pyramidal composition which concentrated attention on the head, where the precisely controlled, but animated,

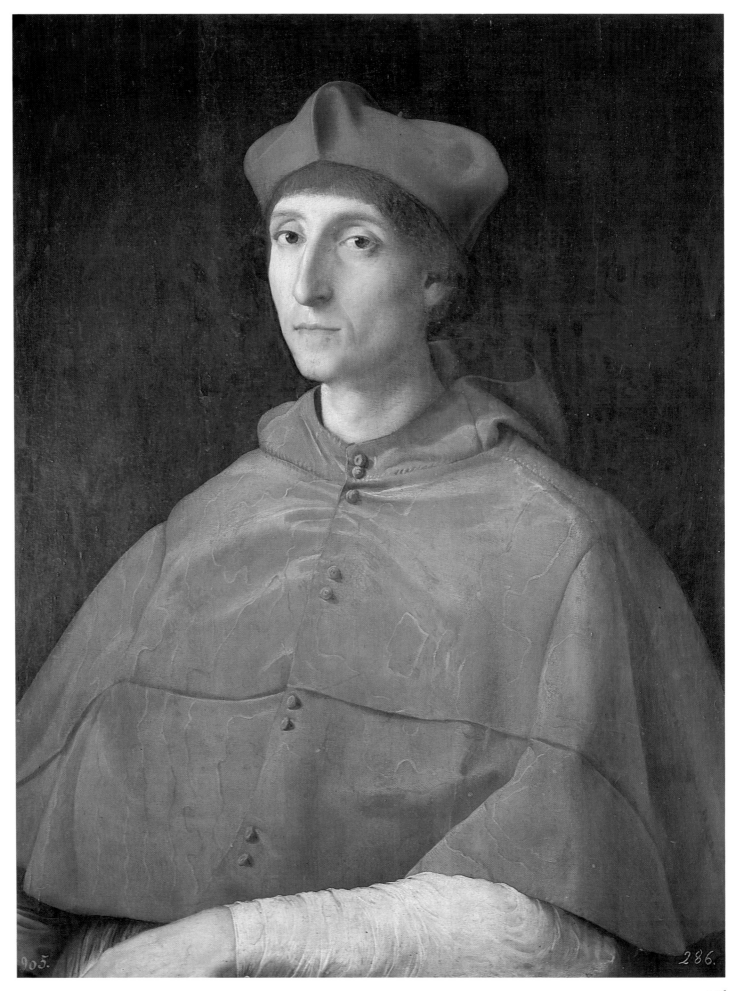

164. *Julius II*. Oil on panel, *c.* 1512, 108 × 80 cm. National Gallery, London.

165. By or after Raphael. *Portrait of Tommaso Inghirami*. Oil on panel, *c.* 1510–14, 91 × 61 cm. Pitti Palace, Florence.

163. *Portrait of a Cardinal*. Oil on panel, *c.* 1510–12, 79 × 61 cm. Prado, Madrid.

description of the surface gives a powerful impression, rightly or wrongly, of a confidently successful ecclesiastical strategist.

Some of Julius II's decorations in the Stanze had, as we saw, a political content, and the inclusion or omission of particular portraits in fresco cycles could be a sensitive issue, as Ludovico Gonzaga of Mantua found out in 1475 from the Duke of Milan's angry response to his exclusion from Mantegna's Camera degli Sposi.[5] In August 1511 Julius had in mind that Raphael should include a portrait of Ludovico's eleven-year-old great-grandson Federico, then a hostage in Rome, and Vasari thought that the boy was in fact portrayed in the *School of Athens*.[6] Less than a year later his mother, Isabella d'Este, was seeking a half-length, life-size portrait of him by Raphael, to replace the one by Francia which she had been obliged to give away.[7] It was doubtless a personal commission, intended to provide a substitute for her absent child (just as her husband Francesco had been accompanied by portraits of her and her sister when imprisoned in Venice in 1509), but Raphael's availability may have been at Julius's pleasure. On 10 January 1513 Federico dressed up in the armour and plumed hat he had worn for the Lateran Council the previous year and was sketched in charcoal by Raphael. He intended to do the painting later, and borrowed the boy's clothes to paint them at leisure, but as Julius lay dying in February he returned them with an apology that he did not have the peace of mind to do it 'for the moment'.[8]

If he did get around to it, the picture is lost, as is the half-length oil painting that Raphael made of one of Julius's favourites, who came from Parma and was apparently a chamberlain whose beauty was proverbial in the demi-monde.[9] But of Julius himself there survive not only the fresco portraits in the Stanze, but also Raphael's red chalk life study (Plate 166) and the magnificent panel which has

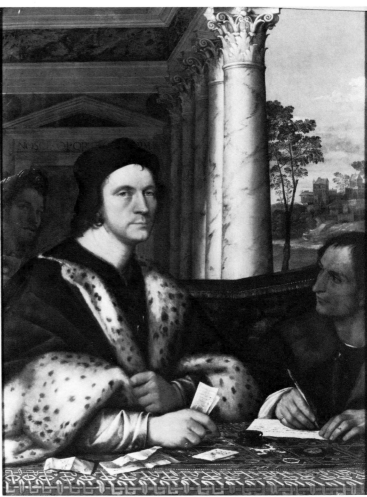

recently been shown to be the original picture first displayed to the public on one of the pillars in S. Maria del Popolo in September 1513 (Plate 164).[10] As with the earlier portraits there is much attention to the description of detail (particularly in the many rings—Plate 168), but compared with the *Portrait of a Cardinal* the technique is a little freer and more suggestive, allowing us to sense the sheen of the material of his sleeves but discreetly soft-focussing the lines of the old warrior's face—which are a marked feature of Raphael's fresco 'portrait' of him as Gregory IX (Plate 88).

Unusually, for an independent portrait, Julius does not regard the beholder, and the picture is also, for its day, exceptional in its portrayal of a particular mood—indeed the sitter is evidently lost in thought, with a distinctly loose hold on the handkerchief in his right hand. This is only superficially in conflict with our impression of Julius as the aggressive personality which Raphael so forcefully conveyed in the *Mass at Bolsena* or the *Expulsion of Heliodorus* (Plates 128, 132), for his left hand grasps the arm of the chair firmly. The enthusiastic crowds who flocked to see the picture in S. Maria del Popolo were struck—Vasari even says they were terrified—by its uncanny truth to life.[11]

The large jewelled rings which Julius displays on six of his fingers are characteristic, too. Although it was an outburst of his to a jeweller, that he would not spend another penny on little stones or big ones, which Michelangelo gave as his excuse for quitting the Pope's service in 1506,[12] Julius was keenly interested in the petrological enhancement of the *Maiestas Papalis*, and his jewel-studded tiara was valued in 1521 at 62,430 ducats, over three times as much as that of his spendthrift successor.[13] He is not shown wearing a tiara here, however, as he was in the fresco of Gregory IX, and although the Della Rovere acorns are prominent on the back of his chair, and the beholder subserviently stands while the Pope sits, the papal insignia

which originally formed part of the background were painted out by Raphael and the picture seems almost more personal than political in intention. The compositional formula used in this first surviving independent picture of an unaccompanied Pope—perhaps prompted by the fresco of Gregory IX—did become a standard one, but the original purpose of Raphael's portrait is unknown.[14]

Also obscure are the circumstances which produced, possibly a little earlier, Raphael's portrait of his friend, the amiable and scholarly Tommaso Inghirami (Plate 165). In this case, of the two very similar versions which Raphael seems to have painted (the other is in Boston), one was recorded in the Inghirami family house at Volterra and the other belonged to the Medici family.[15] We should not be surprised that Raphael may have copied, or had copied, one of his own works. He might indeed have been expected to do so. In 1514 he was engaged by Cardinal Riario to copy two portraits by Bonsignori of members of the Gonzaga family which had been sent to Rome and liked by the Pope.[16] But it should also be noted that there was at least one artist, Andrea del Sarto, who could copy Raphael's style so closely as to deceive even Raphael's assistants. His copy of Raphael's portrait of Leo X, as Vasari reports with some relish, fooled Giulio Romano, who claimed to have worked on the original.[17]

Inghirami wears the red robes of a canon, and is shown at his writing desk. This use of props to indicate a sitter's concerns was to be exploited with increasing frequency in sixteenth-century portraiture. It is also found in some Northern portraits of scholars, but here it may derive from, if it did not influence, Sebastiano del Piombo's portrait of Ferry Carondolet, painted in Rome in 1512 (Plate 167). Like Julius, Inghirami does not regard the beholder, but looks up momentarily from his papers. He may be absently thinking up an appropriate phrase, but he was famously not at a loss for words (improvising madly in Latin verse when the stage set fell down during his youthful performance as Phaedra in Seneca's play *Hippolytus*),[18] and we may perhaps rather imagine ourselves sitting in front of him as he looks up in response to a third party. In any event, his glance is not only an innovative animation of portrait conventions but is also an admirably tactful solution to the problem Raphael faced of presenting an unevasively accurate but undisturbing likeness of a sitter who was wall-eyed[19]—particularly now that the profile format, which had enabled Piero della Francesca to present Federigo da Montefeltro's only good eye to the beholder,[20] was virtually obsolete. Both artists (and patrons) may have been aware of the similar tact shown by Apelles when painting a portrait of Antigonus, who was blind in one eye.[21]

Baldassare Castiglione's problem was that, although profusely bearded, he was, to his shame, bald—a point frankly recognised in what seems to have been the earlier of two portraits which Raphael made of him.[22] In the other (Plate 169) the fact is disguised by his fashionable headgear. He did, however, have clear blue eyes, and they were made the focus of a picture which, apart from a hint of a red lining on his outer garment, is otherwise an extremely subtle orchestration of sober blacks, whites, browns and greys, applied very thinly on the canvas (so that the weave is apparent), and more freely than on the panel of the portrait of Julius. With a technique like this, it is not surprising that Raphael considered 'marvellous' the self-portrait sent to him by Albrecht Dürer, which was done in gouache and watercolour on transparent linen with the highlights left unpainted.[23]

The sober colours are those that Castiglione had recommended for dress in *The Courtier*, and the picture, with its apparently unself-conscious ease yet distinction of bearing, has often been regarded as a visual equivalent of the ideal courtier, painted by one most sympathetic to the ideal, and a close friend. In this connection it is interesting that this is probably the portrait of Castiglione that another friend, Bembo, did not find such a good likeness—though friends of a sitter are always hard to please. The courtier's modesty is studied and is more of a controlled ostentation. Thus the hat is fitted out, as Federico Gonzaga's had been, with a sculpted badge, but the badge is here so intriguingly played down that we cannot be

166. *Julius II* (preparatory study for Plate 164). Red chalk, *c.* 1512, 36 × 25 cm. Chatsworth, Derbyshire.

167. Sebastiano del Piombo. *Portrait of Ferry Carondolet with two companions.* Oil on panel, 1512–13, 112.5 × 87 cm. Thyssen-Bornemisza Collection, Lugano.

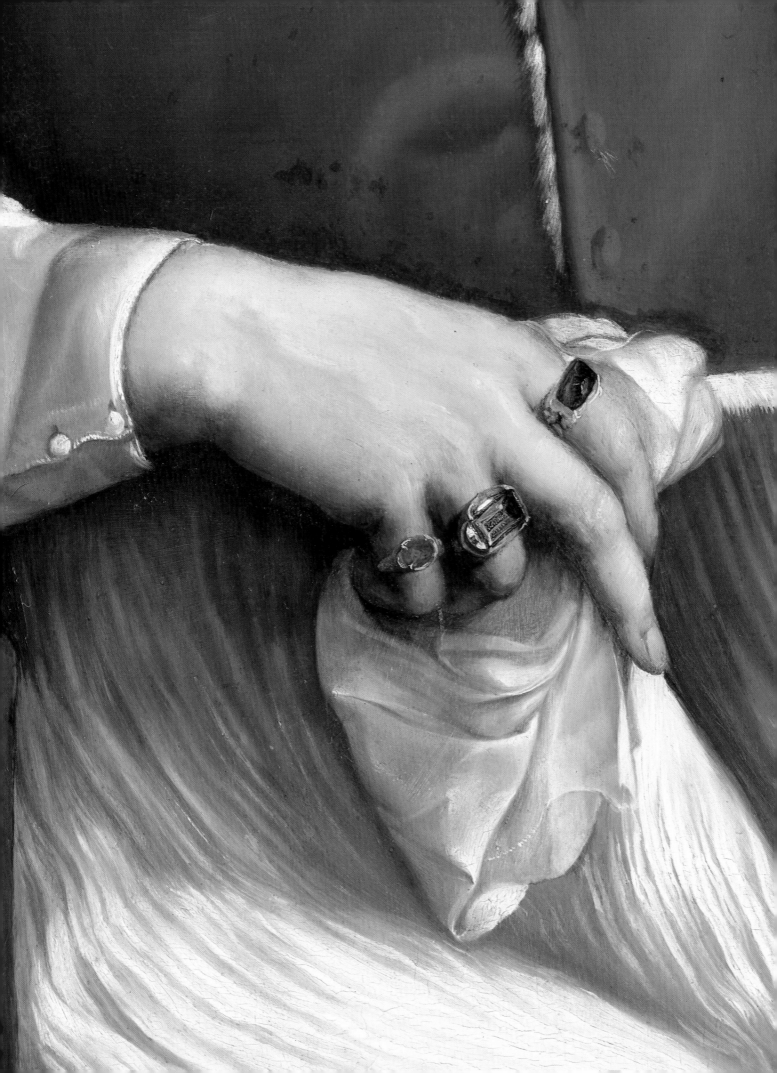

169. *Portrait of Baldassare Castiglione*. Oil
on canvas *c.* 1514–15, 82 × 66 cm. Musée
du Louvre, Paris.

168. (left) Detail from *Julius II* (Plate
164).

170. Perhaps after Raphael. Reverse of portrait medal of Baldassare Castiglione showing *Aurora alighting from her car onto the globe, with genii restraining her horses.* Struck bronze, 3.6 cm diameter. British Museum, London.

absolutely sure that it represents the reverse of Castiglione's own portrait medal, said to have been designed by Raphael himself (Plate 170).[24] And while the colours may be sober, the textures of the clothes are rich and varied, and include fur and velvet, painted with a freedom and conviction which have suggested an awareness of contemporary Venetian painting. Raphael must have been impressed by Sebastiano's picture of a girl of 1512 (now in the Uffizi)[25] which also makes telling use of little flecks of red, but, in its turn, Raphael's painting was influential on the Venetian artist Titian, who seems to have admired it sufficiently to have imitated it in his portrait of Tommaso Mosti (Plate 171),[26] and, much later, on the less formal male portraiture of Rembrandt and Velázquez.

Titian could have seen the picture on a visit to Mantua, where it would have been hanging in Castiglione's house. The portrait is more intimate than any we have discussed so far and seems to have served a specifically domestic purpose. Castiglione left his wife behind in Mantua when he went to Rome, and he wrote a poem in which he imagines her, and their son, fondly communing with Raphael's portrait in his absence, consoling themselves with his likeness and imagining it to be on the point of speech.[27]

Portraits often provided the occasion for poems, sometimes composed, as in this case, by the sitter. Tebaldeo too wrote one about his portrait by Girolamo Campagnola,[28] and also one about Raphael's picture of him.[29] His poems are less gracious than Castiglione's, and in each case his praise of the painter is tempered by the ungrateful observation that poetry is a more durable art than painting—'The divine song of the great Homer still survives, but who can now show me a work by Apelles?' Unfortunately, if aptly, Raphael's portrait of Tebaldeo cannot now be traced.[30]

There can be little doubt that Raphael painted Castiglione's portraits out of personal friendship, and the same may be said of his portrait of their friends the scholars Andrea Navagero and Agostino Beazzano (Plate 173), which was probably painted before Navagero left Rome for Venice at the end of April 1516. Earlier in the month, when Leo X was expected to be spending a few days hunting, they had all planned to go on a trip to Tivoli, 'to see the old and the new and whatever is beautiful in the area', as Bembo, who was also to be of the party, reported in a letter to Bibbiena.[31] The double portrait was in fact probably painted specifically for Bembo, in whose house in Padua it seems to have hung until 1538, when he allowed it to be given to Beazzano, 'asking him to take care not to damage it',[32]

It thus served much the same kind of purpose as the double portrait of 1517 by Quentin Massys of Erasmus and Petrus Egidius, which was intended as a gift for Sir Thomas More.[33] Unlike Erasmus and Egidius, however, Navagero and Beazzano are not shown separately, absorbed in their studies, but are placed close together, as if they had just been conversing informally. They turn to look at the beholder—in the first instance, their friend Bembo. Perhaps this kind of inventive animation of the easel portrait was prompted by Raphael's experience in the large-scale narrative grouping of portrait figures in the Stanze.

For, while finding the time to paint these portraits of his friends, he had been kept as busy as a portraitist by Leo as he had been by Julius. Indeed there are perhaps more portraits in the Leonine frescoes than in the Julian ones, but it is a sign of Raphael's increasing recourse to the use of assistants that the later portrait heads in fresco are generally of distinctly lower quality, as may be seen from a comparison of the portrait of Leo when a cardinal, shown on Julius's right-hand side in the fresco of Gregory IX with his representation as Leo IV in the *Battle of Ostia* (Plates 88, 159).[34]

Raphael also made a number of easel portraits for Leo and his family. A picture of his brother, Giuliano de' Medici who was created Duke of Nemours in 1515, is mentioned in Bembo's letter at the beginning of this chapter, and what may be a workshop version of it survives (Plate 172). Its purpose is unknown. A view of Castel S. Angelo appears in the background, which may be an allusion to his role as *Capitano della Chiesa*, which he was given in June 1515. The original version might

have been a betrothal picture, without this background, painted for Filiberta of Savoy during the marriage negotiations in 1514.[35]

Leo's nephew Lorenzo de' Medici was created Duke of Urbino in 1516 but did not gain full control of the Duchy from Julius II's nephew Francesco Maria della Rovere (Plate 4) until the winter of 1517. By then negotiations had already begun for Lorenzo's marriage with Madeleine de la Tour de Boulogne et d'Auvergne. It is clear that in January 1518 Raphael was working on a betrothal portrait of him. When it was nearly finished, the Duke wrote asking that her portrait, which had been painted in the previous year, be sent to him.[36] The marriage was intended to reinforce a political alliance, and this context would explain why a 1553 Medici inventory describes a portrait of Lorenzo by Raphael as showing him dressed 'in the French style'. This may have been the picture now in New York (Plate 175) or another version of it.[37] Lorenzo is shown formally posed and magnificently dressed in clothes of rich texture and colour in an almost three-quarter length format which draws as much attention to the clothes as to the clothed.

The same is true of the portrait of Joanna of Aragon (Plate 176) commissioned by Cardinal Bibbiena (then papal legate in France) and sent by December 1518 as a present to King Francis I. Raphael did not take so much personal trouble with this commission, however, sending, as he admitted, one of his *garzoni* to Naples to draw her from the life and it seems delegating much of the painting.[38] These circumstances may partly explain the unresponsive face, but this, together with the immobile pose, the elegant but contrived placing of the hands and the attention to rich accoutrements in both this portrait and that of Lorenzo were to be highly influential on later Italian court portraiture, especially as practised by Bronzino, many of whose sitters are made to seem unapproachably exalted.

The object Lorenzo holds in his right hand, and half reveals to the beholder, may

171. Titian. *Portrait of Tommaso Mosti.* Oil on canvas, *c.* 1520–1, 85 × 66 cm. Pitti Palace, Florence.

172. After Raphael. *Portrait of Giuliano de' Medici.* Oil on canvas (transferred from panel), *c.* 1515, 83 × 68 cm. Metropolitan Museum of Art, New York.

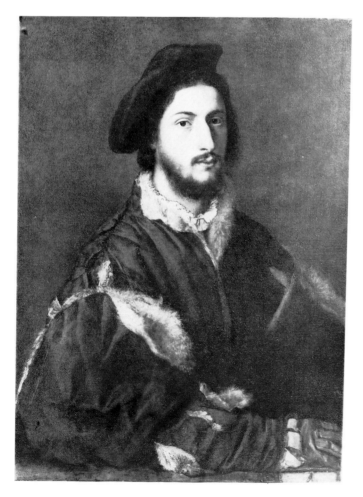

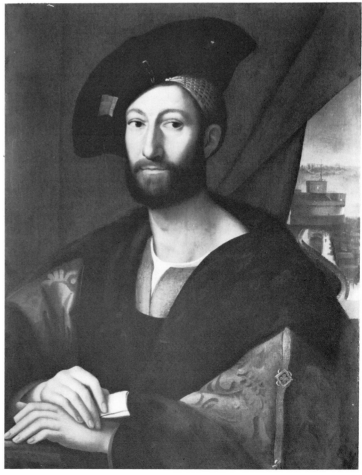

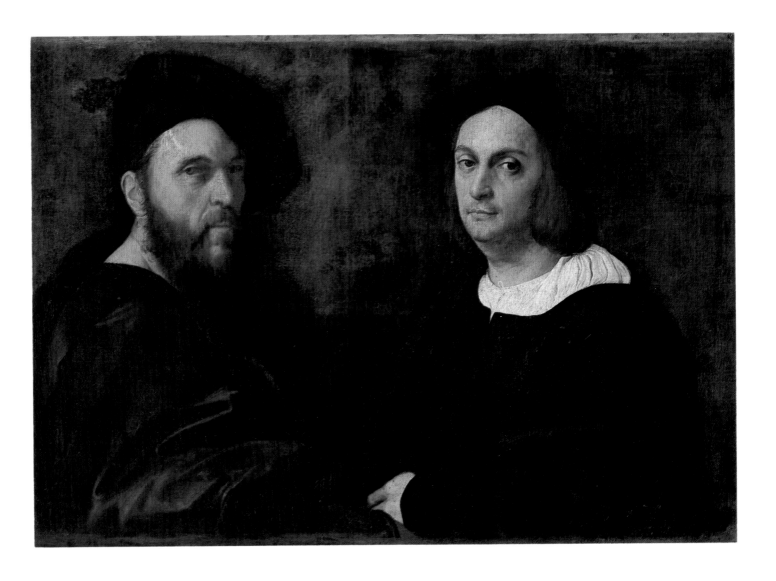

have contained a miniature wax portrait of his betrothed,[39] but this, like Castiglione's hat badge, is the kind of private secret that would only be divulged to intimates and is teasingly withheld from the casual observer. The betrothed couple were married on 2 May in Amboise. They subsequently travelled to Florence where further, extremely elaborate, wedding celebrations took place in September. Lorenzo's mother wrote to Rome on 8 September that at one meal 'the Duke had the portrait of the Pope, Cardinal de' Medici and Cardinal de' Rossi placed above the table where the Duchess and the other gentlemen were eating, in the middle, which made everything very festive'.[40]

This temporary display of the absent guest of honour at a banqueting table is, appropriately, the first recorded use made of Raphael's sumptuous portrait of Leo and his nephews (Plate 177). De' Rossi had been made a cardinal late in 1517, and the picture was probably one of the portrait commissions with which 'the Pope and the Duke [were] keeping [Raphael] so busy' the following March, though it was not sent to Florence until just before the banquet.[41] It was, rather surprisingly, later hung above one of the doors in the Medici palace.[42] This was not an uncommon location for sculpted portraits, however, as one may just detect from the background of the *Joanna of Aragon.*

Vasari particularly admired the rendering of

the velvet with its pile, the damask which the Pope wears, rustling and shiny, the fur linings soft and lively and the golds and silks so well imitated that they seem not paint but actual gold and silk. There is an illuminated vellum book which is more lifelike than life itself and a silver bell of ineffably beautiful workmanship.

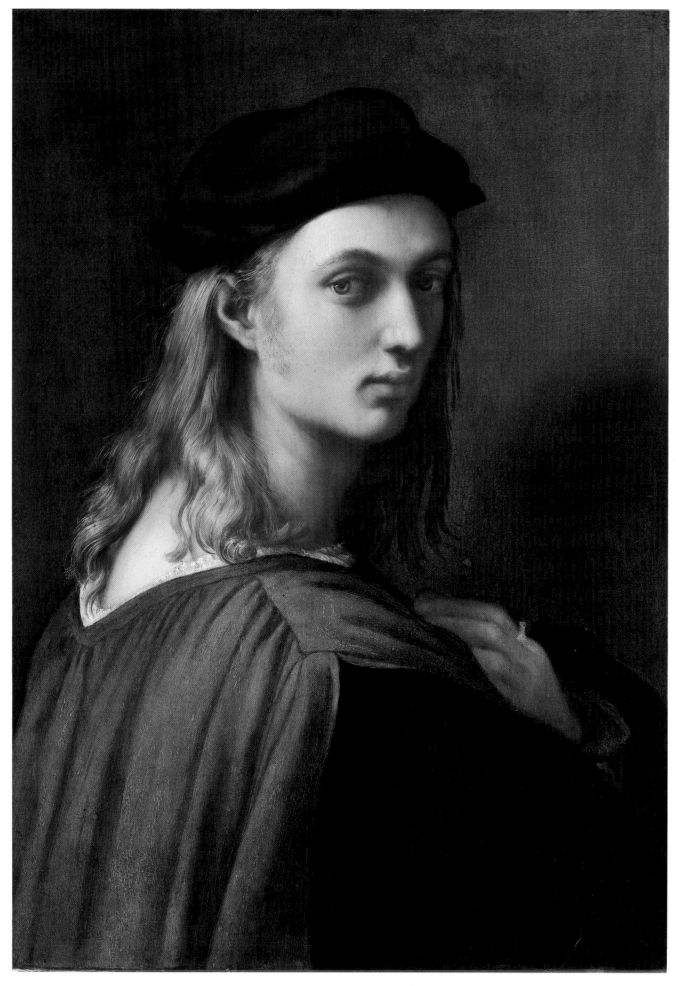

Among other things there is the ball on the chair, burnished with gold, which reflects, like a mirror, the lights of the windows, the shoulders of the Pope and the rest of the room . . .[43]

The ball is not there merely to show off the painter's skill, however. Like the acorn on Julius II's chair, it is, as might be expected in what is essentially a dynastic portrait, a piece of family heraldry—a Medici *palla*. The book—the Hamilton Bible,[44] which the weak-sighted Leo needed an eyeglass to examine—contributes meaning too, since it is open at the beginning of the Gospel of St John, Leo's name saint. These props, and the relationships between the participants in this group portrait, dramatized by the diagonals of the architecture receding behind them, may bring to mind again Sebastiano's portrait of Ferry Carondolet. Raphael's greater experience as a monumental narrative painter is evident if the two are compared, but the exact character of the relationships, whether considered in terms of etiquette or psychology, is now hard to reconstruct.

Another point of contact with Sebastiano is provided by Raphael's sultry and provocative portrait of Bindo Altoviti (Plate 174), a Florentine banker in Rome and the owner of a Madonna by Raphael, the *Madonna dell'Impannata*.[45] The unusual way he is shown looking back over his shoulder is prefigured by participants in the *School of Athens* and the *Parnassus*, but can be more closely matched in Sebastiano's portrait of a *Musician* of c.1515–16.[46] Raphael's picture may be a few years after this and its colours and strong chiaroscuro point towards his late works like the *St Michael* (Plate 202) which Sebastiano characterised in 1518 as being quite opposed to Michelangelo's ideas, with 'figures looking as if they had been in the smoke, or were figures of shiny metal, all dark and all light'.[47]

Bindo, who was in his twenties and had married in 1511, appears confident of his good looks and Raphael may have chosen this kind of presentation to show off the golden locks (an unusual and sought-after hair colour in Italy) which tumble down his low-cut back. Indeed, if there were not good reasons for believing this to be an actual portrait of a particular person, it might have been more natural to see it principally as a picture of a handsome youth, a type of picture recently made popular by Giorgione in Venice and the counterpart to a number of pictures of women which were valued not so much as portraits but as pictures of pretty girls.[48]

Raphael depicted many beautiful women in his subject pictures, but in Rome seems to have made few independent portraits of them. Vasari's Life contains the laconic sentence 'He portrayed Beatrice Ferrarese and other women, and particularly his one, and an infinite number of others'.[49] However, apart from the *Joanna of Aragon*, only two survive (Plates 179, 189).

Beatrice was one of the most famous practitioners of a profession that flourished, particularly in Leo's day, in a city full of official celibates. Some of these women, though not Beatrice, offered intellectual and literary, as well as physical, entertainment and had begun to be called, in Rome anyway, courtesans (*cortigiane*).[50] She did, however, have some distinguished clients, among whom seems to have been Duke Lorenzo, to whom she wrote (if it is not a forgery) a saucy letter,[51] and it could be that Raphael painted the picture for him. Sebastiano also patronised such women, at least as models, if we can believe Aretino, who wrote that he used the features of one 'for the Madonna, for the Magdalene, for St Apollonia, for St Ursula, for St Lucy and for St Catherine'.[52] It is clear that Raphael's Roman Madonnas and Magdalenes have much in common with the women in his two portraits but it is unlikely that either of them is Beatrice, since they both have claims to be his own *donna amata*.

The *Donna Velata* (Plate 179), if we can believe Vasari, is a portrait of the woman Raphael loved till his death.[53] However, the practice of wearing a veil, in Rome, denoted motherhood,[54] and without Vasari's claim it would be more natural to see the picture as a matrimonial one, the gesture she makes with her right hand being generally one of loyalty and affection.[55] It is true that the position of the fingers in

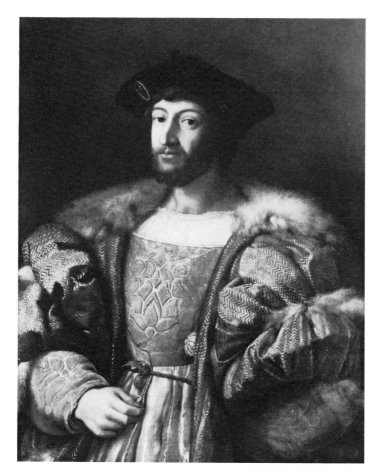

175. By or after Raphael. *Lorenzo de' Medici*. Oil on canvas, completed 1518, 99.5 × 81 cm (slight additions). Ira Spanierman, New York.

176. Raphael workshop. *Joanna of Aragon*. Oil on canvas (transferred from panel), 1518, 120 × 95 cm. Musée du Louvre, Paris.

FOLLOWING PAGES

177. *Pope Leo X with Cardinals Giulio de' Medici and Luigi de' Rossi*. Oil on panel, completed 1518, 154 × 119 cm. Uffizi, Florence.

178. Detail from *Pope Leo X with Cardinals Giulio de' Medici and Luigi de' Rossi*.

this particular case might possibly be thought indecorous, but if Raphael felt desire for this woman it expressed itself rather in the bravura display of gold and white in her extravagantly slashed sleeve, which is, in terms of paint, the most exciting part of the composition (Plate 183).

In fact the image was considered sufficiently proper for it to be converted (in a seventeenth-century print) into a picture of St Catherine,[56] thus reversing a procedure which Leonardo was once asked to effect. He had painted 'a holy subject', and its owner, who had fallen in love with it, asked him, in vain, to paint out the religious attributes so that he could 'kiss it without [arousing] suspicion'.[57] Leonardo tells the story, with its intriguing implication of how pictures might be treated, to illustrate the superior power of painting as against poetry to arouse the beholder, but it also tells us that in the feelings that painters of portraits and devotional pictures now sought to inspire there might be a dangerous overlap.

We are not of course invited to kiss Raphael's *Madonna della Sedia* (Plate 188), though she has touched a chord in the heart of many. Of Raphael's Madonnas it is, however, the one where domestic intimacy between the subject and the beholder, imagined kneeling in front of her, is at its greatest and most like that of the portraits. It is probably contemporary with the *Donna Velata*. At any rate the curving forms of the Madonna and Child, forming interlocking patterns on the surface and in depth which are perfectly adapted to the tondo shape, are the product of the same mentality which had explored the *Donna Velata*'s sleeve.

It has been suggested that the features of the same woman are represented in both pictures, and also that the *Donna Velata* is the same person as Raphael's *Fornarina* (Plate 189), a later picture. The latter equation is attractive, since the *Fornarina*, with her armband surely declaring Raphael's possession of her, clearly demands, in a different way, to be seen as a *donna amata* of the artist, and the picture might reflect a later stage in their relationship. Unfortunately, if we adapt Giovanni Morelli's

167

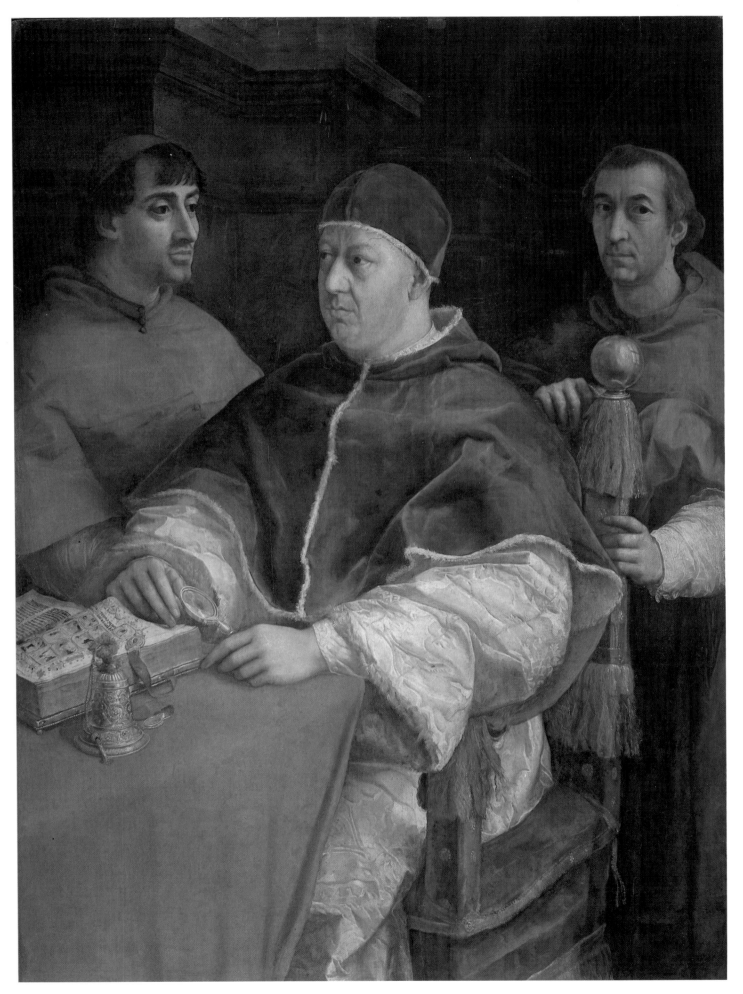

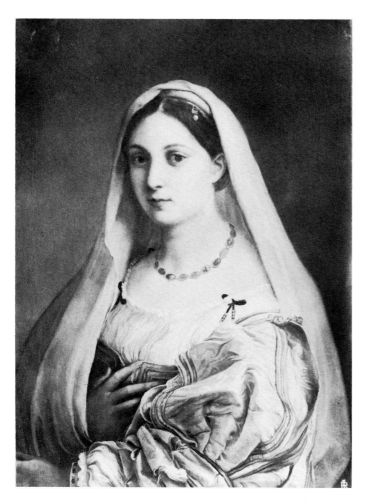

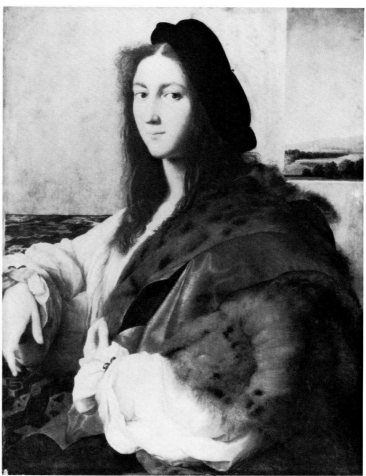

179. *La Donna Velata*. Oil on canvas, *c.* 1514, 85 × 64 cm. Pitti Palace, Florence.

180. *Portrait of a Young Man* (perhaps a self-portrait). Oil on panel, *c.* 1513–14, 72 × 56 cm. Formerly Czartoryski Museum, Cracow.

famous test and compare the way the ears are represented, we must conclude from the lobes that two different women are involved.[58] Raphael's *certa idea* in feminine beauty (see p. 97) may have led him to be attracted to remarkably similar types, or at least to see, and represent, them in terms of his ideal.

As with Giorgione's romantic paintings of handsome boys, which may have been intended as representations of Paris or Cupid,[59] it would be possible, if a pretext were sought for the public display of a female nude, to see the *Fornarina* (who in her half-hearted attempts to cover herself with a transparent veil recalls the attitude of the antique *Venus Pudica*) as a Venus. But it may never have been intended for more than private devotion. Seventeenth-century inventories show that it was once provided with shutters.

Recent X-ray examination has shown that the artist first painted a landscape background as extensive and detailed as that of the *Canigiani Holy Family* instead of the profusion of myrtle, quince and laurel leaves that now provide a more enclosed, intimate setting. These leaves symbolically reinforce the erotic commitment of the sitter, and would be appropriate for a matrimonial or faithful lover's picture—but also for a courtesan portrait, which the *Fornarina* is sometimes taken to be.[60]

Despite the originally restricted audience we have presumed for her, this type of portrait, nude except for the virtuoso representation of transparent material, was much imitated, not only in cabinet pictures, but also in a more intimate art form designed to be handled as well as regarded (Plate 181).

It is not profitable, or necessary, to speculate too extensively on the motives that led Raphael to paint the *Donna Velata* and the *Fornarina*, but in having a portrait of his lover he was in fact emulating the behaviour of his social superiors and friends—like Bembo, who brought with him to Rome a portrait of one of his *innamorate*, painted by Giovanni Bellini in Venice.[61] It would be satisfying to be able to chart

181. Antonio Abondio. *Portrait medal of Caterina Riva*. Cast lead, *c.* 1540, 6.85 cm diameter. British Museum, London.

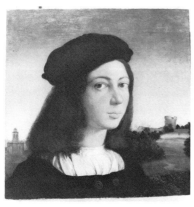

182. *Self-Portrait* (?) Oil on panel, *c.* 1505–7, 37 × 40 cm. Her Majesty the Queen, Hampton Court.

Raphael's climb to the dizzy social heights he reached by reference to what would be invaluably authoritative evidence about how he saw himself—his self-portraits—but this too is a speculative enterprise. There are two early drawings, and two early panels (Plate 182), which have some claims to represent him, as an unassuming youth, as well as the more famous panel in the Uffizi, which is, however, likely to be a later adaptation from one likeness which all agree on—the slightly baby-faced bystander in the *School of Athens*, whom Vasari identified as Raphael, 'young and of very modest appearance'.[62]

A more ostentatious image is given by the confidently poised figure in a picture that was in Cracow until World War II (Plate 180). Surprisingly, it has in modern times been thought to represent a woman, but in the seventeenth century it was taken for a self-portrait,[63] and it is not incompatible with the fresco portrait. If it is Raphael who leans expansively on a carpet-covered table with a fur-lined coat thrown over his shoulder, we may notice that the emphasis is on his status and not on his profession. Judging from his youthful appearance in the *School of Athens*, he might have been as old as thirty when this was painted, and on the point of being able to name his own price.

Raphael apparently grew a beard in his later years, and he can be seen with one hand on a companion's shoulder and the other, seemingly, around the man's waist in a painting which has come to be known as '*Raphael and his Fencing Master*' (Plate 185). Here the problem is not so much one of identification (since a sixteenth-century print of the head at the left declares it to be a likeness of Raphael),[64] but of interpretation. His unidentified companion has a sword, but what we see is clearly not a fencing lesson, and the title must have arisen from baffled responses to the turned head and the gesturing hand (Plate 184) which points out at us with a directness common in Raphael's grand narrative groups (like the *Parnassus* and the *Transfiguration*—Plates 79, 264), but unprecedented in intimate portraiture. Raphael has here extended the attention paid to the beholder by Navagero and Beazzano (Plate 173), who regard us on equal terms, into something quite extraordinary.

To the casual observer, the address might appear arrogant, with the companion looking away from us, but at the same time pointing us out to his superior friend, who regards us with some reserve. But it would surely be a mistake to see the picture as addressed to the world at large. It would make more sense, and create a more sympathetic impression, if it had been addressed to a particular audience, perhaps unknown to Raphael and living far from Rome but consisting of friends or relatives of his companion—who was perhaps about to leave Rome to join them. We could then see the picture as a present for them, showing the friendship between the two men and Raphael's resigned acquiescence in his friend's departure. In any case we suppose that the inventive drama of the portrait, which arrests our attention but excludes our participation, derives from the private circumstances of the painting's commission. The more we study Raphael's portraits the more we must acknowledge that they were not painted for us.

183. Detail of *La Donna Velata* (Plate 179).

184. Detail from '*Raphael and his Fencing Master*'.

185. *Portrait probably of Raphael, with another man* ('*Raphael and his Fencing Master*'). Oil on canvas *c.* 1518, 99 × 83 cm (strips added on all sides). Musée du Louvre, Paris.

174

VIII. The Poetry and Painting of the Ancients

186. Marcantonio Raimondi (after Raphael). *The Judgement of Paris*. Engraving, *c.* 1514–18, 29.2 × 43.3 cm (sheet). British Museum, London.

187. Roman, of the early imperial period. *Sarcophagus relief of the Judgement of Paris*. Villa Medici, Rome.

DUKE Alfonso d'Este of Ferrara, on his visit to Rome in July 1512 to pay cautious homage to his great enemy Pope Julius II, was delighted by the Vatican apartments decorated by Pinturicchio for his wife's father, the Borgia Pope Alexander VI, and enormously impressed by Michelangelo's frescoes on the Sistine ceiling, but tact (or tiredness) kept him from viewing Julius's apartments and Raphael's frescoes.[1] Nevertheless, by the time he hastened from Rome (for the Pope looked liable to clap him in prison) the Duke was doubtless as aware of Raphael's genius as of Michelangelo's. He would also have appreciated that it would be very hard to attract either artist to Ferrara. Oil paintings, however, could be supplied by mail order. With this in mind the Duke's orator at the papal court, the Bishop of Adria, approached Raphael in March 1517.

Raphael agreed to supply a painting for Alfonso's small 'Alabaster Chamber' (the Camerino d'Alabastro)—and also to look out for ancient medals, heads and figures for him.[2] By June Raphael had done nothing because he was busy in the Stanza dell'Incendio, but he had only a couple of days' work to do there.[3] Soon afterwards he does seem to have started to give the project his attention. By September he had heard that a Ferrarese artist, Pellegrino da San Daniele, was at work on a 'Triumph'—the implication seems to be that Pellegrino was executing this from a drawing Raphael had sent—and Raphael wondered whether he should now undertake another subject. What had happened is not clear, but in the following months Raphael repeatedly expressed his keeness to serve the Duke, and he accepted an advance.[4] The Duke, however, was informed in December that Raphael could do nothing because 'the Pope and these Palatine cardinals [Bibbiena, Medici and Pucci] give him quite enough to do'.[5]

Raphael attempted to appease the Duke by sending him the cartoon for the fresco 'of Leo IV'—presumably the *Fire in the Borgo*. A year later he sent another, made for the *St Michael* (Plate 202), which he had painted for the King of France. The Duke's agent was half-inclined to advise the Duke to refuse this in case Raphael thought that he could fob him off with such gifts. At the end of the year Raphael also sent the cartoon for the portrait of Joanna of Aragon.[6] These were reminders, whether intended as such or not, that the Duke was not the most important of Raphael's many importunate patrons.

By the end of February in the following year, 1519, Raphael had still painted nothing, but the Duke's agent persuaded one of Raphael's assistants to show him sketches for both a *Hunt of Meleager* and a *Triumph of Bacchus* which were *beletissimi*.[7] Raphael was then busy making the *apparato* for Ariosto's comedy *I Suppositi* which was to be staged by Leo X's nephew Cardinal Innocenzo Cibo for the papal court.[8]

188. *Madonna della Sedia*. Oil on panel, *c.* 1514, 71 cm diameter. Pitti Palace, Florence.

189. *Portrait of a Nude Woman* (the 'Fornarina'). Oil on panel, *c.* 1518, 85 × 60 cm. Galleria Nazionale (Palazzo Barberini), Rome.

Early in 1520 the Duke urged his agent to tell Raphael 'to think carefully about what it means to give his word to someone like us and then to show that he values us no more than a low commoner, telling us so many lies . . .', but added, more sensibly, 'speak to the most reverend Lord Cardinal Cibo commending us to his Lordship and remind him of the promise he made to manage things so that this Raphael would quickly finish our picture'.[9] Cibo tried to help, but Raphael was working for Cardinal Giulio de' Medici, the Pope's cousin and closest adviser. Raphael died without making further progress. The Duke retrieved his advance payment of 50 ducats from Raphael's heirs[10] and commissioned a subject similar to the *Triumph*, the *Bacchus and Ariadne* (Plate 105), from Titian instead. The whole episode sheds much light on Raphael's circumstances in these years. During the course of his dealings with Raphael the Duke had shown that he was aware that not all 'Raphaels' were painted by Raphael.[11] Had he not done so he might have got a painting after all—but one executed by an assistant.

Raphael's drawing of the *Triumph of Bacchus* which seems to have reached Ferrara in 1517 served as the model for a painting by Garofalo and for a fresco attributed to Girolamo da Carpi, and it (or at least a copy of it) is also recorded in a print (Plate 190). It is a dense composition filled with incident, including both beautiful lyrical passages, such as the graceful faun and nymph with pipes and cymbals and the pair of lovers in the foreground to left and right, and some comedy in the stumbling Silenus. Many motifs are derived from antique sarcophagi and gems and several poses adapted from Michelangelo's *Battle of Cascina*. But, in contrast with Raphael's earlier *Galatea*, there is at least one animal which is likely to have been based on observations made from a living specimen.

The elephant which dominates the centre of the composition steals grapes with a very convincing sidewards movement of his trunk which Raphael had surely

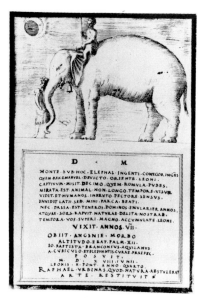

191. Francisco de Hollanda. *Effigy of Hanno the Elephant frescoed by Raphael's assistants on the wall of the Vatican.* Escurial, Madrid.

190. C.M. Metz. *Triumph of Bacchus* (facsimile etching of a drawing (perhaps by Giulio Romano) in the collection of Sir Joshua Reynolds, after a design by Raphael—here reversed to obtain original direction). 35.25 × 38.5 cm. From *Imitations of Drawings*, 1789.

observed in Hanno, the elephant presented (together with leopards, parrots, Indian poultry, Persian horses and heaps of treasure) to Pope Leo X by the embassy of the King of Portugal in 1514.[12] Hanno had delighted all Rome not only by his exotic appearance, but by his piety, or at least good manners, for he knelt to the Pope when they first met. When the animal died, much mourned, at the tender age of seven after only a brief residence in the Holy City, his keeper, Giovanni Battista Branconio dell'Aquila, commissioned a tomb (Plate 191) from Raphael—the inscription gave the date as 8 June 1516.[13]

Raphael did not necessarily choose the subject of the *Triumph of Bacchus* himself, but that he was attracted by mythological subjects of this sort from ancient literature is suggested by the engravings by Marcantonio which he seems to have designed especially for that medium. One of these is certainly the *Judgement of Paris* (Plate 186), which Vasari described as 'astounding all Rome'[14] and which was perhaps more imitated than any of Raphael's other inventions in the decades following his death—the composition, or part of it, was painted on enamel and Majolica, engraved on gems and fashioned into gilt metal cap badges.[15] The Latin tag in the lower left-hand corner may be translated 'Cheap compared with Beauty are Genius Virtue Royalty Wealth'.[16]

Marcantonio seems to have scratched most of the plate with an unidentified abrasive and then engraved with his fine hatching and cross-hatching and his stipple and finally burnished where highlights were required.[17] The plate tone resulting from this experiment is only visible in the earliest impressions (Plate 186). The date of the print is unknown, but the protracted negotiations over the *Triumph of Bacchus* and the time taken over the Stanza dell'Incendio, should prepare us for the possibility that the design evolved over several years.

The group of Paris awarding Venus the prize is to be found in a grisaille painting in the window embrasure of the Stanza della Segnatura, no doubt based on a design by Raphael, executed after he had finished working in the room, perhaps in about 1512 or 1513.[18] But the composition was expanded, perhaps in two stages, and certainly with work in different styles, The pose of the river god on the right resembles (very closely indeed from the waist down) that of the sprawling Heliodorus (Plate 132), the group of nymphs on the left are reminiscent of the closely packed women in the same fresco, and the pose of Minerva is similar to the kneeling woman in the foreground. Minerva's arm, raised to reveal reluctantly (and too late) her beauty to Paris, creates a remarkably long, unbroken and continuously undulating contour, one of the most remarkable of the many outlines Raphael drew that are both beautiful in themselves and superbly suggestive of volume.

The gods in the sky, however, are all rather closely copied from Roman sarcophagi[19]—chiefly from one of the same subject (Plate 187)—and are, like those in the sarcophagi, both congested in composition and redundant in terms of narrative. Such imitation of the antique was something Raphael may have encouraged in his assistants as his interest in ancient Rome became that of the archaeologist as well as the artist, but it is hard to believe that he could have been happy with it here. The conjunction of styles is especially painful where the flat, relief-like, flying Victory contradicts the sense of depth created by the diagonal of nudes extending from Minerva to Mercury. The division of labour was probably similar to that which we proposed for the *Battle of Ostia*: this looks like an invention of Raphael's elaborated, and partly ruined, by an assistant.

Raphael not only took ideas from ancient relief sculpture to portray ancient subject matter, he consulted ancient literature to reconstruct the lost paintings of the ancients. He may have done so when he designed the *Galatea*: he certainly did so in his design of the *Nuptials of Alexander and Roxane* (Plate 192) known to us in copies and prints.[20] In every detail from the cupid removing the bride's sandals to the cupids playing with the hero's armour Raphael follows Lucian's description of a famous painting.[21] To the charge that this was derivative, Aretino in Dolce's dialogue on painting, published in 1557, replied that it is 'so happily expressed that it

192. By or after Raphael. *Nude study for the Nuptials of Alexander and Roxane.* Red chalk over stylus indications, with white heightening, *c.* 1516–17, 22.8 × 31.6 cm. Albertina, Vienna.

would be questioned whether Raphael had taken it from the writings of Lucian or Lucian from the picture by Raphael, had not Lucian lived some ages earlier. But so what. Such robberies are reciprocal.'[22]

Raphael's own preoccupation with the rivalry between painting and writing is more evident in his attempts to represent a sequence of episodes. We suggested that this was the case in his design for the *Morbetto*: it was certainly the case in the *Quos Ego* (Plate 194), an engraving by Marcantonio which although not signed by Raphael was, Vasari tells us, designed by him. It consists of nine separate compartments containing separate narratives, framing a larger central opening. Through this we see Neptune, as Virgil describes him in the *Aeneid*, rising to calm the tempest, which at Juno's request, Aeolus had stirred up to destroy the Trojan fleet. The print takes its name from the way in which the god begins his furious speech to the winds with two pronouns of a sentence he never completes—the most famous example of this device in literature: *Quos ego—*

> Whom I—But first 'tis fit the billows to restrain,
> And then you shall be taught obedience to my Reign.
> Hence, to your Lord my Royal Mandate bear,
> The Realms of Ocean as the Fields of Air
> Are mine, not his.[23]

It is interesting that Leonardo had made a finished drawing of Neptune and his steeds for a Florentine patron which Raphael may have known. A sketch for Leonardo's drawing shows Neptune advancing forwards, his wild hippocamps splaying out in front of him.[24] Raphael's characteristic innovation in this version is to swivel the entire composition around. In representing the turbulent sea and clouds Marcantonio has adopted the conventions employed by Dürer, who, especially in his prints of the Apocalypse, tended to make water, flames and clouds resemble highly agitated fabrics. This too may have been an initiative of Raphael's since he was also interested in the idiom—as may be seen in the ceiling of the Stanza d'Eliodoro, and still more in a preparatory drawing for it (Plates 126, 234).

The idea of surrounding this scene with separate compartments may have been

193. Entrance loggia of Agostino Chigi's villa (the Farnesina), Rome.

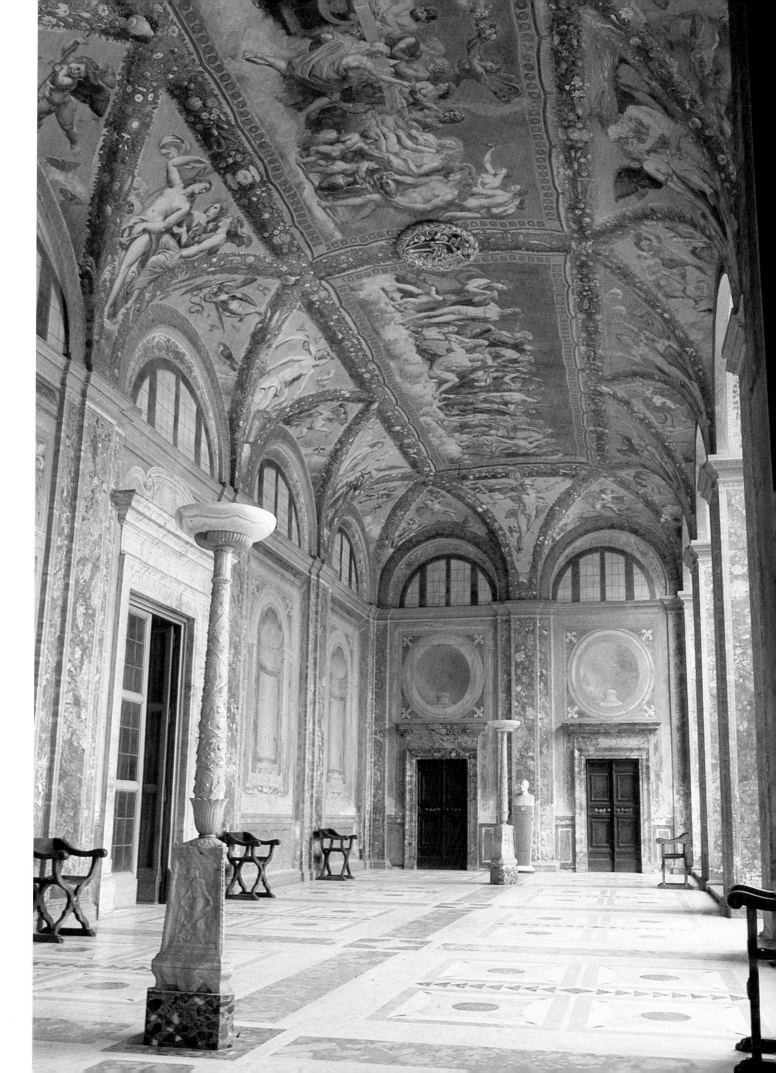

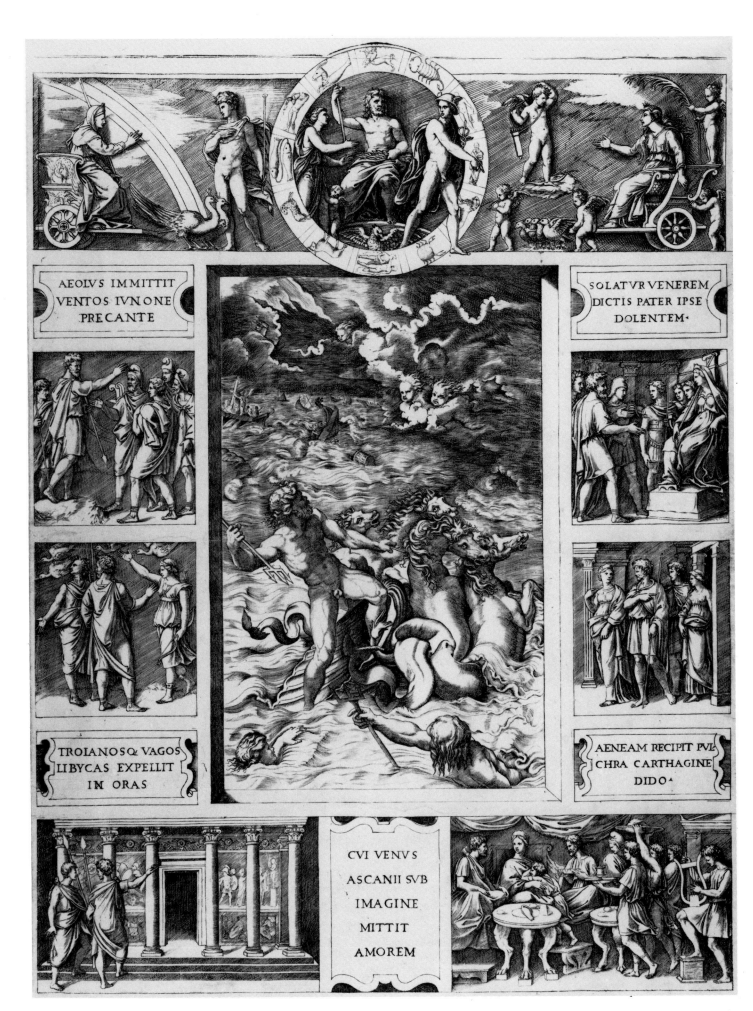

AEOLVS IMMITTIT
VENTOS IVNONE
PRECANTE

SOLATVR VENEREM
DICTIS PATER IPSE
DOLENTEM·

TROIANOSQ. VAGOS
LIBYCAS EXPELLIT
IN ORAS

AENEAM RECIPIT PVL
CHRA CARTHAGINE
DIDO·

CVI VENVS
ASCANII SVB
IMAGINE
MITTIT
AMOREM

195. Frontispiece to Antonio Brucioli's Italian translation of the Bible. Wood engraving, published 1532 (by Luc'Antonio Giunta), 30.5 × 21 cm (page).

194. Marcantonio Raimondi (after Raphael). *Quos Ego*. Engraving, *c.* 1518, 41.7 × 32.5 cm (sheet). Whitworth Art Gallery, Manchester.

inspired by a type of small ancient marble relief popular in the early imperial period and known as the *tabula Iliaca* (or *Odysseaca*) in which separate episodes from Homer's epics were illustrated.[25] Appropriately, Raphael has designed, or, more probably, encouraged his assistants to design, each compartment in imitation of ancient relief sculpture. The contrast with the pictorial style of the central scene (something which is also found in the borders of the Sistine tapestries) is certainly more satisfactory than the confusion of the two styles in the *Judgement of Paris*.

Top left, in a chariot drawn by peacocks, Juno persuades Aeolus to raise the storm. Below, Aeneas addresses his disconsolate companions on the beach after their landing, and below that Aeneas and Achates meet Venus disguised as a huntress. She bids Aeneas go to Dido's palace and shows, as a portent of the safe beaching of the stray ships, some swans in flight. At the bottom of the plate the same pair inspect with emotion Dido's new temple adorned with scenes from the Trojan War. Returning to the top of the sheet we see Jove enthroned and circled by the zodiac. Besought by Venus, he agrees to dispatch Mercury to ensure that the Carthaginians do not give a hostile reception to Aeneas. At top right, Venus in a chariot driven by doves persuades Cupid to step into the shoes of Aeneas's son Ascanius. Below we see Aeneas's first address to the Queen[26]—the profile of the hero is very close to that of the figure who, we suggested, represents Aeneas on the right of the *Morbetto* (Plate 141)—she conducts him, in the next scene, to the banquet which is represented at the bottom of the print, where, fatally, she cuddles Ascanius (in fact Cupid in disguise) and so falls in love with her guest.

If the division of the episodes is inspired by a type of ancient relief it is also connected with the printed book. Pictorial title-pages of the sort which began with the early printed editions of the Bible and which were still employed a century ago for the novels of Charles Dickens adopt a similar convention. Raphael's print seems to have influenced them (Plate 195).[27]

Raphael may also have recalled, when designing the *Quos Ego*, the way that smaller paintings of the gods in chariots were placed above his marine narrative in the garden loggia of Agostino Chigi's villa. In any case when he came to decorate the entrance loggia of the villa (Plate 193) he was concerned with dividing, and connecting, a series of episodes from one classical text, just as he was in the print. His subject here was the fable of Cupid and Psyche from *The Golden Ass*, the racy Latin romance of Apuleius, a source as popular as the *Aeneid*, and one which had also been translated. It had already been painted as the decoration of a villa—in a famous room at Belriguardo near Ferrara for Duke Ercole d'Este, Duke Alfonso's predecessor.[28]

Raphael may have used more than one edition of the classical text,[29] and is likely to have been advised by a contemporary poet. An obvious candidate would be Pietro Aretino who was attached to Chigi's household from about 1516 or 1517. 'I'm not blind to the art of painting,' he wrote much later, 'in fact on many occasions Raphael, Fra Bastiano [Sebastiano del Piombo] and Titian have attended to my judgement.'[30] And in a letter written in 1541 to Raphael's former assistant Giovanni da Udine he referred to the pleasant memories they shared of their youth when the 'divine gifts' of Raphael were matched by the 'regal munificence' of Chigi—the former 'made you what you are', he adds, and the latter 'raised me up'.[31]

A letter informing Michelangelo, who was at that time in Florence, that the frescoes on the vault were completed and that they were a 'disgrace for a great artist' is dated 1 January 1518. But although the Roman year began in January, the Florentine did not, and there are other reasons for supposing that this is really 1 January 1519.[32] It is likely then that the painting took place during 1518 and possible that preliminary work was undertaken the year before that. Vasari tells us that Chigi found it hard to secure Raphael's undivided attention for this work, and that he permitted Raphael's mistress to stay in the villa in order to ensure that Raphael stayed there too.[33] The Richardsons caustically observed that this doesn't seem to have made much difference since the paintings looked as if they were executed by his assistants.[34] It is likely, however, that the design was worked out at the villa, and

many drawings by Raphael for the fresco, perhaps made there, display a close knowledge of the female nude, and some look like drawings of a female model— above all a superb study (Plate 198) in red chalk of a girl with a mirror in which the flesh has a softness and the forms an irregularity (for instance at the top of the thigh) quite unlike anything studied from ancient sculpture. Raphael is not now only consulting a *certa idea*.

Vasari thought Raphael's friends too ready to overlook his constant pursuit of the 'pleasures of the flesh', but his 'dear friend' Agostino Chigi may not have felt inclined to be censorious. He had returned to Rome from Venice in 1511 with the young and beautiful Francesca Ordeasca (or Andreazza). Their union, and their children, were only legitimised in 1519 in a spectacular ceremony at the villa itself attended by Leo X and twelve cardinals.[35] Leo had long urged, and Chigi long contemplated, this step, and it is tempting to connect the fable of Cupid and Psyche, in which a clandestine relationship comes to a respectable conclusion, with Chigi's personal life. The fable was, however, commonly regarded as an allegory of the immortality of the soul, and although there is nothing in Raphael's treatment of the narrative to encourage an eschatological exegesis it would not have been surprising if such an interpretation had occurred to the more high-minded visitors to the villa. Whether or not Raphael and his patrons were thinking of the other world, the story, which had frequently been illustrated on Florentine wedding chests,[36] was obviously appropriate for the resort of either newly wed or unmarried lovers. Sodoma, perhaps significantly, had taken the subject of the marriage of Alexander for a fresco which he executed elsewhere in Chigi's villa shortly before his return to Siena in 1518.[37] (Raphael may have made his designs of this subject for the same purpose.)

Since Raphael had to decorate a loggia, one of the great attractions of the subject of Cupid and Psyche must have been the number of interconnected episodes it provided which took place in the heavens, and thus were suitable for the decoration of a vault. The vault here is painted as if it were a pergola open to the sky. The framework of the pergola consists of festoons of leaves, flowers and fruit, resembling those Mantegna painted in his *Madonna della Vittoria*, and also, apparently, in the chapel of the Villa Belvedere at the Vatican. The niches of the Belvedere statue garden also seem to have been decorated in this way.[38] The pergola here, and the

birds flying about it, are certainly the work of Giovanni da Udine, a pupil of Giorgione who had been recommended to Raphael by Castiglione. He was a still-life specialist and Raphael was particularly delighted by a book which he filled with drawings of birds. Raphael encouraged him to expand his artistic repertoire. He became skilled at landscapes with ruins and at simulating ancient marbles, and a 'Fleming called John' in Raphael's studio helped him to become expert at painting fruit, flowers and vegetables.[39] Among those here Vasari refers somewhat obliquely to the parody of sexual intercourse painted directly above the raised hand of the figure of Mercury (Plate 196).[40] Here the intervention of Aretino, who was later to collaborate in the pornography of Giulio Romano and Marcantonio, and to justify it by reference to an erotic antique sculpture in Chigi's collection,[41] may be suspected. Giovio tells an obviously garbled story about a beautiful high-born lady who was shocked by the Mercury: she may have noticed this detail.[42]

Largely covering the vault of the loggia, and painted as if stretched between the festoons, are two awnings each decorated with narratives. Rising up to the vault from the pilasters which divide the walls are a series of ten pendentives, each distinguished as an area by the pattern of the festoons, containing a separate episode of the story. Each one is enacted by figures foreshortened as if seen from below—a different convention from that employed in the awnings. To emphasise that the latter are paintings of paintings (or paintings of tapestries) the sky is painted a

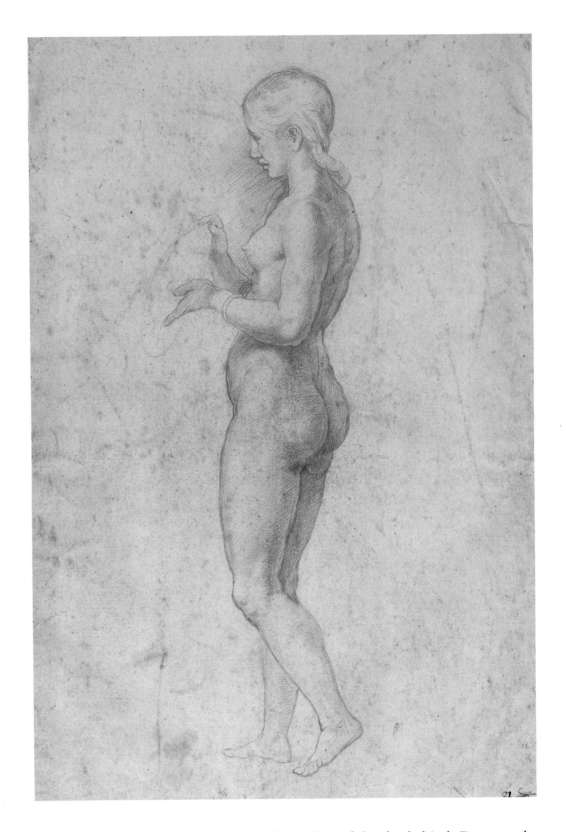

different blue (it is now almost khaki) from that of the sky behind. Between the pendentives are fourteen spandrels in which amorini are painted carrying trophies of their master's victories over all the gods.

The episodes of the story that take place on earth and in the underworld have not been represented, and Raphael may have intended to paint them in the lunettes and on the lower walls—or even to have had them represented on tapestries which could have been hung in the arches then open to the garden as well as on the walls. As it is, the narrative unity proposed here is incomplete and Cupid, to cite one example only, points down at nothing when he directs his servants to attend to Psyche below (Plate 200). The drawing of the girl with a mirror (Plate 198), incidentally, would

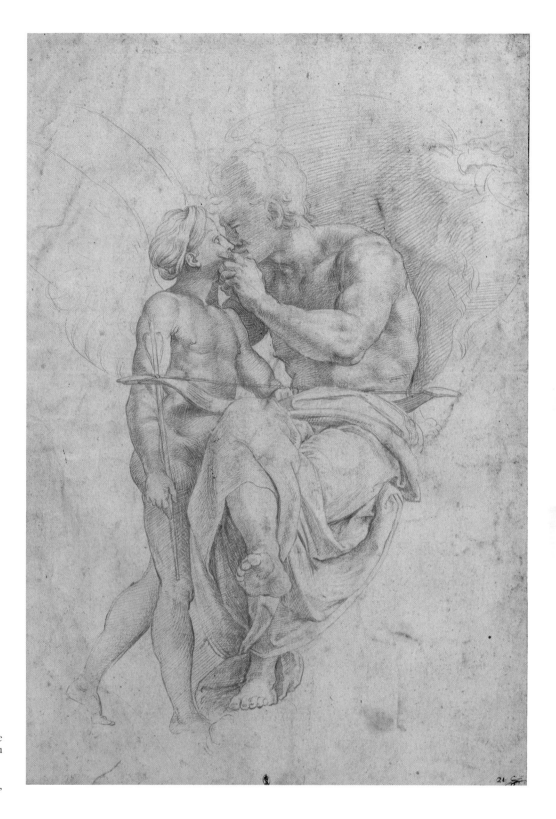

198. *Girl holding a Mirror* (verso of Plate 199). Red chalk, *c.* 1517–18. Musée du Louvre, Paris.

199. *Jupiter and Cupid.* Red chalk, *c.* 1517–18. Musée du Louvre, Paris.

seem to have been planned for a picture in the lower register of Psyche attended by these same servants—a composition which has survived in a print.[43]

Vasari stated that Raphael painted part of the frescoes. He may be right, but the extensive and repeated restorations make it hard to be sure. We sympathise with Bellori who found the painting of the servant (believed by him to be one of the Graces) with her back to us to be so exquisite that he believed that Raphael had painted her.[44] Raphael would certainly have planned the general scheme. The different style in which the episodes of the Council and the Banquet of the Gods on the awnings are treated has sometimes been considered as evidence of his assistants' participation in the design as well as the execution (Plate 197). One of the Hours

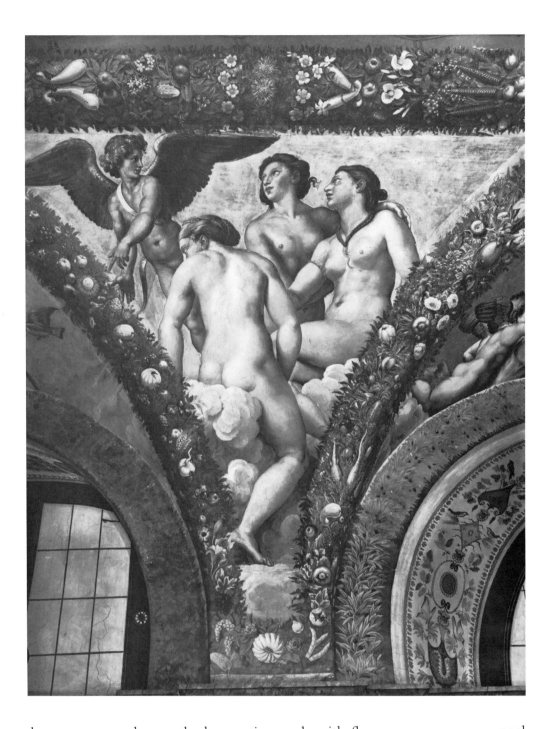

who prepares to shower the banqueting gods with flowers appears as an angel similarly employed in the *Holy Family* (Plate 201) which Raphael designed as a gift from Lorenzo de' Medici (and Pope Leo X) to the Queen of France (the King was given the *St Michael*), a work commissioned in 1517 and delivered to Fontainebleau by June 1518.[45] There is also the fact that preparatory drawings exist for these episodes which are inferior in quality but similar in character to Raphael's own. However, these do not help to decide the question since these may be copies of his drawings made by his assistants as part of their education. And there is a beautiful preparatory drawing for the Graces who pour balm upon the happy couple which must have been made by Raphael himself for this composition.[46]

Raphael must surely have designed all the other major figures in the pendentives of the vault and the superbly aeronautical cupids in the spandrels, even if the assistants were involved in making drawings as well as in the painting. A drawing (Plate 199) for the scene in which Jove interviews Cupid, staring the wanton boy fiercely in the eye to assess the seriousness of his intentions, presents typical problems. The absence of appropriate expression is beside the point—separate studies would

200. Giulio Romano and others (after Raphael). *Cupid directing his Servants.* Fresco, *c.* 1518. Entrance loggia, Farnesina, Rome.

201. *The Holy Family of Francis I.* Oil on canvas (transferred from panel), dated 1518, 207 × 140 cm. Musée du Louvre, Paris.

202. *St Michael.* Oil on canvas (transferred from panel), dated 1518, 268 × 160 cm. Musée du Louvre, Paris.

have been made for the faces—but the lack of convincing structure in the hip, hand and neck of Cupid may suggest an assistant. Also, there are no stylus marks such as Raphael seems to have preferred to use as preliminary guides in red chalk drawings of this sort. On the other hand the chalk is handled with such assurance and sensitive variation in the modelling of the body and in the drapery of Jove that it is hard to believe that this could be a copy. This figure must surely be Raphael's invention, but since portions of the drapery are crudely cut off in the fresco by the adjacent festoon he possibly did not make the cartoon for it, or at least did not supervise in person the tricky problem of transferring the outlines from it.

The figures with abundant flying drapery and outspread arms, tapering in pose, and foreshortened, floating on clouds, or tilted in flight, such as Raphael invented as solutions to the special problems presented by the pendentives, were then transferred by him to other types of painting. The *St Michael* may be compared with the flying Mercury. More remarkably, the figure of God the Father in the *Vision of Ezekiel* (Plate 203), which Raphael may have been commissioned to paint for Count Vincenzo Ercolani of Bologna as early as 1510,[47] is, as Vasari recognised, very close in conception to Jove as he appears twice in the loggia. Furthermore the fluency with which the forms are woven together in this painting and the beauty of the spatial intervals between and around them—a quality which influenced or anticipated the compositions of Correggio—may be paralleled in the design of the three servants addressed by Cupid (Plate 200).

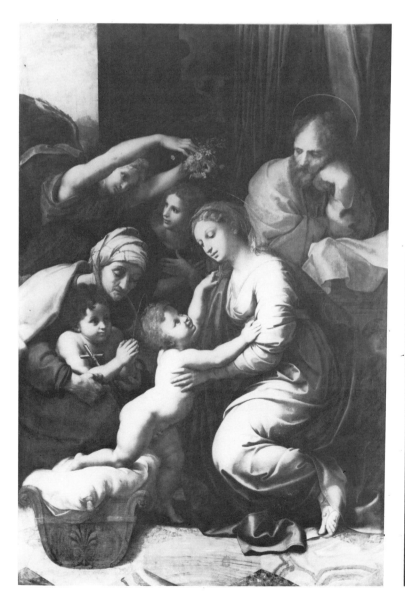

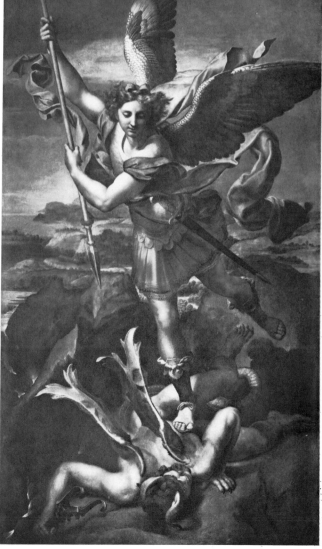

The text is from Ezekiel: 'And I looked, and, behold, a whirlwind came out of the north, a great cloud, and a fire infolding itself, and a brightness was about it, and out of the midst thereof as the colour of amber, out of the midst of the fire. Also out of the midst thereof came the likeness of four living creatures.' These creatures, combining features of lion, ox, man and eagle, were taken by the commentators to symbolise seasons, virtues, humours, elements, types of angels, tribes of Israel and corners of the earth, but the received opinion in Raphael's time was that they represented the four Evangelists,[48] and this excused him from trying to represent the complex creatures in the text. He uses the conventional emblems of the Evangelists instead. When God became manifest to Ezekiel it was in the 'firmament' above the creatures, but Raphael again had good theological reasons for showing him supported by them, as his greatness was made manifest by the four Gospels. In earlier paintings of visions the recipient (St Francis as he received the stigmata, Christ in the garden) is prominent and the vision small, but Ezekiel, who is shown at the moment when the spirit entered into him and set him upon his feet, is reduced to a tiny figure caught in a shaft of light in the distance. The treatment of visionary subjects by Dürer above a landscape may have combined with the ideas for Chigi's loggia in making possible this extraordinary invention.

It is unlikely that many of Raphael's contemporaries would have been concerned at the mingling in his imagination of *The Golden Ass* and the Old Testament. It is true that attempts were made to stop references to the pagan gods in sermons in the Sistine Chapel.[49] And the 'second Virgil', the Carmelite Baptista Mantuanus, in his much-admired sacred calendar described with relish the confusion of the old gods at the Annunciation and their ignominious precipitation into hell at the Nativity.[50] But readers of Sannazaro's celebrated *De Partu Virginis* might be excused for supposing that the entire population of Olympus had been canonised.

We may also think of the small Holy Family which Adrian Gouffier de Boissy obtained (or ordered) from Raphael after his creation as a cardinal late in 1515 before he left Rome for France as legate in 1518.[51] On its sliding cover (Plate 204) was painted what looks like an antique sculpture, probably a goddess, but here surely meant as a personification. In another Holy Family produced by the studio in this period, the *Madonna della Quercia* (Plate 205) the classical world lies in ruins. Mary and Joseph lean upon a candelabrum base, and in the distance, dramatically lit, is the imposing ruin of the 'Temple of Minerva Medica'.[52] The point must be to show Paganism overthrown by Christ, but this is hard to reconcile with Raphael's reverence for these ruins and his imitation of their forms and ornaments in new Christian churches—the subjects of our next chapters.

The attitude, and especially the drapery of the Madonna here is clearly derived from antique sculpture. But the style of Raphael's subject pictures seems not to have been much influenced by antique painting—with the possible exception of the landscape in the *Madonna di Foligno*. On the whole the antique painting that was known involved no figures of large size. Such painting was most familiar from the buried rooms (*grotte*) of the Golden House of Nero which curious antiquarians had, since the 1490s, scanned by torchlight, having crawled on hands and knees through dark and toad-filled tunnels.[53] Elements from the schemes of decoration *a grottesche* which had been seen there were quickly incorporated into Italian interior decoration,[54] and Raphael must have been familiar with these from his association early in his career with Pinturicchio and from the work of the closest imitator of such decorations, the melancholy Morto da Feltre, who had been in Florence in 1506–7 and was employed by Raphael's patron Agnolo Doni.[55] There is little to suggest that Raphael had any very strong interest in this kind of decoration until about 1515, when he was sponsoring the very close study of it by Giovanni da Udine and must have become keenly interested in the ways it could be used.

Vasari records that it was when Raphael and Giovanni da Udine were summoned to inspect some miraculously preserved painted rooms which had been uncovered in a ruin near S. Pietro in Vincoli that Giovanni determined to imitate them,[56] but he

203. *Vision of Ezekiel*. Oil on panel, c. 1518, 40 × 30 cm. Uffizi, Florence.

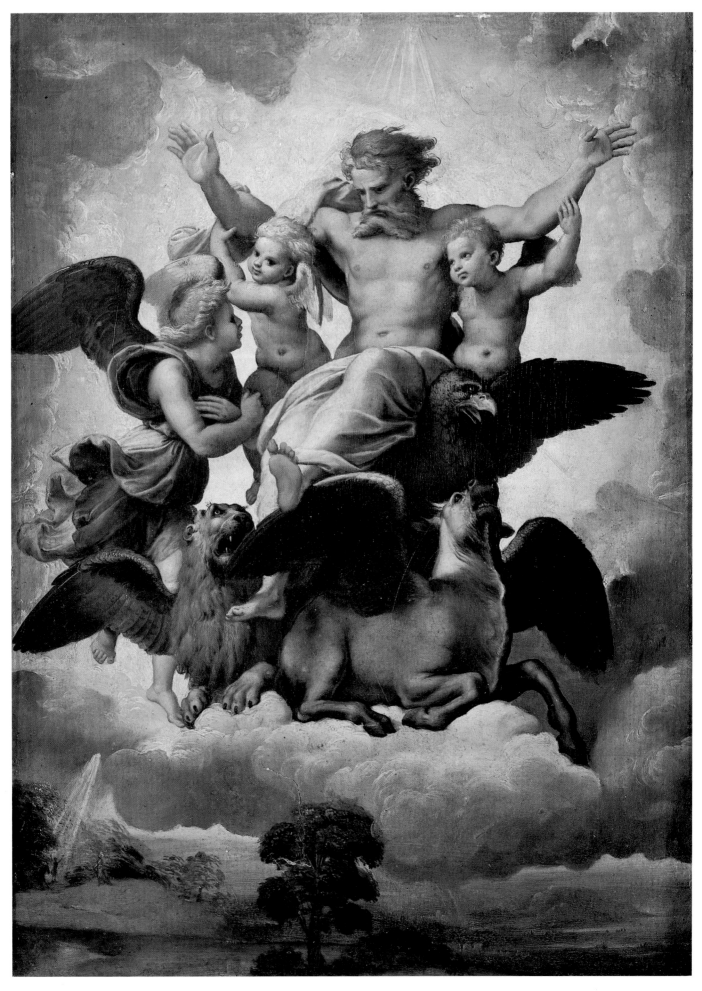

204. Assistants of Raphael (perhaps Giulio Romano and Giovanni da Udine, probably after Raphael). *Lid of the 'Small Holy Family'*. Oil on panel, *c.* 1518, 38.4 × 31.3 cm. Musée du Louvre, Paris.

205. *Madonna della Quercia*. Oil on panel, *c.* 1517–19, 144 × 110 cm. Prado, Madrid.

may have had this ambition earlier, for Morto da Feltre was working with Giorgione at the same date that he was. In any case by 1516 he had helped Raphael to decorate, for Cardinal Bibbiena, the earliest surviving rooms to be created in modern Europe which can be mistaken, even by expert eyes, for decorations of the early Roman empire.

During the early years of Leo's pontificate when Cardinal Bibbiena was at the height of his power he was also exceptionally close to Raphael. He owned 'a picture by the hand of Raphael with a figure of the Blessed Virgin' which he bequeathed to Castiglione;[57] and Raphael was employed in the apartments which he occupied in the Vatican. He did not build, buy or lease a palace of his own as most cardinals did—when he died one had to be borrowed for his lying in state—and he was free to spend lavishly on his apartments, which must have been quite large, for he staged his own comedy *La Calandria* there for Isabella d'Este in 1514, with sets by Peruzzi. 'The bathroom [*stufetta*] is being finished and truly it will be most beautiful; the new rooms and the loggia are finished. You alone are lacking', wrote Bembo on 16 May 1516 to the cardinal who was then in Florence, and again on 20 June: 'the loggia, the bathroom, the rooms, the hangings of leather . . . are all ready and waiting for you'.[58] Bibbiena had little time to enjoy them, however, for in the following years he was more often away from Rome than not.

The *stufetta* which has survived in a very damaged condition (Plate 208) is a small, dark room, little more than eight feet square, with one window. Water spouted from a mask on one of the white marble relief panels below the two niches, probably intended for statues. Bibbiena owned a small statue of Venus which Raphael could not accommodate suitably here. (Bembo asked for it to adorn his *camerino* together with the statues of her father Jupiter and brother Mercury which he already had.)[59] Walls and vault are divided into small compartments. In them we discover a diverting mixture of still life (submarine specimens are painted on the mauve

borders to the dado), and whimsical fantasy (cupids in shells are pulled by snails, turtles and so on, on black, inside these borders). More prominent are the lyrical and erotic episodes from Ovid, such as would agitate the celibate, all with landscape or seascape settings—Pan planning to ravish Syrinx, is one, and Venus raising a leg to extract a thorn from her foot is another; the former has been scratched out by the pious, the latter is only recorded in prints (Plate 206). Bibbiena himself chose the subjects and he cannot have given much prior thought to them, for Raphael asked Bembo to forward a request for the 'other narratives' he wanted when it was time to paint them, on 19 April 1516. This shows that Raphael was at least directing the decoration. Its coherence must owe much to him. Perhaps some inventions in the narratives were also his, especially the Venus extracting the thorn, although the evidence of the drawings is not clear.[60]

Cardinal Bibbiena's loggia (Plate 209), which has been uncovered and restored in this century, forms a deliberate contrast with the bathroom, for it is light and airy and the prevailing colour is that of the white plaster which is entirely covered by a type of fantasy architecture, also employed (but against a red ground) in the upper sections of the bathroom walls. It is composed of knitting-needle columns, miniature canopies and pergolas, fragile candelabra and delicate tendrils, among which putti, song-birds, the heads of greybeards and metamorphic freaks perch or dangle. The most ambitious figure composition shows the manufacture of Cupid's arrows and the largest figures are the statues (one is similar to that on the cover of Cardinal de Boissy's *Holy Family*—Plate 204). The pairs of griffins facing each other on the dado were clearly transferred from two sides of the same cartoon by means of charcoal rubbed through perforated lines, but most of the decoration was drawn free-hand in red pigment (*sinopia*) and then painted. Spontaneity of execution and at least the illusion of equally quick invention were essential ingredients in the appeal of such decoration—and it is worth noting that poetic improvisers were popular at Leo's court.

The elements of ancient Roman interior decoration most obviously missing in these rooms are mouldings, ornaments and small framed scenes in low relief. Pinturicchio had combined relief elements with his painted decorations, but his

206. Marco Dente (perhaps copying Marcantonio Raimondi, after a fresco probably executed by Giulio Romano, and perhaps designed by Raphael). *Venus extracting a Thorn from her Foot.* Engraving, after 1516, 25.6 × 16.8 cm (sheet). Whitworth Art Gallery, Manchester.

207. Probably Gianfrancesco Penni (perhaps after Raphael). *Modello for the fresco of Jacob's Dream in the vault of the private loggia of Leo X.* Pen and wash and white heightening, squared for transfer, over black chalk, *c.* 1518, 19.9 × 26.3 cm. British Museum, London.

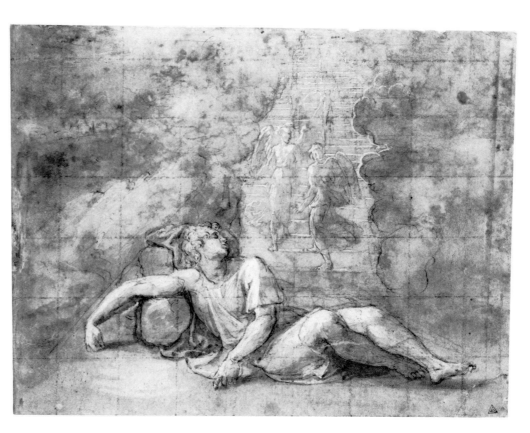

208. The bathroom of Cardinal Bibbiena (the *stufetta*). Fresco, 1516. Vatican Palace, Rome.

209. The loggia of Cardinal Bibbiena (the 'Loggetta'). Fresco, completed 1516. Vatican Palace, Rome.

210. *Joseph recounts his Dream*—vault of central bay of the private loggia of Leo X (Plate 215).

211. *Moses receiving the Tablets of the Law*—vault of a bay of the private loggia of Leo X.

stucco had none of the smoothness, whiteness, crispness and delicacy of the ancient work. Giovanni da Udine, having studied the methods being used by Bramante's workmen in St Peter's, made his own experiments, finally succeeding with a mixture of pulverised white marble and the lime of white travertine. 'Greatly delighted, he showed Raphael what he had done.' The results of his experiments were probably first displayed in the Pope's private loggia.

The Pope, Castiglione informed Isabella d'Este on 16 June 1519, 'delights in architecture and is forever devising something new in this palace, and now a loggia is complete, painted and fashioned in stucco in the ancient manner: a work by Raphael, as beautiful as can be, and perhaps more so than any modern thing that is now to be seen'.[61] Another letter writer noted on 4 May that it was complete.[62] Raphael was already being paid in March 1518.[63] Marcantonio Michiel noted at the end of the year that the loggias beneath it were public thoroughfares and crudely decorated, but this loggia was private and only opened at the Pope's pleasure. The Pope was placing many antique statues there, some from his own collection, some from among those bought by Julius II.[64]

Leo X's private loggia (Plate 215) consists of thirteen bays, each one with its opening (now glazed) and balcony (now cemented) opposite a window or door. The vault of each bay incorporates four biblical narratives, all but the last set from the Old Testament, and all but the one in the middle, which is dominated by Leo's arms, include panels decorated with an angel holding Leo's devices, the diamond ring and the yoke. In this central vault (Plate 210) stucco figures and candelabra, their brilliant white enhanced by gilding, frame the biblical narratives. In the vaults of four of the other bays coloured marble architecture appears to soar up behind the narratives into a blue sky filled with birds (Plate 211). These alternate with other schemes in which the sky is more or less closed off, and in which the real structure of the vault is ingeniously denied, so that what might have been a monotonously

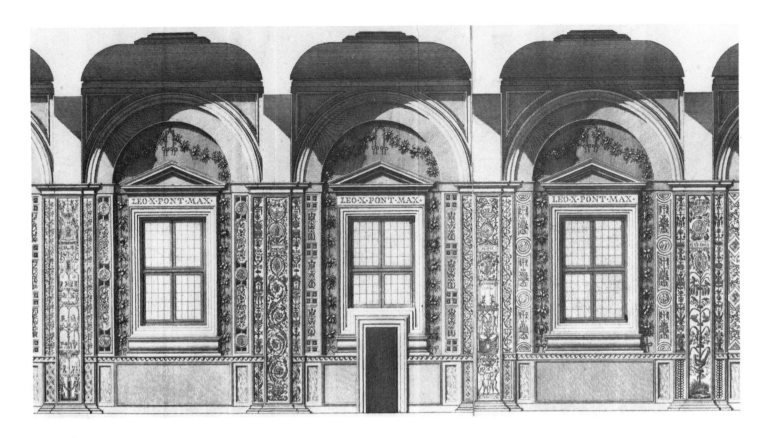

212. J. Ottaviani (after C. Savorelli and P. Camporesi). *3 Bays of the private loggia of Leo X*. Engraving, from the *Loggie di Rafaele*, Rome 1772–7.

213–14. J. Ottaviani (after C. Savorelli and P. Camporesi). *Details of ornament from the pilasters of the private loggia of Leo X*. Engraving, from the *Loggie di Rafaele*, Rome 1772–7.

215. (far right) The private loggia of Leo X (the 'Loggie'). Fresco and stucco, 1518–19. Vatican Palace, Rome.

repeated sequence of identical spaces is entertainingly varied both in structure and ornament.

'Raphael's Bible', as this loggia used to be called, is as exclusive as an illuminated book of devotion (like the Bible which appears in Raphael's portrait of Leo—Plate 177) and the very opposite to the public religious art which served as a 'Bible for the unlettered'. Michiel, in his comments on the loggia, added pointedly that the work on the fabric of St Peter's was slowing down for lack of funds.[65] Just as illuminated books provided abundant distractions from the devotional text, as well as illustrations of it, so here there were, as well as the 'Bible', marvels of nature and monsters of the imagination, over a hundred miniature scenes in stucco, many taken from ancient gems and statues, and of course there was the view.

Giulio Romano was employed here 'in particular', as was Penni, but Vasari states that Giovanni da Udine was 'head' (*capo*) of the stuccoes and grotesques—a position equivalent to that of Giulio who was in charge of the 'figures'. Giovanni surely invented ornament, and also perhaps schemes of ornamentation here, but the coherence of the architectural system, as well as the actual architecture of the doors and windows, was due to Raphael. New recruits to the studio were needed, and Vasari mentions several new names.[66] Polidoro da Caravaggio delivering lime to the loggia was first attracted to an artistic career by what he saw there. The talent of Perino del Vaga having been drawn to Raphael's attention by Giulio and Penni, Raphael recommended Giovanni to employ him.[67]

Assessment of the part Raphael played in designing the narratives on the vaults has varied enormously. Vasari claims that Raphael produced 'designs and sketches',[68] but very few drawings by him have been connected with these narratives and these are of controversial status. There are some finished drawings for the compositions— *modelli* eminently suited for showing to the patron for approval and from which a full-scale cartoon could then be prepared. Such a drawing for the *Dream of Jacob* (Plate 207) is, significantly, squared for transfer. It is accomplished, but there is no sense in it of creative effort, and whoever made it may not have been responsible for the invention of the figure which in the rhythm of the pose and character of the lighting is close to the Apostles awakening on Mount Tabor in the *Transfiguration*

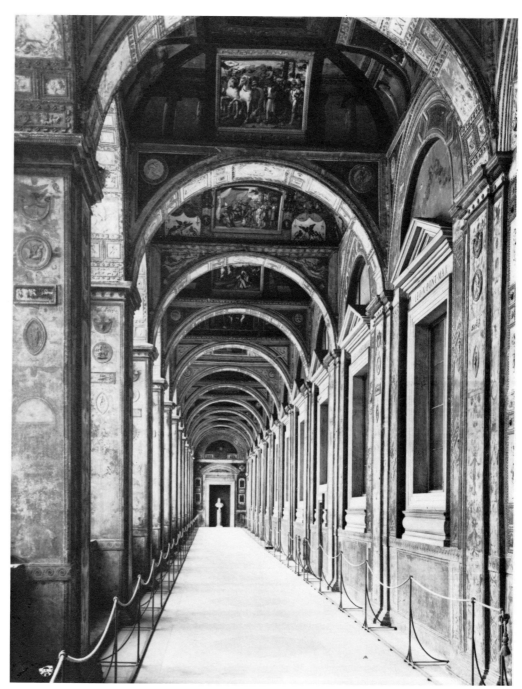

(Plate 264). Penni has been suggested as the draughtsman, perhaps working over a faint drawing, or copying a less tidy one, by another hand.[69] If, as seems likely, this other hand was Raphael's, and if this example is typical, then Raphael's participation would have been one or two stages further removed from the completed frescoes than was the case with the Loggia of Psyche or the *Battle of Ostia*.

Raphael's assistants had by now greatly increased in number—according to Vasari fifty painters followed him daily to court! The periphery of his studio is also impossible to define. We have, for instance, no idea whether the failed painter Ugo da Carpi who came to Rome from Venice after 1516 and pioneered developments of the chiaroscuro woodcut to reproduce drawings by Raphael and his assistants, like the one for the *Dream of Jacob*, was in any sense a professional associate of Raphael. We are told that Raphael was prepared to leave his work and help even artists whom he did not know, treating them as sons and not as mechanics. By nature he was 'so full of kindness and so brimming with charity that the very animals honoured him' and in his presence even the most ambitious artists worked together in concord.[70]

197

198

IX. 'Seeking Rome in Rome'[1]

> So MANY heroes and such a long time it took to build Rome!
> So many enemies and so many centuries it took to destroy it!
> Now Raphael is seeking Rome in Rome, and finding it.
> To seek is the sign of a great man, to find—of a god.

This fashionably ornate tribute was written in classical Latin by Celio Calcagnini, a Ferrarese scholar, probably after his return to Rome in 1519.[1]

We have already seen how extensively Raphael's painting and sculpture were influenced by ancient Roman art and literature. However, it was not this rediscovery that Calcagnini had in mind in his poem, but more specifically Raphael's pioneering activity as an archaeologist. This is clear from a letter he wrote at much the same time to the mathematician and historian Jacob Ziegler in which he excitedly reports on Raphael's current, and apparently latest, project, that of drawing up, on the basis of excavation and the evidence of ancient writers, a scientific reconstruction of the original appearance of the whole of ancient Rome.[2]

The widespread enthusiasm that this project generated can be judged from the reactions expressed at Raphael's untimely death in the following year. Amid the general regret at his passing, a surprising number of people were saddened particularly by the thought that it would never be completed—he had finished only one of the fourteen regions into which the city was divided.[3]

Such a project was an impossible dream for one man to realise in any detail. One of his collaborators, the Roman antiquarian Andrea Fulvio, admitted as much in his topographical study of the ancient city, the *Antiquitates Urbis* of 1527.[4] But the scientific scope of Raphael's survey is well borne out in a letter to Leo X, in which Raphael's ideas were put into polished prose by Baldassare Castiglione.[5]

Raphael's letter begins by declaring his belief that the ruins of the city bear true witness to the greatness of Rome as it is described in the ancient sources, and continues:

> Having therefore devoted much study to these antiquities, and taken no little trouble to seek them out in detail and measure them with care, constantly reading the good authors and comparing their descriptions with the monuments, I think I have acquired some knowledge of the ancient architecture. To know about such an excellent subject gives me the greatest pleasure, but at the same time it is very painful to see how miserably lacerated is this noble and bountiful city.

He goes on to lament the destruction of the ancient city by the barbarians, and its continuing dilapidation by builders in search of building material, such that,

216. *Landscape with Classical Ruins* (perhaps Trajan's Forum; study for—or adapted for—the *Morbetto*). Metalpoint on grey prepared surface, with white heightening, *c.* 1512–13, 21 × 14.1 cm. Royal Library, Windsor.

I would venture to say that all this new Rome of today, however great, beautiful and adorned with palaces, churches and other buildings, was all built with mortar made from ancient marbles. Nor can I recall, without being moved to pity, that since I have been in Rome, which is not yet twelve years, many beautiful things have been ruined.

Unlike earlier writers on this theme, he then goes on to give a specific list of monuments recently destroyed or damaged, and urges the Pope to put a stop to it.

But to return to the subject I touched on earlier, your Holiness has commanded me to draw as much of ancient Rome as can be known from what is still to be seen, with [all] the buildings of which there are sufficient traces to permit a logical and correct reconstruction of their original appearance, supplying the parts which have been destroyed or lost to sight in correspondence with those that are still visible and standing . . . Although what I propose to set forth has been drawn from many Latin authors, I have principally followed Publius Victor, who, as one of the latest of them, has more detailed information to offer about the later buildings, while not omitting the earlier ones. It is also clear that his account of the regions of Rome accords with certain ancient marbles in which they are also described.

[To help the reader, he explains that] . . . there are only three styles of building to be found in Rome. One is that of the good antique period, which lasted from the early emperors up to the time when Rome was broken and ruined by the Goths and other barbarians. The next lasted as long as Rome was dominated by the Goths, and for a century afterwards. The other is from that time till the present day. The modern buildings are the most recognisable, both because they are new and because they have not yet quite reached the excellence and immense richness which can be seen and pondered in the ancient ones. It is true that in our day architecture has very much revived and seems close to the style of the ancients, as one can see in the many beautiful works of Bramante, but, all the same, the ornaments are not of such precious material as was used by the ancients, who seem with infinite expense to have been able to put into effect what was in their imagination and by sheer will power overcome all difficulties. The buildings of the time of the Goths, on the other hand, are so completely lacking in grace or style that they are quite unlike the buildings of the ancients or moderns . . .

Nor should anyone be in doubt and think that the more recent of these ancient buildings might have been less beautiful, less well understood or in a different style, since they were all of one principle. It is true that the ancients themselves often rebuilt many of their buildings—one reads that the Baths of Titus, his house and the Amphitheatre [the Colosseum] were built on the site previously occupied by Nero's Golden House—but they were nevertheless built in the same style, and on the same principle, as other buildings contemporary with the Golden House or even earlier than the time of Nero. It is also true that literature, sculpture, painting and almost all the other arts went into a long period of decline, getting worse and worse by the time of the last emperors, but architecture maintained its good principle and they built in the same style as before. It was the last of the arts to be lost, as many things bear witness, among them the Arch of Constantine, which is well composed, and well made as far as its architecture is concerned, but its [contemporary] sculptures are quite ridiculous, without art or any sense of good design. Those sculptures that it has from the spoils of [the monuments of] Trajan and Antoninus Pius are most excellent, and perfect in style. The same can be seen in the Baths of Diocletian, where the sculpture of his time is in the worst style, and badly made, and what remains of the painting has nothing in common with that of the time of Trajan and Titus, but nevertheless the architecture is noble and well understood.

[After the barbarian invasions] . . . it is as if the men of those days lost not only their empire, but also their art and their wits, becoming so ignorant that they did

not know even how to make bricks, let alone any other kind of ornament, and stripped down the ancient walls to get at them, cutting up the marbles into little rectangles, and using them to build, dividing up the wall with that mixture of materials which can be seen in the tower called 'delle Milizie'. Thus for a good while they continued in this ignorance, as is clear from everything built in their time. And it seems that this horrible, cruel storm came not only to Italy, but spread also to Greece, where the inventors and perfect masters of all the arts once lived. Even there a very bad style in painting, sculpture and architecture came into being, which was of no value. Then, almost everywhere there arose the German [i.e. Gothic] style in architecture, which is very far indeed from the beautiful style of the ancients and the Romans, as can be seen from its ornaments, for the ancients, in addition to the excellence of the overall structure of their buildings had most beautiful cornices, friezes, architraves, columns, capitals, bases and, in short, all the ornaments of a perfect and most beautiful style. The Germans, whose style still continues in many places, often use for the bracket supporting a beam a little crouching figure, badly executed and worse in conception, or other strange animals, figures and foliage without any sort of order. Not that this architecture does not have some sort of order, since it derives from [the forms of] uncut trees, whose branches are bent and tied together to make their pointed arches . . .

Now that we have sufficiently clarified which of the ancient buildings of Rome are to be the subject of our exposition, and how easy it is to recognise them, it remains for us to explain the method we have used in measuring and drawing them, so that whoever wishes to attend to architecture may know how to do both without error, and may appreciate that in drawing up this work we have been governed not by chance or mere practical experience, but by true principles. The method we have used is that of measuring with a magnetic compass. I have not seen any written account of it, nor heard of one in the ancient sources, so I judge it to be a modern invention, but I think it would be good to give a careful account of it for those who do not know how to use it. [There follows a thorough description of a surveying technique which is capable of producing a ground-plan of a given area, on the basis of compass readings and ground measurements taken from a given central spot. Heights are to be taken with a quadrant.]

Since the method of drawing which is proper to the architect is different from that of the painter, I will say what seems necessary for understanding the measurements and learning how to establish all the parts of the buildings without error. Architects' drawings of buildings are of three kinds. The first is the ground-plan. The second is the outside wall, with its ornaments [the elevation]. The third is the wall inside, also with its ornaments [the section].

[After a brief explanation of the principles of the ground-plan, he explains that in the elevation] . . . there should be no [perspectival] diminution at the sides, even if the building is round or if it is rectangular, to show two sides, since the architect cannot take any correct measurements from these foreshortened lines—and it is vital in this procedure for him to have the measurements correspond to the reality, drawn with parallel lines and not those which look right but are not . . . Thus it is always necessary to have to hand the correct measures of *palmi*, feet, *diti*, and *grani* right down to the most minute divisions.

The third type of drawing [the section] . . . is no less necessary than the other two, and like the elevation, is made from the plan with parallel lines. It shows the inside half of the building, as if it had been cut in two, and shows the courtyard, the correspondence between the height of the cornice on the facade with the inner parts, the height of the windows, the doors, the arches and the vaults, whether they be barrel vaults, cross vaults or any other kind of vault. In short, with these three methods, one can study in minute detail all the parts of any building, both inside and out . . .

We have, in addition to the three types of architectural drawing already mentioned, drawn some of the buildings, where it seemed appropriate, in

perspective, so that the eye may see and judge the grace of that appearance which is presented by the beautiful proportion and symmetry of the buildings, which is not apparent in the architecturally measured drawings. For the thickness of the members cannot be shown in one plane if those parts which are more distant from the eye are not proportionately diminished, the way the eye naturally sees them . . . And although this method of drawing in perspective belongs more properly to the painter, it is still useful for the architect. For, just as the painter should know about architecture in order to make well-measured and proportioned ornaments, so the architect should know perspective, because the technique improves his ability to visualise the whole building with its ornaments.

He concludes by discussing the ornaments, which he says are all derived from the five orders used by the ancients. Raphael is the first modern writer to use the term 'orders', but, referring the reader to Vitruvius for a full account, he deals only briefly with their origin and character, and how they should now be used, among other things 'so that the purpose of the building be well matched, particularly in the case of temples, by its appearance'.

The letter is elaborately composed and was probably intended for publication. Indeed it would make a suitable dedicatory epistle for a book of the kind that another of Raphael's collaborators, Fabio Calvo of Ravenna, in fact published in 1527, containing a series of plates illustrating ancient Rome, with explanatory comment—the *Antiquae Urbis Romae cum Regionibus Simulachrum*.

It is not clear from Raphael's letter whether he intended to produce a single drawing of the whole of ancient Rome, even though the surveying method he describes has elements in common with the project for a survey of the city outlined by Alberti[6] and with the compass method actually used by Leonardo to produce a map of the town of Imola (Plate 217).[7] Most of what he has to say relates rather to the recording of individual buildings, in measured plans, elevations and sections. The plates of Calvo's book (Plate 218) may reflect Raphael's intentions for a circular plan of the whole city,[8] but the individual buildings shown are far from being measured architects' drawings and are presented as they had been in traditional city-views or on the reverses of Roman coins. Raphael may well have been interested in the evidence of coins, but his measured drawings must be considered lost, and many years had to pass before anything approaching the exactitude called for in the letter was published. The chief pioneer of such publications was the architect Palladio, and it is at least of symbolic significance that the only surviving measured drawing by Raphael of a piece of antique architecture probably later belonged to him.[9]

As might be expected, Raphael's proposal was not so much a new one as an

219. *Drawing of one of the Horses at Monte Cavallo, Rome.* Red chalk over indications with a stylus (with measurements in pen and ink), *c.* 1515, 21.8 × 27.2 cm. Chatsworth, Derbyshire.

217. Leonardo da Vinci. *Plan of the town of Imola.* Pen and ink and watercolour, *c.* 1502, 44 × 60.2 cm. Royal Library, Windsor.

218. Woodcut from Marco Fabio Calvo's *Antiquae Urbis Romae cum Regionibus Simulachrum*, Rome 1527, showing Ancient Rome with the regions of Augustus.

attempt to synthesise and systematise a number of earlier ambitions. In the early years of the fifteenth century, the architect Brunelleschi had first shown an interest in measuring the ancient buildings, while scholars like Flavio Biondo in the 1440s had scoured the ancient writers for information about the city. Alberti was exceptionally well equipped to combine the evidence of the literary sources with the physical remains, but did not do so systematically, and it was still true in Raphael's day that there was a gap between the researches of those who read and those who dug and measured. The latter were for the most part artists and, especially, architects, and their growing interest is shown by the number of drawings and sketchbooks of antiquities which survive. These provide vital evidence for modern archaeologists interested in parts of the city which have since been destroyed, but few of them before Raphael were, or were even intended to be, exact objective records. Rather, even with the more archaeologically minded, they tended to be studies of ornamental details, or slightly fanciful views of buildings, as in a drawing by Giuliano da Sangallo (Plate 220) where what looks to be a fairly reliable view of the now destroyed Basilica Emilia, with indications of measurements, is capped with an inscription from the Arch of Septimius Severus.[10] Nor are the measured plans of the Sienese architect Francesco di Giorgio Martini entirely accurate.[11] Vasari reports Bramante to have made measured drawings, but they do not survive.[12]

But while the men of letters showed little interest in the visual evidence, these artist-draughtsmen did not neglect the literary sources, and Raphael would have been as keen to question Giuliano da Sangallo in this area as to consult his sketchbooks when the two men worked together in 1514–15 on the building of new St Peter's. At this time Raphael was studying (and complaining about the inadequacies of) Vitruvius (see p. 97). By the time the letter to Leo was written, he was able to claim an extensive knowledge of other Latin writers like Publius Victor, and his knowledge, in addition, of the writings of Pliny is demonstrated by the letter he wrote about the Villa Madama, which we will discuss later. Calcagnini, in the letter of *c.* 1519 already mentioned, stressed Raphael's ability to debate the finer

220. Giuliano da Sangallo. *Drawing of the Basilica Emilia, Rome* (with other material), from his sketch-book. Pen and wash, before 1503, 45.5 × 39 cm. Vatican Library, Rome.

points of Vitruvian studies 'so gracefully that his criticism is quite uninvidious'.

Given this mastery, it may seem surprising that we are unsure whether Raphael could read Latin unaided. Possibly he could, but we should perhaps not go as far as to imagine him sitting up late in his study poring alone over ancient texts. Just as his painting shows a remarkable power to assimilate what others had to offer, so too it seems to us likely that his intellectual development benefited from his ability to pick expert brains effectively. In particular he was able to consult the leading authority of his day, Fra Giocondo of Verona, who had published the first illustrated and annotated edition of Vitruvius in 1511.[13] The two men worked together at St Peter's in the last year of Fra Giocondo's life, 1514. Fra Giocondo's text must anyway have been in Raphael's house, where it was used by Fabio Calvo to make a translation of Vitruvius, which Raphael subsequently annotated with corrections and paragraph headings, probably with a view to publication.[14] Among Raphael's other learned friends was the topographer Andrea Fulvio mentioned earlier, who recalled going round Rome with Raphael shortly before he died, pointing out ancient sites which Raphael then drew.[15]

Fulvio goes on to make a distinction between his own approach to antiquity—geographical, etymological and historical—and that of an architect. There may be an element of intellectual snobbery in this preference for the literary source over the visual. While it may be possible to overestimate Raphael's literary studies, his visual acuteness was exceptional, and led to correct observations about the city's monuments which eluded those who were more interested in the written evidence. His stylistic analysis of the phases of Roman art and architecture may now seem simplistic, but it was among the first of its kind. Indeed his letter influenced Vasari, and it represents a significant step in the development of art history. He seems to have been the first to note the stylistic disparities between the sculptures on the Arch of Constantine which contained fragments reused from earlier monuments, something of which Fulvio remained unaware.[16]

This underlines the fact that Raphael was as much interested in the monumental sculpture of ancient Rome as in its buildings—one of his few surviving drawings of antique sculpture is of a panel on the Arch of Constantine.[17] Raphael and his

assistants also made drawings of Trajan's Column, and while the purpose of these (like that of Plate 216) may have been artistic rather than archaeological,[18] he may have intended to include in his survey of Rome accurate drawings of its principal sculpted monuments. His drawing of one of the colossal marble horses on the Quirinal (Plate 219), carefully noting the breaks in the stone, can almost be thought of as an elevation drawing, seen from the viewpoint of one standing on a level with it, rather than from the more normal viewpoint from the ground below.[19] If the measurements on it are his, or contemporary with him, it is the earliest surviving measured drawing of an antique sculpture. Drawings of this character became a standard part of academic education, but only did so a century after Raphael's death.

Raphael states that he had embarked on the reconstruction at the instigation of Leo X. It was one of a number of efforts made by the Pope to preserve Rome's heritage. Fulvio's prose treatise had also been written at Leo's request,[20] and papal protection was extended to the first printed collection of Rome's ancient inscriptions, eventually published in 1521 by the printer Mazzocchi.[21] Raphael was at least indirectly involved in this, too, as a result of powers vested in him by the Pope in a Brief of August 1515.[22]

The Brief had a dual purpose. Primarily the Pope was interested in obtaining building materials for St Peter's, and, having established that the ruins of the city could provide a good source of supply, he nominated Raphael as 'prefect' in charge of the purchase of suitable marble and stone. He was to be informed, on pain of a fine, of any material excavated within the city, or outside it within a mile's radius. Secondly, since the Pope had been informed that marble workers were in the habit of sawing up, for raw material, ancient blocks which had been inscribed or ornamentally carved, he ordered, again on pain of a fine, that no marble workers were to work on any stones bearing inscriptions, without Raphael's permission. Leo's expressed interest in preservation was literary—'for the cultivation of literature and elegance in the Latin language'. Presumably after recording the text of the inscription, or drawing it to the attention of interested parties, Raphael was free to consider the block as building material. The location of one of the inscriptions recorded in Mazzocchi's book is given as 'On an oblong block of travertine taken to the building site of St Peter's, lately split into two parts by the stonemasons'.[23]

The Brief shows that Leo's interest in conservation was selective, and neatly encapsulates a striking paradox—that the study of ancient inscriptions and the emulation of ancient architecture not only coincided with, but actively stimulated, an organised destruction of the ancient ruins.

As is clear from the letter, Raphael himself was concerned with the preservation of much more than merely inscriptions, and he may have felt frustrated that his powers as 'prefect' were not more extensive. He at any rate overestimated them. When in July 1518 he attempted to expropriate an antique statue that had been bequeathed by the collector Gabriele de' Rossi, he pleaded papal authority. But it was decided, on an appeal to the Pope made by a city magistrate, that he was exceeding his powers.[24] The statue, with others of de' Rossi's collection, passed to the City Council (the *Conservatori*), who were, as it happens, more concerned with the preservation of the physical monuments of the city than was the Pope, passing a resolution a few days before Raphael's death calling, vainly it seems, for stiff penalties for those found 'devastating' its monuments.[25]

Raphael's ambitions as a scholarly archaeologist, then, were substantial, but the results of his activities, and the progress of his interest in the subject, are hard to trace—so much so that a recent attempt to date his learned letter to the Pope to 1513–14 instead of the customary 1519 is not inherently implausible.[26]

But his researches were not simply scholarly and indeed, with their emphasis on drawing procedures, were perhaps only a by-product of his artistic activity in a field where we can appreciate the remarkably inventive practical use he made of them— that is in the design of new buildings, where the accession of Leo, and the death of Bramante, offered his talents opportunities on the grandest scale.

X. 'All this new Rome'

A PROTÉGÉ of the court of Urbino, Raphael had been familiar from boyhood with an architectural complex surpassing any of its day in Italy, both for the sophistication of its *all'antica* ornament, the range and practicality of its apartments, and for its domination of a difficult hillside site (Plate 1).[1] As a boy painter he could hardly have imagined that he would in his last years himself be responsible for designing for the Pope's family a complex of comparable richness—the Villa Madama.

However, the transition from painter to architect which Raphael made in Rome is likely to strike a modern observer as more radical than it would have seemed at the time. No institutionalised architectural profession existed, and the designers of buildings were generally people who had been trained in another art, especially as painters. Nor was there such a clear distinction drawn between these two arts. Indeed, the links between them were of unusual significance. A goldsmith-turned-architect, Brunelleschi, had given painters their one-point perspective, and stylistic developments in architecture can often be found foreshadowed, and are sometimes only traceable, in the perspectives of painters.

All the same, buildings in paintings are not interchangeable with actual structures, and the architecture in Raphael's earliest pictures has perhaps more in common with what he had seen in paintings than with the buildings he knew. We have seen that the setting of the Ansidei Madonna (Plate 25) is related to a formula of Perugino's, and that her throne if actually built would not be very comfortable. Some of the structures in the backgrounds of his early pictures, like some of the landscape features themselves, also resemble those in Northern prints or in Flemish paintings.

The actual architecture of Urbino did have its impact on him, though, even if he showed little detail interest in its ornamental style. Features of the Ducal Palace appear in his drawings[2] and its paired towers may have been in his mind when sketching landscape backgrounds like that in the cartoon for one of the predella panels of the *Coronation of the Virgin* (Plate 222).[3] The carefully drawn architecture of the foreground has elements, like the continuous moulding on the walls at capital level, which can be found in Perugino's settings, but the powerful volumes of the shaded columns (so much more monumental than the protagonists themselves) recall those of the imposing columns in the Duke's courtyard. The capitals too are like those of the courtyard, but at the same time the schematic way in which they are represented recalls as well the graphic procedure used for the foreshortening of capitals by Piero della Francesca, who had worked for the Duke, at least as a painter.[4]

A painter (and sculptor and engineer) who was actually employed on the architecture of the palace was Francesco di Giorgio Martini. The ducal mausoleum that he built at Urbino, the church of S. Bernardino, is reflected in the background

of the *Small Cowper Madonna* (Plate 34) and his drawings and, possibly, models of round temples may have influenced the design of a remarkable 'building' that plays a more important part in one of Raphael's compositions—the Temple of Solomon in the *Sposalizio* (Plate 24).[5] Calculation reveals its height to be well over fifty feet, but Raphael's Temple looks, in the distance, like a piece of jewellery. The impression is reinforced particularly by the ornamental scrolls of the buttresses, which would look absurd if executed on this scale (which they could not be in stone) and whose impracticality may be compared with that of the bizarrely dainty headgear of Perugino's heroes in the Cambio (Plate 60). However, if the scrolls are subtracted, the Temple is not implausible as a structure.

It is not known when Raphael became involved in the design of actual buildings. Architectural studies on the back of drawings made for a Florentine work, the *Madonna del Cardellino*, which underline his interest in Francesco di Giorgio's S. Bernardino, significantly include ground-plans, but they cannot be related to any recorded commission.[6] Nor, sadly, did anyone record the 'beautiful discussions and important debates' held in the house of the Florentine architect Baccio d'Agnolo, in which Vasari reports Raphael took a leading role.[7]

There is in fact little in his work (if we except the setting of the *Madonna del Baldacchino* (Plate 56), which he almost certainly did not design) to show that he was much impressed by Florentine architecture. He did, however, pay attention to the way Ghirlandaio had extended the space of Florentine monastic refectories by painting their end walls with frescoes of the Last Supper, in which the actual vaulting of the room was notionally continued in the painting.[8] Raphael's rare compositional drawing (or rather half-drawing) for a *Last Supper* (Plate 223) is clearly an essay on this theme, apparently combining it with dividing pilasters to be painted as supports for the real vault brackets, in a way reminiscent of Perugino's Florentine mural *Crucifixion*.[9] The sheet is also of interest as containing, at the bottom, an even rarer example of what must be the most elementary stage in his graphic preparation of a design—in this case a tiny notation of the table top surrounded by pin-headed participants, which can almost be thought of as a ground-plan.[10]

The verso of this sheet shows studies of an antique statue then in Rome.[11] Some of Raphael's 'pre-Roman' paintings, for example the Washington *St George* (Plate 6)

222. *Cartoon for the Annunciation* (one of the predella panels for Plate 23). Pen and wash over indications with a stylus, partly pricked for transfer, *c.* 1503, 28.5 × 42.2 cm. Musée du Louvre, Paris.

223. *Study for a Last Supper.* Pen and ink, *c.* 1508–9, 26.2 × 37 cm. Albertina, Vienna.

224. School of Marcantonio Raimondi, *Base of the Column of Theodosius in Constantinople* (from a drawing sent to Raphael). Engraving.

or the unfinished *Esterhazy Madonna*, also appear to contain references to Roman monuments.[12] It is hard to say from these references whether he had at this point actually been to Rome. Artists, as we have seen, had begun to make drawings of the city, and Raphael could have been familiar with them, at second hand.

Such drawings were keenly sought after, and were frequently copied, by other artists, and some of Raphael's own drawings of antiquities are, like Michelangelo's,[13] almost certainly copies. His appetite for this kind of information about antique art and architecture became immense. Even after settling in Rome his curiosity led him to retain the services of draughtsmen 'throughout Italy, in Pozzuoli and even in Greece'[14]—and a drawing of a column base in Constantinople made for Raphael survives in a print (Plate 224).[15]

Given this context, his famous drawing of the interior of the Pantheon (Plate 225) poses some complex questions. It was itself probably copied in one of the most celebrated sketchbooks of the period, the Codex Escurialensis, which left Italy by 1509, and if it had been made by Raphael on the spot this would point to his having been in Rome some time earlier. The drawing has been reworked by another artist, using a different ink, and it is these additions that detract from its accuracy—and also from its extremely economical, and effective, account of the complex system of the building's interior articulation. It is still possible, of course, that Raphael's drawing in its unaltered form was based on a drawing by another artist—and it is really only the handwriting which confirms that the sheet is his. But it does anyway indicate that he was interested in the monumental language of Roman architecture before he settled there.[16]

But even this does little to prepare us for the setting of the *School of Athens* (Plate 87), and it is not surprising that Vasari thought it the work of his fellow Urbinate, Bramante. Even though the height of the pilaster order has only been increased by about a seventh, compared with the Temple in the *Sposalizio*, there has been a massive increase in the sense of scale. This is partly because of the deft use of perspective, which leads one to relate Plato and Aristotle to the distant arch which frames them, rather than to the barrel vault which looms up at the top of the picture. The vault looks, from the way it is cut off by the frame, as if it might be covering the participants (and indeed the beholder) but in fact springs from a point just behind them. The sense of scale is also enhanced by the fact that the coffering of the barrel

vaults is based on that of the gigantic, ruined Basilica of Maxentius, then believed to be Vespasian's Temple of Peace.

A similar increase in scale, inspired by the architecture of imperial Rome, had taken place in Bramante's architectural imagination when he came to live in Rome a decade earlier, and the *School of Athens* is often compared with his plans for St Peter's, which were later characterised as a proposal 'to place the dome of the Pantheon on the vaults of the Temple of Peace'.[17] The busy relief of the walls, an effect heightened by the angle of view of the colossal statues in their niches, is hard to match in what we know of Bramante's work, but the only good reason to question Bramante's participation is the unbuildable way in which the curving pendentives, with their sculpted tondi, relate to the rectangular cornices below.[18]

Although the setting does relate well to the figures, they do not in fact occupy much of its space and it can be thought of as a detachable backdrop. For paintings of any earlier date such an analogy with the conventions of the modern theatre would be anachronistic, but these years did see the origins of the architectural perspectival view for stage sets. The one which Raphael himself painted in 1519 for the performance of Ariosto's *I Suppositi* attended by Leo X (who admired it through his eyeglass) showed a perspective view of the city of Ferrara.[19] The commonest type for the architectural stage set was a view of a city street or piazza, rather than an individual building, and the paintings of Raphael that come nearest to stage design are later than the *School of Athens*—the *Sacrifice at Lystra* (Plate 151) and the *Fire in the Borgo* (Plate 157).[20]

★ ★ ★

Bramante's—and Julius II's—ambitious project for St Peter's was just one of a series of grand schemes planned by them for the renovation of the Vatican in particular and Rome in general. This renovation, begun by earlier Popes, had reached a stage at which Raphael could appeal with some force (in his letter to Leo) to the size of 'all this new Rome of today . . . great, beautiful and adorned with palaces, churches and

FOLLOWING PAGES

228. Stefano Du Pérac, published by Antonio Lafrery. Detail from *A View of Rome*. Engraving, 1577, 79.4 × 100.7 cm (whole). British Museum, London.

225. Raphael (with additions, especially at the right, by another hand). *Interior of the Pantheon*. Pen and ink, before 1509, 27.8 × 40.6 cm. Uffizi, Florence.

226. Unidentified French draughtsman. *Drawings of (left) the street façade and (right) the entrance façade of the Chigi stables (designed by Raphael)*. Pen and ink, c. 1560. Metropolitan Museum of Art, New York.

227. Unidentified Italian draughtsman (sometimes attributed to Palladio). *Drawing of the now destroyed Palazzo Caprini (later Raphael's house, designed by Bramante)*. Pen and wash, c. 1550, 27.5 × 37.5 cm. Royal Institute of British Architects, London.

other buildings'. Much of the initiative for urban improvement came from Julius himself, who laid out important streets like the Via Giulia (Plate 228, n) and the Via della Lungara (Plate 228, q),[21] but it was necessary for other individuals to play their part in putting up buildings on them. This predominantly involved cardinals and other ecclesiastics at the papal court, whose disposition to build had been encouraged by dispensations making it possible for clergy to bequeath property, but there were also the great bankers, above all Agostino Chigi, who tactfully chose a site on the Via della Lungara for his villa (Plate 228, b). Visiting the building site at an early stage, Julius sceptically enquired if the villa (which was set back from the road) would be the equal of the palace being built by his cousins the Riarii, on the other side of the street but not set back from it. Stung, Agostino replied that his stables would be more elegant than their palace.[22] He bought some more land in 1510 and got Raphael to design the stable block. Raphael's rough sketch plan of the site is on the same sheet as figure studies related thematically to Chigi's *Galatea*. Building was in progress in 1514 and almost finished by 1518. The stables, like some of Raphael's other buildings, do not seem to have been very stoutly built. They had been mostly demolished by 1808, and only the ruined brick bases of the pilaster order in the Via della Lungara now remain.

But Chigi's boast had not been an idle one. The interior of the stables, of an advanced design and related to an idea of Leonardo's,[23] contained stalls for around forty horses, and the street facade, which is known from drawings (Plate 226), was as large and as stylish as the more magnificent palaces then being built. Raphael's design matched that of the main building of the villa, in that pilasters were used to articulate each storey, but he paired the pilasters as Bramante had paired the engaged columns on the facade of a building which was to become a model for Roman palace design—the now destroyed Palazzo Caprini (Plate 227). On Raphael's building, the pilasters of each storey were of a different order, the more robust Doric type on the ground floor supporting, as at the Colosseum and on some of Bramante's other architecture, a more delicate order, in this case Corinthian. Unusually, an attempt was made to make the orders conform to canonical proportions, and the ground-floor bases are closely modelled on those of the Forum of Nerva.[24]

All that is left of the street facade is brick and *tufa*, but Chigi's villa was noted for the splendour and variety of its marbles, and it is possible that the columns of the entrance portal to the stables were of marble (Plate 226). Their partial recession into

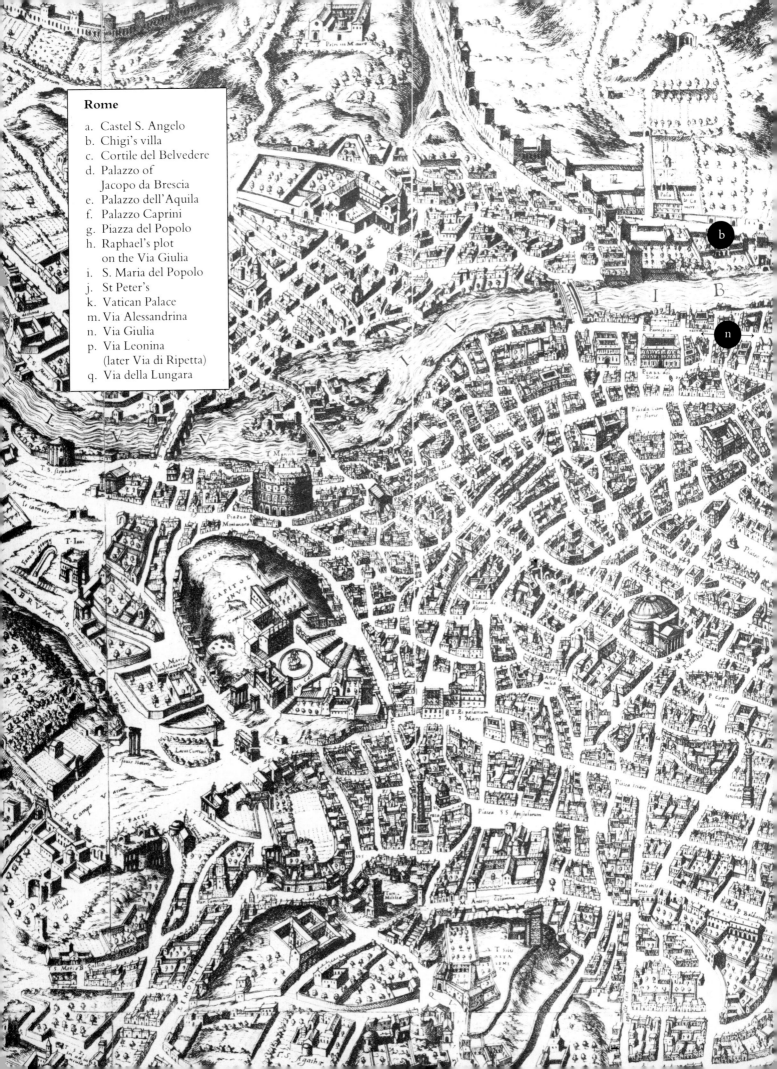

Rome

a. Castel S. Angelo
b. Chigi's villa
c. Cortile del Belvedere
d. Palazzo of
 Jacopo da Brescia
e. Palazzo dell'Aquila
f. Palazzo Caprini
g. Piazza del Popolo
h. Raphael's plot
 on the Via Giulia
i. S. Maria del Popolo
j. St Peter's
k. Vatican Palace
m. Via Alessandrina
n. Via Giulia
p. Via Leonina
 (later Via di Ripetta)
q. Via della Lungara

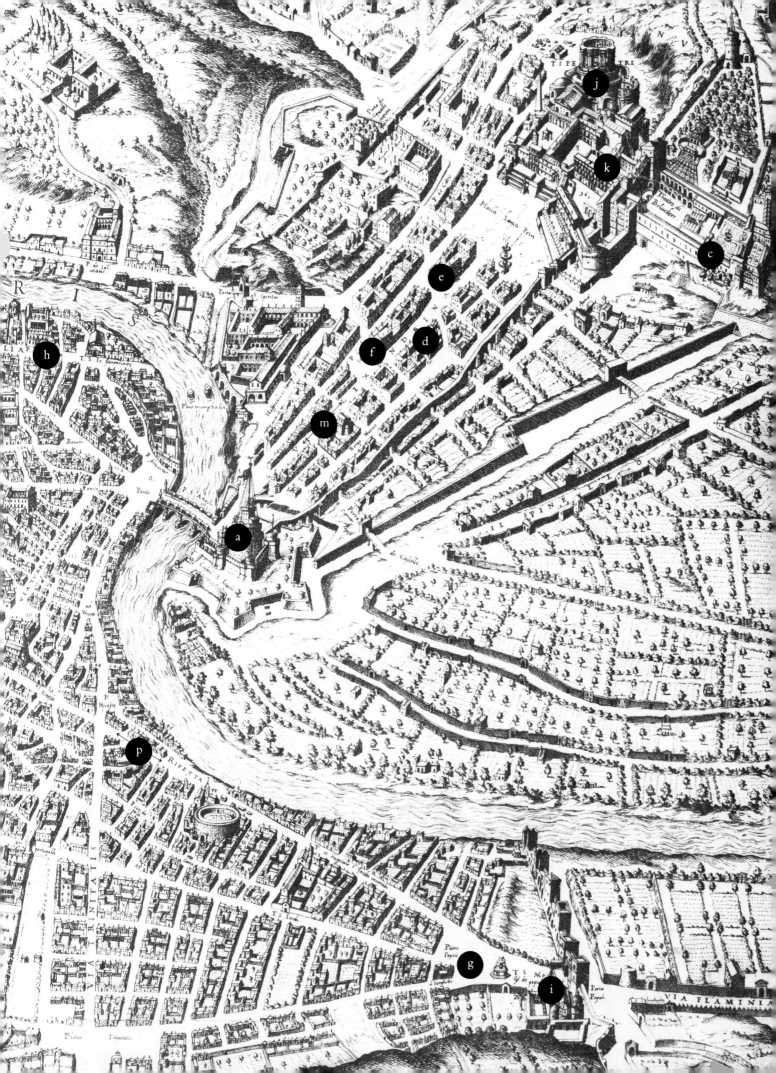

the wall was a significant innovation in contemporary architecture[25] and foreshadows the plasticity of Raphael's later work.

Chigi's conspicuously lavish life style not only kept up with the Riarii, but apparently caused Julius's successor to suggest ironically at a party held in the stable block in 1518 that he was, in effect, surpassing the Pope in magnificence. The story goes that Chigi had, for the occasion, decorated the interior with an unbroken row of silk hangings from Belgium, worked with gold and gems, but deftly disarmed Leo's feigned apprehension by drawing aside the hangings to show the humble role their present eating-place was designed to serve.[26]

We have already remarked on the colourful materials of Chigi's chapel in S. Maria del Popolo (Plates 119, 221), perhaps designed at much the same time as the stables. The chapel gives striking embodiment to the ideas on good architecture, and particularly to the attitude to Bramante, expressed in Raphael's letter to Leo. His respect for the master is shown in a very basic way, since the scheme by which the corners of a square plan are bevelled and set with paired pilasters, and a circular dome is set on pendentives above them, is a reproduction in miniature of Bramante's plan for the crossing of St Peter's and cannot be paralleled in the architecture of ancient Rome (Plate 118—a similar indebtedness is shown in Raphael's other small religious building, the much-transformed S. Eligio degli Orefici).

In other respects, each individual element 'seems close to the style of the ancients', especially to that of the portico of the Pantheon (Plate 229). The bases and superbly carved capitals of Raphael's pilaster order are almost identical, as is the way the pilasters at the entrance to the chapel are linked by horizontal white marble panels between their shafts. And, in Raphael's day, the Pantheon portico still retained its coloured marble panelling between these horizontal panels.[27] Today the visitor has to enter the Pantheon to appreciate the rich polychromy of its marble cladding, a feature which Raphael perhaps had particularly in mind when he complained that in Bramante's architecture 'the ornaments are not of such precious material'.

The marble panelling of the chapel walls was not unprecedented in recent architecture—the walls of Giuliano da Sangallo's Gondi chapel in S. Maria Novella in Florence had also been faced with coloured marble, as had the Duke's little chapel at Urbino and some buildings in Venice. Given the cost and availability of marble, however, monuments like these were rare, and a more common expedient had been to paint walls with imitation marble panelling, a tradition perhaps unbroken since antiquity, and notably exemplified in Giotto's Arena Chapel.

The most prized, and imitated, stones were the deep red porphyry, flecked with little pinkish-white spots, and the deep green serpentine, with little greenish-yellow flakes, whose value was not only aesthetic, but also depended on their associations, scarcity and durability—they are both extremely hard, and therefore expensive, to work. All that was available for use was what was left in the ruins of what the Romans had imported 'with infinite expense', respectively from Egypt and Greece.

Even a man of Chigi's means, prepared to pay 300 *scudi* for the monolithic granite step at the entrance to his chapel,[28] would have had to think hard about the cost of lining its walls with porphyry and serpentine, even if they had been available in suitably large pieces. Fortunately there were available in the ruins larger quantities, and larger pieces, of other more easily worked stones which were attractively coloured and also had the cachet of antique authority. The honey-coloured, or at times flesh-pink, *giallo antico*, the *africano* with its bruised patterns of dark green, red, black and white, and the deep blood-red *rosso antico* that can be seen in the chapel also grace the walls and floor of the Pantheon, and the use of these particular materials, with their characteristic colouring, marks a significant, almost concluding, stage in the recovery of the full richness of the language of imperial Roman architecture.[29] These marbles had not, it seems, previously been used in this way by architects in 'this new Rome', but were to become extremely popular, and it was probably this feature which made the chapel 'the most visited in Rome' in the seventeenth century. Raphael's example, which is not easy to reconcile with the attitude to the

229. *The portico of the Pantheon* (verso of Plate 225). Pen and ink, before 1509, 40.6 × 27.8 cm. Uffizi, Florence.

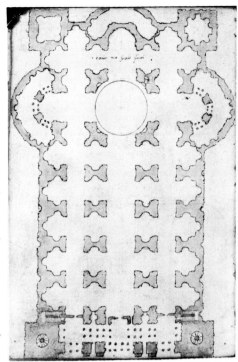

230. Domenico da Varignano (?) *Elevation and section of Raphael's project for St Peter's*. Pen and ink, *c*. 1516–17, 21 × 28.8 cm. The Pierpont Morgan Library, New York.

231. Domenico da Varignano (?) *Raphael's plan for St Peter's*. Pen and ink over indications with a stylus, *c*. 1516–17, 21 × 14.4 cm. The Pierpont Morgan Library, New York.

ruins of the city expressed in his letter, was thus a significant accelerating factor in a process which saw the transference of large quantities of stone from archaeological sites to the interiors of churches and palaces.

★ ★ ★

The initiative at the Chigi chapel may have been as much Chigi's as Raphael's, and represents a taste also shared by Leo, shown not only by the kind of work done at St Peter's in his pontificate,[30] but also by the fireplaces and door-frames in the Stanze which bear his name and which may also have been designed by Raphael. After the death of Bramante in 1514, Raphael became Leo's chief architect, in charge 'of all the things in painting and architecture that were being done in the [Vatican] palace'.[31] The latter task may have been quite a demanding one, and Castiglione noted how much Leo delighted in architecture and was 'forever having something new made in this palace'.[32]

After assuming, in April 1514, the appointment as architect of St Peter's, for which Bramante on his deathbed had recommended him, and for which he would receive 300 ducats a year, Raphael wrote that he felt it to be 'a great weight on my shoulders', but was encouraged by the fact that Leo liked the model he had promptly made showing how the building should be completed. He was also, in the first years of his office, sharing the responsibility with Fra Giocondo and Giuliano da Sangallo.[33]

In the papal Brief of August 1514 which confirmed the appointment, Leo envisaged that it would be built 'as magnificently and as quickly as possible'.[34] But in fact, despite the sale of indulgences to raise funds, which so irked Martin Luther, the pace of building slackened, and Leo showed considerable interest in projects less connected with the papacy and more with Florence and his family. Raphael was one of those involved in 1515 in his project to make a facade for the Medici family church in Florence, S. Lorenzo,[35] and later, in 1518, he was invited to submit a design for the church of the Florentine community in Rome, S. Giovanni dei Fiorentini, a project supported by the Pope.[36]

232. Bramante. *Unexecuted plan for St Peter's.* Pen and wash on parchment, c. 1505, 111 × 54.4 cm. Uffizi, Florence.

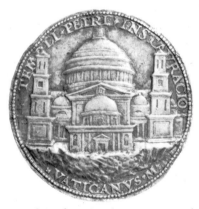

233. Cristoforo Caradosso. Reverse of portrait medal of Julius II, showing the *Projected elevation of St Peter's by Bramante.* Struck yellow bronze, dated 1506, 5.65 cm diameter. British Museum, London.

Much of what was built at St Peter's under Raphael's supervision was later demolished, when Michelangelo's plan was accepted. Nor does Raphael's model survive. But some idea of his intentions can be gathered from drawings produced for the project when he was in charge, and from a written criticism of his design by his successor and erstwhile assistant, Antonio da Sangallo. From the latter, and from the ground-plan preserved in an assistant's drawing (Plate 231), it is clear that Raphael took a decisive line on a problem that Bramante had left unresolved, at least in his first, partial, plan of the church (Plate 232)—whether the four massive piers of the central crossing, which were the first parts to be built, were to be part of a centralised or a longitudinal church. Perhaps as a result of Leo's interest in correct liturgical and ceremonial procedure, it was decided to make a church with one enormous main nave—which Sangallo criticised for being long, narrow, tall and poorly lit—'it will seem like an alley', he wrote.[37] A more sympathetic view would be that it was to have looked, in this respect at least, like the dark flickering interior of the Temple from which Heliodorus was expelled (Plate 132).

But the darkness of the nave Raphael planned was not necessarily an aesthetic preference. Bramante's plan was based on audaciously slender supports, and the thickness of Raphael's nave piers, and his closing up of the spaces in the arms of the crossing—modifications of Bramante's plan that would make it darker and which were also criticised by Sangallo—were doubtless primarily motivated by structural considerations. One of the things that had to be done after Bramante died was the reinforcement of the foundations.[38]

Raphael's plan for the facade (Plate 230) also retains many of the features Bramante had envisaged when the foundation medal (Plate 233) was cast. Some of his modifications were doubtless motivated by the desire to match its organisation with that of a longitudinally planned interior. The giant Corinthian order of the central, pedimented portico corresponds directly with the pilasters of the nave, as can be seen from the section on the right-hand half of the drawing, which 'shows . . . the correspondence between the height of the cornice on the facade with the inner parts'.

The words are quoted from Raphael's account of the purpose of an architect's section drawing in his letter to Leo which emphasised the need for an architect to use unforeshortened (i.e. orthogonal) projection in his drawings, using the painter's perspective only to 'improve his ability to visualise the whole building'. The foundation medal was clearly based on a foreshortened drawing, and indeed most of the architectural drawings of elevations and interiors which have survived from before Raphael's time are foreshortened rather than orthogonal projections. This, and the fact that Raphael was the first to write extensively about the question, has led to his being credited with an innovation in architectural practice of considerable magnitude—the introduction of the kind of elevations and sections which have since been taken for granted in the architectural profession.

The normal practice had been for the architect to produce a measured ground-plan and a three-dimensional model which could be used to explain the design to the patron. Details of the design could be conveyed by the architect to the builders during construction by means of models or drawings of individual features. But if the project were a particularly large one, and if the architect wished to exercise tight control over the design, this would take up much of his time.

The introduction of the type of drawings discussed by Raphael enabled the architect to plan a building in great detail but relieved him of the need to supervise its construction closely. It is clearly significant that while Raphael was its architect a new job was created in the workshop of St Peter's which had not existed under Bramante—that of *coadiutor*. It was performed by Antonio da Sangallo and it seems that one of his tasks was to produce the detailed measured drawings that Raphael's designs called for. Thus Raphael's architectural ideas could be developed in a quite sketchy manner, as in a rare autograph drawing for St Peter's (Plate 234), while the detailed drawings could be, and generally seem to have been, produced by assistants.

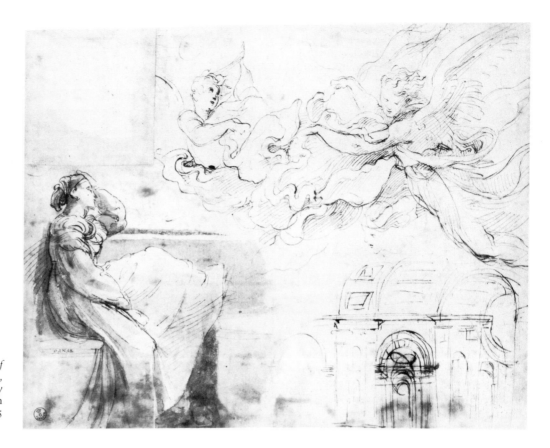

234. *Preliminary drawing for the Dream of Jacob on the ceiling of the Stanza d'Eliodoro, with a sketch of a seated woman and a study for St Peter's.* Pen and brown ink with some black chalk, *c.* 1513–14, 26.4 × 34.5 cm. Uffizi, Florence.

235. Probably Matteo dei Pasti. Reverse of portrait medal of Sigismondo Malatesta, showing the *Projected elevation of S. Francesco, Rimini, by Alberti.* Cast bronze, dated 1550, 4 cm diameter. British Museum, London.

The function of these detailed drawings may be compared with that of the finished *modelli* for paintings.

But to put this claim for Raphael's contribution in perspective, as it were, it should also be borne in mind that this was a time of considerable experiment in drawing techniques, particularly shown in the work of Peruzzi and Giuliano da Sangallo, and the picture is likely to be distorted by the accidental pattern of survival of drawings which were of no use after a building was constructed. Alberti had many years earlier briefly distinguished between a painter's and an architect's perspective, as indeed had Vitruvius, and the medal recording Alberti's design for S. Francesco at Rimini seems to have been based on an unforeshortened elevation (Plate 235). However, Raphael's insistence on the importance of the section drawing is novel, and the systematic approach implied by the use of such drawings is characteristic of his methods. His half-elevation and half-section in Plate 230 may be compared with his unusual half-drawings for figure compositions (e.g. Plates 70, 223).[39]

If we return to the actual project recorded in the plan and elevation, it will be noticed that Raphael's facade is much richer in the number and variety of its elements than Bramante's (even allowing for the compact presentation of the latter's project in a medal). This is particularly true of the bell tower at the side, raised by Raphael to equal the height of the cupola lantern. The piling up of elements here, although possibly suggested by the kind of buildings shown on Roman coins, foreshadows elements of Sangallo's later design which were to be criticised by Michelangelo for looking too much like Gothic architecture.[40] The exterior of Raphael's building was, however, to have been given an overall unity by the continuous succession of the columns of the small Doric order running round the building. It was an appropriately masculine order for the Church of St Peter, which Raphael also used for the Temple of Mars in the cartoon of *Paul preaching at Athens* (Plate 152). Its frieze here was to have contained the heraldic devices of Leo X.[41]

At the entrance, the plan shows that these exterior columns were to form the first row in a colonnaded vestibule, a formal type that particularly exercised the

217

imaginations of contemporary architects, impressed by the Pantheon and baffled by Vitruvius's recommendations on the subject.[42] Raphael's interest in the form showed itself also in the splendid vestibule that he designed for the *Healing of the Lame Man* (Plate 148), where the extravagantly ornate columns recall those which once framed the *confessio* in the interior of old St Peter's.

It is possible that Raphael intended to use some of the other marble columns from the old church for this facade entrance. The two *africano* columns which greeted the visitor on entering the still-undemolished part of the old church were particularly esteemed—an earlier, Venetian, Pope, Paul II, had declared them to be worth more than the city of Venice,[43] and Carlo Maderno re-used them on the facade eventually built for the new church. Michelangelo lamented Bramante's unnecessary destruction of some of the columns of old St Peter's,[44] and Raphael must certainly have appreciated them himself, since he imitated these *africano* ones in the foreground of the *Fire in the Borgo* (Plate 157), as part of his stage-set reconstruction of the piazza in front of old St Peter's, subliminally reinforcing the contemporary spectator's impression of being near the church.

In this view of the piazza, next to an accurate view of the facade of the old church Raphael set an imaginary building which develops in a most exciting way some of the themes in Bramante's architecture, especially the Palazzo Caprini (Plate 227). In the years that followed he was to make similar interventions in the actual architecture of the Borgo, providing designs for at least two palaces built by members of Leo's court, one of which, the Palazzo dell'Aquila, was to be built on the site of the flaming building on the left of the picture. For, as well as persevering with the rebuilding of the church itself, Leo also continued his predecessors' policy of encouraging the embellishment of the area between the church (Plate 228, j) and Castel S. Angelo (Plate 228, a). With his own palace, he enhanced the monumentality of the piazza by having Raphael complete, and add to, the loggias begun by Bramante (Plate 236). Above his private loggia was added another one, with an imposing row of thirteen granite columns.[45] In 1519 Raphael hoped also to install in the piazza one of the two granite obelisks which had just been found near the Mausoleum of Augustus. He offered to arrange it for 90,000 ducats, but the plan, which would have fulfilled an ambition of the fifteenth-century Pope Nicholas V and foreshadowed an important feature of later city planning in Rome, came to nothing.[46]

237. Palace of Jacopo da Brescia, Rome (photographed before transfer to its present site). *c.* 1515–19.

238. Marten van Heemskerk. *Drawings of (right) the side façade of the palace of Jacopo da Brescia and (left) Antonio da Sangallo's Banco di S. Spirito (or a project for it).* Pen and wash, . 1534–5, 13.5 × 21 cm. Kupferstichkabinett, Berlin.

236.(left) Marten van Heemskerk. *Panorama of St Peter's and the Vatican Palace, from the Piazza of St Peter's.* Pen and ink, 1534–5, 27.6 × 62.3 cm. Hofbibliothek, Vienna.

The piazza was connected to the bridge next to Castel S. Angelo by a main street which had been laid out by Alexander VI the year before the Jubilee of 1500, in anticipation of the pilgrims. Known as the Via Alessandrina, it was a prime site for the impressive palaces built by members of the papal court (Plate 228, m). The trickle-down of ecclesiastical funds was now so great that not only cardinals but also lesser members could afford, and were encouraged, to build. Probably the first of the palaces designed by Raphael was for Leo's doctor, Jacopo da Brescia, who acquired a site on the Via Alessandrina in 1515 (Plates 237, 228, d).[47] It was built by 1519 and still survives, but not on its original site. It was dismantled and re-assembled a few blocks away during the disastrous urbanistic initiative of Mussolini which turned the street into a boulevard.

More obviously than the Chigi stables or the building in the *Fire in the Borgo*, this palace is a variant of the Palazzo Caprini (Plate 227), which stood on the same street (Plate 228, f). Both have a rusticated ground floor which provided premises for

219

239. Unidentified Italian draughtsman. *The (now destroyed) Palazzo dell'Aquila, Rome* (the width of the palace somewhat exaggerated). Pen and wash, 16th century, 24 × 34 cm. Uffizi, Florence.

shops; and above it the main floor (*piano nobile*) reserved for the owner, its facade articulated by a Doric order and heavy pedimented windows. Raphael's site was an awkward triangular one, and he did the best he could to obtain a practical disposition of the rooms, but the greatest ingenuity was devoted to giving the building an imposing presence in the Via Alessandrina, and in particular to address those coming down the street from St Peter's, who would see it at an angle, as in Plate 237. On the short side facade, a sculpted lion with a ring in its mouth supported a huge display of the arms of Leo X, whose generosity was declared in an inscription of *cipollino* marble. These do not survive, but were recorded in a drawing by Marten van Heemskerk, who also noticed that the facade resembles Antonio da Sangallo's slightly later one for the Banco di S. Spirito, both being related to ancient ideas of the triumphal arch (Plate 238).

An oblique view of the long facade shows the windows of the *piano nobile* to monumental advantage. These are more exciting rhythmically than those of Bramante's palace, since Raphael adopted the alternation of segmental and triangular pediments that he could see exemplified at the Pantheon, or at the Farnese palace then being built by Antonio da Sangallo. He also devised a remarkable trick for making the building appear longer than it really is. One would naturally assume that all five window bays were as wide as the first one, but in fact they diminish in width the further away they are. This perspective device, which involved a most irregular difference in the number of metopes in the frieze above the other windows, is an extension of Bramante's idea for the terraces of the Belvedere (Plate 258), where in the most distant section the height of the pilasters progressively diminishes in real

terms, exaggerating the impression of perspectival recession. Both are striking instances of the advantages for architecture of the painter's eye. The Palazzo Caprini had also deceived the beholder, since its columns and rusticated blocks were not of stone but a cast imitation, 'a new invention' of Bramante's.[48] On the other hand, the rustication of Raphael's palace dramatises the size and roughness of the real blocks of which it was composed.

Further up the Via Alessandrina, where it led into the piazza, the street widened out and, unusually, had a wide pavement as well. This meant that when Raphael came to design a palace here for Giovanni Battista Branconio dell'Aquila, Leo's chamberlain and keeper of the Pope's elephant, he was able to design its facade from the point of view of one who could stand back to admire it, and he placed the papal arms at its centre (Plates 239, 228, e).[49]

There was certainly a lot to admire, for it was among the most festively decorated buildings of its day. It was later demolished as part of Bernini's plans to enlarge the piazza and can now only be appreciated from literary and graphic sources (Plates 239–40). They give a suggestive idea of its richness, but much is still lost, since a significant part of its effect was provided by figural decoration which was not recorded in detail. On the *piano nobile* were niches, some filled with (antique?) statues, and above them portrait medallions framed by swags (executed in stucco by Giovanni da Udine),[50] while the top floor had a series of painted scenes which can barely be deciphered.

Like Chigi's villa, an increasing number of palaces were being decorated in this fashion—it was a cheap way of imitating the kind of sculptural decoration so much admired on triumphal arches and storiated columns, and has parallels of both form and purpose in the exuberant temporary festival architecture then built for special public celebrations like the *Possesso*. Most of these decorations have perished, but descriptions of them suggest the range of subject matter that might have been displayed on the Dell'Aquila facade. One, in particular, was designed by Raphael for another palace in the Borgo and executed by Vincenzo Tamagni. It included, along with 'most beautiful nude figures [*ignudi*], statues and other stories,' representations of the Cyclopses making thunderbolts for Jove, and Vulcan making arrows for Cupid. It was the palace of Giovan Antonio Battiferro, a cousin of Raphael's, and, as Vasari explains, these subjects alluded to his name,[51] which in English would have to

240. Unidentified Italian draughtsman. *Section of the (now destroyed) Palazzo dell'Aquila.* Pen and wash, 16th century, 27 × 19.5 cm. Biblioteca Nazionale, Florence.

241. Cherubino Alberti. *Part of the Sistine ceiling frescoed by Michelangelo, including the Libyan Sibyl and the prophet Daniel.* Engraving, 1577 (this edition 1628), 42 × 54 cm (image). Victoria and Albert Museum, London.

242. Giulio Merisi da Caravaggio (?) Courtyard of Palazzo Spada, Rome. *c.* 1550–5.

be translated as 'Smith'. Thus, since *aquila* was the Italian for an eagle, on Dell'Aquila's facade the papal arms were flanked by eagles—and a suitable subject (which may in fact have been represented in the third panel from the left at the top) would have been the Rape of Ganymede. But Christian subjects might be included too and, in drawings of the palace,[52] the second panel from the left looks very like a *Baptism of Christ*, a subject particularly dear to Giovanni Battista (John Baptist) Branconio and one which he seems to have had depicted, rather unusually, in the background of an altarpiece of the *Visitation*, which was painted for him by Raphael's workshop.[53]

The reference to '*ignudi*, statues and . . . stories' on Battiferro's facade may bring to mind another work which shares with the kind of decorations we have been discussing an interest in emulating the Arch of Constantine's grand ensemble of architecture, figures and narratives—Michelangelo's Sistine ceiling (Plate 241).[54] But Raphael's Dell'Aquila facade remained above all a piece of architecture, and what distinguished it from a later, surviving, building, which it influenced, the Palazzo Spada (Plate 242), was the way in which all the elements were bound together in a framework that was highly ordered but at the same time rich in the variety and complexity of its rhythm. This comes out most obviously in the relationship between the three main levels of the facade. Raphael abandoned the strict vertical continuity favoured by Bramante (Plate 258) and others, in which a solid vertical element like a column or pilaster would be matched in the floor above by another solid vertical. Instead, above the columns of the ground floor, in the corresponding place on the next level is a niche, and above this is another, wider, framed element. The gradual expansion in width of the elements above the columns is complemented by a gradual diminution in the width of the framed openings, so that above the round arches of the ground-floor shops are narrower window tabernacles, themselves wider than the window frames above. There is thus an increasing emphasis on horizontal continuity and regularity as one looks up at the ascending levels, though even the novel and highly influential crown of the building—the open, and at first sight completely regular, balustrade—retains vestigial vertical divisions. The levels gradually diminish in plasticity and volume the higher up they are, but increase in the complication of the figured ornament.[55]

This latter feature is an extension of the antique principle by which at the Colosseum the orders of the ascending levels become slighter, but more ornate, with the succession Doric, Ionic, Corinthian.[56] For the more general lack of obvious vertical continuity within a system which nevertheless does have an overall vertical rhythm, the best comparison is with the complex system of the Pantheon's interior, which had not been made obvious in Raphael's early drawing (Plate 225).

The architecture therefore 'seems close to the style of the ancients' in principle as well as in detail, but, to adopt a linguistic metaphor, the conventions of the classical language have been used to make a completely new statement. Real languages and the language of classical architecture in different ways both embody sets of rules, and it is indicative of the depth of Raphael's understanding of Roman architecture that his research into the 'one principle' which lay behind all the ancient buildings in the city did not result in a pedantic following of archaeological precedent. He valued also the quality of 'grace' (*grazia*) which he detected in it. He did not define the term himself, but for Vasari it seems to have involved 'a certain licence'.[57]

At the Dell'Aquila palace, there is an obvious inconsistency between the Doric order of the courtyard (Plate 240)—which shows, by the relation of window frame to half-column, how familiar he was with the exemplary Doric of the Basilica Emilia in the Forum (Plate 220)—and that of the facade, where the Doric columns lack the conventional frieze of barred triglyphs and decorated metopes above them, but do have the little suspended guttae which belong with such a frieze. It is as if, in the interests of unifying the different levels, Raphael has squashed them together. However, Roman architecture was itself 'licentious' and an archaeological precedent for this elision did exist in Rome.[58]

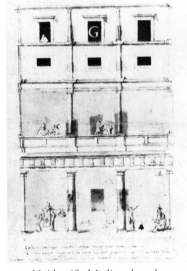

243. Unidentified Italian draughtsman. *Elevation of the entrance wall of the courtyard of the (now destroyed) Palazzo dell'Aquila*. Pen and wash, 16th century, 27 × 19.5 cm. Biblioteca Nazionale, Florence.

244. Baladassare Peruzzi. Courtyard of Palazzo Massimo alle Colonne, Rome. Begun 1533–5.

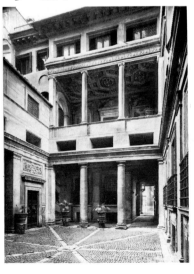

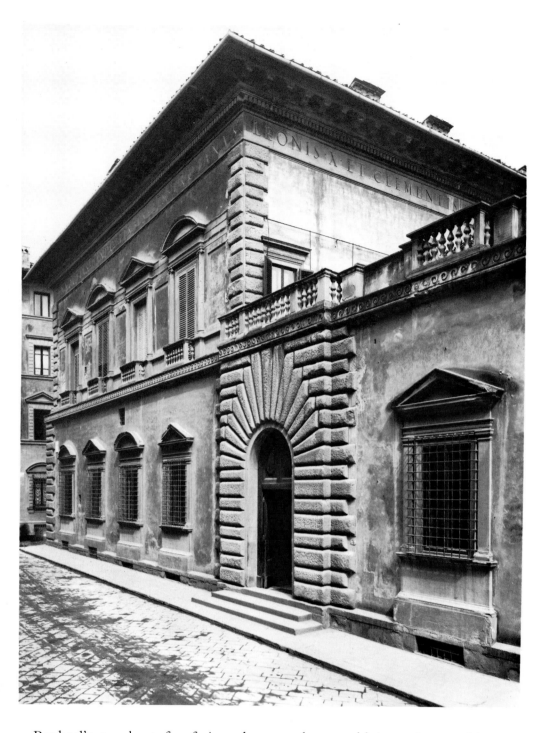

245. Palazzo Pandolfini, Florence. Begun *c.* 1515.

Raphael's penchant for fusing elements that would in antique architecture normally be kept separate is more evident in the side facade of Jacopo da Brescia's palace (Plate 238) and in the interpenetration of window and door in the Vatican loggia (Plate 212). The latter is a vivid example of the wilfulness which Michelangelo was to take to much greater lengths in his design for the Medicean library at S. Lorenzo in Florence. This kind of licence is to be distinguished from the capriciousness of earlier *all'antica* architecture, well exemplified by Donatello, by the fact that the 'rules' were now much better understood, thanks to the systematic archaeological research undertaken by Raphael and his contemporaries.

The courtyard of the Palazzo dell'Aquila, small in area and compact in design, but with its columns generating a powerful sense of plastic volume in the lower section, looks impressive in the drawings made of it (Plates 240, 243).[59] A sense of what it must have been like can now be experienced only in palaces which it influenced, like Peruzzi's Palazzo Massimo alle Colonne (Plate 244).

The pedimented window tabernacles of the Dell'Aquila facade were used by

Raphael in an almost identical form for the facade he designed, some time after 1515, for a palace which is otherwise quite different in the degree of its ornament (Plate 245). It was built in Florence under the supervision of members of the Sangallo family for Giannozzo Pandolfini, Bishop of Troia.[60] The marked difference in style, which shows the variety and flexibility of his approach, is perhaps due to the different fashions then prevailing in Rome and Florence. Despite Alberti's example at the Rucellai palace, around 1460, Florentines had been reluctant to use the orders to decorate palace facades, and Raphael's failure to do so here may represent a concession to Florentine restraint in the visible expression of family status. Florentines seem to have been acutely sensitive to such stylistic issues, and stuck abusive graffiti on the palace of the Bartolini family, built around 1520 with orders and rectangular pedimented windows on the facade, saying that it looked more like a church than a palace.[61]

It is an indication of Raphael's own growing status that he was himself able to acquire a distinguished palace. In 1515 he was buying up property in the Borgo.[62] Perhaps he was accumulating land for the construction of a new palace, but in 1517 he paid 3,000 ducats for the building on the Via Alessandrina he had so much admired, the Palazzo Caprini (which had been built for the apostolic protonotary Adriano Caprini).[63] He lived there till he died, but he was soon not satisfied with it and in 1519 started designing a palace to be built on a prominent site he had acquired on the Via Giulia (Plate 228, h), which would have rivalled those of some of the senior ecclesiastics, if not the greatest cardinals, at the papal court.[64]

Informative drawings of his ground-plans for this palace survive (Plates 246–7). The irregularly shaped site had a good frontage on the street, and Raphael again gave careful thought to the impression it would make in what was intended to be one of the city's most distinguished thoroughfares. The two longer sides were of quite different lengths, and he intended to regularise their appearance with another perspectival trick, by dividing their facades into an equal number of window bays. The site also formed an acute angle at the junction of these two sides, and his proposed cutting off of the corner would not only minimise the awkwardness, but also enable him to present a monumental aspect towards S. Giovanni dei Fiorentini, which was to be built diagonally opposite. It seems that all four walls of the palace were to have had a giant pilaster order, rising the full height of the *piano nobile*, a grandiloquent feature unprecedented in private palace design.

Raphael showed exceptional ingenuity in the organisation of the interior spaces.

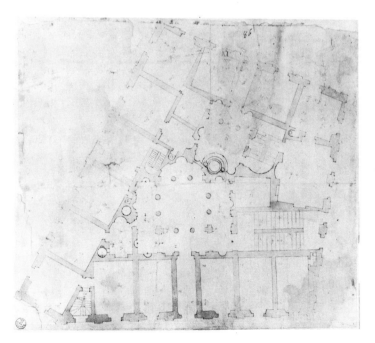

248. Villa Madama, Rome. Begun
c. 1518.

246. Workshop of Antonio da Sangallo
the Younger. *Copy of Raphael's project for
the ground floor of his palace in Via Giulia.*
Pen and wash, c. 1519–20. Uffizi, Flor-
ence.

247. Workshop of Antonio da Sangallo.
*Copy of Raphael's project for the first floor of
his palace in Via Giulia.* Pen and wash,
c. 1519–20. Uffizi, Florence.

Undeterred by the awkward shape of a site that was not especially large, he found
room for two separate palatial establishments in one block, each with its own
monumental colonnaded courtyard, the visitor to each of which might assume the
owner to inhabit the whole block. But it was not all for show. The arrangement of
the rooms was highly practical and involved the most advanced modern
conveniences, particularly in his own part, the larger of the two, occupying the two
longer sides. These included not only the by now customary inside lavatories, which
can be seen on the plan of the first floor, but also a bathroom (*stufa*) with a curvaceous
bath plumbed for hot and cold water. The heart of the palace for Raphael would
have been his small *studio* on the *piano nobile*. Off one of the north-facing rooms, it
had its own lavatory, was not far from the *stufa*, had convenient stairs down to the
shops on the ground floor, which were perhaps intended for use by members of his
workshop, and had a window through which he could keep an eye on his
neighbours' courtyard—a privilege they did not share.

But it was never built. If it had been, it would have been the most impressive, but
not the first, example of what became a remarkable if minute genre—the artist's
house, designed by himself. An earlier artist who had also achieved exceptional
status, Mantegna, had built himself an original house at Mantua on a somewhat
smaller scale.[65] Giuliano da Sangallo had built one in Florence, and more were to be
designed in Rome by architects following their example.[66] Such buildings could be
ideal advertisements of the talents of their occupants.

225

The colossal order Raphael designed for his facade would have harmonised with that apparently intended for a much larger building in progress further down the Via Giulia, the great Palace of Justice, projected by Julius II and designed by Bramante as the central landmark on the new street.[67] This project of his predecessor's was not one which Leo made much effort to continue. He did not neglect the Via Giulia (encouraging building, however, at the end inhabited by the Florentine community), but his interest in improving, and impressing the Medici stamp on, the fabric of the city was more obvious elsewhere. An exceptionally wide new street, for a time known as the Via Leonina (now the Via di Ripetta—Plate 228, p) was laid out as part of a scheme to facilitate access to the Vatican and other quarters from the main entrance to the city from the north, the Porta del Popolo. It also led, in particular, directly to S. Luigi dei Francesi, the new church being built for the French community, which Leo had particular reason to honour. It was one of two straight streets apparently projected at this time to link up with the main north–south thoroughfare, the Corso, and the trident they created, radiating out from the newly designed Piazza del Popolo, is still one of the most distinctive large-scale patterns imposed on the city map (Plate 228, g).[68]

A plan for the area, involving the Via Leonina, the Corso and the Piazza del Popolo is described in a document as having been provided by Raphael, Antonio da Sangallo, the officials of the Apostolic Camera, and the *maestri di strada*, the officials in charge of urban projects.[69] Raphael's precise contribution to this plan is not specified. Since the document shows that he did not have executive responsibility, which fell to Sangallo, he must rather have been one of the brains behind it.

★ ★ ★

Raphael's ability to think big in architectural terms is most evident in his unfinished masterpiece—the Villa Madama, which involved him in designing a large building of complex spatial organisation and setting it with landscaped gardens on an extensive site, not far to the north of the Vatican, on the slopes of Monte Mario. It was a project of Cardinal Giulio de' Medici, but one in which his cousin Leo X took a strong personal interest, visiting the site during construction and perhaps providing some of the funds. It was never completed, but Raphael had thought out the design in detail by 1518 and significant progress had been made by the time he died.[70]

An almost entirely unforeshortened elevation by Raphael (Plate 249) for an attractive but fairly small villa, with some traditional details suggestive of fortification, has been thought to represent an earlier plan simply to remodel an existing villa on the site.[71] But its Medicean emblems—the series of balls and the diamond ring on the balustrade—would have been equally suitable if this were intended for another villa altogether, to be built by a supporter of the Medici. Baldassare Turini, Leo's datary (and creditor), was also a building one at this time (the Villa Lante on the Gianicolo), and Raphael, who may have been involved with this, too,[72] could have made the drawing for him. At any rate the villa for the Pope's family was to be much grander.

The design of many of the palaces of Raphael's day, including his own, was strongly influenced by a desire to re-create the ancient Roman house as described in the literary sources. His plan for the Villa Madama was also very much a literary enterprise, drawing extensively on accounts of ancient Roman architecture and particularly on the letters in which the younger Pliny described his villas at Tusculum and Laurentium. It is therefore appropriate that we should be able to acquire the most detailed understanding of Raphael's intentions from a recently discovered copy of a letter of his, describing the villa in Plinian terms[73] (a translation is given in the Appendix).

249. *Design for a villa.* Pen and wash over indications with a stylus, *c.* 1516–20, 25 × 36.2 cm. Ashmolean Museum, Oxford.

FOLLOWING PAGES

250. (top) Garden loggia, Villa Madama, Rome, Begun *c.* 1518.

251. (bottom) Fishpond and garden loggia, Villa Madama, Rome.

252. (facing) Raphael (with decorations by Giulio Romano and Giovanni da Udine). Garden loggia, Villa Madama, Rome.

In the form of a guided tour, the letter opens as if the villa actually existed, but it is clear from what follows that Raphael is really describing something as yet unbuilt. His assistants' drawings (Plate 272–3) show that the design underwent considerable evolution, and the letter represents an intermediate stage of its planning. The ground-plan in Plate 253 combines material from the surviving drawings to give an idea of the project described in the letter.[74]

Raphael begins by stressing that his orientation of the villa's buildings is the healthiest possible, given the site and the way it is exposed to the elements. The arrangement also has the virtue that its central, shorter axis, up the hill, is directly aligned with the Tiber bridge at the bottom. A new, straight road was to be built between them (Plate 253, ref. 2).

The villa was to present a monumental facade to those arriving by this road (3), but the tour begins at the principal entrance, that of the long, horizontal axis, approached by the road from the Vatican (1). Two round towers, grand and beautiful but also defensively functional, were to flank a Doric portal (6), through which the visitor passed to enter a courtyard (7) 22 Roman *canne* long (about 49 metres) and 11 *canne* wide. It is clear from the letter that Raphael was interested in proportions, but he does not explain the choice of these unusual numbers. More multiples of 11 are found in the earlier drawing (Plate 272) and perhaps they were intended to gratify Leo X, who was superstitiously attached to the number.[75]

From the courtyard Raphael takes the visitor through a three-aisled colonnaded vestibule 'in the antique style' (8) and an atrium 'in the Greek style' (9) and has a quick look at the central, round courtyard (10). Returning to the first courtyard, we find that the (less salubrious) area between it and the hillside has been set aside for service rooms, while on the other side, but not visible from the courtyard, is a private garden of orange trees with a fountain (11) and a loggia (12), which will catch the sun and is for use in the winter. A notable feature here is that the round tower at the corner of the garden (4) was to have glass windows all round offering a panoramic view of the countryside. 'It will be a most pleasant place in winter for civilised discussion—the customary function of a *diaeta* [the unusual word is one much used by Pliny and interpreted by Raphael to mean a place of private recreation].' Access to the private garden was from the main suite of state rooms

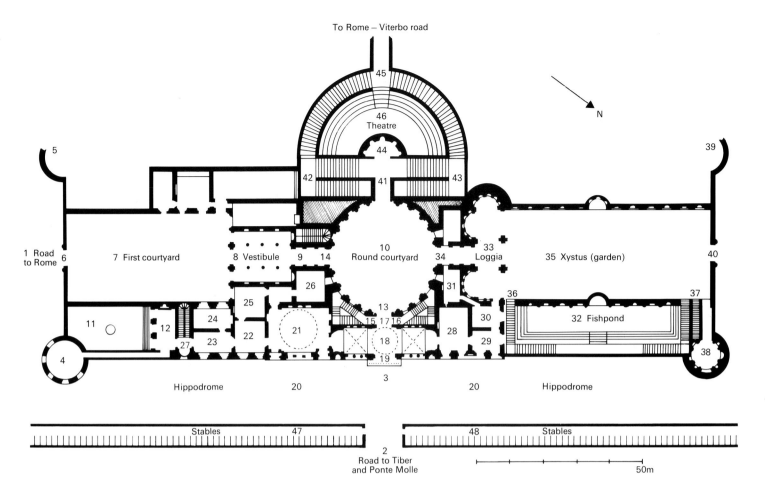

To Rome – Viterbo road

45

46
Theatre

N

5

39

44

42

41

43

1 Road
to Rome 6

7 First courtyard

8 Vestibule

9 14

10
Round courtyard

34

33
Loggia

35 Xystus (garden)

40

26

31

36

37

25

13

30

32 Fishpond

11

24

15 17 16

21

28

29

12

22

18

27

23

19

38

4

3

Hippodrome

20

20

Hippodrome

Stables

47

48

Stables

2
Road to Tiber
and Ponte Molle

50m

(21–6). Raphael takes us to them via the round courtyard (10), pausing en route to describe the grand Doric loggia of the long facade, with its imposing view out over the country (18). He also takes us through the rooms on the other side of the loggia (28–31). In both sections he emphasises not only the rooms' proportions but also their lighting, and designates some for use in summer and others for winter.

Returning to the round courtyard, we continue along the villa's long axis and enter a section which was eventually built. This includes the 'most beautiful loggia' which was sheltered from the sun and included the summer *diaeta* (33 and Plates 252, 254). It gave onto a garden terrace (35) the same size as the first courtyard. This garden too was planted with trees, and Raphael uses the Vitruvian term *xystus* to describe it. It overlooks a fish pond (32 and Plate 251) which was functional but also a delightfully cool place to sit and dine by. Another round tower (38) was also intended, but never built, at the end, to match that of the principal entrance. It was to house the villa's chapel, in the form of a round temple. Complementary to this was a round defensive tower by the hillside (39), so this end of the villa's buildings would match the main entrance.

Raphael does not discuss the decoration of the loggia, although it was evidently a high priority for Cardinal Giulio. It bears his, and not Leo's, heraldic devices and seems for the most part to have been executed after Raphael's death by the workshop. With the master gone, dissension arose about the distribution of labour between Giulio Romano and Giovanni da Udine, the 'madmen', as the cardinal called them in June 1520. He proposed to settle it by having Giovanni do the stuccoes and Giulio do the paintings, or at least design them for Giovanni to execute. At the same time, he desired that the subjects be well-known stories from Ovid, and not from the Bible—'There should be enough Old Testament stories at the Pope's loggia [in the Vatican]'.[76]

All this shows that the decoration had not been planned in much detail before Raphael died, but there can be little doubt that as the artist responsible for the

Vatican loggia (Plates 209–15) he would have approved of the stucco here, which is equally beautiful but in deeper relief, and the painted decoration, both of which harmonise perfectly with the architecture.

This loggia, like those of Chigi's villa, was not originally sealed off from the garden, and the intimate relationship between the two is shown in Heemskerk's drawing (Plate 254), which also shows something else not mentioned in Raphael's letter, that the niches and the loggia itself were eventually filled with sculptures.

Inside the loggia, the scale and magnificence of the grandest Roman architecture can be experienced as in no other building erected since antiquity. The whole can never be perceived at once, but the spaces all flow into each other because of the emphasis on the hollowed surface of domes and semi-domes, apses and niches. The wall is all important and the pilasters appear as projections of it, rather than applied to it, their capitals continued as a frieze (a constant theme in Raphael's architecture). On the comparatively flat exterior of the loggia (Plate 250) the distinction between pilaster and wall is also minimal, as if Raphael was trying to emphasise the planar volume of the villa's main block, his interest in curving forms confined to the boldly swelling pulvination of the friezes and plinth (Plate 256).

The architecture of the round courtyard, to which Raphael returns us, is quite different (Plate 255). The impression of plasticity and powerful rhythm is no less great than inside the loggia, but here there is almost no wall surface visible, only the brick and *tufa* column shafts (still not clad in stucco) of the windows alternating with the larger cylindrical volumes of the never completed giant order pressing forward between them. This courtyard was initially conceived as a rectangle (Plate 272) but in its round form would have provided a central focus for the complex, bringing into dynamic balance the unsymmetrical grouping of spaces on the two main axes of the villa.

Raphael does not put it this way, but it is implicit from the fact that he now goes on to describe the features of the villa's other axis, that running up and down the hill. At the hillside edge of the circle he first indicates a semicircular fountain set into the hill and equipped with seats for use as a *diaeta* in extremely hot weather (44). The rustic decoration with sea shells proposed here (and carried out in one of the garden fountains) was to become enormously popular in Italian grotto design later in the century.

253. Reconstruction of the plan of the Villa Madama as described by Raphael in his letter, on the basis of drawings by his assistants (Plates 272–3), and indebted to interpretations published by John Shearman. The numbers are keyed to the translation of the letter in the Appendix.

254. Marten van Heemskerk. *View of the loggia and garden of the Villa Madama, Rome.* Pen and ink, *c.* 1534–5. 13.6 × 21.1 cm. Kupferstichkabinett, Berlin.

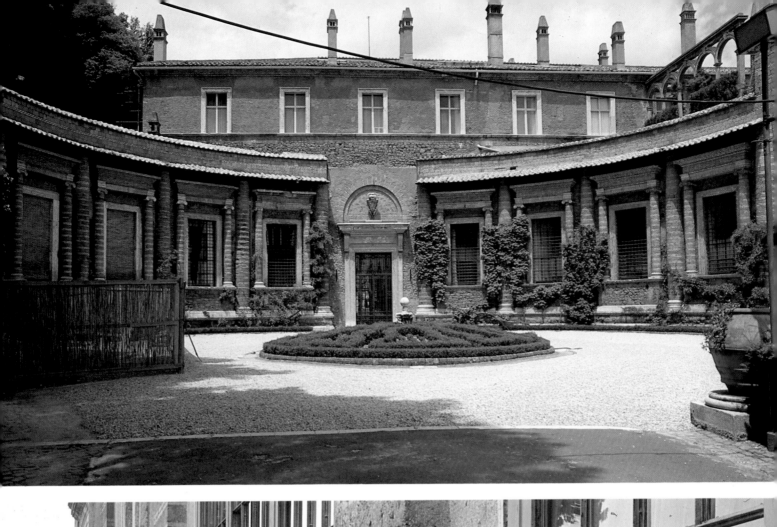

255. Unfinished round courtyard of the Villa Madama, Rome.

257. Probably Raphael. *Plan of gardens for the Villa Madama, Rome.* Pen and ink, c. 1518–20, 53 × 37.7 cm. Uffizi, Florence.

258. G.A. Dosio. *View from the Vatican Palace of the Cortile del Belvedere (designed by Bramante).* Pen and ink. c. 1558–61, 22 × 33 cm. Uffizi, Florence.

256. (left) Detail of the basamento of the garden loggia, Villa Madama, Rome.

Comfortably inclined stairs were to lead up from it to a larger semicircle, forming a theatre sheltered from the sun (46). Raphael's description of its proportions and his terminology show his familiarity with Vitruvius's prescriptions for the theatre,[77] though the way it was to be set into the hillside may, like the forms of the fish pond, have been suggested by the remains of Roman villas at Tivoli.[78] Raphael envisaged that it would have moveable painted scenery, and was particularly concerned that there should be a good view of the country when plays were not being performed.

Moving down again, Raphael observes that the main living rooms are set apart from the hillside for reasons of health, passes over the facilities to be built below the main floor and invites us to consider the vast hippodrome, or exercise ground for horses, planned to stretch the whole length of the villa (20) and to be supported by an embankment, the building of which would also conveniently provide sheltered stabling for four hundred horses (47–8).

Visitors coming on the road from the Tiber bridge would, after crossing the hippodrome, arrive at a Doric portal below the grand loggia of the main floor. Entering, they would find a basement—for which Raphael uses the Plinian term *cryptoporticus*—also decorated with a fountain and giving access to the villa's lower level. The principal feature here was to be an unusually extensive and sophisticated bathing establishment. Raphael was evidently proud of its plumbing (a subject of particular interest to Cardinal Giulio).[79] There were also to be further kitchen facilities here, and stairs up to the next floor and to the living quarters of the large household at the top.

Raphael breaks off the letter rather abruptly here, with the observation that 'the grounds of the villa abound with trees . . . but I will not labour to describe them'. Perhaps he was tiring of literary composition, for he certainly thought the rest of the grounds worth labouring on, and what may be his only autograph drawing for the villa is a plan of a series of intriguingly shaped parterres, to be laid out on the slope below the eastern tower (Plate 257).

The elaborate project conveyed in Raphael's letter is highly original, but also, needless to say, a development of earlier ideas. We have already noted its Plinian character. The literary flavour would have appealed to Leo, who owned a copy of Pliny's letters, though the villa was predominantly the project of Cardinal Giulio and was called the 'Villa Iulia Medica' in a parallel literary enterprise of 1519, a long

Latin poem by Francesco Sperulo describing it.[80] One of the earliest buildings which perhaps shows signs of Plinian influence was the Ducal Palace at Urbino.[81] It is not of course a villa, but it does have features that must have informed Raphael's thinking—most obviously, the paired round towers of the entrance facade and, less demonstrably, the great importance attached in the design of the building to the view of the countryside. Pliny's ideas had also found some expression in actual villa buildings, perhaps most significantly for this Medicean project in the earlier Villa Medici at Fiesole, where the arrangement of a loggia looking out over a terraced hillside with stables below prefigures the Villa Madama.

The Villa Madama, however, is a more extensive and complicated project than this, and incorporates other ideas than those of Pliny. The theatre is Vitruvian, and so is the sequence of vestibule and atrium, which Giuliano da Sangallo had adopted in 1488 for his design for a palatial villa of more directly comparable magnificence, for King Ferdinand I of Naples.[82] But the project which the Villa Madama was perhaps most consciously intended to rival, and one much closer to hand, was the Vatican Cortile del Belvedere, designed by Bramante for Leo's predecessor, with its hillside terraces and spaces for theatrical productions (Plate 258, 228, c). It seems to have been a conscious emulation of the villas of the Roman emperors coupling features drawn from historical descriptions of, for example, Nero's Golden House with imitations of surviving ancient buildings of all types.[83]

Raphael took this a stage further, and his design is much more sophisticated, rich and Roman than Bramante's, both in the variety, complexity and compactness of its spatial organisation and in the way this relates to Roman building practice, studied intensively by him in the city's ruins.[84] The modern visitor's impression of Roman authenticity is particularly reinforced by the fact that Raphael's building is, like the ancient ruins, only a fragment of a grander scheme. But it is significant that it was equally persuasive to that great villa designer Palladio, and seems to be the only post-antique building in Rome of which he made a measured drawing.[85]

The design was not, of course, simply an advanced exercise in applied archaeology, as the practical details in the letter demonstrate. However, apart from drawing attention to the facilities for entertainment and cultivated relaxation, Raphael's letter does not specify the function the entire villa was intended to serve. It may have been taken for granted, but the term 'villa' was not self-explanatory and could cover a variety of purposes. Many earlier villas had been intended not simply as pleasant refuges from the summer heat but also as parts of utilitarian agricultural establishments or as bases for hunting expeditions. But, as with Bramante's Belvedere and Chigi's villa, this was not the case here, even if the trees which Raphael did 'not labour to describe' were to have constituted orchards. Leo did his hunting elsewhere, for example at the earlier papal villa outside Rome, La Magliana, and the most plausible explanation is that it was at least partly intended to serve much the same function that, by a happy accident, it serves today—that of providing dignified accommodation for distinguished foreign visitors on their way to the city from the north. The stables could accommodate the many horses of a travelling court, and the villa was repeatedly used for the lodging of ambassadors,[86] until, that is, it received the less welcome visit of the *Landsknechts* of the German army on their way to sack the city in 1527. Cardinal Giulio, who had become Pope Clement VII, must have been mortified, though he remained philosophical, when, from the safety of Castel S. Angelo, he saw smoke rising from the villa, which had been set alight by his vengeful and opportunistic rival, Cardinal Colonna.[87]

XI. The Last Works

FOR THE Olivetan monks of S. Maria dello Spasimo in Palermo Raphael produced an altarpiece in which Christ is portrayed collapsing on the way to Golgotha (Plate 259). As Simon of Cyrene lifts the Cross from his shoulders Christ turns and sees his mother who kneels by the path. The shudder of pain which she experiences and which is so powerfully represented by Raphael has given the painting its name—*Lo Spasimo*. The painting or at least a *modello* must have been completed by 1517, the date on a print by Agostino Veneziano reproducing the composition.[1] It may not, however, have reached Palermo by then. According to legend the ship carrying it was wrecked and all lost except the panel, which was fished out of the sea by the Genoese who would not relinquish it until ordered to do so by the Pope. Vasari adds that after its installation in Sicily it became as famous as Mount Etna.[2]

It is not difficult to relate this altarpiece to Raphael's earlier paintings. The pose of the soldier who leads Christ by a rope is developed from that of the executioner in the *Judgement of Solomon* (Plate 62) studied in reverse. For the composition as a whole, comparisons suggest themselves with Raphael's earlier *Entombment* (Plate 49) in which the pattern of movement is the same: men coming from the distance on the right now turn in the foreground towards the distance on the left, leaving behind a group of women. There is greater coherence here, but no repose, and the more pronounced shadows and sharper lighting help to isolate the pathos on the faces of Christ and the three Marys.

The desperate physical conditions and extreme emotions represented in this painting were among Raphael's chief preoccupations in the last and most ambitious of all his paintings in oil, the *Transfiguration* (Plate 264), and in the mural of the *Victory of Constantine* (Plate 267) which he was planning when he died. Like *Lo Spasimo*, the *Transfiguration* was made for export from Rome. It was commissioned before, but probably not long before, January 1517,[3] by Cardinal Giulio de' Medici for his archiepiscopal see, the Cathedral of Narbonne in France. The cardinal had just become the closest adviser of his cousin the Pope. 'Cardinal Bibbiena is pretty close to the Pope, but that Medici is everything to him [*fa il tutto*]' was the estimate of a Venetian diplomat.[4] With the probable exception of the *Sistine Madonna*, no altarpiece of Raphael's was made for a more exalted patron. And none was larger. Vasari emphasised that Raphael worked steadily on the painting 'with his own hand', painting, 'with all possible concentration', the face of Christ shortly before his death. In another passage he even claimed that Raphael worked on it entirely unaided because he was conscious of the inadequacy of his assistants.[5] Revisions to the design during the course of execution confirm his close involvement at all stages.[6]

FOLLOWING PAGES

259. *Lo Spasimo di Sicilia*. Oil on canvas (transferred from panel), *c.* 1516, 318 × 229 cm. Prado, Madrid.

260. Detail from *Lo Spasimo di Sicilia*.

235

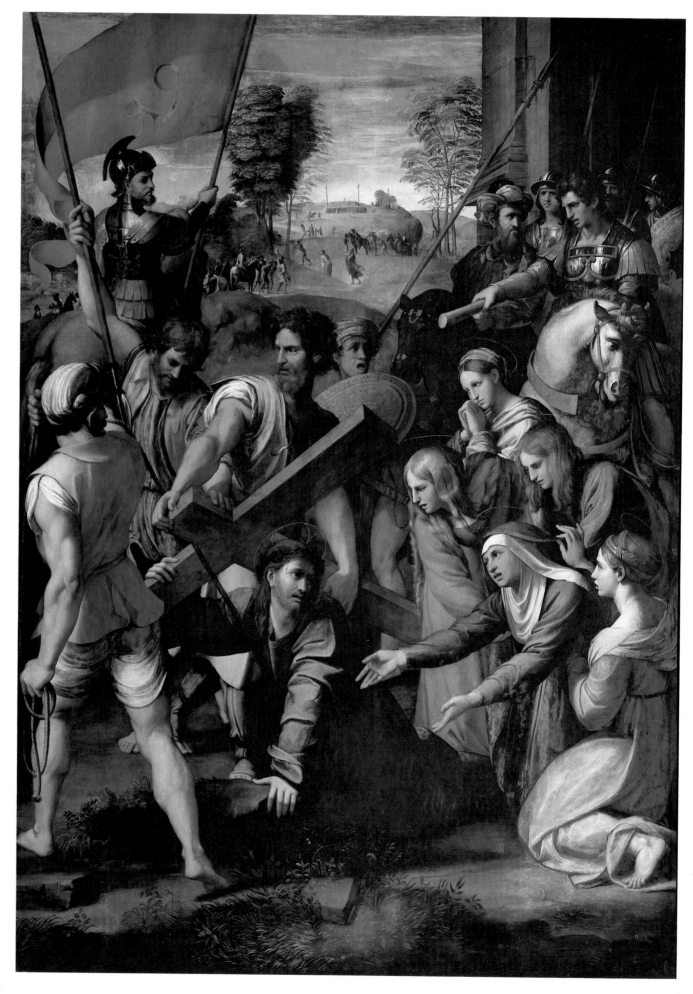

261. Sebastiano del Piombo. *The Raising of Lazarus*. Oil on canvas (transferred from panel), 1517–19, 381 × 289 cm. National Gallery, London.

Raphael had an additional motive for devoting special attention to the painting. For Cardinal de' Medici also commissioned Sebastiano del Piombo to produce an altarpiece of the same size (Plate 261) for the same Cathedral. This rival commission seems to have followed the one given to Raphael and may have been suggested by Michelangelo, who was to provide Sebastiano with drawings for it.[7] Sebastiano, however, got to work first—on 2 July 1518 he told Michelangelo that Raphael had not started painting—and also finished first. Raphael had many other commissions, of course—among them the great villa for Cardinal de' Medici, work on which seems to have begun about this time.

Vasari states explicitly that Raphael completed the painting, but it has often been suggested that it was completed by Giulio and Penni, to whom (as Raphael's heirs) payments for it were made after Raphael's death. Since the picture has been cleaned, it has become clear that it must in fact have been left untouched by them, because a few small parts (most notably the lower right-hand corner) were never finished.[8] Furthermore, it was exhibited immediately after Raphael's death, first at the head of his body as it lay in state in his studio and then in the Vatican.[9] There is some evidence to suggest that Raphael may at first have intended to paint only the Transfiguration of Christ on Mount Tabor but extended his subject to include the episode which occupies the foreground of his painting—the failure of the disciples whom he had left behind to heal a boy possessed by demons. The new subject would make the picture a better companion altarpiece (and a more direct competitor in artistic terms) with Sebastiano's painting the *Raising of Lazarus*.[10] Raphael was in addition now able to portray an equivalent range of emotions to those which are found in *Lo Spasimo*. The Medici were attached to metaphors of healing and to the image of Christ as 'Medicus', and this may be relevant for the choice of both Sebastiano's and Raphael's subjects.[11] But there is no particular reason to look for further, hidden, meanings here. Cardinal de' Medici valued clear and explicit narrative paintings and ridiculed those which required explanatory texts.[12]

The two episodes Raphael painted were not only consecutive in the four Gospel narratives but were theologically connected. The possessed boy is included in the verse for the Feast of the Transfiguration in the celebrated *Sacred Calendar* of Baptista Mantovano published just before Raphael began this painting.[13] The disciples' failure to heal him would not of course have made an appropriate subject by itself. In Raphael's picture we can see Christ above 'pouring on our souls his healing light', and the disciples, who are ranged to the left confronting the boy and his family, although they cannot see this, point up to the mountain indicating that Christ, who will heal the child, is there. It may seem that Raphael has squeezed two separate episodes into one painting (rather as he did in his early *Coronation of the Virgin*), but these two episodes occurred simultaneously and Raphael was able to represent them together, whereas the Gospel writers could only describe them consecutively. Given Raphael's interest in interconnected narrative episodes in the contemporary frescoes of Cupid and Psyche, the initiative may well have been his.

In the upper part of the painting Christ appears floating in a blaze of light wearing a white robe, with Moses, who clutches his tablets, and Elias, who holds his prophetic book, on either side of him, and, since they discuss the nature of his sacrifice, Christ's arms are outstretched as they will be upon the Cross. Sts James, Peter and John are portrayed as they waken from sleep to see Christ in glory— Raphael here follows St Luke's Gospel[14]—and if St Peter is, as seems likely, the central figure it may be significant that he will be the first to see.[15] To the left of the mountain top two figures kneel separately as witnesses. They are most probably intended for St Justus and St Pastor to whom the Cathedral of Narbonne is dedicated, and whose relics are preserved there.[16] Opposite, on the right, the warm colours of dawn (so different from the cool supernatural light in the rest of the painting) break over a landscape remarkably atmospheric in its indistinct forms and its transition from green to misty blue.

'That poor fellow Raphael [*quel povero de Rafaello*] is dead', Sebastiano wrote in a

letter to Michelangelo on 12 April 1520, less than a week after the event.[17] 'I am sure this has much saddened you, may God have mercy on him.' Rivalry with Raphael was, however, by no means over. 'Today I have carried my painting [the *Raising of Lazarus*] once again to the Palace' in order to exhibit it beside the *Transfiguration*. 'I don't regret it', he added. According to Vasari both works were greatly admired, but Raphael's was deemed incomparable.[18] Cardinal de' Medici decided to keep Raphael's painting in Rome and it was placed on the high altar of S. Pietro in Montorio. A copy of it together with Sebastiano's altarpiece was dispatched to Narbonne.

In the same letter Sebastiano also alerted Michelangelo to the fact that a room in the Vatican Palace was to be decorated and that Raphael's heirs were boasting that they had got the job and were proposing to do it in oil. Sebastiano enlisted Michelangelo's support in an attempt to secure the commission for himself and in June Michelangelo wrote to Cardinal Bibbiena, begging 'your most Reverend Lordship not as a friend or dependant, because I am unworthy to be one or the other, but as a poor and stupid yokel' to arrange for Sebastiano to paint in the palace now Raphael was dead. 'As onions appeal to those who are surfeited with capons, so perhaps this humble request will find favour . . .'[19] This burlesque of an obsequious petition caused much merriment at court, but Bibbiena courteously explained to Sebastiano that the room would be given to Raphael's heirs who had put on show there a figure painted in oil, 'a thing of such beauty that no one could look any more at the rooms Raphael had done'. Sebastiano claimed to have heard whispers that it was only a claque of Raphael's admirers and not the Pope himself who were impressed by the experiment, but he was only offered the chance of working elsewhere in the palace. A deciding factor seems to have been that Raphael's heirs had some of the master's drawings for the room.[20]

The room was the largest in the suite so much of which Raphael had already frescoed for Julius II and Leo X, and it connected with both the Pope's private loggia and the Stanza d'Eliodoro. It was described as a banqueting hall by Giovio[21] and it was also used for official audiences.[22] It is now known as the Sala di Constantino on account of the four large narratives portraying Constantine embracing and defending the Christian Faith and submitting to the authority of the Church. The idea for this decoration may have originated in 1519 when the election of the Holy Roman Emperor, the successor of Constantine, was the chief concern of papal and indeed European politics. But it would always be appropriate as a background for the reception of the great Christian powers by the Bishop of Rome. Each narrative (Plate 269) is painted on a fictional tapestry with a border of Medici emblems, and at either end of each, in the corners of the room, are the Popes who had exercised their authority alongside the earliest Christian Emperors, enthroned beneath sumptuous baldacchinos and flanked by appropriate Virtues. Above the latter are caryatids effortlessly supporting the yoke—a Medici emblem—and with it the cornice of the room. (The effectiveness of this device was seriously diminished when the ceiling was raised later in the century.) Around each figure are wound long scrolls (a convention which Raphael had not employed since his earliest altarpiece) bearing the motto *Suave* (With Ease).

Vasari mentions 'inventions' and 'sketches' by Raphael for the walls, he also credits him with the *partimento*, the scheme of decoration, and, in the second edition of his Lives, he specifies that Raphael made cartoons.[23] The superb nude studies (Plate 265) for soldiers on the right of the *Victory of Constantine at the Milvian Bridge* (Plate 267), the largest of the narratives and the first to be executed, are of the quality we associate with Raphael and he is not likely to have made such studies unless he had worked out the composition to which they belong. A drawing in the Louvre seems likely to reflect his ideas for this.[24] The differences between it and the composition of the executed fresco are superficial and can be explained as additions of the sort we would expect from Giulio Romano in whose subsequent independent works there is little tolerance of lucid intervals, and a love of repeated motifs and

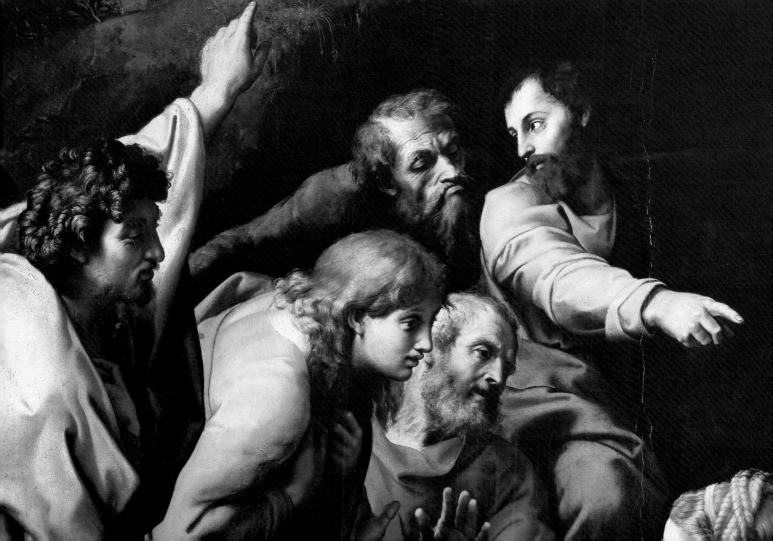

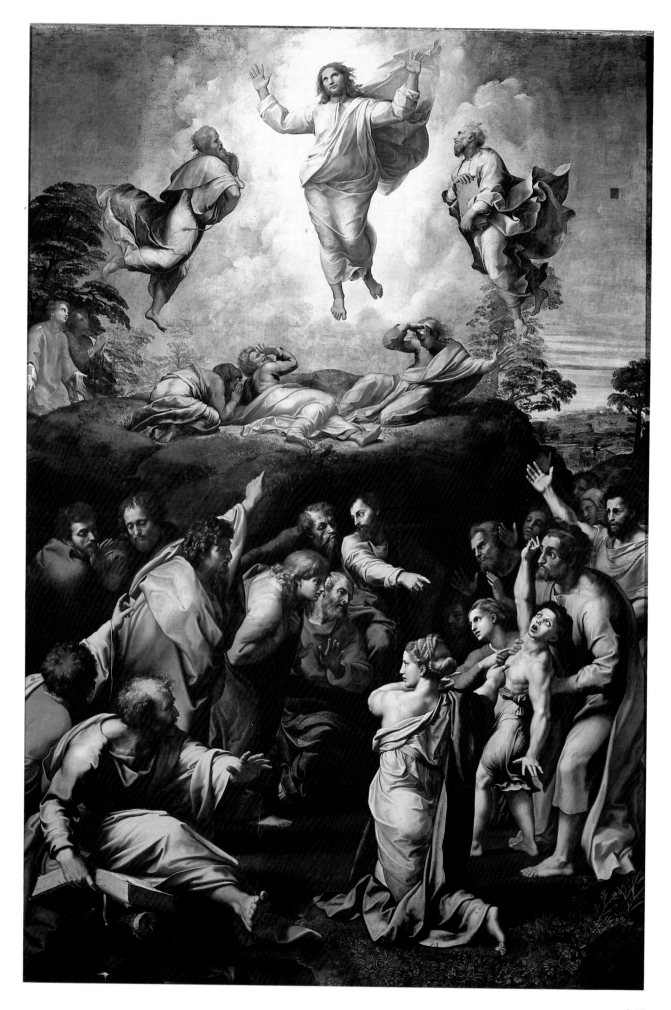

PRECEDING PAGES

262–3. Details from the *Transfiguration*.

264. *The Transfiguration*. Oil on panel, 1518–20, 405 × 278 cm. Vatican Museum, Rome.

265. *Life drawings of a nude youth in two poses* (preparatory for the *Victory of Constantine*—Plate 266). Black chalk with white heightening, 1519–20, 25.7 × 36.2 cm. Ashmolean Museum, Oxford.

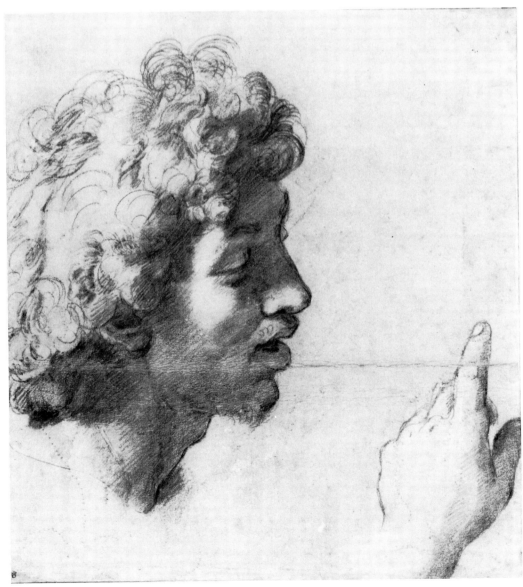

266. *Large studies of head and hand ('auxiliary cartoons') for the Transfiguration* (Plate 264). Black chalk, partially pounced, *c.* 1518–19, 36.3 × 34.6 cm. Chatsworth, Derbyshire.

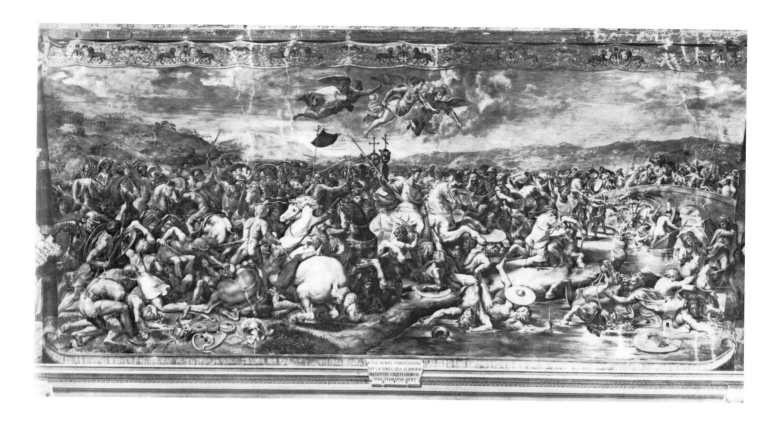

267. Giulio Romano, probably with Gianfrancesco Penni (in part after designs by Raphael). *The Victory of Constantine at the Milvian Bridge.* Fresco, 1520–1. Sala di Constantino, Vatican Palace, Rome.

multiplied ornament. Surviving drawings also suggest that Raphael played some part in designing another narrative, Constantine's vision before the battle (Plate 269), and was equally involved in designing the allegorical figures and therefore also the setting for more than one of the enthroned Popes.[25]

It was at Raphael's initiative that the *mistura*, a plaster suitable for experiments with an oil medium, was applied to the walls, and payments for scaffolding seem to confirm that this was done in Raphael's lifetime.[26] It was later thrown down when problems developed and fresco was employed instead, but the figures of Justice with an ostrich (beside Pope Urban I) and Comity with an almost invisible lamb (beside Clement I) which had been painted in oil were preserved (Plates 268, 270). It must have been to one or the other of these figures that Cardinal Bibbiena referred in conversation with Sebastiano. They are of such outstanding quality that it is tempting to attribute their execution to Raphael himself, but any suspicion that this was the case would surely have been recorded by Sebastiano, and it would seem that using Raphael's cartoons and working in this medium, and at this moment, with his own example fresh in mind and their future reputation at stake, his former assistants could paint this well. By comparison the other allegorical figures are either dull or meaninglessly busy. Among the caryatids, one, above Urban I on the side opposite Justice, is of outstanding elegance and there are drawings which suggest that Raphael had a part in this invention also.

In his last paintings Raphael seems to have returned, yet again, to the works by Leonardo which he had seen when he first came to Florence. The great battlepiece obviously has much in common with the *Battle of Anghiari* which, we should also recall, Leonardo had started to paint with an oil medium. The violent expressions in the heads as painted by Giulio have a frozen and mask-like appearance and to appreciate the character that Raphael would have given to them we should turn to the *Transfiguration* and to the superb auxiliary cartoons (Plate 266) for the heads in that picture.

Several of the heads in the *Transfiguration* may be compared with those in Leonardo's *Adoration* (Plate 31), as may the general plan of the agitated wheeling groups of figures in the foreground. Above all, Raphael, while preserving all the strong local colours characteristic of his earlier altarpieces, here adopted Leonardo's

243

268. Giulio Romano and Gianfrancesco Penni (after Raphael). *Comity*. Oil, 1520. Sala di Constantino, Vatican Palace, Rome.

dark shadows, employing—rashly, Vasari thought—printer's lampblack.[27] Particularly daring and effective are the outspread hands of the disciples which are lit only from behind, and the heads in which the principal features are not lit and which thus encourage intense scrutiny. Raphael knew that he could not match in fresco the depth of the shadows and the richness of the colours here, and this, rather than any impatience with the finality of fresco, explains his desire to experiment with an oil medium.

Appropriately, it is the figures which were executed in oil in the Sala di Constantino which are most reminiscent of the *Transfiguration*. In particular, the profile of Justice, her coiffure, both the folds and the cold but brilliant colour of her drapery, strongly recall the kneeling woman in the foreground of the altarpiece. A similar figure had been employed rather less centrally in both *Lo Spasimo* and the *Entombment*, and also of course in the *Expulsion of Heliodorus*. In the latter fresco, however, the pose strikes us as an instantaneous reaction, whereas in the *Transfiguration* it solicits admiration as a difficult but beautiful position.

Between the allegories in the Sala di Constantino are the enthroned Popes who resemble, in some respects, the prophets and sibyls on the Sistine ceiling (Plate 241), above all because their majestic scale is enhanced by pairs of small angelic acolytes. The caryatids with the Medici yokes above the thrones are equivalent to Michelangelo's nude youths with the Della Rovere acorns, but represent, of course, together with the seated allegories, a feminine ideal quite alien to anything in Michelangelo. Whatever its debts to the Sistine ceiling the *partimento* of the Sala di Constantino was highly original and was to be highly influential. In later Roman palace decorations its witty confusion of history, allegory and ornament, and its setting of works of art within works of art, are brilliantly extended (Plate 271).

269. General view of the Sala di Constantino, Vatican Palace, Rome.

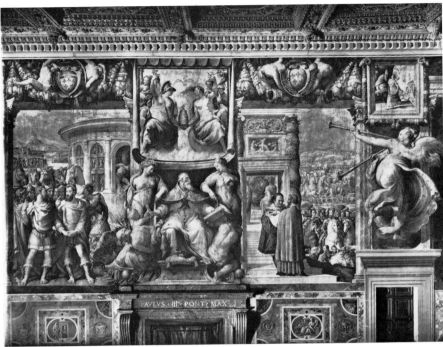

270. Giulio Romano and Gianfrancesco Penni (in part after designs by Raphael). *Urban I flanked by Justice and Charity*. Fresco (with the exception of the figure of Justice), 1520–1. Sala di Constantino, Vatican Palace, Rome.

271. Francesco Salviati. *Pope Paul III enthroned with Allegories and Histories*. Fresco, 1549–54. Sala dei Fasti Farnesiani, Farnese Palace, Rome.

It is impossible to say for certain in what directions Raphael's art was developing at his death; but equally impossible, whether we consider his survey of ancient Rome, the Villa Madama or the Sala di Constantino, not to feel that he died at the height of his powers. Why he died we do not know. Vasari believed that it was because he 'continued with his amorous pleasures to an inordinate degree'. One night returning home he contracted a 'very great fever which the doctors believed was a chill' and because he did not confess that he was exhausted with debauchery they rashly bled him. 'Accordingly he made his will: and first, as a Christian, he sent his beloved out of the house giving her the means to live as an honest woman.'[28] He died on Good Friday (6 April) 1520. 'The Pope himself', it was reported, 'is sunk in measureless grief'—during the fifteen days of Raphael's illness he had 'sent people at least half a dozen times to visit and to comfort him'. Soon after his death there were earth tremors and the Pope quit his palace in fear. Heaven, it was said, wished to repeat one of the signs shown at the death of Christ.[29]

The artist's fortune was reckoned at 16,000 ducats. Of this he ordered 1,500 to be spent on embellishing a chapel in the Pantheon, consisting of an altar, and, above it, a statue of the Madonna by Lorenzetto in one of the ancient aedicules and, below it, a grave for himself and one for his betrothed, Maria Bibbiena. Six hundred ducats were assigned for the upkeep of the chapel and for masses to be said for his soul.[30] The court poets competed to commemorate him.

APPENDIX

Raphael's Letter on the Villa Madama[1]

"THE VILLA is situated half way up the slope of Monte Mario which faces directly north-east, and, because the hill is curved, the part [of the site] which looks towards Rome faces south and the opposite end faces north-west.[2] The west and the south-west lie behind the hill, so that the villa is exposed to six of the eight winds, that is south, south-east, east, north-east, north and north-west. This will enable Your Excellency to appreciate how the land lies. However, to give it a healthier orientation,[3] I have directed the length of the villa onto a straight south-east/north-west axis, and it is to be noted that there should be no windows or living rooms facing south-east, except those which need the heat.

The villa has two principal entrances, one by way of a road which one travels when coming from the [Vatican] palace and through the meadows (1), while the other is a newly made road which goes straight to Ponte Molle (2). Both are 5 *canne*[4] wide. You would say that Ponte Molle had really been made for the villa, because the road arrives exactly at the bridge. At the upper end of the road there is a great portal placed at the centre of the building (3). But to avoid confusing Your Excellency in giving an account of the parts of the villa, I will begin with the entrance road which comes from the Vatican and through the meadows (1). For it (and not the Ponte Molle one, which arrives at a point 4 *canne* higher up the slope of Monte Mario) is the principal entrance. It rises so gently that it seems not to be rising at all, and on arrival at the villa one is hardly aware of having travelled up to a high point, in a dominant position in the landscape. The most immediately striking feature of this entrance is the pair of round towers on either side of it, which not only give it beauty and grandeur but also contribute a little to its defence (4,5). Set between them, on a smaller scale, is a most beautiful Doric portal (6), which leads into a courtyard 22 *canne* long and 11 wide (7). At the head of the courtyard is the vestibule, whose form and function is in the antique style, with six round Ionic columns and the piers which this type requires (8). From this vestibule one passes to the atrium, made in the Greek style and like the kind of thing Tuscans called an 'androne' (9). Through this one passes into a round courtyard (10), which I will not speak of now, to avoid confusion, returning instead to describe the layout and the living rooms of the first courtyard.

Because [part of] it faces south-south-east, it has been set aside for the kitchen, the pantry and the servants' hall. There is also a cellar, cut into the hillside, to serve these public rooms, with its windows facing north, in a very cool place, as Your Excellency may imagine. These parts are all between the vestibule and the hillside on the left, as one enters. On the right there is a beautiful garden of orange trees, 11 *canne* long and 5½ wide (11), and in the middle, among the orange trees, is

a beautiful fountain of water brought by various conduits from a natural source. In the corner, on top of the right-hand entrance tower, is placed a most beautiful *diaeta* as the ancients call it, circular in form and 6 *canne* in diameter (4). It can be reached, as I shall explain later, by a passage, which [also] provides shelter for the garden in the north-east. Other parts of the building shelter it to the north and north-west. As I said earlier, the *diaeta* is circular, and has glass windows all around it, which the sun will successively fall on and shine through on its journey from sunrise to sunset. The place will thus be most charming, not only because of the continuous sunshine but also because of the view of Rome and the countryside, which, as Your Excellency is aware, the clear glass will not obstruct at any point. It will really be a most pleasant place in winter for civilised discussions—the customary function of the *diaeta*. It occupies the corner of one end of the garden. At the other end, towards the living quarters, is a loggia which is also intended for use in the winter and faces south-south-east (12). One enters the loggia from the living quarters [of the main block], and not from the first courtyard, even though the two are adjacent. Indeed, from the entrance to the courtyard it is impossible even to see the loggia or the *diaeta* because of the dividing wall constituted by the right-hand wall of the courtyard. So much for the four sides of the first courtyard.

The second courtyard, which is in the middle of the building, is circular, with a diameter of 15 *canne* (10). On the right, to the north-east, is a large portal (13) similar to the one by which one enters this courtyard (14). On either side of the portal is a triangular staircase (15,16), 11 *palmi*[5] wide, which leads up to an entrance hall [*androne*] the length of which is equal to two flights of the stairs (17). From the *androne* one enters the middle of a most beautiful loggia, facing north-east, 14 *canne* long, 3 wide and 5 high, with a most beautiful apse at either end (18). Its opposite side is divided into three arches, the central one of which is completely open, and leads out onto the top of a little rectangular tower, with parapets all round (19), the lower part of which acts as a portal (3). From here one can look directly down the road which leads from the villa to Ponte Molle and survey the beautiful countryside, the Tiber and Rome. At the foot of the loggia is the hippodrome, which Your Excellency will hear more of later and which will run the whole length of the villa on its south-east/north-west axis (20). The other two arches of the loggia are sub-divided by two round Doric columns. At the right-hand end of the loggia, to the south-east, one passes through a door in the middle of the niche into a large and very beautiful reception room, with five windows facing north-east, looking out over the hippodrome (21). It is 8½ *canne* long and 5½ wide, and has a round vault 7 *canne* high, like a dome,

and supported by four arches set at right angles. From here there is access to five smaller rooms, of which two face north-east (22, 23), one faces the hillside and gets its light from the first courtyard (24), another faces south-east and likewise gets its light from the first courtyard (25), and the other faces north-west and looks out over the round courtyard (26). Of these rooms, three are of a good size while the other two are a little smaller. The first three measure 4 *canne*. At the end of the suite there is a private staircase (27) leading down to the rooms below, and up to the rooms above, made for the household. From here one may also pass to the south facing loggia (12), to the little garden with the orange trees (11), and, by means of the passage I referred to earlier, to the *diaeta* (4).

Returning to the loggia which faces north-east (18), opposite the door which leads to the reception room I have just described is another door in the middle of the apse at the other, north-west, end of the loggia. It leads to a fairly large reception room, 4½ *canne* wide, and with a length equal to the diagonal of a 4½ *canne* square, and with windows facing north-east (28). Off this are three rooms, two of which face north-west (29,30) and the other looks out over the round courtyard (31). The first two are of sexquitertian proportion,[6] and are for use in the summer, since they will never receive the sun, which is obscured in the afternoon by the hill. They overlook a beautiful fishpond (32), and give access to another loggia (33), about which Your Excellency will soon be informed.

I have already described for Your Excellency two of the portals in the round courtyard, one at the entrance to the atrium (14) and the other giving on to the north-east facing loggia (15). Opposite the atrium portal is another, to the north-west (34), which leads to a most beautiful loggia, 14 *canne* long, composed of three bays (33), in the middle one of which is the entrance. The other two have in the corresponding position a semicircular area and they make the loggia [more] spacious, with a bay of 5 *canne*. Toward the hillside the loggia forms [another] semicircle, in which there are cushioned(?) seats. In the middle there is a most beautiful fountain. This is the summer *diaeta*, and quite delightful both because it will never receive the sun and because the water and the greenery make it beautiful. [For] the loggia gives on to the *xystus* (to use the ancient term), a place full of trees planted in order (35). The *xystus* is of the same length and width as the first courtyard. Thus, as Your Excellency will have understood, the villa is divided into three parts. The *xystus* has some parapets which look down 4 *canne* wide, and down below can be seen a fishpond (32), which is as long as the *xystus* and 55 *palmi* wide. [Around it] are some steps which go right down and may be used for sitting or stretching out on. It is reached by two broad staircases, one at either end of the *xystus* (36–7). At the

end of the staircase to the north-west (37), there is a dining area next to the water, which will be quite delightful both because it is cool and because of the view. At the end of the *xystus* in the northern corner, there is another tower (38) matching that of the winter *diaeta* (4). Above it is a round temple, of the same dimensions as the *diaeta*, which serves as the chapel of this place. At the other corner of the *xystus*, next to the hill, is another tower (39), serving to fortify the place. Between the two towers is a most beautiful portal (40), through which one may leave the *xystus*. This, then, is the long axis of the building of the villa.

I have already described for Your Excellency three portals in the round courtyard, one leading into the building to the south-east (14), another to the north-east facing loggia (13) and the other to north-west where the *xystus* is. There remains the part of the building toward the hillside. In the middle, opposite the portal to the north-east facing loggia, is an area (41) which is as wide as the ramps (42,43) which rise to the theatre, which I will describe later. Facing on to it, on the side of the hill and between the ramps, is a beautiful fountain, which is cut out of the hill in a semicircle (44). It is adorned with a variety of seashells and turtleshells, set in patterns as the artist pleased, with seats all around. This is another *diaeta*, intended for times when it is extremely hot. On each side of the *diaeta* rise three ramps towards the south-east and north-west, so comfortably that one can go up them with the greatest of ease, without steps or banisters. At the end of each ramp are two others which together form a semicircle. Where they meet they form a straight road (45), from north-east to south-west, which reaches to the top of the hill and comes out onto the Monte Mario section of the road from Viterbo to Rome, so that from the Monte Mario road to that of Ponte Molle there is an absolutely straight road, [the axis of] which passes through the exact centre of the villa.

Now, in the flat area between the two ramps which make a semicircle, in this space there is a beautiful theatre (46) made to the following measures(?) and principles: First a circle is made, the same size as the theatre is to be. Then four equilateral triangles are inscribed in it, with their points touching the circumference. The side of the triangle which faces north-east, and whose corners are to the south-east and north-west, determines the front of the stage. A line [is] drawn parallel to this through the centre [of the circle], which separates and divides off the platform of the proscenium from the area of the orchestra. After the area has been divided and laid out according to these measures, the seats, the stage, the platform and the orchestra are constructed. The actors' dressing rooms are built on either side(?) so as not to block the view of the countryside. This [view] will only be closed off when plays are performed, with painted scenery so that the voices will carry to the audience. The theatre has been placed so that it will not catch the sun in the afternoon or evening, which is the customary time for such entertainments. This, then, is the whole of the upper level [of the villa].

All the living quarters of the villa are, for the health of those living there, set apart from the hillside, and between the [main] rooms and the hillside are the courtyards, as Your Excellency will have realised. The courtyards do not have vaults below them, but the living quarters do, and there are rooms below, 4 *canne* high, corresponding to the difference in level [of the two entrances] that I explained above. These rooms are for storage(?) and arranged in a manner which Your Excellency will understand later.

The road which comes from Ponte Molle, and forms the entrance to the centre of the villa, first enters the hippodrome, which is 200 *canne* long and 10 wide. One of the long sides of the hippodrome is formed by the buildings of the villa itself, while on the other are stables for four hundred horses (47,48). The stables make an embankment to support the whole length of the side of the hippodrome and make it level. The horses face east-north-east, like the rest of the building, and it is possible to give them all water in their mangers.

Facing onto the hippodrome, directly in line with the Ponte Molle road, is a beautiful Doric portal (3) which, as I have explained, forms a little tower. This leads to what the ancients called a *cryptoporticus*. We would call it an underground portico, although there are a number of different kinds of *cryptoporticus*. But this is one which acts as a vestibule. Opposite the portal is a fountain in a niche, and on either side are two triangular staircases which lead up to the round courtyard and the north-east facing loggia which I spoke of earlier (15,16). From the left-hand side of this *cryptoporticus*, as one enters, one can go south, to the baths, which can also be reached by the private staircase from the floor above (27).

The baths have been arranged so that there are two changing-rooms and then a warm open space for oiling oneself after bathing or being in the hot room. There is also the hot dry room [itself], with its *temperatura*(?), and the hot water bathroom, with seats that permit the user to choose which parts of the body are to be bathed by the water. Under the window there is a place where one can lie down in the water, such that the servant can wash people without getting in the way. Then there is a warm bath, and also a cold one which is big enough to permit swimming if desired. The room where the heat for these places is generated contains the tank, the water and the boilers, so arranged that the water can circulate between the hot, warm and cold rooms. These, then, are the rooms on one side of the *cryptoporticus*. On the other side are the private kitchen, the rooms for the cook and a private staircase leading to the top of the building. Between the vaults and the roof there is a space 2 *canne* high for the living quarters of the household, which is extremely large.

Your Excellency may imagine that the grounds of the villa abound with trees, as is fitting for such a building, but I will not labour to describe them."

272. Raphael workshop (Giovanfrancesco da Sangallo?) *Plan project for the Villa Madama*. Pen and wash, *c.* 1518. Uffizi, Florence.

273. Raphael workshop (Antonio da Sangallo). *Plan project for the Villa Madama*. Pen and wash, probably after 1518. Uffizi, Florence.

Notes to the Text

THE FOLLOWING ARE ABBREVIATED IN THE NOTES:

Barocchi, Paola and Renzo Ristori. *Il Carteggio di Michelangelo.* 4 vols. Florence 1965–79.

Bartsch, A. *Le Peintre-Graveur.* 21 Vols. Vienna 1802–11.

Bellori, G.-B. *Descrizzione delle imagini dipinte da Raffaelle d'Urbino.* Rome 1695.

Burns, H. et al. *Andrea Palladio, 1508–1580: The Portico and the Farmyard.* London 1975.

Coffin, D. *The Villa in the Life of Renaissance Rome.* Princeton 1979.

Cugnoni, G. 'Agostino Chigi il Magnifico', *Archivio della Società Romana di Storia Patria*, 1879, pp. 46–83 (the *Commentarii* on the life of Agostino Chigi by Fabio Chigi) and pp. 209–26, 475–90; 1880, pp. 213–32, 291–305, 422–48; 1881, pp. 56–75, 195–216 (Cugnoni's notes on Fabio Chigi's text). We refer to Cugnoni's note numbers, which are common to the rare edition of this article as a book, and only give page references to Fabio Chigi's text.

Dussler, Luitpold. *Raphael.* London 1971.

Fischel, O. *Raphaels Zeichnungen.* 8 Vols. Berlin 1913–42, together with text volumes paginated continuously and sometimes bound together.

Frommel, Christoph. *Der Römische Palastbau der Hochrenaissance.* 3 Vols. Tübingen 1973.

Golzio, V. *Raffaello nei documenti nelle testimonianze dei contemporanei e nella letteratura del suo secolo.* Vatican City 1971.

Hirst, Michael. *Sebastiano del Piombo.* Oxford 1981.

Oberhuber, Konrad. *Raphaels Zeichnungen* (Vol. IX of Fischel). Berlin 1972.

Paris de Grassis. Transcript of the MS diaries. 5 Vols. British Library Add. MSS 8440–4.

Parker, K. T. *Catalogue of the Collection of Drawings in the Ashmolean Museum*, II (Italian Schools), Oxford 1956.

Passavant, J.-D. *Raphael d'Urbin et son Père Giovanni Santi.* 2 Vols. Paris 1860.

Pastor, Ludwig. *The History of the Popes from the Close of the Middle Ages.* 36 Vols. London 1950.

Pouncey, P. and J.A. Gere. *Raphael and his Circle* (Italian Drawings in the Department of Prints and Drawings in the British Museum). 2 Vols. London 1962.

Richardson, Jonathon Snr and Jnr. *An Account of the Statues, Bas-reliefs, Drawings and Pictures in Italy, France &c with Remarks.* London 1722 (we also refer to the translated and extended edition published Amsterdam 1728).

Sanuto, Marino. *I diarii di Marino Sanuto.* 63 Vols. Venice 1879–1903.

Schulz, J. 'Pinturicchio and the Revival of Antiquity', *Journal of the Warburg and Courtauld Institutes*, 1962, pp. 35–55.

Shearman, John. 'The Chigi Chapel in Santa Maria del Popolo', *Journal of the Warburg and Courtauld Institutes*, 1961, pp. 129ff.

Shearman, John. 'Die Loggia der Psyche in der Villa Farnesina und die Probleme der Letzen Phase von Raffaels graphischem Stil', *Jahrbuch der Kunsthistorischen Sammlungen in Wien*, XXIV, 1964, pp. 59–100.

Shearman, John. 'Raphael's Unexecuted Projects for the Stanze' in *Walter Friedlaender zum 90. Geburtstag.* Berlin 1965. pp. 158–80.

Shearman, John. 'Raphael at the Court of Urbino', *Burlington Magazine*, February 1970, pp. 72–8.

Shearman, John. *The Vatican Stanze: Functions and Decoration* (Italian Lecture, British Academy, London 1971). London 1972a.

Shearman, John. *Raphael's Cartoons in the Collection of Her Majesty the Queen and the Tapestries for the Sistine Chapel.* London 1972.

Shearman, John. 'Raphael, Rome and the Codex Escurialensis', *Master Drawings*, 1977, pp. 107–46.

Vasari, Giorgio. *Le Vite de' più eccellenti pittori, scultori, e architettori.* ed. G. Milanesi. 9 Vols. Florence 1878–85.

Weiss, R. *The Renaissance Discovery of Classical Antiquity.* Oxford 1969.

NOTES TO CHAPTER I

1. Vespasiano da Bisticci, *Vite*, ed. P. d'Ancona and E. Aeschlimann, Milan 1951, pp. 191ff; G. Franceschini, *I Montefeltro*, Varese 1970.

2. Castiglione, *Il Cortegiano*, I, iii (sculpture); Cecil H. Clough, 'Federigo da Montefeltro's Patronage of the Arts', *Journal of the Warburg and Courtauld Institutes*, 1973, pp. 129–44.

3. Golzio, p. 3.

4. M. Mallet, *The Borgias*, London 1969, pp. 194–5.

5. R. Dubos, *Giovanni Santi*, Bordeaux 1971, p. 39, pl. xiv.

6. Ibid., pp. 39–43; A. Luzio, 'Federigo Gonzaga Ostaggio alla Corte di Giulio II', *Archivio della Società Romana di Storia Patria*, IX, 1886, p. 571.

7. Op. cit. in n. 5, pp. 46–7.

8. Santi, *Cronaca rimata*, lib. XXII, cap. xcvi, 74–142 (ed. H. Holzinger, Stuttgart 1893, pp. 188–9)—also given in Passavant, I, pp. 423–8.

9. Cugnoni, n. 75.

10. C. Gamba, 'Lorenzo Leombruno', *Rassegna d'Arte*, VI, 1906, p. 66n.

11. Walter Pater, 'Raphael', *Miscellaneous Studies*, London 1895, p. 44.

12. E. Camesasca, *Tutta la pittura del Perugino*, Milan 1959, p. 177.

13. Vasari, III, pp. 569–70, 585.

14. Ibid., IV, p. 317 (Golzio, p. 197).

15. Golzio, pp. 5–6.

16. Published before Vasari by Fornari (Golzio, p. 195)

but, as Charles Hope pointed out, he had the same publisher as Vasari, and his account has no independent value.

17. He misnames her as Isabella—Golzio, p. 284.

18. Ibid., p. 10.

19. Ibid., p. 18.

20. Vasari, IV, pp. 322–3 (Golzio, p. 199).

21. Golzio, pp. 15–16, 165–7.

22. Ibid., p. 171 (for Bembo); Shearman, 1970, p. 77, n. 26 (for Guidobaldo).

23. Shearman, 1970, pp. 72–3, n. 5. He also suggests spring 1507 but an apple would be odd at that season.

24. Ibid., passim.

25. Castiglione, *Il Cortegiano*, III, ii, provides evidence of the equivalence of these honours.

26. Shearman, 1970, p. 77, n. 23.

27. See Vasari, VI, p. 365, for Sanmichele's *St Michael*.

28. Marcantoni Michiel, *Notizie*, ed. G. Frizzoni, Bologna 1884, p. 44—see also the discussion of this text in Clifford M. Brown, 'Un tableau perdu de Lorenzo Costa et la Collection de Florimond Robertet', *Revue de l'Art*, LII, 1981, pp. 24–8.

29. James Dennistoun, *Memoirs of the Dukes of Urbino*, London 1851, II, pp. 443–7; C. H. Clough, 'The Relations between the English and Urbino Courts', *Studies in the Renaissance*, XIV, 1967, pp. 206ff. The tradition (first recorded in the early eighteenth century in a form more garbled than would be likely if it were a recent fabrication) is brushed aside by Helen Ettlinger and doubted by John Shearman in articles on the painting in the *Burlington Magazine*, January 1983. Shearman connects the *St George* mentioned by Lomazzo (Golzio, p. 309) with one in the d'Este collection.

30. *Punica*, XV, 18–120.

31. Erwin Panofsky, *Hercules am scheidewege*, 1930, pp. 76ff, proposed that it was painted for the Borghese but it is likely to have been acquired by them after Francucci's poetic inventory of 1613 in which it is not listed (Archivio Segreto Vaticano, Fondo Borghese, Ser. IV, 102).

32. Vespasiano da Bisticci, op. cit. in n. 1, p. 191.

33. Castiglione, *Il Cortegiano*, I, xlv–xlvii.

34. Vasari, III, pp. 544–5; IV, p. 493, n. 1, p. 494, n. 2.

35. Ibid., IV, p. 498.

36. 'M.G.M.A.V.', *Memorie Ecclesiastiche e Civili di Città di Castello*, Città di Castello 1842–4, V (Memorie Ecclesiastiche), pp. 111–12.

37. Golzio, pp. 7–8.

38. Op. cit. in n. 5, pp. 151–3.

39. Sylvie Béguin, 'Un nouveau Raphaël; un ange du retable de *Saint Nicholas de Tolentino*', *Revue du Louvre*, 1982, pp. 99–115.

40. Luigi Lanzi, *Storia pittorica della Italia*, Pisa 1815–16, II, p. 45.

41. PRAECEP/ TA. PATR/ IS. MEI/ SERVA/ VI DEO M/ ANEO. I/ N EIUS/ DILECT/ IONE.

42. 'Dominicus Thomae de Gauris'. For the chapel, see op. cit. in n. 36, IV (Memorie Ecclesiastiche), p. 234.

43. For the Albizzini, ibid., II (Memorie Civili), pp. 85, 92–3. For the ring, see Matarazzo, *Chronicles of the City of Perugia*, trans. E. S. Morgan, London 1905, pp. 7, 22.

44. Matarazzo, op. cit. in n. 43, p. 240. For Maddalena and Leandra, see Alison Luchs, 'A Note on Raphael's Perugian Patrons', *Burlington Magazine*, CXXV, January 1983, pp. 25–9.

45. The Virgin was crowned (but not by her son) in Perugino's destroyed fresco altarpiece of the *Assunta* in the Sistine Chapel (Shearman, 1972, fig. 9 is a copy)—Thomas was also prominent here with the *cintola*. The coronation is portrayed separately in a lunette above the *Assunta* by Ambrogio de Fossano of 1522 (Brera, no. 1512).

46. Konrad Oberhuber, 'The Colonna Madonna . . . and Problems of the Early Style of Raphael', *Metropolitan Museum Journal*, 1977, pp. 51–91.

47. Op. cit. in n. 11, p. 60.

48. Golzio, p. 11.

49. Hannelore Glasser, *Artist's Contracts of the Early Renaissance* (Columbia University Thesis 1965), New York and London 1977, pp. 31, 67–8; F. Canuti, *Il Perugino*, Siena 1931, II, p. 258.

50. Op. cit. in n. 12, pp. 98–9.

51. Ibid., p. 62.

52. Sylvia Ferino Pagden, *Disegni Umbri del Rinascimento da Perugino a Raffaello*, Florence 1982.

53. C. L. Eastlake, *Materials for a History of Oil Painting*, London 1847, II, pp. 124–47, 152–64.

54. Vasari, III, p. 574.

55. Ibid., III, p. 464; IV, p. 319 (Golzio, pp. 198, 233); op. cit. in n. 12, p. 147.

56. Vasari, IV, p. 319 (Golzio, p. 198).

NOTES TO CHAPTER II

1. Golzio, p. 19.

2. Shearman, 1977, pp. 130–6.

3. Golzio, p. 11.

4. Vasari, IV, pp. 326–7—cf. IV, pp. 183–4 (Golzio, pp. 201, 236).

5. Now in Museo di San Marco, Florence. Christian von Holst, 'Fra Bartolomeo und Albertinelli', *Mitteilungen des Kunsthistorischen Institutes in Florenz*, XVIII, 1974, pp. 273–318.

6. Uffizi, Florence 505; Fischel, III, no. 105.

7. George Eliot, *Mill on the Floss*, end of Ch. II.

8. Ronald M. Steinberg, *Fra Girolamo Savonarola, Florentine Art, and Renaissance Historiography*, Athens (Ohio) 1977, p. 51.

9. Vasari, IV, p. 38; see also Martin Kemp, *Leonardo da Vinci*, London 1981, pp. 220–1.

10. L. Beltrami, *Documenti e memorie riguardanti la vita e le opere di Leonardo*, Milan 1919, pp. 65–6. As a cleric he probably meant to Christ's left, but too much can be made of this—he was in any case writing from memory.

11. A. E. Popham, *The Drawings of Leonardo da Vinci*, London 1964, pp. 13–14.

12. E. H. Gombrich, *Norm and Form*, London 1966, pp. 58–63.

13. Dussler, pp. 11–12.

14. The drawings are very close in style to some for the *Madonna of the Meadow* of 1505 (Fischel, III, no. 115).

15. Vasari, IV, p. 325 (Golzio, p. 201); Dussler, p. 17.

16. E. Camesasca, *Tutta la pittura di Raffaello: I Quadri*, Milan 1962, p. 49.

17. Ibid., p. 47, pl. 61.

18. H. M. Jameson, *Legends of the Madonna*, London 1888, p. 124.

19. Baldinucci, *Opere*, Milan 1811, VI, p. 230.

20. Bembo refers to this friendship in a letter to Taddeo Taddei's son (of the same name) in 1524—*Opere*, Venice 1729, III, p. 214.

21. Vasari, IV, p. 321 (Golzio, p. 198).

22. Golzio, p. 19.

23. Vasari, IV, pp. 321–2 (Golzio, p. 199).

24. Ibid., IV, p. 328 (Golzio, p. 202).

25. For an intriguing interpretation, see Malcolm Easton, 'The Taddei Tondo: A Frightened Jesus?', *Journal of the Warburg and Courtauld Institutes*, 1969, pp. 391–3.

26. J. Pope-Hennessy, *Italian High Renaissance and Baroque Sculpture*, London 1970, pp. 305–6.

27. Vasari, VII, p. 137, for Michelangelo; IV, p. 316 (Golzio, p. 196), for Raphael.

28. Ibid., IV, pp. 325–6 (Golzio, p. 201).

29. C. Gould, 'Leonardo's Great Battle Piece', *Art Bulletin*, 1954, pp. 117–29; Kemp, op. cit. in n. 9, pp. 234–47.

30. Matarazzo, op. cit. in I, n. 43, pp. 90, 263ff.

31. Paris de Grassis, II, fol. 24v; Machiavelli, *Discorsi*, I, xxvii.

32. Luchs, op. cit. in I, n. 44.

33. Vasari, IV, pp. 325, 327–8 (Golzio, pp. 200–3).

34. Another of the same composition was used by Marcantonio and, later, Agostino Veneziano—Bartsch, XIV, 43, 37.

35. National Gallery 790 (Michelangelo); A. M. Hind, *Early Italian Engraving*, London 1948, V, no. 2 (Mantegna).

36. C. L. Ragghianti, *La Deposizione*, Milan 1947.

37. Alberti, *De Pictura*, ed. C. Grayson, London 1972, xxxvii, pp. 74–5.

38. Daniel Arasse, 'Extases et visions béatifiques à l'apogée de la Renaissance', *Mélanges de l'École Française de Rome*, 1972, p. 416.

39. E.g. Parker, 539; Fischel, IV, no. 173—cf. IV, no. 166.

40. Perugia, Galleria Nazionale 184. See the entry by Francesco Santi in *Storia e restauro della Deposizione di Raffaello*, ed. L. Ferrara, S. Staccioli, and A. M. Tantillo (Museo Borghese), Rome 1972–3, pp. 48–9.

41. Perugia, Galleria Nazionale 281, 288.

42. O. H. Giglioli, 'Notiziario', *Rivista d'Arte*, VI, 1909, p. 151.

43. Vasari, IV, pp. 328–9 (Golzio, p. 202); V, pp. 158, 354–5.

44. P. A. Riedl, 'Raffael's "Madonna del Baldacchino"', *Mitteilungen des Kunsthistorischen Institutes in Florenz*, VIII, 1959, pp. 223–46.

NOTES TO CHAPTER III

1. Paris de Grassis, II, fol. 170.

2. Vasari, III, pp. 497–8, 503; Schulz, pp. 50–1, n. 45.

3. Shearman, 1971, pp. 5–6.

4. Golzio, p. 21; Vasari, IV, p. 333 (Golzio, p. 204).

5. Vasari, IV, p. 329 (Golzio, p. 202); Lomazzo in Golzio, p. 314.

6. Golzio, p. 370.

7. Shearman, 1965, pp. 159–60; 1971, pp. 14–17.

8. Pastor, VI, p. 457n.

9. Vasari, VII, p. 171.

10. Lippomano in Sanuto, XI, col. 722.

11. Bembo, *Epistolae Familiares*, Venice 1552, p. 188.

12. L. Dorez, 'La Bibliothèque privée du Pape Jules II', *Revue des Bibliothèques*, VI, 1896, pp. 97ff. The list may only record the most precious items.

13. T. E. Mommsen, 'Petrarch and the Decoration of the Sala Virorum Illustrium in Padua', *Art Bulletin*, 1952, pp. 95–116.

14. E. H. Gombrich, *Symbolic Images*, London 1972, p. 87.

15. Vasari, IV, p. 337 (Golzio, p. 206).

16. Shearman, 1965, p. 161.

17. The drawings may be partially conjectural reconstructions but are based on vaults such as that recorded in the early sixteenth century by Giuliano da Sangallo, for which, see Schulz, p. 50.

18. Vasari, IV, p. 333 (Golzio, p. 204); Golzio, p. 21.

19. D. Redig de Campos, *Le Stanze di Raffaello*, Milan 1965, p. 20.

20. Golzio, p. 21; for the Fleming, see Shearman, 1965, p. 160, and Vasari, VI, p. 550 (not in Golzio).

21. Edgar Wind, 'The Four Elements in Raphael's Stanza della Segnatura', *Journal of the Warburg and Courtauld Institutes*, 1938/9, pp. 75ff.

22. Fischel, V, text p. 225.

23. N. Dacos, *Le Logge di Raffaello*, Rome 1977, pp. 252–3.

24. Gould, op. cit. in II, n. 29, pp. 126–7; J. Pope-Hennessy, *Italian Renaissance Sculpture*, London 1958, figs. 138–9.

25. F. Haskell and N. Penny, *Taste and the Antique*, New Haven and London 1981, p. 259.

26. N. Rash-Fabbri, 'A Note on the Stanza della Segnatura', *Gazette des Beaux-Arts*, XCIV, October 1979, pp. 77–104.

27. Fischel, text pp. 271ff; and VI, passim.

28. C. L. Frommel, 'Eine Darstellung der "Loggien" in Raffaels "Disputa"?', *Festschrift für Eduard Trier zum 60 Geburtstag*, Berlin 1981, pp. 103–27.

29. E. Tietze-Conrat, *Mantegna*, London 1955, pls. 1–22.

30. See especially H. Pfeiffer (S.J.), *Zur Ikonographie von Raffaels Disputa*, Rome 1975.

31. Philipp Fehl, 'Raphael's Reconstruction of the Throne of St Gregory', *Art Bulletin*, 1973, pp. 373–9.

32. Vasari, IV, p. 333 (Golzio, p. 204) for *ordinano*; pp. 331, 336–7 (Golzio, pp. 203, 206) for *disputano*.

33. Vasari, III, p. 468; illustrated in A. Scharf, *Filippino Lippi*, Vienna 1935.

34. Golzio, p. 192.

35. Richardson, 1722, p. 199.

36. Barocchi and Ristori, III, p. 8.

37. Shearman, 1971, p. 16; E. Schröter, 'Raffael's Parnass: Eine Ikonographische Untersuchung', *Actas del XXIII Congreso Internacional de Historia del'Arte*, Granada 1978, III, pp. 593–605.

38. Op. cit. in n. 25, p. 148.

39. Richardson, 1722, p. 197.

40. Vasari, VII, pp. 185–6.

41. Richardson, 1722, p. 219.

42. Schröter, op. cit. in n. 37.

43. D. Redig de Campos, 'Dei ritratti di Antonio Tebaldeo . . .', *Archivio della Società Romana di Storia Patria*, LXXV, 1952, pp. 51ff.

44. D. Redig de Campos, 'Il ritratto del poeta Ennio', *Roma*, XIII, 1935, pp. 193–200.

45. G. Hoogewerff, 'La Stanza della Segnatura', *Atti della Pontificia Accademia Romana di Archeologia* (Rendiconti), XXIII, 1947–9, p. 326.

46. Fischel, text p. 255, fig. 221, confirms that this does reflect Raphael's own design.

47. Bellori, p. 25.

48. Paris de Grassis, II, fol. 23; M. Creighton, *A History of the Papacy*, London 1897, V, pp. 201, 314.

49. Luzio, op. cit. in I, n. 6, p. 544.

50. British Library C.30.e.16 (broadsheet entitled *Silva Francisci Marii Grapaldi*—for Grapaldi's laurels; the portrait in his *De Partibus Aedium*, Parma 1516.

51. Paris de Grassis, III, fols. 251v–252.

52. Salvatore Settis, 'Roma 1513: Il gioco delle parti', *Storia d'Italia* (Annali 4: Intellettuali e Potere), Turin 1981, pp. 701–8.

53. E. Winternitz, 'Archeologia musicale del Rinascimento nel Parnaso di Raffaello', *Rendiconti della Pontificia Accademia Romana di Archeologia*, 1952–4, pp. 373ff.

54. Op. cit. in n. 25, p. 184.

55. Vasari, VII, p. 488–9 (Golzio, p. 260). Shearman, 1977, pp. 136–7, provides arguments for supposing that this may have been on a visit to Rome in 1506 or 1507.

56. G. Hoogewerff, 'A Pie del Parnaso', *Bollettino d'Arte*, XX, 1926–7, pp. 3ff.

57. Golzio, pp. 181–7.

58. Richardson, 1722, p. 221.

59. Vasari, IV, p. 339 (Golzio, p. 208), for Bramante.

60. G. Becatti, 'Raffaello e l'Antico' in *Raffaello*, ed. M. Salmi, Novara 1968, II, p. 522.

61. Richardson, 1722, p. 8.

62. For a daunting list of proposed identifications, see Passavant, I, pp. 120–32, and A. Springer, 'Raffaels Schule von Athen', *Die graphischen Kunste*, 1883 (especially the diagram on p. 87).

63. Ambrosiana, Milan (Fischel, VII, 313–44).

64. Vasari, IV, pp. 159, 331 (Golzio, pp. 236, 203).
65. Passavant, I. p. 128.
66. Golzio, p. 24.
67. Shearman, 1965, pp. 164–5.
68. E. Wind, 'Platonic Justice. Designed by Raphael', *Journal of the Warburg and Courtauld Institutes*, 1937/8, pp. 69–70.

NOTES TO CHAPTER IV

1. David Landau, 'Mantegna as Engraver' in *Prints by Mantegna and his School* (Catalogue of exhibition held at Christ Church Picture Gallery), Oxford 1979.
2. Vasari, VII, p. 431.
3. Ibid., V, p. 411 (Golzio, p. 245).
4. Fernanda Ascarelli, *La Tipografia Cinquecentina Italiana*, Florence 1953, pp. 62–4. But Baviera may be the Baviero Carocci of Parma, painter, mentioned in legal documents connected with Raphael in 1515—Golzio, p. 40.
5. Vasari, V, p. 414 (Golzio, p. 246) and p. 611 (not in Golzio).
6. Shearman, 1977, p. 128.
7. Vasari, V, p. 414 (Golzio, p. 246).
8. Ibid., IV, p. 339 (Golzio, p. 207); *Codice Magliabecchiano* (Golzio, pp. 173–4).
9. S. Béguin, et al., *La Madone de Lorette* (Les Dossiers du département des peintures, no. 19), Paris 1979—contribution of Cecil Gould.
10. Hirst, pp. 84–5.
11. Pouncey and Gere, I, p. 22.
12. Vasari, IV, pp. 341–2 (Golzio, p. 209).
13. Vasari, I, p. 539. Cf. H. von Einem, 'Raffael. Kritisches Verzeichnis', *Kunstchronik*, 1968, p. 24.
14. Dussler, p. 32 with bibliography.
15. Virginia Anne Bonito, 'The St Anne Altar in Sant'Agostino in Rome', *Burlington Magazine*, December 1980, pp. 805–12; May 1982, pp. 268–76.
16. F. Dante in *Dizionario Biografico degli Italiani*, and Cugnoni.
17. Sanuto, XV, cols. 163–4, 166, 227.
18. Cugnoni, n. 75.
19. Coffin, pp. 90–109.
20. Cugnoni, p. 62 and n. 102.
21. An early printed account is Hedrianus Junius (Adrien de Jonghe), *Animadversorum Libri Sex . . .*, Basle 1556, lib. iv, cap. 8, pp. 167–8.
22. Golzio, p. 23.
23. Ibid., p. 50.
24. Blosio Palladio, *Suburbanum Augustini Chisii*, Rome 1512, fol. B ii recto.
25. F. Saxl, *La Fede Astrologica di Agostino Chigi*, Rome 1934.
26. E.g. Palazzo Schifanoia, the Este *suburbanum* at Ferrara, and Lorenzo the Magnificent's *spedaletto* (for the last, see op. cit. in II, n. 12, p. 52).
27. A. M. Tantillo, 'Restauri alla Farnesina', *Bollettino d'Arte*, LVII, 1972, p. 35.
28. L. Dolce, *Dialogo della pittura intitolato l'Aretino*, Venice 1557, p. 46.
29. Agnolo Ambrogini (Poliziano), *Stanze cominciate per la Giostra di Giovanni de' Medici*, I, 115–18.
30. Hirst, pp. 84–5.
31. Op. cit. in n. 27, p. 35.
32. Ibid., pl. 9 (a map of *giornate*).
33. Charles Hope, *Titian*, London 1980, p. 59.
34. Golzio, pp. 30–1.
35. Many details in Philostratus do not correspond: his Galatea, for instance has four dolphins and hair which is too wet to be disturbed by the wind. For Palladio, see op. cit. in n. 24.
36. Letter of Fabio Chigi of 26 December 1626 in Cugnoni, n. 188.
37. Vasari, IV, pp. 340–1 (Golzio, pp. 208–9).
38. Michael Hirst, 'The Chigi Chapel in S. Maria Della Pace', *Journal of the Warburg and Courtauld Institutes*, 1961, pp. 161–85.
39. L. D. Ettlinger, 'A Note on Raphael's Sibyls in S. Maria della Pace', *Journal of the Warburg and Courtauld Institutes*, 1961, pp. 322ff.

40. Golzio, p. 37.
41. E.g. Louvre 3927.
42. Vasari, IV, pp. 340, 377 (Golzio, pp. 208, 227).
43. F. Bocchi, *Le Bellezze della Città di Firenze*, Florence 1591, pp. 129–30.
44. Barocchi and Ristori, II, pp. 206–7, 212–13.
45. Golzio, p. 32.
46. Parker 557v; and see op. cit. in n. 38, p. 168.
47. Vasari, IV, pp. 494–5 (Golzio, p. 238).
48. Collection of the late Dr Louis Clarke (Cambridge) and Uffizi 1475r—op. cit. in n. 38, pls. 31b and 32a.
49. Lille, Musée Wicar 439. The connection has not generally been appreciated, the stylus drawing indicating the position of the arms not being legible in photographs. The point was first noted in print in N. Nobis, *Lorenzetto als Bildhauer*, Bonn 1979, p. 257.
50. For the chapel in general, see Shearman, 1961, from which much of what follows is derived.
51. A contract of 1520 (Golzio, p. 126) implies that he had not.
52. C. L. Frommel, 'Das Hypogäum Raffaels unter der Chigikapelle', *Kunstchronik*, XXVII, 1974, pp. 344–8.
53. See also Shearman, 1961, p. 145.
54. See ibid., p. 142, for another view.
55. A possibility suggested by Parker, p. 309. For wax models owned by Fra Bartolomeo, see F. Knapp, *Fra Bartolommeo della Porta*, Halle A.S. 1903, pp. 275–6.
56. Shearman, 1961, pl. 23b.
57. Vasari, II, p. 598.
58. Golzio, p. 51.
59. Ibid., p. 149; C. Astolfi, *Raffaello Sanzio Scultore*, Rome 1955.
60. E. Loewy, 'Di alcune composizioni di Raffaello', *Archivio Storico dell'Arte*, 1896, pp. 246–51.
61. Vasari, IV, pp. 579–80.
62. Fra Mariano da Firenze, *Itinerarium Urbis Romae*, Rome 1931, p. 226.
63. Cugnoni, n. 188.

NOTES TO CHAPTER V

1. A. Luzio, 'Isabella d'Este di fronte a Giulio II', *Archivio Storico Lombardo*, XXXIX, 1912, p. 326, n. 1.
2. Shearman, 1971, p. 17.
3. Golzio, pp. 31–3.
4. Shulz, p. 48, n. 38.
5. Pastor, VI, pp. 595–7.
6. Paris de Grassis, II, fol. 24.
7. Pastor, VI, p. 418.
8. Ibid., p. 406.
9. Sanuto, XVI, cols. 29–30.
10. Raphael's source is Platina, op. cit. in VI, n. 41.
11. Donato in Sanuto, X, col. 369.
12. Pastor, VI, p. 322n.
13. Paris de Grassis, III, fols. 224–7.
14. Shearman, 1965, pp. 171–2.
15. Ibid., p. 173, n. 65; Paris de Grassis, IV, fol. 29v.
16. Shearman, 1965, p. 175 (acknowledging Rumohr).
17. Richardson, 1728, III, p. 385.
18. Cecil Gould, *The Studio of Alfonso d'Este and Titian's Bacchus and Ariadne*, London n.d., p. 19.
19. For the horse, etc., see Windsor 12,339.
20. Bellori, p. 40.
21. Vasari, IV, p. 342 (Golzio, p. 210).
22. Richardson, 1722, p. 206.
23. Op. cit. in IV, n. 38, pp. 172–3.
24. Richardson, 1722, pp. 236–7.
25. Dussler, pp. 36–7.
26. M. Putscher, *Raphaels Sixtinische Madonna*, Tübingen 1955, Taf. XXI.
27. Castiglione, *Il Cortegiano*, I, li.
28. *Aeneid*, III, 140–1.
29. Ibid., 147–52. This text, unlike that on the base of the term, was surely added as an afterthought, and there is a copy of the print in the British Museum (1863-1-10-72) without it.
30. Uffizi 525E. A counterproof from a red-chalk

drawing could have served as a reverse *modello* for the printmaker, but Raphael may have felt that red chalk was not a suitable medium for these light effects.
31. Golzio, pp. 31–2.
32. Castiglione, *Il Cortegiano*, I, xix.
33. Angelo Maria Bandini, *Il Bibbiena*, Livorno 1758, pp. 9–10.
34. Paolo Giovio, *Opere*, ed. R. Meregazzi, Rome 1972, VIII, p. 90.
35. Pastor, VII, pp. 84–7; Sanuto, XV, cols. 40–1.

NOTES TO CHAPTER VI

1. Paris de Grassis, V, fol. 91 (discussed in Shearman, 1972, p. 10).
2. Pastor, VIII, pp. 147–8n; Shearman, 1972, p. 13.
3. Shearman, 1972, p. 109, n. 67.
4. Ibid., pp. 3, 38.
5. Michiel in Golzio, pp. 103–4 (see also Shearman, 1972, p. 13, n. 77).
6. Giovio in Golzio, pp. 193–4 (referring also to expenditure on Leo's private apartments).
7. Luke 5 : 1–11.
8. Matthew 16 : 13–20.
9. John 21.
10. Acts 3 :1–11.
11. Shearman, 1972, pp. 56–7, 80, offers an alternative symbolic interpretation.
12. Acts 4 : 34–7; 5 : 1–11.
13. Shearman, 1971, p. 21ff.
14. C. L. Eastlake, *Contributions to the Literature of the Fine Arts*, London 1848, pp. 285–6. Eastlake already had a good idea of how the tapestries must have been intended to hang. Ibid. p. 253.
15. Acts 7 : 54–60.
16. Acts 9 : 1–9.
17. Acts 13 : 1–13.
18. Acts 14 : 8–16.
19. Acts 17 : 16–34.
20. Vasari, IV, p. 370 (Golzio, p. 224).
21. S. J. Freedberg, *Painting of the High Renaissance in Rome and Florence*, Cambridge (Mass.) 1961, I, p. 285.
22. Alberti, *De Pictura*, II, 40 (ed. C. L. Grayson, London 1972, pp. 78–9).
23. Joshua Reynolds, *Discourses*, ed. R. Wark, New Haven and London 1975, pp. 154–5, 216.
24. Golzio, p. 36.
25. Op. cit. in n. 21, p. 285.
26. John Ruskin, *Collected Works*, ed. Cook and Wedderburn, XXIV, p. 248.
27. *The Diary of Joseph Farington*, ed. K. Garlick and A. Macintyre, New Haven and London 1979, III, p. 787 (5 March 1797).
28. S. Mossakowski, 'Raphael's St Cecilia', *Zeitschrift für Kunstgeschichte*, 1968, pp. 2–4, for the choice of saints. For Elena's life, see Giovambattista Melloni, *Atti, o memorie degli uomini illustri in santità, nati, o morti in Bologna*, III, 1780, pp. 300–86 (especially pp. 317–19 for her marriage and p. 332, n. 13, for the relic).
29. Melloni, op. cit. in n. 28, pp. 328, 344, 346.
30. A curious precedent is provided by an altarpiece by 'Botticini' (National Gallery 227).
31. Vasari, IV, pp. 370, 644 (Golzio, pp. 224, 240).
32. Op. cit. in n. 53, II, p. 166.
33. Vasari, VI, p. 551 (Golzio, p. 258).
34. Golzio, p. 32.
35. Ibid., p. 54.
36. Ibid., p. 56. Golzio does not identify the room as the Stanza dell'Incendio, but see Shearman, 1971, pp. 21–2.
37. Golzio, p. 57.
38. Giovio in ibid., p. 192.
39. Shearman, 1971, pp. 21–2 (also nn. 129, 142–5).
40. Pastor, VIII, pp. 144, 151.
41. Platina, *Historia de Vitis Pontificum*, Paris 1505, fol. cxxx (trans. Paul Rycaut, London 1688, p. 162).
42. The ultimate source is the *Liber Pontificalis* (ed. Duchesne, Paris 1892, II, pp. 7, 111, 117).
43. Narrative connections have, however, been ingeniously proposed by Shearman, 1971, p. 22.

44. Op. cit. in n. 41, fol. cxxi verso (Rycaut, p. 151).
45. Pastor, VII, pp. 71–2.
46. Ibid., p. 146.
47. Ibid., pp. 158, 213ff—also K. M. Setton, *Proceedings of the American Philosophical Society*, 1969, pp. 367ff.
48. Op. cit. in n. 41, fol. cxxxi (Rycaut, p. 163).
49. Shearman, 1971, p. 58, n. 151—citing *Liber Pontificalis*.
50. Richardson, 1722, p. 240.
51. Ibid., p. 241.
52. Bartsch, XV, p. 94, no. 60.
53. Giovio in Golzio, p. 192.
54. Bellori, p. 45.
55. [F. M. Valeri], 'Nuovi documenti', *Archivio Storico dell'Arte*, VII, 1894, pp. 367–8; Melloni, op. cit. in n. 28, pp. 358–9n. The drawing may date from before the completion of the chapel's architecture in 1514, because the lighting in the drawing is not calculated in relation to the window which would in fact be the chief source of illumination.
56. Vasari, III, pp. 546–7 (Golzio, p. 234–5), says that Francia died in 1518, but Zanotti provides (in his 1841 edition of C. Malvasia's *Felsina Pittrice*, I, p. 46 n. 3) evidence that he died on 6 January 1517. The patroness presented the altar to the Lateran fathers on 9 September 1516 (see sources cited in n. 55) and this was perhaps as soon as it was furnished with the painting.
57. Vasari, V, p. 224 (Golzio, p. 244).
58. Konrad Oberhuber, 'Die Fresken der Stanza dell'Incendio', *Jahrbuch der Kunsthistorischen Sammlungen in Wien*, LVIII, 1962, p. 24.
59. Shearman, 1971, p. 9.
60. Vasari, VI, p. 555—cf. IV, p. 362 (Golzio, pp. 258–9, 221).
61. Shearman, 1971, pp. 7–8.
62. Vasari, VI, p. 555 (Golzio, pp. 258–9).

NOTES TO CHAPTER VII

1. Golzio, pp. 43–4.
2. Ibid., p. 171.
3. E.g. Ugolino Verino's poem on Filippino Lippi's portrait of Piero del Pugliese, in A. Scharf, *Filippino Lippi*, Vienna 1935, p. 92.
4. Vasari, IV, p. 335 (Golzio, p. 206); D. Redig de Campos, 'Dei ritratti di Antonio Tebaldeo e di alcuni altri nel "Parnaso" di Raffaello', *Archivio della Società Romana di Storia Patria*, LXXV, 1952, pp. 51ff.
5. R. Signorini, 'Federico III e Cristiano I nella Camera degli Sposi di Mantegna', *Mitteilungen des Kunsthistorischen Institutes in Florenz*, XVIII, 1974, pp. 227–50.
6. Golzio, p. 24; Vasari, IV, p. 331 (Golzio, p. 203).
7. Golzio, p. 26.
8. Ibid., pp. 27–8.
9. Ibid., pp. 171–2, for the portrait. For the beauty, P. Aretino, *Sei Giornate*, Bari 1969, p. 310.
10. C. Gould, *Raphael's Portrait of Julius II*, London [1970].
11. Vasari, IV, p. 338 (Golzio, p. 207); Sanuto, XVII, col. 60.
12. Barocchi and Ristori, I, p. 13.
13. Shearman, 1972, p. 13.
14. For some suggestions, see L. Partridge and R. Starn, *A Renaissance Likeness, Art and Culture in Raphael's Julius II*, London 1980.
15. Dussler, p. 34.
16. A. Luzio, 'Isabella d'Este nei primordi del papato di Leone X', *Archivio Storico Lombardo*, XXXIII, 1906, p. 136.
17. Vasari, V, pp. 41–2 (Golzio, p. 242).
18. A. Rugiadi, *Tommaso Fedra Inghirami*, Amatrice 1933, p. 26.
19. Something very noticeable in his ex-voto painting in the Lateran, illustrated by Weiss, pl. 7.
20. K. Clark, *Piero della Francesca*, London 1951, pl. 104.
21. Pliny the Elder, *Natural History*, XXXV, 90.
22. J. Shearman, 'Le Portrait de Baldassare Castiglione par Raphaël', *Revue du Louvre*, XXIX, 1979, pp.
261–70; for an illustration of a copy (?) of the earlier portrait, see M. Imdahl, 'Raffaels Castiglionebildnis im Louvre', *Pantheon*, XX, 1962, p. 44 and fig. 7.
23. Vasari, IV, pp. 353–4 (Golzio, p. 216).
24. G. F. Hill, *A Corpus of Italian Medals of the Renaissance before Cellini*, London 1930, no. 1158.
25. Hirst, pl. 49.
26. C. Hope, *Titian*, London 1980, pp. 62ff.
27. Golzio, p. 43.
28. Redig de Campos, op. cit. in n. 4, pp. 57–8.
29. Golzio, p. 43.
30. For an illustration of what may have been a copy of it, see Shearman, op. cit. in n. 22, fig. 9.
31. P. Bembo, *Lettere*, Rome 1548, pp. 83–4 (partly quoted in Golzio, p. 42).
32. Golzio, p. 162.
33. J. Pope-Hennessy, *The Portrait in the Renaissance*, Princeton 1966, pp. 92ff.
34. For the identifications, see Vasari, IV, pp. 337, 360 (Golzio, pp. 207, 219).
35. F. de' Maffei, 'Il ritratto di Giuliano, fratello di Leone X, dipinto da Raffaello', *L'Arte*, N.S.XXIV, 1959, pp. 309ff.
36. Golzio, p. 65.
37. K. Oberhuber, 'Raphael and the State Portrait: II. The Portrait of Lorenzo de' Medici', *Burlington Magazine*, CXIII, 1971, pp. 436–43; J. Beck, 'Raphael and Medici "State Portraits"', *Zeitschrift für Kunstgeschichte*, XXXVIII, 1975, pp. 127–44.
38. Golzio, pp. 76–7.
39. Oberhuber, op. cit. in n. 37.
40. A. Parronchi, 'La prima rappresentazione della Mandragola', *La Bibliofilia*, LXIV, 1962, p. 52.
41. Golzio, p. 67; R. Sheer, 'A New Document concerning Raphael's Portrait of Leo X', *Burlington Magazine*, CXXV, 1983, pp. 31–2.
42. Vasari, V, p. 41 (Golzio, p. 242).
43. Ibid., IV, p. 352 (Golzio, p. 215).
44. P. Wescher, *Beschreibendes Verzeichnis der Miniaturen des Kupferstichkabinetts der staatlichen Museen Berlin*, Leipzig 1931, pp. 54–61.
45. F. R. Shapley, *National Gallery of Art: Catalogue of the Italian Paintings*, Washington, D.C. 1979, no. 534. For the ownership of the *Madonna dell'Impannata*, see C. Avery, 'Benvenuto Cellini's Bronze Bust of Bindo Altoviti', *Connoisseur*, CXCVIII, [May] 1978, p. 69.
46. Hirst, p. 100.
47. Barocchi and Ristori, II, p. 32.
48. E.g. Titian's *La Bella*, discussed by Hirst, p. 93.
49. Vasari, IV, p. 365 (Golzio, p. 222).
50. G. Masson, *Courtesans of the Italian Renaissance*, London 1975, p. 146.
51. L. Ferrai, *Lettere di cortigiane del secolo XVI*, Florence 1884, pp. 81ff.
52. Aretino, op. cit. in n. 9, p. 311.
53. E. Ridolfi, 'Di alcuni ritratti delle gallerie fiorentine', *Archivio Storico dell'Arte*, IV, 1891, pp. 441ff.
54. D. Brown and K. Oberhuber, 'Monna Vanna and Fornarina: Leonardo and Raphael in Rome', *Essays presented to Myron P. Gilmore*, Florence 1978, II, p. 55.
55. Hirst, p. 96.
56. Dussler, p. 32.
57. J. P. Richter (ed.), *The Literary Works of Leonardo da Vinci*, Oxford 1939, I, p. 64.
58. C. Gould, 'Raphael versus Giulio Romano: The Swing Back', *Burlington Magazine*, CXXIV, 1982, p. 484. For more on the differences, see op. cit. in n. 54.
59. E.g. T. Pignatti, *Giorgione*, London 1971, pls. 106, 110, 131, and the notes on pictures like this by Marcantonio Michiel, ibid., p. 166.
60. For the leaves, the X-ray and the shutters, see op. cit. in n. 54. For a recent discussion of courtesan portraits, see H. Ost, 'Tizians sogenannte "Venus von Urbino" und andere Buhlerinnen', *Festschrift für Eduard Trier zum 60 Geburtstag*, Berlin 1981, pp. 129–49.
61. Vasari, III, p. 169.
62. I.e. Fischel, I, nos. 1, 38 (Parker no. 515; Pouncey and Gere, no. 1); Hampton Court, no. 710 (Dussler,
p. 60); Munich, Alte Pinakothek, no. 1059 (Dussler, p. 62); Vasari, IV, p. 332 (Golzio, p. 203).
63. Dussler, pp. 41–2. The image was also used for the frontispiece of Bellori.
64. Bonasone, Bartsch, XV, 347.

NOTES TO CHAPTER VIII

1. Luzio, op. cit. in I, n. 6, pp. 540–1 (partially in Golzio, p. 26).
2. Golzio, p. 53.
3. Ibid., p. 54.
4. Ibid., p. 55.
5. Ibid. For the Palatine cardinals, see Sanuto, XX, col. 193.
6. Golzio, pp. 76–7.
7. Ibid, pp. 92–3.
8. Ibid., p. 94.
9. Ibid., pp. 105–6.
10. Ibid., p. 122–5.
11. Ibid., p. 77.
12. Pastor, VII, pp. 75–6 with bibliography.
13. Golzio, p. 47.
14. Vasari, V, p. 411 (Golzio, p. 245).
15. *The Triumph of Humanism* (Fine Arts Museums), San Francisco 1977, nos. 95, 110; *Le Triomphe du manièrisme européen de Michel-Ange au Greco*, Amsterdam 1955, no. 488.
16. SORDENT PRAE FORMA INGENIUM VIRTUS REGNA AURUM. The translation was kindly supplied by John Sparrow.
17. Cf. W. M. Ivins, *How Prints Look*, New York 1943, p. 94, who however suggested that burnishing preceded engraving.
18. Op. cit. in III, n. 60, II, p. 660.
19. Op. cit. in IV, n. 60, pp. 241–51; op. cit. in III, n. 60, II, p. 517.
20. For the provenance of an original drawing, see the note by 'J.E.' to the anonymous English edition of Dolce's 'Aretin' (1770, p. 187).
21. Lucian, *Herodotus or Aëtion*, 5–7.
22. Op. cit. in IV, n. 28, p. 46.
23. *Aeneid*, I, 135–9 (trans. Dryden, I, 193–7).
24. Vasari, IV, p. 25; Windsor 12,570.
25. Lawrence Nees, 'Le Quos Ego de Marc-Antoine Raimondi', *Nouvelles de l'Estampe*, 1978, pp. 18–22.
26. Iloneus has also been suggested—i.e. lines 520ff rather than 595ff.
27. Francesco Barberi, *Il frontespizio nel libro Italiano del quattrocento e del cinquecento*, Milan [1969], I, p. 132, discusses early Italian frontispieces.
28. For the Belriguardo pictures, see the account in *Giovanni Sabadino degli Arienti's Art and Life at the Court of Ercole I d'Este*, ed. W. Gundersheimer, Geneva 1972, pp. 21–2, 62–5. Venetian pictures of this subject are described very prominently by Carlo Ridolfi as by Giorgione in his life of that artist in *Le Maraviglie dell'Arte* of 1648 (I, pp. 84–7), but they may be of later date than Raphael's.
29. Shearman, 1964, pp. 62–4.
30. Aretino in Golzio, p. 286; cf. op. cit. in IV, n. 28, p. 8.
31. 'Del qual sono allievo'—Aretino in Golzio, pp. 286–7 (for the context, see Aretino, *Lettere sull'Arte*, ed. E. Camesasca, I, p. 198).
32. Golzio, p. 65; Barocchi and Ristori, II, p. 138.
33. Vasari, IV, p. 366 (Golzio, p. 223).
34. Richardson, 1722, p. 119.
35. Cugnoni, p. 77.
36. Luisa Vertova, 'Cupid and Psyche in Renaissance Painting before Raphael', *Journal of the Warburg and Courtauld Institutes*, 1979, pp. 104–21.
37. Andrée M. Hayum, 'A New Dating for Sodoma's Frescoes in the Villa Farnesina', *Art Bulletin*, 1966, pp. 215–17.
38. See the drawing by de Hollanda reproduced in op. cit. in III, n. 25, pl. 4.
39. Vasari, VI, p. 550 (not in Golzio); cf. III, n. 20.
40. Ibid., VI, p. 558 (not in Golzio).
41. Aretino, edition cited in n. 31, I, p. 110.

42. Paolo Giovio, *Lettere Volgari*, ed. L. Domenichini, Venice 1560, pp. 14v–15r.
43. Shearman, 1964, pp. 68–9.
44. Bel</br>lori, p. 77.
45. Golzio, pp. 67–8.
46. Shearman, 1964, p. 90.
47. C. Malvasia, *Felsina Pittrice*, Bologna 1678, I, p. 44, cited a payment of 80 ducats to Raphael in 1510, but it might have been for something else.
48. The interpretation is mentioned as standard by Calvin who rejected it—see his commentaries on Ezekiel (trans. Thomas Myers, I, Edinburgh 1849, pp. 63–4) and for other interpretations, W. J. Schröder, *The Book of the Prophet Ezekiel*, Edinburgh 1876, p. 41.
49. Pastor, VIII, pp. 223–4 and bibliography.
50. Baptista Mantuanus, *De Sacris diebus*, Milan 1540, pp. 64–5, 225–7.
51. For the provenance of this picture, see Louis Hourticq, 'Un amateur de curiosités sous Louis XIV', *Gazette des Beaux-Arts*, XXXIII, 1905, pp. 237–42.
52. Tilmann Buddensieg, 'Raffaels Grab' in *Munuscula Discipulorum* (Kunsthistorische Studien Hans Kauffmann zum 70), ed. Buddensieg and Winner, Berlin 1968, pp. 64–6.
53. Schulz, p. 47 with bibliography.
54. Ibid., pp. 47–8.
55. Vasari, V, p. 203.
56. Ibid., VI, p. 552.
57. Op. cit. in V, n. 33, p. 50.
58. Golzio, pp. 45, 48.
59. Ibid., pp. 44–5.
60. Ibid., pp. 43–4. The paintings are catalogued by Passavant, II, pp. 228–33. For Raphael's part here, see Oberhuber, p. 141, and for the Venus in particular, p. 144 (no. 453), and Pouncey and Gere, no. 282.
61. Golzio, p. 100.
62. Ibid., p. 98.
63. Ibid., p. 68.
64. Ibid., p. 104.
65. Ibid., p. 98—cf. Giovio in ibid., pp. 193–4.
66. Vincenzo Tamagni, Pellegrino da Modena, Tommaso Vincidor.
67. Vasari, IV, pp. 362–3, 490, 650; V, pp. 142, 524, 594; VI, p. 552.
68. Ibid., IV, p. 362; V, p. 524 (Golzio, pp. 221, 248). For recent assessments of the problem, see op. cit. in III, n. 23; also Oberhuber, pp. 147–82.
69. Pouncey and Gere, no. 65, and for Penni in general, pp. 50–1.
70. Vasari, IV, p. 384 (Golzio, pp. 230–1).

NOTES TO CHAPTER IX

1. Golzio, p. 79.
2. *Ibid.*, pp. 281–2.
3. *Ibid.*, pp. 79–80, 113, 192, 232.
4. Fol. Bii recto, quoted by F. Castagnoli, 'Raffaello e le antichità di Roma', in M. Salmi et al., *Raffaello*, Novara 1968, II, p. 576.
5. Golzio, pp. 78ff; Shearman, 1977, p. 137 and n. 55.
6. R. Valentini and G. Zucchetti, *Codice topografico della città di Roma*, Rome 1953, IV, pp. 209–22.
7. K. Clark and C. Pedretti, *The Drawings of Leonardo da Vinci in the Collection of Her Majesty the Queen at Windsor Castle*, London 1968, I, no. 12284.
8. First suggested by R. Lanciani, 'La pianta di Roma antica e i disegni archeologici di Raffaello Sanzio', *Rendiconti della Reale Accademia dei Lincei, Classe di Scienze Morali Storiche e Filologiche*, Ser. V, III, 1894, pp. 791 ff.
9. G. Zorzi, 'Due schizzi archeologici di Raffaello', *Palladio*, II, 1952, pp. 171–5; Burns, et al., p. 263.
10. C. Huelsen, *Il Libro di Giuliano da Sangallo*, Leipzig 1910, pp. 34–5.
11. E.g. Francesco di Giorgio Martini, *Trattati*, ed. C. Maltese, Milan 1967, I, p. 277 and Tav. 133.
12. Vasari, IV, p. 154.
13. Golzio, p. 32. The 'Letter to Fabio Calvo of August 1514' (Golzio, pp. 34–5) has not been used in this

account on the grounds that it is probably a forgery (Shearman, 1977, n. 68).
14. V. Fontana and P. Morachiello, *Vitruvio e Raffaello*, Rome 1975.
15. Golzio, p. 161.
16. Weiss, p. 88.
17. Munich (Inv. 2460), illustrated in O. Fischel, *Raphael*, London 1948, pl. 217.
18. Golzio, pp. 175–6.
19. A different purpose is suggested by A. Nesselrath, 'Antico and Monte Cavallo', *Burlington Magazine*, CXXIV, 1982, p. 357.
20. Weiss, p. 30.
21. Ibid., p. 158.
22. Golzio, pp. 38–40. An English translation is given in R. Klein and H. Zerner, *Italian Art, 1500–1600*, New Jersey 1966, pp. 44–5.
23. Fol. clxv verso, quoted by E. Müntz, 'Raphael archeologue et historien d'art', *Gazette des Beaux-Arts*, XXII, 1880, p. 9 of the offprint.
24. Golzio, pp. 72–3.
25. R. Lanciani, *Storia degli scavi di Roma*, Rome 1902, I, p. 195.
26. Shearman, 1977.

NOTES TO CHAPTER X

1. P. Rotondi, *Il Palazzo Ducale di Urbino*, Rome 1951.
2. E.g. Fischel, I, no. 6.
3. See also Fischel, I, no. 3.
4. G. Marchini, 'Le Architetture' in M. Salmi, et al., *Raffaello*, Novara 1968, II, p. 432.
5. E. Rosenthal, 'The Antecedents of Bramante's Tempietto', *Journal of the Society of Architectural Historians*, XXIII, 1964, pp. 55–74; H. Burns, 'Progetti di Francesco di Giorgio per i conventi di San Bernardino e Santa Chiara di Urbino' in *Studi Bramanteschi*, Rome 1974, pp. 293ff.
6. J. Shearman, 'Raphael . . . "Fa il Bramante"' in *Studies in Renaissance and Baroque Art presented to Anthony Blunt*, London 1967, pp. 12–17.
7. Vasari, V, p. 350 (Golzio, p. 244).
8. E.g. E. Borsook, *The Mural Painters of Tuscany*, Oxford 1980, pl. 140.
9. E. Camesasca, *Tutta la pittura del Perugino*, Milan 1959, pls. 70–3.
10. This would be still more true of the diagram beneath the draped figure in Plate 76, if, as is possible, it is a study for the perspectival diminution of figures in the *Disputa*.
11. Fischel, V, no. 219.
12. Dussler, pl. 61; Shearman, 1977.
13. J. Wilde, *Italian Drawings in the Department of Prints and Drawings in the British Museum: Michelangelo and his Studio*, London 1953, pp. 31ff.
14. Vasari, IV, p. 361 (Golzio, p. 220).
15. Bartsch, XV, 31.4. For drawings of architecture in France, see Golzio, p. 176.
16. Shearman, 1977.
17. We have not been able to trace the source of this much quoted observation.
18. Shearman, 1965, p. 169.
19. Golzio, pp. 93–4.
20. K. Badt, 'Raphael's "Incendio del Borgo"', *Journal of the Warburg and Courtauld Institutes*, XXII, 1959, pp. 35ff; Shearman, 1972, pp. 130–1; C. L. Frommel, 'Raffaello e il teatro alla corte di Leone X', *Bollettino del Centro Internazionale di Studi di Architettura Andrea Palladio*, XVI, 1974, pp. 173–87.
21. C. L. Frommel, *Die Farnesina und Peruzzis architektonisches Frühwerk*, Berlin 1961, pp. 163ff.
22. Cugnoni, p. 63, cited by Frommel, p. 168, in his fundamental account of the Chigi stables.
23. Op. cit. in n. 6, p. 16, n. 33.
24. Burns, et al., p. 207.
25. Op. cit. in n. 6, p. 16, n. 33.
26. Cugnoni, p. 67.
27. See Antonio da Sangallo's drawing (Uffizi no. 1157A), illustrated in A. Bartoli, I Monumenti Antichi di Roma, III, Rome 1917, pl. cciv.

28. Cugnoni, n. 174.
29. For these, and the previously mentioned marbles, see R. Gnoli, *Marmora Romana*, Rome 1971; D. Gnoli, 'La Sepoltura di Agostino Chigi', *Archivio Storico dell'Arte*, II, 1889, pp. 317ff. The *verde antico* of the sarcophagi is a contribution of Bernini, who was also responsible for the balustrade.
30. Shearman, 1972, p. 31.
31. Vasari, IV, p. 363 (Golzio, p. 221).
32. Golzio, p. 100.
33. Ibid., p. 30.
34. Ibid., p. 33.
35. Ibid., p. 36.
36. Vasari, V, p. 454; VII, pp. 497f (Golzio, p. 261).
37. W. Wanscher, *Raffaello Santi da Urbino*, London 1926, p. 183.
38. Vasari, V, pp. 266–7 (Golzio, p. 244).
39. For the whole question, see W. Lotz, 'The Rendering of the Interior in Architectural Drawings of the Renaissance' in *Studies in Italian Renaissance Architecture*, London 1977, pp. 1–41.
40. Vasari, VII, pp. 218–19.
41. See the drawings illustrated and discussed (with the others for St Peter's) in Franz Graf Wolff Metternich, *Die Erbauung der Peterskirche zu Rom im 16. Jahrhundert*, Vienna 1972, pls. 62, 87.
42. Frommel, I, pp. 54ff.
43. F. Albertini, *Opusculum de mirabilibus novae et veteris urbis Romae*, Rome 1510, fol. Oiv verso.
44. A. Condivi, *Vita di Michelagnolo Buonarroti*, Milan 1964, p. 51.
45. A. Bruschi, *Bramante architetto*, Bari 1969, pp. 935–6.
46. Golzio, p. 101.
47. Frommel, esp. II, pp. 45ff.
48. Vasari, IV, p. 160.
49. Frommel, esp. II, pp. 13ff.
50. Vasari, VI, p. 555.
51. Ibid., IV, p. 490 (Golzio, p. 238).
52. This is particularly clear in Frommel, III, plate 8d.
53. Dussler, pl. 110.
54. For this aspect of the Sistine ceiling, see S. Sandstroem, *Levels of Unreality*, Uppsala 1963, pp. 173ff.
55. John Shearman, *Mannerism*, Harmondsworth 1967, pp. 76–7; and 'Raphael as Architect', *Journal of the Royal Society of Arts*, CXVI, 1968, p. 388ff.
56. A succession which Raphael used more literally for the orders of the loggia wall of the palace courtyard—see Plate 243.
57. Vasari, IV, p. 9.
58. The so-called Crypta Balbi. See Shearman, op. cit. in n. 55, 1968, p. 400.
59. Frommel, III, pls. 7c, 9a.
60. Frommel, esp. II, pp. 355ff.
61. Vasari, V, p. 351.
62. Golzio, p. 40; Frommel, II, p. 265.
63. Frommel, II, pp. 80ff.
64. Ibid., pp. 263ff.
65. E. Rosenthal, 'The House of Andrea Mantegna in Mantua', *Gazette des Beaux-Arts*, LX, 1962, pp. 327ff.
66. Frommel, I, p. 3.
67. Ibid., esp. II, pp. 327ff.
68. Ibid., I, pp. 18ff.
69. Golzio, pp. 77–8 (where the document is wrongly interpreted as showing that Raphael was himself one of the *maestri di strada*).
70. Coffin, pp. 245ff.
71. Shearman, op. cit. in n. 6, and in Burns, et al., p. 264; H. Macandrew, *Ashmolean Museum Oxford: Catalogue of the Collection of Drawings*, III (Italian Schools—Supplement), Oxford 1980, p. 279.
72. Coffin, pp. 261ff.
73. P. Foster, 'Raphael on the Villa Madama: The Text of a Lost Letter', *Römisches Jahrbuch für Kunstgeschichte*, XI, 1967–8, pp. 307–12.
74. The drawings are discussed in Burns, et al., pp. 264–5, and C. L. Frommel, 'Die architektonische Planung der Villa Madama', *Römisches Jahrbuch für Kunstgeschichte*, XV, 1975, pp. 59–87.
75. Frommel, op. cit. in n. 74, p. 66.
76. R. Lefevre, 'Un prelato del '500: Mario Maffei e la

costruzione di Villa Madama', *L'Urbe*, XXXII, May–June 1969, pp. 6–7.

77. Vitruvius, *De architectura*, V, vi.

78. N. Neuerberg, 'Raphael at Tivoli and the Villa Madama', *Essays in Memory of Karl Lehmann*, New York 1964, pp. 227–31.

79. Coffin, p. 252.

80. Frommel, op. cit. in n. 74, pp. 62, 79.

81. L. Heydenreich, 'Federico da Montefeltro as a Building Patron' in *Studies in Renaissance and Baroque Art presented to Anthony Blunt*, London 1967, pp. 1ff.

82. Frommel, op. cit. in n. 74.

83. J. Ackerman, 'The Belvedere as a Classical Villa', *Journal of the Warburg and Courtauld Institutes*, XIV, 1951, pp. 70–91; and *The Cortile del Belvedere*, Vatican City 1954.

84. This is still true, even if his design is compared with that of the 'Nymphaeum' at Gennazzano, which may have influenced Raphael and was perhaps designed by Bramante (Coffin, pp. 243–5).

85. Burns, et al., no. 163.

86. Coffin, p. 254.

87. *Ibid.*, p. 246.

NOTES TO CHAPTER XI

1. Bartsch, XIV, 28.

2. Vasari, IV, p. 358 (Golzio, p. 218).

3. Golzio, p. 53.

4. Sanuto, XXXI, col. 576.

5. Vasari, IV, pp. 371–2, 378 (Golzio, pp. 224–5, 227).

6. Fabrizio Mancinelli, 'La Trasfigurazione' in Bruno Santi, *Raffaello*, Florence 1977, p. 74.

7. Hirst, pp. 66–8.

8. Op. cit. in n. 6.

9. Vasari, IV, p. 383; V, p. 570 (Golzio, pp. 230, 252).

10. Konrad Oberhuber, 'Vorzeichnungen zu Raffaels "Transfiguration"', *Jahrbuch der Berliner Museen*, IV, 1962, p. 116.

11. Shearman, 1972, pp. 77–9; Hirst, p. 68.

12. Op. cit. in X, n. 76.

13. Op. cit. in VIII, n. 50, pp. 152–3.

14. Luke 9 : 31–2.

15. E. H. Gombrich, 'The Ecclesiastical Significance of Raphael's *Transfiguration*', *Ars Auro Prior— Studia Joanni Bialostocki Sexagenario Dicata*, Warsaw 1981, pp. 241–3.

16. H. Von Einem, 'Die "Verklärung Christi" und "Heilung des Besessenen" von Raffael', *Abhandlungen der Wissenschaften und der Literatur Mainzer Akademie*, 1966, pp. 299ff.

17. Golzio, p. 125.

18. Vasari, V, p. 570 (Golzio, p. 252).

19. Golzio, p. 128.

20. Ibid., pp. 129–32.

21. Giovio in ibid., p. 192.

22. Rolf Quednau, *Die Sala di Constantino in Vatikanischen Palast*, Hildesheim and New York 1979, pp. 44–70.

23. Vasari, IV, pp. 369, 645; V, pp. 527–8 (Golzio, pp. 224, 241, 250–1). See also the observations in Shearman, 1965, p. 177.

24. Oberhuber, no. 485.

25. Shearman, 1965, pp. 179–80; Oberhuber, no. 478.

26. Shearman, 1965, p. 178, n. 91.

27. Vasari, IV, p. 378 (Golzio, p. 227).

28. Ibid., IV, pp. 381–2 (Golzio, pp. 228–9).

29. Golzio, pp. 113–15; also Sanuto, XXVIII, cols. 424–5.

30. Golzio, p. 116; and op. cit. in VIII, n. 52, pp. 45ff.

NOTES TO THE APPENDIX

1. For the Italian text, see op. cit. in X, n. 73. Number references in parentheses are to Plate 253.

2. Raphael, like other Italians of his day, indicated directions by using the names of winds, e.g. *scirocco*. Except in the sentence that follows, we have translated these into points of the compass, i.e. north, south, etc.

3. Literally 'to expose it to healthier winds'.

4. 1 *canna* = 2.23m.

5. 1 *palmo* = .223m.

6. I.e. in proportion of 3 : 4.

Photographic Acknowledgements

Index